DIVIDED

Published in the United Kingdom by Divided in association with Dia Art Foundation, dépendance gallery and Galleria Nazionale d'Arte Moderna e Contemporanea.

Divided Publishing
Avenue Louise 251, level 2
1050 Brussels
www.divided.online

Dia Art Foundation
535 West 22nd Street
New York, NY 10011
www.diaart.org

dépendance gallery
Varkensmarkt 4 Rue du Marché aux Porcs
1000 Brussels
www.dependance.be

Galleria Nazionale d'Arte Moderna e Contemporanea
Viale delle Belle Arti 131
00197 Rome
www.lagallerianazionale.com

Front cover design by Allison Katz
Printed by Graphius Brussels

ISBN 978-1-9164250-8-8

Carla Lonzi

Self-portrait

Accardi	Alviani	Castellani	Consagra
Fabro	Fontana	Kounellis	Nigro
Paolini	Pascali	Rotella	Scarpitta
	Turcato	Twombly	

CONTENTS

Translator's note

Carla Lonzi was always interested in letting the artist and the works speak for themselves. *Self-portrait*, a collection of recorded and transcribed interviews with fourteen artists made between 1962 and 1969, continually challenges the very notion of the artist or writer – or translator – at work in a capitalist patriarchal society. It asks how to go on in an environment so hostile to creativity (it is frustrating that, over fifty years after its publication, many of the problems and barriers to making works of art persist, and have in some cases worsened). The result is deceivingly simple, filled with chatter, non sequiturs, fillers, gaffes and gossip. Initially it feels like eavesdropping on a very personal studio visit.

Most artist interviews published today have been cleaned up, edited, made coherent. Here the artists jump from topic to topic and change their mind mid-sentence: following them becomes an adventure that carries the reader to unexpected places. Lonzi transcribed every utterance, every sigh, every 'ha'. This translation attempts to keep this spoken nature of the text and to bring it into English with clarity and fluidity while allowing Italian rhythms and structures to rise to the surface – to allow English to perform Italian voices. To anglicise the conversation or to polish it felt to me disloyal; this is a live record, not perfect Italian literary prose.

The artists speak openly, carrying their prejudices into the conversation: certain of them at times make sexist and racist comments. Mimmo Rotella speaks explicitly about his conception of female sexuality and what he believes women need in terms of eroticism; Pino Pascali expresses his view of 'Negro art' as something primitive and pure. Such passages remain. I believe that translators are stewards of culture:

here that means presenting the realities of 1960s Italian speech and the legacy of patriarchal–colonial Eurocentrism that it evidences.

At the beginning of the text Lonzi, Accardi, Fabro and Kounellis discuss the role and behaviour of the critic – he is always male, bourgeois, power-hungry. The artist is also always assumed to be male: men compare themselves to other men, whether that's Consagra talking about Raphael, or Fontanta discussing Manzù, or the great pride with which he talks about Manzoni's experimentalism, and his own. While in my own writing I use 'they' as a third-person singular, I felt it was important here to retain the 'he', both for historical accuracy and to highlight the ubiquity and normativity of machoism in Lonzi's world. By pushing back against this impersonal 'he', Lonzi shows us what she was up against. She was attempting to dismantle the idea of the male artist-genius: showing the artists' ignorance is integral to that process.

There are some factual errors that have been carried over from the original; these have been reproduced in various editions and I have kept them as they are – they represent the way a given artist (mis)remembers something, and as this is a recording of a conversation, I remained true to that conversation and the inaccuracies of spontaneous speech.

It goes without saying, perhaps, that this translation – like all translations – is an iteration. It reflects my reading and inhabiting of Lonzi's work over many years, and the process of solidifying my own understanding of the text over time. The work remade the shapes of my particular language, and thus remade me. Lonzi is a complex writer, a complex figure, and I wanted to be as true to her voice and pursuit as possible, and, in my own way, to participate in it.

<div align="right">Allison Grimaldi Donahue, October 2021</div>

Self-portrait

Carla Lonzi

Introduction

This book emerges from the collection and rearrangement of discussions with some artists. Yet the conversations did not originate as material for a book: they respond less to the need to understand than to the need to spend time with someone in a fully communicative and humanly satisfying way. The work of art felt to me, at a certain point, like a possibility for meeting, like an invitation to participate, addressed by the artists to each of us. It seemed to be a gesture to which I could not respond in a professional manner.

Over these years I have felt my perplexity grow about the role of the critic, in which I've noticed a codified alienation towards the artistic fact, along with the exercise of a discriminating power towards artists. Even if the technology of recording isn't automatically, in and of itself, enough to produce a transformation in the critic, for whom many interviews are nothing but judgements in the form of dialogue, it seems to me that from these discussions an observation emerges: the complete and verifiable critical act is part of artistic creation. Whoever is a stranger to artistic creation can have a socially determined critical role only in as far as he is part of a majority that is also distant from art, a majority that avails itself of this bond in order to in some way find a point of contact. This is how a false model for considering art has been established: a cultural model. The critic is he who has accepted measuring creation with culture, giving the latter the prerogative of acceptance, of rejection, of the artwork's meaning. Our society gave birth to an absurdity when it made the critical moment institutional, distinguishing it from the creative moment and attributing to it cultural and

practical power over art and artists. Without realising that the artist is naturally critical, implicitly critical, by his very creative framework. Certainly not through the mental, cultural, didactic, professional methods of the critic. But the artist is also on the level of reflection and not only of procedure, even though he has no incentive to make this ability socially effective. So this routine with artists, the speaking together, the listening, bring this fact to consciousness: there is no critic who can trigger the interest of the artist, work-wise. He will be interesting to the artist, naturally, very much as a situation, analogous to any other person who has an artistic experience.

Think of Vasari: an academic painter, official, not comparable to those artists whose lives he wrote about. That's why, perhaps, he found the energy to write. But, frankly, is it possible he said something about the artists that they hadn't already lived out, at least in the work itself? And how many layers of culture, of structures, of commonplaces and passing tastes didn't he put between them and the public. If it had been possible to record what those artists said in their daily discussions, would it be necessary to read Vasari's *Lives* to enter into contact with them? I don't think so; rather, if anything, the reader enters into contact with Vasari the man, with Vasari the exemplar of the sixteenth century, with Vasari the writer and his personal charge. Artists live for that which others will have them live, it's true; however, if Vasari was legitimate in his time, three centuries later Fénéon is already much less so, and contemporary critics truly belong to an anachronism, since here criticism is no longer about bringing to life, but rendering sterile.

Perhaps without being aware of it, the critic plays the game of a society that tends to consider art as an accessory, a secondary problem, a danger to transform into diversion, an unknown to transform into myth, in any case, an activity to contain. And how to contain it? Precisely through the practice of criticism, working on the false dissociation: creation-criticism.

This book does not intend to suggest a fetishism about the artist, but to call him into another relationship with society, negating the role, and thus the power, of the critic as repressive control over art and artists, and above all in terms of the ideology regarding art and artists at work in our society. But how could one distinguish the true artist from the false artist, if there were no more critics, this is the question that emerges in this case. However, first, one must ask why this distinction is considered so essential by society. Where does this need for a guarantee come from? Isn't the saint recognised by the scent of sanctity he releases? Is it possible to hypothesise a critic of sanctity? Despite the intermediary of the Churches, the tally of the elect is beyond the purposes of this world. The conviction of the believer is that the phenomenon exists even when it is trivialised and that this is not an indifferent element to its value. Therefore no one, essentially, renounces being a saint: independently from religions, religiosity is part of the structure of humanity.

Aesthetic behaviour, art, are part of the structure of humanity too, but this conviction is not a patrimony of those who deal with art: it is a patrimony reserved for artists. Differently from Churches, Cultural Institutions are founded on the need to offer the spiritual quota of a world, the salvation of which is none of their business. This is why art, also, like every other human expression, becomes accessible only as an object of evaluation. Through Cultural Institutions art does not appear as a responsibility of human achievement: the tasks of consuming art and of identifying oneself as public are reserved for 'others'. In this scenario the profession of the critic shows all of its functionality in service of a System. But why not ask if this way of consuming art is compatible with the sense of art, with its true *raison d'être*? Why be satisfied with the alienated role, even if it is elevated to the very same condition of judgement itself?

The discussions collected here were not done with the intention of demonstrating the above, but in order to initiate

myself in an activity and a humanity to which I was drawn, when at the same time I found ridiculous the claim handed to me by the University of being a critic of a humanity and an activity that were not my own. To seek to belong to it and to see the role of the critic collapse happened all at once. What remains, now that I've lost this role within the art world? Maybe I've become an artist myself? I can respond: I am no longer alienated. If art is not in my abilities as creation, it is as creativity, as consciousness of art in the willingness to do good.

This book is composed of tracks arranged freely in a way to reproduce a sort of convivium, real for me since I lived it, even if it didn't happen in a single unit of time and place. The tracks are parts of recordings: in '65 Fabro; in '66 Kounellis, Accardi, Pascali, Paolini; in '67 Nigro, Fontana, Alviani, Turcato, Consagra, Paolini, Castellani; in '68 Paolini, Scarpitta, Kounellis, Fabro, Rotella, Consagra, Castellani, Accardi; in '69 Nigro. The questions directed at Twombly are from '62: they were written, and they betray my previous behaviour towards the artist. By chance, perhaps, Twombly didn't respond, but it came to me to put them in the book anyway, both because his silence, made me reflect, and because they bring forth a somehow gracious echo of the academic language.

LUCIO FONTANA: What do you want me to say if you don't tell me what to talk about . . . What do I have to say, more or less . . . You have to ask me questions, or something . . . provoke me.

CARLA LONZI: We can start from anywhere because I simply want . . .

PINO PASCALI: I would prefer to have some little topics. Haha! . . .

MARIO NIGRO: I could stop being a painter, a producer of objects and do other things . . . I don't know, an explorer, a warrior, a Franciscan monk, I don't know what.

ENRICO CASTELLANI: I forgot what I told you last year and I don't know what to tell you this year.

GIULIO PAOLINI: I'm pretty sure I already talked about some works, but out of gallantry it might be best if I repeat myself.

GETULIO ALVIANI: Look, let's just do this, take it easy.

LONZI: Here: Rome, the 13th of . . .

LUCIANO FABRO: . . . September. Early afternoon. Test to hear the recording and make sure the sound is okay. So: Carla, tell me something. Excite me.

SALVATORE SCARPITTA: You are so beautiful . . .

PIETRO CONSAGRA: I'd like to say this.

GIULIO TURCATO: You should do something like this, but conversational, that is, don't ask questions.

LONZI: Yes yes . . . no no . . . in fact, I've always . . .

MIMMO ROTELLA: Actually . . . Can you repeat that? Because I didn't really understand.

LONZI: You give your paintings very precise titles – *Scuola d'Atene, Ratto delle Sabine, Amore e Psiche* ('The School

```
1970

1960          Pop art

1950          Neo-dada
              Informale

              Tachisme
1940          Astrattismo
              Espressionismo

1930

              Surrealismo
1920

              Dada
              Pittura metafisica
              Costruttivismo
              Neoplasticismo
              Cubismo sintetico
1910          Orfismo
              Futurismo
              Pittura astratta
              Cubismo analitico
              Espressionismo tedesco

              Fauvismo

1900          Jugendstil
```

of Athens', 'The Rape of the Sabine Women', 'Psyche Revived by Cupid's Kiss') – that very much recall the most important topics of the Renaissance masters. Then again, the world of antiquity, with its myths, became a topic of interest after the emergence of psychoanalysis. Do you see this connection?

CY TWOMBLY: (silence)

CARLA ACCARDI: I am so completely instinctive, for now, that if just for a moment I lose interest, the thought vanishes.

FABRO: I'll tell you about that later because it arrives later.

LONZI: Ah, that later . . . Okay, tell me in chronological order.

FABRO: Chronological order?

LONZI: In order of what's most exciting.

JANNIS KOUNELLIS: It's better to begin from the most recent things, isn't it? And then, maybe, we can even go a bit further back . . . But, I don't know, going back, speaking like this, in this sense, it doesn't mean anything, because there isn't a formal process. That is, you say 'After Cézanne's landscapes come the Cubists, after the Cubists comes Mondrian, etc.' It's very reasonable, and that's where criticism is based, right. A process like this puts the painting in an extremely different condition than when I see it now, a detached condition. Reasoning about the painting comes from the painting itself, they say painting gives way to more painting, the world outside doesn't exist, does it? Or it exists in a very relative way. Today there is no process as such. Our very conscience has been transformed in this sense, that there no longer exists a formal, logical process. Today, something is born because there the conditions for it to be born naturally exist, right?

FABRO: Let's take the example of *Buco*: it is not a problem of form. In fact, I call it the 'hole', *Buco*, not by way of the pattern that I used to make the hole, because it cannot be a definite pattern and, even less, a visual pattern. Even a blind man can discover the hole, he doesn't know its shape, but he discovers it. Same goes for a baby. All of our senses intervene as a total organising mechanism to take hold of a situation.

It's a pattern that we cannot define visually: form has nothing to do with it, nor does colour. Me, I don't gain experience from a painting, a mirror, a structure: I gain experience from living, looking at things, taking possession of them. When you're alive you're interested in everything, aren't you? It never crossed my mind to do something analogous to Jasper Johns but, at the same time, his concerns resonate with me, they interest me: when he took the American flag and put it there, like that. It's so different from the made-up experience of the Surrealists. Surrealism pointed out man's behaviour when he doesn't see things: a saddle placed next to the handlebars becomes a bull. The American flag doesn't become something else, it's not Magritte's tree. But, even to Johns, something strange happens, he takes things, he remakes them exactly the same and he realises they are no longer the same. They have become a pictorial fact. So, I've understood that through the re-proposal of the object itself we do not re-propose the experience: the problem is still beyond. It's not a figurative process, even at the tautological level, it proposes the thing to us again, but there is some different element that must occur. A stiff board feels stiff, although it is quite different than a line with the same form. I want to get back to that moment there. My interest in Johns is from 1961–1962. It was necessary to start anew, from the beginning. Once the figurative elements were taken apart . . . I express myself this way because also, Abstract Art, at its core, depicted through form and colour . . . I could have set out quietly, to look at things. And these things no longer interest me on an emotional level, but they interested me for their cognitive value. So, the approach changes: you set out to really look at things. You know you can't copy them because in copying them they are no longer the same things . . . you know that form, even copied, synthesised, transposed, is temporary: you can make a thousand and help the procedure of the designer. So, what do you do? Look at how things are, the reason why you take hold of them, and you realise – it's really wild, it's evil, look,

painful – you realise that we never manage to take hold of things. Yes, we take them, yeah, we see them . . . but to possess them, and know how we possess them, it always escapes us. I am able to make one or two works in a year. To pass from one mental step to another, even if they are on the same plane, it's always a leap. I look and try and turn and reverse and see. There's this moment of attention: I look. I realise that I've taken possession of a situation, like that of the hole or of reflection and transparency. From this last one I could have made a little game out of it, creating, I don't know, a chessboard of mirror-reflectors. It would have been more fun than co-ordinating an experience. An experience, in and of itself, is neither pleasant nor unpleasant: it is pleasant only in how much, when we have lived it, we're happy. We are forced to put things into some kind of order, not because of an outside force, but because that's how it is, when we become aware of disorder, we should make some order . . . if we're not imbeciles, or we're not in some state of imbecility, which is 99 per cent of the hours of the day. To take hold of the world does not have an abstract value, but it is an opening so that everyone who's up for it can pass through. Now, the pleasure of opening those gates, it is a true pleasure, to feel like oneself, to understand others, to move together . . . When you feel like you have lived and all of the moments have had meaning in their existence, the knowledge that you did things, that you were part of something . . .

PASCALI: What I'd like is to be as natural as possible. But not natural . . . um, I don't know how even to explain this idea of the natural myself. That rhinoceros there, besides being a rhinoceros, it's a form that I looked for without really looking, exactly because of its very structure as the form of the rhinoceros, but it isn't because of this that I sacrificed other factors. I rescued what was salvageable of this form. Within it there might be discoveries that aren't even a part of me, discoveries by other sculptors, of another way of thinking: the structure of this species of snake could also seem like something from

Brancusi. I say that because Brancusi is also a part of a world
we consider almost natural, right? It's like somebody sees
whatever animal, sees . . . a horse, I have a regular horse in
mind, and after, I've never made horses, who knows why . . . a
horse, a bird, a fish . . . and he says 'Brancusi', it's part of a kind
of imaginary that's already completed. It isn't that I'm inter-
ested in a formal departure from Brancusi . . . no, Brancusi
already exists and is already sculpture . . . maybe it was simply
easier for me to understand it in this way. I like animals, but
that doesn't mean I want to remake animals: it's a subject, it's
an image, it's an outline that's already in place, a word already
printed that still fascinates me, the reason why I get into that
discussion, I take it as a presupposition.

PAOLINI: I absolutely do not believe that one can arrive
at covering spaces, whether they are mental or physical, cov-
ering them in an effective, concrete way, that is with objects,
with formal proposals, or any other kind. Rather, it is possi-
ble, I'm not sure whether it'd be better to say to evoke them
or to allude to them, anyway, to present them even through
a modestly constructed model, with materials that are not
already preloaded with meaning . . . These results, to arrive at
not having them replicate themselves, but, rather, to become,
who knows what else. It is in this unpretentious way one
can work, better than with the most up-to-date tools, what
technology can offer us today, to arrive at this, in order to
achieve this, although I believe that once they are achieved
one is never satisfied. When I think of Manzoni, for example,
I maintain that within him there was still a pictorial implica-
tion, let's call it, in the sense that maybe, maybe he still wasn't
aware of using the canvas, the frame, the brush itself as medi-
ated and established limit. Anyway, he acted naturally, in a
field of the destruction of image and form, without thinking
of the refusal of other more modern techniques, let's say. I
believe that to do it consciously, to want to remain, on pur-
pose, before these canvases, these jars of paint and to use them
to not arrive at a result, to console myself for not having made

use of electric current, for example, that is to have given life to a model, to an idea rather than to an object in and of itself.

CONSAGRA: Having lost animality, spontaneous life, there is nothing except the city as possibility for reclaiming contact with nature inside us. Within ourselves, what does it mean? You mirror yourself based on the human contact you have. Now, the city gives us most of these kinds of relationships, the city removes nostalgia, absorbs all of your intelligence, it unleashes you, it moulds you. The possibilities are there, that is, the possibility to meet people who can give you the maximum of their human experience, who can give you the richness of spontaneity, taken up in the identity of the city. You don't want to go to the city and find peasants, that is: you want to go to the city, and you want to go to the biggest city, where there are fewer neurotic people. Because a provincial person is exactly this: a disassociated person, who might have all of the sweetness in the world, all of the best qualities in the world, but also has this dissatisfied nostalgia, an incapacity, within, to get used to anything. One feels that this makes the city ... it's the activity, still, there's a lifeforce within it. Then of course this relationship can result in a complete failure, there are some people rendered so nervous, so disturbed that they

can run backwards towards a 'possible return'. Every so often
we think that there is a completely natural camel-driver . . .
who gives you a sense of nature that's purer than one can
imagine, more innocent, more disarming . . . disarming in
the sense of artificiality, isn't it true? Well, this may no longer
exist either . . . Yes, the sadness at watching journalists ven-
turing into the forest to discover a tribe . . . you see there is a
disappointment . . . We, in these reportages, on the one hand
we seem curious about this very state of naturalness, and on
the other hand you're bitter that these tribes have actually
already lost it . . . we begin to lose naturalness. And you see
that, like this, the photographer, the journalist, the scholar . . .
has already ruined this, like someone has stepped on a beau-
tiful flower.

NIGRO: When you go outside or we're in the city also, I,
for my part . . . more than the crowds, more than the traffic, I
like to see the sky. Even in the middle of the city. This may be
something common to many people, it's obvious, of course.
Don't you think? . . . It's a link . . . yes, it is a link . . . in the
sense that I have really to be an actor in this world, I have to
participate in the tragicomedy of this world . . . otherwise is it
possible that, at a certain point, I don't take part in it?

ALVIANI: The nature of things in their − I'd say autoch-
thonous, but I'm not sure if it's the right word − state, mean-
ing the trees, plants, flowers, rivers, I don't know, grasses,
clouds . . . they're all excellent elements, meaning 'good'
because they are 'good' in and of themselves, aren't they?
They are. We're also 'good', made with two hands, etc. Man
has always ruined these elements, he ruined them, this is
clear, with architecture, he made terrifying things, horri-
ble . . . why? Because man wanted to express himself, each
one needed to see himself realised in the environment, in a
building, in a thing, to remove himself from the monotony.
I am for the contrary, for this absolutely functionalist life in
every aspect, like for a bathroom, get it? And the toilet is func-
tional for a given objective . . . see, and like this the bed should

be the place that welcomes two people when they speak or four people and that's it, right? Things that are less irritating, to your neighbour, it's possible . . . that they don't create these enormous problems that are everywhere, crooked roads, all of it . . . And man says 'And then, what do we have?' We have this enormous nature which one could analyse, each in a precise manner, because there are billions of things in nature and I think that man, really getting close to them, we would no longer need to create all of these things: crooked villas, little stucco hallways where natural light doesn't come in . . . Now I, idealistically, bring forth, very well, these serial objects, that are very small, because one can have phenomena created by man that are also quite valid, don't you think? Actually, I think that one sets out to make things and does make things . . . like the grass was made . . . as it was created, I don't know, the sun, get it? But, he leaves everything at the right point, where they are useful, don't harm anyone, you can't say 'They don't do harm to one' . . . don't hinder, or rather, they happen gradually.

PASCALI: I like the sea, for instance, I like spearfishing, any silly thing about it, I like the rocks, near the rocks there is the sea, I played there as a child, I was born near the sea, of course, here it's quite common . . . I like animals because they look like intruders, something that doesn't belong to our race, something that moves us, sometimes in the country, sometimes in the city: you try to understand it. Then you say, 'Yeah, okay' and you put it aside. But the very fact of seeing a horse walking down the street or a tree growing out of the pavement on a city block, I don't know in which way I see it, but I see it: it isn't that one tree is part of all the other trees . . . anyway, it's very dear to me. An animal, for me, is such a strange thing, it's already a phenomenon to see sheep passing by houses or men, there's a shift in something that isn't a part of what's already organised, it appears as something other. For me, it is much stranger to see a horse than to see a car, or a missile that goes 7,000 kilometres an hour, you know? It isn't like I live in New York; I live in Rome. It's like the story of taking a bird that once flew in your hands, a sparrow, a swallow . . . really, I find myself in contact with a being that isn't part of the calculations, you know, it has already existed and has the same presence as me, the same lifeforce,

the same nature. I am talking about a purely physical nature, not a nature created rationally like that of machines: man existed, the animal existed . . . first, maybe, man didn't exist, there were other animals, but it doesn't matter. Sure, I feel very close to animals . . . it's funny but it's true. I am much more amazed to see, I don't know, even a small baby, simply because babies aren't part of my . . . and once I am able to see their softness, the way they are, really it takes me to the next level . . . Automobiles, houses, trams, everything that I do every day doesn't interest me: once in a while one notices something that has its own heat, a heat . . . now I don't want to sound sly here . . . it isn't a human heat, but it's simply that it doesn't matter, and because it doesn't matter it's very beautiful . . . it seems like the Last of the Mohicans, you know, or there might be lots of Mohicans, what do I know?

LONZI: I wanted to make a book that's a bit meandering, you know? Because what really bothers me . . . no, what I really like in artists but what really bothers me in critics, where there's none, is this sense of measure, this moving from one argument to the next. Critics, on the other hand, are always stubborn types. For me . . . I just can't stand this sense of mind that fixates on one thing. This need to produce knowledge . . . the cultural worker, that one has to work over and over the culture itself, so they become obstinate about pulling something out . . . What do they call it . . . 'obsessive praise', the existentialists, that is this imbalance between one's concrete personality and one's ideas, to extract all of the possible mental consequences from an assumption and, really, go on to infinity.

ACCARDI: When someone wants to make a book like this, she's got to actually put a lot of herself into it, as if it were also a part of her life, you know? You could never do it, Carla, as you want it, I'm sorry, I have to tell you . . . I don't know, if we're talking about the level of creativity, yes . . . Now, it is an extremely great leap you are asking yourself to make, or so at least it seems to me, because as a creative person, you

should put yourself in there as you are in particular moments of your life, do you know what I mean? How can you do that? It's that, maybe, artists are able to communicate this a bit better, it's what makes others suffer . . . Maybe, I don't know, I keep saying 'maybe'. You say, 'Look how artists talk, and they are more, yes, casual . . .' Yes, because in that moment, they are doing work that is practically a continuation of the work they've already done so far . . . so, can you imagine what calm, what ease they speak with. Hey, it isn't all based on what they are saying . . . did you think of that?

PAOLINI: Look, I would like Carla to remember my painting from 1965 titled *Delfo*. In that painting I appeared, I appeared from behind the frame, life-sized. I mention this in order to describe another work that is, in fact, called *Delfo II*. The painting has the same dimensions, 95 × 180 centimetres, and the same technique, screen-printing on canvas, as the previous painting. It reproduces my image, nothing more, so, on the same level as the canvas, which is in this juxtaposition, but in the foreground, it's in its entirety, and therefore: I am wearing a long white tunic and in my right hand I hold the *Bandiera* ('Flag') in one fist and in my left hand I am holding the bust of *Saffo* ('Sappho'), which covers my face and hides it, in the same way that you couldn't see my face in the previous work since it was covered by the frame of the canvas, an identity . . . Yes. This time I'm hidden by the bust of Sappho and so I'm in this ecstatic mood, I don't know . . . Behind me, as a background, appearing as a work of mine, also from 1965, there is that white staircase with the perspective that leads to an infinite point.

CONSAGRA: I only use painting rarely, since I am not a painter, but I could have been because I very much like a painting I have in my head, but I have never made it because as soon as I add colour, as soon as I touch the brush, etc. Then, even to think of other materials with colour, it has always been so difficult for me, I don't like to paint, it doesn't satisfy me. And I think: I wouldn't even like to be Raphael because

I don't like painting the way Raphael did and I think nobody will ever like it again. You can't become Raphael if his manner of painting is no longer appreciated: one becomes Raphael because one likes that kind of painting. What's an even more banal sort of reasoning? That no one could become Raphael because they aren't as intelligent as Raphael. No, a priori one has no interest in being him, one has excluded being Raphael, therefore the process of the artist is a process of pleasure, continually confronting what one thinks through a determined material, which absolutely does not need to be liked by others, in fact, others have already excluded him from doing this particular thing.

TURCATO: If you want to talk about Raphael, let's talk about Raphael. And you know, Raphael is undoubtedly . . . First of all, at least I don't think, he was ever really understood. He wasn't truly understood when he did things that were really for himself, because he's been generally remembered for the *Madonna della seggiola. The Raphael Rooms*, which are,

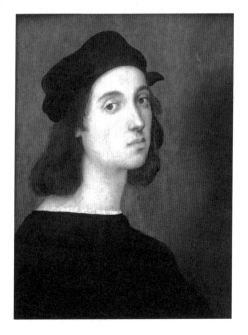

undoubtedly, quite . . . *The School of Athens* etc. are magnificent things; some others, they're already . . . well they anticipate the Baroque. And then, he had a great . . . he was a genius, that is the genius . . . He, deep down, was a stupid artist, but he had this strength that, for the very reason that it comes from a genius, well, it can transform things. Add to that the fact that he arrived from a mystic sort of painting, like Perugino, etc., etc. Then, at a certain point he was the biggest proponent of a kind of sixteenth-century realism and he saw a completely new understanding of space. Undoubtedly, though, in many things he's like a set-designer, so is Michelangelo, but his agility, his freshness in making things is undoubtedly a sign of his greatness . . . And then, having had such a short life, starting with a mysticism, so shielded, so provincial also, if you like, like the art in the Marche, however he managed to create this extremely strong understanding of space. And then, it had a drawn quality . . . It is also all fruit of the work of the Renaissance from which it emerges . . . it's not like these individuals emerge by chance. They emerge because there was this will to arrive at a certain situation.

CONSAGRA: There is a barrier between what I myself do, and the others, right? But the artist, I think, today . . . or maybe this has always been the case, transmits himself to others to change their perspective: the artist continually imagines himself as another person who enjoys this thing the artist does. When I split myself in two, I split myself with a non-professional, someone without a profession, I split myself with someone who has a somewhat animal intelligence, a man of sacrifice, though they may be small, all to say, I imagine myself as a guy with a really generic intelligence, who has to live inside the things I make, am I explaining myself? At a certain point, the artist means just this: the man who liked to do that given thing, and the others, who aren't artists, those who have refused to do this thing here. For the others, it always remains a question of knowledge, of culture, but never of experience . . . it is an experience the others will

never have, they aren't interested in it, if it interested them, they would become artists and they would do it in some way.

ACCARDI: In an old interview of mine, the one in *Marcatrè*, you know, I said, 'I have this urgent need to understand.' Do you remember, Carla? It's something vital I carry with me, that surely everyone has: some deny it and close themselves off in their own pride, they no longer have the desire to understand, and so they say, 'So, what does this thing do? and what does that thing do?' Whether it's in politics or in art. Others, on the other hand, have the vital attitude of wanting to understand, to be in contact with things – I'm very much part of this second group – but, then, I thought I didn't much like this thing I said, it seemed too rigid, there was something hungry inside what I said, something controlling, that wants to devour the other. This bothered me for a long time, then I realised that it was important to not let it become a sort of neurotic fixation. If it becomes self-defensive it becomes neurotic, and then, the first thing one always remembers is 'to try and understand others in order to have control over them'. On the other hand, if one does it a little, doesn't do it a little, loses interest, you've also got to think of the facts of humanity . . . This year I thought of things on a larger scale, I concerned myself with the problems women face . . . certainly I have more love, I don't know how to say it, because if not, if you always stay there focused on the creative fact, fixed, within a collective, you lose a lot, because you begin to feel the presence of others. This, even as a girl, is something I always avoided, but instinctively . . . I remember I had none of this thinking then, I was completely indifferent to understanding others fully, as is common with young people; I disengaged for a long, long time. Even now I like, sometimes, to think about something for a while, and then really rest, I can even become indifferent to it. And like this, I realised that this understanding between artists can happen at certain times, while at other times, during youth perhaps, you don't care about it at all. I can feel the indifference in a

young person because I can . . . I can remember it. But, I, I'll
leave this alone, but I realised a lot of things . . . and there is
a point I want to clarify. If you bring me to someone else's
studio, to Fabro's or to Kounellis's, I, in that moment, I have
a liveliness, this love, this interest, because I have respect and
kindness, they are also friends, above all, there is an affinity,
I like them very much. So, I enter and say, 'Ah, look, here I
am in front of their work' and in that moment I feel all of the
pleasure of assimilation . . . But it doesn't last long, I cut it off,
I don't insist upon it, do you see what I mean? And like this
it remains beautiful. This winter there were debates between
artists and critics, sometimes I didn't go, because when I
don't feel rested . . . One time there was Dorazio there to talk,
and given that I understood that there was within him all the
weight of humanity that came before him, I didn't go. An art-
ist like Dorazio puts too much weight into these debates, he
goes there with his heart and leaves it there. No. For me this
is too painful, I can't relate to it, I don't want to go see these
shows, it's like watching a melodrama, you see? Because I

know them very well, and it's not like I know just one side . . .
On the other hand, sometimes, I went, maybe I'd arrive late,
because I wanted to hear someone in particular. And natu-
rally, I am interested in those who are younger than me and
have different experiences, they always draw very authentic
emotion out of me. So, one night I was disheartened because
I got there and I saw Argan, I didn't know . . . and so I said,
'What goes on in their heads, calling artists from certain
periods, and young artists, and then they call up Argan.' In
Rome these curious things happen: you have a debate about
demonstrations and you call Cagli on stage! But let me tell
you, how false it all is. Look, it seems to me that in Italy
there is actually a tradition of falsity, because people think,
'It does no harm, falsity isn't what destroys ideas . . . deep
down maybe there are good ideas, new ideas . . .' No, this isn't
the way. One must be a bit tougher, a bit more puritanical
and should say, 'No, where we find good ideas, new ideas, we
can cut them out, we can make a division.' And it isn't like
someone like Argan needs to intervene, and then be mixed
in with critics at random: it's a mess. It would be better to
invite someone who is more tied to the artists, someone with
whom they share a personal affinity. For this reason, a debate
emerged, that one there, pathetic, from this point on. Why
had artists spoken so little and critics rambled on so much . . .
I don't want to add more, it will diminish it. So, I wanted then
to clarify: what does the critic do? He does the opposite of
everything I previously mentioned, he does everything at
random, comments waft about like when you smell a good
fragrance, a rose and you remember 'roses exist,' or you go
into someone's studio and say 'Oh, look at this thought that
he had . . .' But the critic has knowledge locked in a certain
phase, in its own neurotic form.

LONZI: I want to kiss you!

ACCARDI: His life itself depends on his comprehen-
sion, and the faster his comprehension of the work of an
artist, naturally the more right he has to continue his work,

in a certain sense. And so, what does he do? He's dreadful. He goes so fast, that he begins right away to intervene in the work of this other, and in this way takes ownership of it. As soon as he has taken ownership, he absolutely has to alert the public to the fact that he is in control, and so has to publicise his knowledge. And soon after comes this neurotic fact of consumption. That they themselves, the critics, have invented, because who is it that invented this idea of consuming art? I understand that we live in a consumerist society, but I don't feel consumption as part of my very being. I can live . . . it seems to me we can all continue to live with things for years, then we have our experiences, we consume them, and we move on to consume other things. But this rapid consumerism still hasn't got to me, or maybe the European himself won't let it get to him. So: I was saying this little portrait of the critic, we can title it 'Little Portrait of the Critic' . . . haha . . . just like that. What came out of it? This thing full of indiscretions. This word indiscretion sounds a bit like indecency . . .

FABRO: The critic is like the mediocre artist whose problem is to finish something on time. He doesn't have the serenity of the good artist who isn't worried, who knows that he'll get things done on time, because, I don't know, his experience has taught him to say 'I do things on time.' While the other one . . . and, this happens quite often, it's just like the critic . . . who has to be over-informed, has to know everything, who panics if someone does something, if someone does something right before or . . . or right after. I think the critic, hyperbolically, feels excluded from the activity of art, and for this reason runs behind the artist, the so-called militant critic, in the avant-garde there is also that other type, who at a certain point tries to stop things, so he breaks them . . . Like when you go to take a walk: there is the guy who continues to stay behind you and then there's the other guy, who stops you every five minutes to say 'Look at the view.' Probably, if things continue as they are, the youth, critics and non-critics, will be different.

But maybe, you know, the fact of saying 'the young critic' is presumptuous, like saying 'the young artist'. The young critic is someone who has just finished university, who set out to get to work right away . . . I think, however, there are people that you don't know . . . Probably, there will be, at a certain point, if things go well . . . well, are apparently going well . . . things will happen.

KOUNELLIS: Who is the critic today? He's somehow a mediator, isn't he? He stems from a preconceived notion that's integrated into our thinking, of a socially integrated man and seeks to integrate all of this in the critic, right? With the pretence of providing, exactly, a vision of something that is common to all, who does nothing but misinterpret the values that are in the paintings themselves. He characterises them in another sense, he interprets them, and this interpretation is made for the very reason that he is socially integrated and sets off from that very concept. In fact, critics see what they want to see in paintings, but they rarely see what's there, you know? And, afterwards, they defend themselves immediately if one of the painters attacks their position, they step up right away, on the defensive, because that constitutes their privileges as men of prestige, and of many other things. Isn't that so? Painters always create a crisis for other painters, even the values which are essential to being a painter create a crisis for painters, but critics never bring them to that point. Naturally, I can't go around spreading propaganda about my work, or anything really: I simply accept all that they say . . . In the end, I really don't care at all about this business, it no longer constitutes a problem because, you understand, in principle, if someone is nervous they try to solve it, right? Afterwards, nothing bothers them any more. One has to finish by also understanding these things: if one doesn't understand them, then one doesn't understand them . . . what can I do? I have enough problems to take care of, I mean, I can't worry about this, too. Because, here, the critics are an organisation of people who are highly

organised, socially and all that, and I am a poor devil, and I can't go up against all of that. It's only that this all lacks common sense, doesn't it?

CASTELLANI: You, when you make something . . . then, it gets away from you, because you don't possess the means of distribution, it's in the hands of others, in the hands of those who give you something so you can continue working, something to live off of . . . but, then, they take what you've given them and they do what they want with it. The market is a moment of this general mystification, but when I say I'll give you a few *lire* for your product, I'm not talking about the market, I'm talking about society, which pays you to let it hide what you've done or to misinterpret it . . .

LONZI: There are two moments: the moment of the critic and the Cultural Institution and the moment of the market. At this point I am more likely to think of the critic's moment as the most negative, and the Cultural Institution as the actual point of maximal deformation for an artist's work. Then, his product is considered an object, more or less a decorative object, and it is inserted through the justification of who has a surplus, that is to spend – I mean, that is a problem, but it seems quite clear to me that this is how it is, there's nothing else to discover in that sector. Where, on the other hand, the contortion occurs . . . it's curious, because all artists think up ideas about it, saying, 'Let's see if I can manage to put things the right way . . .'

CASTELLANI: . . . to put it up the rear end of one person in particular who said some things about me. Sometimes it's mistaken or done unwittingly, but he did it by sabotaging what I wanted to say.

KOUNELLIS: See: I know that critics say so . . . but, the way they say things, I don't want to respond, so I don't. Usually. Because it creates absurd problems later, and later, since I don't really believe it anyway, I never say anything, right? Because, I don't know, I do the things that are, for me, congenial and extremely natural, indeed . . . I'm not having

experiences, I confront life in all senses, each day, you know? And the problems that occur with each day.

LONZI: Artists realise that they don't have efficacy, that they're misinterpreted, that they're misunderstood, but their stories are told perfectly to the public. So, what does this mean? When museums function well, they function like in the United States, and this distortion still happens . . . I don't understand when people come from the United States and say 'How wonderful to see these museums, these museum directors, these galleries of . . .' What's it mean? It means that it's spread with a megaphone to a million people, rather than to a few people, a point of distortion in which the work loses its charge for others, let's say, to find themselves connected to the work of art, to feel it a bit more closely, I don't know . . . The young people who go to India, say, it's curious, to have a more spiritual form of reasoning . . . Here there are artists: it's possible that the culture has managed to . . . one is unable to consider the work of an artist and make sense of it? . . . There

was Duchamp . . . if one considers him there's plenty . . . you
don't need to go to India. Am I explaining myself? It's this
dynamic of a person who's put in the world that wants to pick
her up and meanwhile she's giving signals to escape and . . . is
able to escape the hold. Yes, people have to be woken up . . .
because everyone's a bit sleepy . . . it seems to me most people
are sleepwalking, a little sleepy . . .

FABRO: Bp! A kiss from Luciano Fabro.

KOUNELLIS: There is an actual structure, I don't know, an
official American culture, and then, it chooses its representa-
tives, right? But this is pre-existent. American painters, who
I admire a great deal, aside from what they may represent,
are smart, really, but this doesn't take away from the fact
that they're chosen . . . There is a tradition, really, of choos-
ing people who don't make a fuss, who don't do anything
against the system, and they are chosen by the system to rep-
resent it. And there, how is art understood? It's an essential
fact, also in that system, because really, I don't know, they

employ the same method for toothpaste as they do for artists, I'm not saying how one paints, I mean how they present him, how they distribute him, it's a compact society, monolithic, that creates and destroys all on its own. And then what? This doesn't mean anything, right? Us, here in Europe, we find ourselves before . . . 'in Europe', one always says, talking, 'in Europe' . . . since we have a much more specific vision here in Italy it's better to say, 'in Italy'. Because of this charm American art holds over us, all of this, it gives off a phoney image, like a postcard of skyscrapers. Truly phoney, because it diminishes it as a phenomenon and, afterwards, leaves you with the feeling of something fantastic. I believe that, here, we've been given a phosphorescent image of the American artist, while he is a much realer man than us, this is certain, who confronts real situations, of all kinds, even when he makes abstract things. Only, here, there is a defensive feeling, a political defence: you never face anything when you're defended, it's not like you ever touch anything. And, there, it's much more open and they face reality in a much more explicit way. They do well to stay there, you know what I mean? I admire them because there is tension

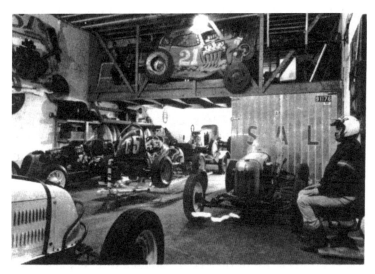

and they manage to stick it out, because over there they are able to face their problems. It's a good thing not to run away, that they stay there to get destroyed, right? And over there, I really find it extraordinary, this fact. I think, I don't know, that the artist today has to be much more . . . Here, even when he wants to, he can't, you know: it's a vicious cycle, really, political, with various interests, that never lets you be . . . And the American painter aims to set the basis for it some way, because it's the only thing that protects him, while here, you have to keep on destroying those things, because you end up being ridiculous, a salon painter, it works like this, doesn't it? . . .

SCARPITTA: One, two, three, four . . . One, two, three, four . . . Scarpida . . . Scarpida . . . Close-up. Happily, Carla. Look at you, in front of one of the cars, Carla, that I'm working on at this very moment: a car built on a 1928 model, an American racing car built for tracks that were once used for horses, for horse-racing. It's different than a European car, which are designed to completely different criteria. I'll keep describing this car to you. Here we are in front of the chassis: this chassis is a long, welded rectangle, in this case it's welded steel, here they're called rails, they're two rectangular rails, more or less 90–100 inches, and the chassis is made for power, in relation to the width of the axles, to drive on this type of track. The suspension, on this car, is leaf-sprung parallel to the axles, elliptical leaf-springs, both anterior and posterior, with two Hartford motors that work with adjustable pressure. On this base, the car has, let's say, attachments to the chassis that are more or less made for a certain kind of racing: the axles, the axle shafts are connected to the cockpit as well as to the chassis, with leaf-spring length according to how the car needs to handle turns. This particular car that we're looking at now, since it is made for a 1-mile race track, has these cross-bars which are more internal to the chassis, because it is a car that has to drive on longer, oval tracks. Since the American tracks are oval, more or less, the longer straights allow for

a longer chassis ratio, longer than for a car that would run on a half-mile track, where it would almost always be on a continuous curve. With a 1-mile track, there are already notable straights, for which we can have a car that appears to be longer than the other cars we make . . . for example, that little nano-car back there.

ACCARDI: So, you, to put a vital part of your life out, you have to put out a whole lot . . . as you are in relationships with others, like you are . . . they become things of extraordinary value, but I don't know if they have ever been considered artistic productions, let's say, in the world. You know what's terrible? To invent . . . So this could be . . . for example, about you, putting on the records to record . . . – look, I'm thinking of you, you know – how you are in the evening, at dinner, when you call your son, Battista, little Tita, then he comes over or someone comes over . . . and they tell you their personal story and you're there to listen . . . So we see this person being listened to in the films, you understand? Eh . . . it would be lovely. Because you, it's true, you're not fully like a critic. Yes, yes, it's partial how it comes out, in a certain sense, in the work. Isn't it true? All of this? And, instead, it is a work of participation, of comprehension, yes . . .

LONZI: What personally attracts me to recording? It's a simple elementary fact: the ability to transform sounds into a score, into writing, to find a page that isn't a written page, but it's a page that . . . In the end, it's like a chemical process, when there's condensation . . . that from the sound it condenses into a sign, just like gas turns into liquid. I like this very much, I couldn't tell you why . . . and I like to be able to read something that's different from the usual things you read that are always products of cerebral efforts, which by now are so tiring just to think of. A person who sits at a table and puts down ideas, alone with herself and with this task of getting ideas down . . . it seems like such an unnatural effort to me, such a tiring exercise, for someone who already feels neurotic and . . . yes, and the fury of all that.

ACCARDI: For others it may be banal, for others, life . . . for example, how a person is during their daily life. There are those who during their day . . . oh of course, you're there for a week, nothing vital really happens but maybe they make you laugh, something pure. But I am talking about you and some people who have, like, all together, if you had to write a book about these people, I'm sure it would be blurred in some way. Well, just like the effort you're making for this book that you're putting together in a montage from disordered pieces . . . you want to get as close as possible, as close as you can, right? To save something of the others, but deeply also some of yourself, and more profoundly, to save yourself, right?

LONZI: I have realised many times that what I have recorded, it all seemed boring or I don't know, you can't imagine afterwards, I wouldn't take out a comma, because I have an obsession with whatever occurred as it was and all that it implies. Even a miserable fact implies everything, really, you know? It recalls something so whole it drives me crazy . . . Then, when I listen to it, I wouldn't want to leave anything out.

CONSAGRA: But, but . . . I feel like when I haven't written anything for a long time, when I haven't sat down for a

good reason – I sit down to write with the necessity of writing something, okay? – so, I feel like I will start to summarise this period I was thinking about, in which I went forward speaking, without writing. How did it seem? I didn't construct a structure of myself. Writing forces me to . . . to notice my capacity for attention and synthesis and to distil . . . what I think about things. Because it's also good to let things go, I don't know, one enjoys this, but it is also scary, one becomes scared the brain might turn to pulp . . . therefore, concentrating and attempting to set it up . . . Because then, exactly, according to the layer one touches, you come upon one thing, you hit on another layer and something else, slowly what one really thinks about something is revealed, but one knows that there are all the . . . all the layers. Anyway, writing, concentrating, is also pretty practical, useful, yes, it conveys a tone. Now I am writing this thing for *La città* ('The City') and I remember that, after I wrote that book *L'agguato c'è* ('The Snare Exists'), already, at that time I said, 'Who knows why I will write again, what will be the subject that compels me to write something new.' And it is this, for *La città*. Now I am thinking, 'Who knows when, again, I will sit down and write something, who knows what it will be about, what argument.' Because it is like, as we say, taking account, every so often, to see if things are going well, because then . . . you know, one begins to have the sense that out of the pulp of the brain there can be relaxation, an abandonment . . . That on the one hand, you feel like this is your right, as a pleasure, and on the other hand though, you don't want to reduce yourself to the level of some people, who you've seen, who've really lost it, who tell you ridiculous things. That's it.

LONZI: Mine wasn't an interest in art, in the beginning, to be honest, if I retrace the steps from very early on it comes out that I immediately had this existential feeling, a feeling inside of me, and in humanity at large, since I was a girl, of strong possibilities, rich possibilities, of great moments of exaltation and happiness, of opening, as if extraordinary things were

possible between beings, and then I felt, something else, the frustration of closed situations, where I didn't understand where it came from, where I felt limitations that cut off all pleasure. So, I, from this existential feeling, I began to look, being certain that it was expressed somewhere, that it would be manifested somewhere, a potentiality that I felt humanity possessed. I knew I had it and that I felt that it belonged to everyone, also to those who . . . Besides the fact that I considered myself, let's say, someone on the border, who hadn't yet entered into the country, and yet, I knew this country existed and I surely had periods when I said 'I will spend my entire life here at the border.' So, I thought that to find this path would require actions that would destroy this environment that was keeping me out, and I took these actions, one after another, as you know. Then, I understood that these actions corresponded to a kind of initiation, so to speak. This seems like a fact to me . . . For example, I had a religious period, from age ten to thirteen: it was extremely important for me. I definitely won't manage to explain it because it isn't as interesting as other periods . . . but, I understood that . . . I didn't turn to culture, this is what I want to say. For me culture wasn't the solution, neither was religion, but in the religious experience I understood an initiation into other layers of reality that would validate what I thought was possible, in line with my aspirations, and it helped me understand how humanity was actually something, let's say, bottomless and without real distinctions, like I felt it was. I arrived at art when, having passed through my religious experience, I found in the artistic experience an activity that didn't require belief, which

hadn't really interested me anyway, but satisfied an analogous need. That's how I came closer to art. Then I thought that, since . . . then, I finished university and, for me, university hadn't been very satisfying, I mean, it was a bureaucratic fact, of culture, rather repressive . . . even philosophy hadn't enthused me, but my excitement for art continued to grow, visual art to be exact. And, so, I set about to concern myself with visual art. To concern myself . . . let's say, with spending a great deal of time reflecting on these facts, and later, needing to find an occupation, a profession, I decided to become an art critic. But not thinking that this activity corresponded to judgement, to an acquisition of power, to manipulate certain situations, or to the work of the historian or organiser. When I found myself working as an art critic, I saw that it was a phoney profession, completely phoney, that it had . . . maybe 90 per cent, let's say, was the University. And so, I kept away from the professional aspects of the activity of the art critic and little by little individuated the elements that, for me, are completely intolerable. The most intolerable is this: that art criticism should be an activity that calls forth individuals, like myself, who wanted to have a deeper initiation than what is typically considered a cultural one, right?

ACCARDI: When I was a girl, I never had what you had, seeing humanity and those thoughts . . . In fact, I knew a bit about you, but I never thought about it, right. Then also, you're from Florence, this seems an interesting element, because Florence had so much artistic activity in the past. To judge it now, it's one thing . . . well, that has nothing to do with the judgement one gives . . . but, about art, it comes out of a girl from Florence, you know? So, the artist could no longer go on, didn't want to: that's, something else, I don't know how to say it. An artist thinks of other things, simpler things. Me . . . I never had this meditation about people, you know? No, not at all. So, it is a curious thing. I remember myself behaving really immaturely. Maybe, also, it's that artists are immature people, because if they're too mature, maybe they

can't be artists. I remember some things . . . things I wanted
to paint, that I wanted to go here or there, to become impor-
tant . . . anyway, I don't know . . . it's interesting. Other ideas,
other things.

LONZI: The critic has discomfort in his psychological
makeup, along with a sense of exclusion. In fact, critics are
all . . . they're not very friendly people, I mean, psychologi-
cally, they aren't commendable, in the sense that I don't even
like how I started out. Yes, I had this sense of being an out-
sider, very strongly, to worldly things, and I think this came
from a childhood experience, feeling excluded from some-
thing . . . And it's probably this that brought me to be inter-
ested in artists, because they seemed to me those who had
the least of these characteristics: they're the least detached,
I think, they have less of a sense of discord . . . I don't know.
Because my behaviour as a critic coincided with a need to
interfere in other people's situations. If I have to identify a
moment at which this disposition manifested itself, which
would then lead to becoming an art critic . . . since I was lit-
tle, in public gardens, if I saw other children, for example,
with an adult watching them, I went over to play with them,
I remember this sense of not wanting to go back very clearly,
of belonging to something other. It was for this reason, I think
that, at age nine I wanted to go to boarding school, to choose
a situation that belonged completely to me, and in the end, I
blended into that way of life to the point that my father, when
he noticed, brought me home right away. If I think back on
my life, there are many of these moments. Then, I remember
in middle school, when I had to write an essay about what
I wanted to be when I grew up, I wrote that I would con-
duct interviews, I even remember I said I wanted to inter-
view Laurel and Hardy, specifically. I think all critics have
this element, this desire to intrude on other people's lives.
Naturally, it isn't so pleasant when, from this rather interest-
ing beginning, it isn't good or bad, it is a fact, existential, then
it becomes a profession, an institution, so, there, it becomes

something that's no longer justifiable, and at the same time, no longer even benefits the critic, because the only thing that benefits the critic is this meddling, to be able to continue to do this, to keep doing it until one doesn't become conscious of it and does it without any qualms, well. Instead, then, to turn it into a career, to acquire an attitude of power, this is an incrustation that develops over it and doesn't really have anything to do with it. The critic, with this need to interfere, is the most likely to initiate things or experiences around the business of others and this is necessary to maintain, because, for me, it is very important that a part of society, small as it may be, is close to artists, and this should be the group most willing and interested in them. And artists should keep these people close, so as in a certain sense to present themselves as something artists need and represent, in a way, the needs of society. But this should be maintained in a pure state, not as an institution, because once it is made into an institution, it takes on all the vices of the institution and all of its ideologies.

The critic, rather than being he who is accommodating and in need, becomes he who judges and creates a hierarchy. And in this activity he ends up carrying out, he erases the point of departure from which he began, and becomes a completely inauthentic person, no longer authentic. There was a moment when Rimbaud said: everybody will be a poet, there will be a world in which everybody is a poet. So, what does this mean? It means it isn't possible, no, no, it isn't possible, from my point of view now, since we are talking about criticism, that this . . . Ultimately, a part of humanity produces things, okay, a creative part, a whole other part of humanity comments on these things. Now, this commentary as a function that society performs on art, seems to me quite useless and in the end becomes damaging because that part of humanity that pro-duces things should, I think, inspire another part of humanity to absorb and to produce. Not to produce in a specific way, by painting or making objects, but to produce movements of life, as beings . . . to develop a creative condition in people, to live life in a creative way, not in obedience to the mod-els that society proposes over and over. That everybody will be poets, artists, not in the sense that everyone will paint the motorways and apartment buildings, but that people will live in a creative way, live in a way that isn't detached and at peace with themselves, that is, alive. Because I cannot understand the way critics talk about artists, and then, they have such a phoney life or they are phoney when they talk about artists or they're phoney when they're living their lives, because you can't understand how a person could be that disconnected. How can a critic, whose way of writing should be a testimony to his way of life, instead he lives in another way . . . like a little bureaucrat, a little careerist, an industrious person . . . who from that little territory he possesses, trespasses onto things that humanity has toiled at much more and much more deeply, and says his piece and then he returns to his small-minded things. This seems strange to me. Then it seems that . . . since humanity has no shame in commenting,

yes, this I need to understand, how humanity isn't ashamed of passing its time blabbering on about things that should shock it, disturb it, that should help it, that should . . . but instead humanity chatters, and what it's talked about has been neutralised and exhausted . . .

PASCALI: It's obvious that within me there is, psychologically, still something in my world, my imagination, something from the adventure novels I read much more than all the serious books. Those books helped me to understand, to get me going, like going to school again . . . and by the way, later on I didn't even read that much: at a certain point in my life I read everything like this, in one go, not like you're supposed to read . . . In fact, now, I can't concentrate on books, I prefer to look at figures actually because they grant me a different space to think in. It's clear that rational discourse, where it all comes from, I don't know, as an organising principle for the brain, is great, it helps me, but it bores me to death because, if I were to continue infinitely, this discourse would really destroy me: it would be like a point endlessly spinning on a sheet of paper. It can fill up the whole thing without ever having created an image, yes, it makes me understand 'This is

a long road, crossroads are made this way . . .' But, in the end,
I don't know, a point or a line is what remains. Then, one can
see, on this piece of paper, a sort of blueprint, can pull other
stories out of it, but that isn't my way of . . . I'm not so intro-
verted in this sense.

NIGRO: In painting, I see the justification of the sign
as a fundamental issue, like in music with the sequence of
notes, in the simultaneity that's in counterpoint, in the entire
musical structure. I had understood the structure of music:
so, based on its example, I looked for a structure in painting.
Therefore, the rhythms, repetitions, what today they call iter-
ations, came to me spontaneously. The rhythmic movement
that justifies and involves the painting and goes beyond it, ide-
ally. This rhythm is what interests me, this harmony between
one element and another, one colour and another. But what's
important is the set of problems of all these rhythms, because
otherwise we fall into Concrete Art, in which one makes
diverse geometric forms and places them besides each other
for no reason at all. The problem, on the other hand, should
go beyond this. It seems to me that, more than solving a sin-
gle problem, I think in 1948 – I don't want to be presump-
tuous – I made a break with the whole tradition because, up
to that moment, a painting was just the square of the canvas,
the composition was all within the square of the canvas that
made up the painting, whether the composition was made up
of geometric forms or of objects. But I didn't care about the
square, I cared about rhythm. The canvas was a particular, a
portion of the problem that I couldn't continue to endlessly
expound upon, it's obvious, the canvas was the excuse for
imaging a project to undertake, maybe, this rhythm in great
proportions, life-sized proportions if it were possible. The
vision is projected to infinity. I think I had really found the
problem with painting, because up until that period, the artist
was inhibited by the task of representing objects, he wasn't
free to express these signs, these colours, like musicians had
already been doing for 2,000 years. Music has its essential

nature which one can't escape from: it's not that, at a certain point, music ends. Music never ends. One kind of research into music ends and another begins. There are fundamental things: for example, if you make a sound and continue with the same intensity, to me, it isn't music. Music begins when this sound has variations or takes on a rhythm. So, the simplest music is the music of songbirds, or the African's tamtam. Birdsong is a series of variations on one motif, just the one, it is characteristic, they last for half-hour segments, while the African tam-tam has a precise rhythm, simply produced with drums, a poor sound that comes close to a non-sound in a certain sense, but it has its value, it's like making a black and white painting, there's no colourful patterns, but the essential nature of the rhythm. Around 1954, my painting was close to New Orleans jazz, it was actually analogous. The New Orleans style is based on accentuations of loud, low and lively passages and it always has a precise framework: there's the soloist, then the accompaniment, then the accompaniment comes to the forefront, then there's the whole band, and after opening, the piece closes. In free jazz, which is the successor of cool jazz, one studies a theme, usually the soloist, which more or less means analysing it, but there's no concern about closing the piece. That's the sort of thing that's closest to my more recent experiences, with *Tempo totale* ('Total Time'). Even in 1952 I worked with variations, though those were closer to Bach. But, in its substance, Bach's music, I think, is really close to the structure of free jazz . . . I don't want to speak heresies. Electronic music is still more of an experimental study: it takes a sound, makes it louder, makes it vibrate more swiftly, less intensely. The research is fitting, but then, if you hear electronic music, you end up returning a bit to tradition.

KOUNELLIS: Recently, I heard this guy say, 'I love good painters, I love those who paint, it's such a noble thing.' But I know perfectly well what the painter . . . yes, it is this noble thing indeed and everything else, but there is an enormous tendency to speculate about this nobility, and the speculations

are incredible. Velázquez is a great painter, isn't he? I don't know, like Lichtenstein . . . All of this is essential, there is an urgency there to be completed, then, there, it totally lacks speculation. Either made through painting or made through . . . Because no one can exclude the fact that one can be a painter, that is, stand there and paint, it doesn't make sense to say that. This is a mode of expression and it can't be abandoned, it's a true necessity, I mean it can be abandoned, but, this absurd behaviour painters have that, for loads of reasons, I don't know, tradition, nobility, to make things into gold, you know? The painter needs to be cut off, to let painting fit into its true countenance, of a free man with ideas, who undertakes the work. Shouldn't it be this way?

TURCATO: We're all for the object, but more so than for painting. As it is currently understood it was established in the 1600s, actually at the end of the 1500s with the still life. But, effectively, the object has always been there, the object made by unknowns, which undoubtedly has its own beauty, and appeal, doesn't it? I had this habit of making paintings, but it isn't like I was so attached to the form. I find that painting is still the most economic form in which to make art, in the current moment. There is the factor of economics in art or, let's say, in this discipline, that allows us to spend less to have more. It is also a rational economy, because you can transport a painting, a small painting is easier for doing business. An object needs its packaging, right . . . yes, and this is important. We are used to making paintings, okay, we move forward mechanically, also in order to make them. But, I'd also say, you can do other things, this isn't . . . you could also build a boat. I've made objects . . . as a hobby. But, I don't have the mindset to say, 'Okay, I'll make an object.' If I find that this object is necessary to make, well, then I'll make it. Necessary for me. But, if I don't find it necessary, I won't make it. But then again, I also find it is unnecessary to make paintings. The request is always, maybe – if one can talk about commercial or market requests – for paintings, which people have arrived quite

late at understanding, but you have already moved beyond and have to keep making them. So, this is very boring. On the other hand, I don't know how you can get by economically in a world like this one, because the artist should always be ready, always heroic, always . . . Okay, I think this is quite absurd, don't you? Yes, because, I ask, what are we claiming? Undoubtedly, making an object, a painting, statue, a sculpture of any kind, implies a certain economic situation which, if you don't have any money you can't make it, there's no doubt about it. Sure enough, my production and the production of many peers, I find that we . . . we set out from disastrous economic situations, it would have been better, maybe, if we'd had better economic situations. Because, undoubtedly, then the need to make money is damaging. On the other hand, you can't really say, because there are artists who started off with excellent economic situations, and then went on to make really boring work. Balla is a great artist because he, like the general situation of painting, does what is essential, you can say that he makes . . . not in a pejorative sense, but he makes sketches, that is he reveals something; but, then, a work of art comes out of it. This is the immediacy and, therefore, also its great contemporariness. Now, broadly speaking: the first time that I saw one of Rembrandt's paintings, *The Night Watch* . . . it's a trompe-l'œil, but it's stupefying, but a trompe-l'œil, *The Night Watch*, is so wrought. Actually, I don't know how Rembrandt could have made a work so large, because all of his works, every one of them, are made very well, and you need a lot of time to make things like that. And then, there is a lot of human energy . . . it's not like everyone can have the strength to refine things like this. See, the argument is vast and also difficult to concretise because you can't say how far someone will go, up to where someone . . .

PAOLINI: Another thing that I'd like to make is a painting of minimal dimensions and still on the subject of the painter in the studio but reduced to the image of the painter who embraces the canvas and, just so, so the hand ends in

the depth of the painting . . . But I mean, very very small,
13–15 centimetres each side. Maybe it would be better to see it
hanging high on the wall. So, this canvas, that yes, represents
the painter, should show him as suspended in space . . . as if
he were a kite or something . . . From there, strings made of
beautiful nylon colours emerge from tiny holes. A colourful
mane raining down towards the earth and it reaches, maybe,
even to the floor, I don't know. It should be that way, so that
the colours go beyond the canvas and come forward with a
kind of diffused effect of alternating colours, as many colours
as possible . . . And the title . . . the title is *Icarus*.

ALVIANI: The economy is the reason why I work, the real
reason, so, it's a bit like my coat of arms, can I say that? Yes,
I prefer to state it without defining it: the maximum result
with the maximum economy, it's also fair to say maximum
knowledge, maximum consciousness. So that there is noth-
ing dispersive and, effectively, the products coming out of
the machine, when the machine is made for a determined

action, never stops. When it doesn't do what it's meant to do, it's broken, it's KO. For which, it's really the economy, the machine, and obviously, it's the economy for all the knowledge we have. Today, machines make, for example, objects, let's say 10,000 units per hour, because the power we're capable of through the speed of electricity, technique, material, is enough to bring us to this point. Tomorrow, we will have other knowledge, enriched by constant development, and machines will have the possibility of making 100,000 pieces in a given amount of time. And therefore, it will be even more economical, but it is always the economic maximum as well as the measure of knowledge: this thing, you see, won't become, let's say, trendy. You see that, right? It's fair to say it was registered in 1964 but in 1965 it was surpassed. It's in this constant becoming, in this constant progress, constant progress, which is the same as the progress I see in nature and the reason I think this way, it's a bit like this with everything, with the economy, with the nature of things. We men, if we weren't in progression, we simply wouldn't be. Right? Ours is a life of progression, for this reason we can be regenerated, we can develop, etc. Outside of a time constraint as a fixed point. This is really a constant becoming, a progression, a constant perspective form that, fundamentally, seems to me today to belong to machines. Yesterday, other things could have had it, warlike conquests, I don't know, military strategy in and of itself, right? To make progress, therefore to conquer lands and spread . . . Today, the dividing element

of our time is organisation – technical organisation, pro-
ductive organisation, because it is, in fact, action. And I feel
this is tied to everything: in one of Wachsmann's joints, or in
another one, in every millimetre, if each element didn't exist
it would be unstable . . . it lives because of the dimension it
has, for that which it . . . if you remove just a little bit, you
understand, it becomes something else, or, if you add one,
it is no longer what it was. This microphone, in its form, is
easy to read, but it isn't useful. Because, if it weren't made
like this, nothing would change: its economy is in picking
up the voice, in transmitting it, therefore, I would remove
this object from the form, which is a matter of style, I would
leave the device naked and raw, you know? Maybe I would
make other adaptations, I would have the box to put it away
in, but that, I am sure, wouldn't be contaminated with taste,
it wouldn't be conditioned . . . you can't say the word 'con-
ditioned', I didn't mean to say that: it's the current state of
man's knowledge which was able to make this gumdrop that
captures the voice. Tomorrow, knowledge will increase, then
progression. It will no longer be a gumdrop, but rather a
point, but understand how the gumdrop can't bear any style,
nor can a point. While yesterday this was round, today it is
rectangular . . . it's all style, it has the mark 'this here was
used last year': see, and this is the condition of time upon the
object. To get out of the conditions of time . . . not an exit,
but to not be under the conditions of time, which after all, is
static nature, it's obvious that one must live in functionality,
in the precision of functionality.

CONSAGRA: I, still, have a problem with rich people: when
I meet a really rich person, I freeze up, I no longer know how
to have a normal, natural interaction. I meet them through
their collecting, these very rich people, and for me . . . this
relationship with the collector causes me to lose all sponta-
neity. Now, rethinking it, I realise it's still quite unclear to me,
for myself, I'd like to understand . . . for example, Picasso, who
is very rich, no, actually richer than any collector who goes to

buy one of his paintings, what pleasure does he take in selling them, in what capacity does it bring pleasure to sell a thing. Picasso must see the rich person as a poor one, as an equal, like me taking to you and I have no problem, as I speak to many people and have no paranoias . . . Me, I've never traded a sculpture with someone on the same level as me, I don't know what it is like, I don't know, like giving a work to a lawyer I could casually meet in my everyday life, right? When did I realise this? When, in America, I was about to meet a very rich person who had purchased one of my sculptures . . . she was in a little store, and I was walking into this little store. A meeting in a really banal situation, between me and the collector, I felt so awkward . . . I realised my situation. Probably since childhood, or when I began to make art, until very recently, I always felt this pressure, like a sausage in a machine being squeezed out, this pressure to push my work into a realm of let's say, formality, a realm of power, where people would take it and do something with it. I never thought that this object of

mine, on the other hand, could ever be acquired by someone like me, on my economic level.

CASTELLANI: You also considered this a kind of revenge on the rich, the simple fact that he's rich, was frustrating for us in a way, it's something that kept us down.

CONSAGRA: I didn't feel this need for revenge because I was too, let's say . . . I was too satisfied to feel vengeful. So, I say this: however, I ended up becoming an artist, I was always thinking, and did it in a very emotional way, I was always thinking about how my sculpture could be absorbed by as many people as possible, also by common people, and instead, then, my real feelings, yes . . . the work ended up with someone because that person had power. So, I say, there are probably these kinds of behaviours, I am not the one who invented them. Besides, within all of this it isn't just a question of my work, that some rich guy buys, there is also the human side: contact with someone who is completely autonomous, independent, free from economic factors, I create this confused reasoning for myself. But think of the fight I have to put up, on the other hand, to be and to present myself as a person with grit, a certain disgust . . . People think I am a very . . . very proud person, yes, that's it. Turning again to Picasso, I wanted to understand, for example . . . does he have a mythological motivation, within himself, of this kind here?

LONZI: There are lots of mythical things that push young peoples' work forward, then they change, always. This is an awareness, like others have another awareness, don't you think? Today you need to go and see for yourself what kinds of thoughts are behind certain choices, behind activities, without being too shocked if they're not so clear and precise, ideals that were attributed to artists of the past . . . It's extremely interesting to see what stimuli, what myths, what complexes, what thoughts, and after there are still thoughts, a young artist has when he begins his career, what do they dream of . . . Then, naturally, over the course of a lifetime, they diminish little by little. So, today, all of these demystifications are done

like this, saying, 'But I, but you, really, when we began, what did we think? what . . . ?' I began with big ideas like that. And this is interesting because you see that those who have these big ideas don't have, really, that other side . . . that strength that an artist has . . . Instead, perhaps, the other is weakened, more afraid, I don't know, if they begin right away with everything a bit exaggerated, which is how I was as a girl, I swear, you know what I mean?

KOUNELLIS: There are bird cages around the great painting with the black rose.

LONZI: Around where?

KOUNELLIS: Around the painting like a frame, you know?

LONZI: Ah, real cages.

KOUNELLIS: Yes, with real birds inside. Because I thought that . . . this painting that I sold that a musician bought to put on his terrace . . . so I thought . . . really a painting . . . In every way, it seems to me like an important gesture that this man must make . . . because the painting is very rigid, like something that falls, that black rose . . .

LONZI: Painted?

KOUNELLIS: Yes, black, shiny black, but big . . . I liked his gesture: going in the morning, going out to feed the birds . . . There is also a 2-metre painting and above it a rose, one of those enormous black things, at a certain point the rose splits in half, almost in the middle of the painting and, underneath, leaves come in, in a natural way, these are also painted shiny black and, inside, there is a hook to hang a cage with a bird, right?

LONZI: Inside the painting.

KOUNELLIS: Yes, yes.

LONZI: A hook comes out of the painting.

KOUNELLIS: A hook that . . . this is the place for a bird.

SCARPITTA: You asked me, Carla, something, something about my childhood. Naturally, I am an expert on infantile things and so I brought out a drawing that my mother, who is an old superstitious Russian, saved. It's a drawing

from probably 1930, which would mean I was ten years old. A drawing which I will describe as follows: it is a sheet of writing paper, it's probably 15 centimetres by 10 centimetres, and at the top is written, Racery number five, meaning racing car no. 5. Here there is a description of the pieces needed to make this car no. 5. There's this writing: a carriage bolt for the front wheels, a broom handle; on the other part it continues: four tricycle wheels, obviously to be stolen from some neighbourhood kid, two semi-axles, two pieces of wood 1 metre and 80 centimetres long, a steering wheel, the paint should be yellow and red, two fake exhaust pipes, a radiator with boards this way and then, below that, there is the description, naturally drawn, of the radiator viewed from one side then the other. Here inside there is also the explanation of how to use the broom handle to steer, and then there's a drawing, quite a cute one, of an automobile for racing, naturally not made like this, for kids, but 'lateral view'. I brought this thing out here because I remember, not

only the moments, but I also remember that I liked building things . . . Seeing as how there was lots of talk about Constructivism, where many tirelessly laboured to render these forms, like in *Metropolis* by Fritz Lang, or whoever the director was who made that, I don't know, these things to frighten people a little bit. On the other hand, this drawing is cheerful: it has its way of being about construction that remains without anxiety, it has a way of presenting itself simply, full of colour and sincerity. And its function is much less than it declares for itself, because a broom handle won't work so well as a gear stick but, as it is, I'd say it has a joyful childish function, already found in the domestic nature of the choice of objects. All this to say, here there is a concern for detail, but without the rhetorical weight of describing its function in Expressionist or heroic terms.

CASTELLANI: When an artist starts out, I don't think he's got many problems, what do you think? Because he likes, for instance, to manipulate certain material, he does it . . . I believe, more or less viscerally, don't you think? Because he likes, I don't know, to work with materials . . . to use certain techniques. Little by little he gives content to all this making . . . at least . . . that's how it happened for me. Little by little, actually rather quickly, you realise the uselessness, really . . . and immediately devour all this technique, the desire to make things, this purely visceral stimulus. Then, other problems sneak in.

NIGRO: I always followed a reasoning, ironically, in mathematics it's called infinitesimal, tending towards zero but it's not zero, tending towards the infinite but not infinite. This comes from a scientific education that by now has got deep inside me, but also because of my psychology because, I don't know, maybe I'm prone to contemplation . . . I'm unable to project my reasoning to something with an ending . . . get it? When I was a boy, around thirteen or fourteen, I began to paint and I had a real passion: I had abandoned music because my parents weren't interested in getting me a new violin when

the one I had was destroyed, and I, very lazily, submitted to this sacrifice. So was born my passion for painting which substituted for the passion for music, that is, I always needed this psychological element, an element of love, and then, definitively. At that time my mother always brought me to church, I was pretty religious, I'll admit that, I believed strongly in Hell, Heaven. And I thought, 'Okay, when I die, I'll go to Heaven, it's a beautiful thing . . . but, in Heaven, I might not be able to paint, that's disappointing.'

ROTELLA: It's important for an artist to have this quality – instinct. Which, in art, I think, is one of the major factors, one of the most important factors, instinct and also this sense, not of brutality, but . . . but of strength, a strength that's a bit primitive. Which then can flow into the magical feeling of the work of art, otherwise a work comes out, that's, let's say . . . weak . . . Therefore, I think that an authentic artist, besides having his style, his personality, must transmit this magical feeling into the work of art, if not, it seems to me that the work falls into the categories of imitation or the academy. In the artwork, mechanical or not mechanical, we must, thus, transmit a sense of magic: this doesn't come from technique, it depends on the artist, on his magnetic charge that, then, comes through the work of art. The

portraits I made result in this kind of effect. I think that, more than from photomechanical techniques, it depends on the artist who works, who touches, who imagines. From the very first moments of my artistic career, I was drawn to these studies of occultism, hypnotism, magnetism . . . I was so interested in this that I always kept on going with these subjects: concerning hypnotism, I sat for many sessions; I was also able not only to experiment on patients, but on my art, as well. I observed magnetic vibrations in my own body through which I was able to cure various physical ailments like toothaches, headaches, stomach aches. Especially in my left hand, I discovered that there are vibrations that allow me to be able to cure, with these magnetic passes, as they call it in the technical jargon, certain kinds of pain. I also read that various painters have this metaphysical or surreal ability, if we can call it that, I don't know. I could also cite paintings from De Chirico's metaphysical period: I think that the paintings De Chirico made during his metaphysical period are very important ones, they are the paintings that interest me the most and that move me the most, the ones I admire the most, really, among all the modern painters.

LONZI: De Chirico claims he can see his hands in the dark, he claims that they have a phosphorescence . . . really, as a matter of fact.

ROTELLA: Without a doubt, in De Chirico's metaphysical paintings there's a magnetic force and there's a metaphysical inspiration that allowed this great master to be able to create these great important works. As far as my work is concerned, I see it, first of all, in some of the décollages that I made at the beginning, I'm talking about in like 1954. I saw that ripping these papers or framing what was there, some of them which were torn naturally, since they're posters ripped from walls that I appropriated, I noticed that when I glued them, when I glued these pieces of paper, a certain kind of force emerged, a certain mysterious force of these things. I don't know, one time I had assistants or I think just one assistant, but I could see that it was another . . . the touch of my hand gave a different result than the touch of the assistant's hand. So, I realised that, effectively, there was this mysterious charge that I could transmit. In the works made with mechanical tools it's the same thing, just that, instead of touching, it's about conceiving . . . this mysterious concept of transmission, of protecting the image on the canvas. First of all, it happens . . . when I take photographs, photography of the subject made by me, but I am concentrating, concentrating my mind in a way, I'd called it magnetic, okay? Actually, when I'm inspired, I take pictures that, whether they're in Paris or New York, some photographers, professionals, have told me that they, maybe, weren't able to take pictures like I take them with that rudimentary camera, one of those old Polaroids. And, so, they praised me, and I explained that I'm not a photographer, I didn't want beautiful photographs, but I wanted the photograph I needed for a painting. There were also people who, at a particular moment, weren't knowledgeable and mistook these portraits of mine for photographs. So, I tried to explain that they weren't photographs: the moment I projected them onto the canvas they stopped being photographs, but they became a

work of art, and therefore had all the requirements of a work of art. This was the fact. In the works of *Concilio Vaticano II* ('Second Vatican Council') my contact with the work is also very close, in as far as I choose the work and then I project the negative of this work onto a canvas coated with photographic emulsion, so I have this constant manipulation. Then there is the colouration, mechanical or by hand. While, for example, on printed paper, in the printing tests I use, there is no real contact, because there it is only a matter of selecting, I don't operate on anything, it's just about picking up some sheets at the print shop, to which then, at a certain moment, I apply a backing. During the projection, on the other hand, there's this tension, and during this tension, at the same time, there is this projection of my will, right? Of this force, that is mine, that I want to project in the work of art. See, it is a reciprocal fact, reciprocal labour between the artist and the work, at the same time . . . it's like when a traditional artist paints a work and while he paints it, he thinks of the result of his work, therefore there is always this tension on the part of the artist towards his work. Also, here, in my case, in this mechanical technique, there is, in some sense, this same thing.

PAOLINI: The meandering around this image of the painter in all of his possible work habits is justified a bit also by my sticking to a technique I know, with the usual materials, a certain kind of system for working. So maybe, this use of traditional materials corresponds somehow also. This falls – when it's time to procure an image for the painting – on the painter, who's looking for an image. The two facts should contribute to saying: I don't know which is the image that's more aesthetically appropriate, so this falling of the image onto the painter corresponds also then to this relapse of the painting to its traditional craftsmanship. Since I do not give life to optical or aesthetic ensembles that, let's say, would aspire to become proper unique formal propositions, aimed at bringing taste forward, even the most worthy medium for this idea would be the same as it's always been.

LONZI: One has the impression that you consider every sign individually, loaded with its own meaning, which is also a mythical charge. So much so, that the composition that comes out of these various signs, made of intersections and relations, has echoes of myth. If one thinks of one of Raphael's or Leonardo's paintings, one has the impression that this is how they worked: various characters, the variety of grasses, certain trees or mountains in the landscape are each conceived completely on their own, like shapes full of myth, and from this comes the feeling of mystery provoked by the relations of these shapes. Were you very much taken with Renaissance art and who are the artists from that period of particular interest to you?

TWOMBLY: (silence)

ACCARDI: Matisse made many interesting things through his old age but, certainly, he lived . . . I don't know how Matisse lived, right, I wouldn't know if he had one of those genius-like personalities, right? But given that he left very little evidence

of who he was outside of his art, you can't understand . . .
rather, I would like to better understand how he was as a
man, if he was very rarefied . . . Then you go and discover that
these men, who were such great artists, like Joyce, were very
rarefied in some ways, they had, for example, some . . . this
is of great interest to me . . . some impossibilities and small
anomalies of a sexual nature right? Did you know that Joyce
was a feti . . . fetishist: In fact, he describes his protagonist in
Ulysses as such. Who knows what kind of love Matisse put in
his paintings given the fact that, as soon as he touched life
he burned himself, what do I know, you know, who knows
what the heck . . . Because, in youth, a great love for painting
can be this very great love, passion . . . the rest, there, seems,
so grey, spent . . . You don't even have experiences of other
things, you stay there . . . I see it, it doesn't just happen to
me, because I see it in others, even if today everyone's eyes
are more open. Nothing, I see it nonetheless. But, after, if it
stays, for me it's infantilism because a transformation has to

occur in a person, it's more meaningful if a transformation happens. In Dorazio, let me tell you, he's someone who seems like he's stayed twenty-five years old . . . aside from his kinder traits, I don't know, a kind of respectful audacity, love for his work . . . oh he's surely always more respectable than . . . Ah, so, I . . . this fact like Matisse . . . who knows what I'll do? Before everything else that, today, when I finish a period in which I've worked a lot, I always think, 'I finished, I don't know if I'll paint again, if I'll ever start painting again.' For now, there's this . . . then, I told you the other day coming back from the sea that, well, in life, you can't have more than two or three great loves, why? Because, if this sense of repeating experiences happens too quickly, for this very issue of maturity, for this temporal issue of evolving, you won't manage; if you have more you already become an anomaly, a super-Don Giovanni, you know, these things that I've read every so often. So, let's look a bit at the typology of a person who follows a certain path of seventy years of life, I don't know, right? So . . . he's got to have the years of infancy, learning to walk, learning to eat, then he learns to see himself in relation to others, to free himself from mistakes made when he was young, all of that . . . Then, the moment of creative strength, that comes, let's say, between ages twenty and thirty, you get everything written down because suddenly your eyes are opened, you see things and get it all down, violently, so . . . then from thirty to forty you do a certain thing, and so . . . So, you continue to find pleasure in the work, in its beauty, but still feeling the influence of others, what happens around you . . . Maybe, after, someone, even if he closes himself up in his studio, begins to see himself a bit from the outside and what he's dealing with, you know what I mean? Because one can't deny being in very nice company, sure, because I've noticed that also after I've had some extra thoughts, that I arrived at a point of detachment . . . then I worked very well. One evening, last year, I was overcome with enthusiasm . . . because I had begun a new period, I remember, you know, this one with the

transparent pieces, and then I had the show at Marlborough. Uh, that evening I had this real moment of vitality, I don't know where I read this about creativity. Ah yes, the points of high consciousness, I don't know, that you arrive at in many ways in life, or even during orgasm, or else through creativity or contemplation or doing something for someone you care about, something that's good for them, I don't know . . . So, I remember that you don't lose these things.

TURCATO: Any artistic expression is in a rather curious situation, it's made in a moment in which you, really, it isn't that . . . your intuition, then, goes forward and you arrive at making this object. But, afterwards, you can't be truly conscious of how it happened: you know how, you're conscious of it, but . . . Even if others don't understand, it doesn't matter, it isn't really a thing . . . Undoubtedly romantic forms, given that they're more, all of them, full of feeling, people understand them better . . . I'm pleased with a certain space that I was able to imagine in this painting, and also with a particular light, anyway, that there's, and also with a colour. Which then, now, the forms have come out . . . maybe the forms are an excuse to make stand out . . . some spatiality, this painting undoubtedly has a spatiality. The forms have to be minimal, by and large. No, what I can't understand, for example, is this. How is it possible that certain old paintings, and I'm especially talking about primitive paintings from any period, Chinese or Tuscan, have such extraordinary colours, and they're never vulgar, truly unexpected colours . . . they have these pinks, which were undoubtedly invented out of everything, even a craft, because it had a technical aspect. How was it possible? And then it's not like these were artists bequeathed with fame, some were anonymous, or else they have something . . . Now, this, I still haven't figured out where it comes from. It's not that simple, right. No, look, I think, I mean, when there are accusations at critics, in this very moment here, it's this: for them it's enough that whatever artist, painter or sculptor, at a certain point would adhere to a particular hypothesis or

theory. They really don't care at all how this theory was more
or less resolved. Because a theory can be resolved in a way
that is purely academic and in a way that is absolutely poetic,
genius. But not for them: what matters to them is that they
stay within the theory. I think it is an act that lowers the whole
perception of quality . . . because quality is necessary, right . . .
quality and aptitude. I don't know about you, how you see it,
but to me, it's really important. I don't mean quality in some
bubbly sense. I don't know, to make some practical, examples:
the quality of one of De Chirico's metaphysical paintings is
superior to one of Dalí's. Anyway, De Chirico is within that
theory, which then, in the end, is also a theatrical theory, he
comes from the Munich School, in the end, his was a kind
of classical revolution . . . but the quality of his paintings is
superior to those of Dalí and Magritte. Then, later, everything
gets lumped together, and so . . . okay. For example: Duchamp
attaches a toilet to a string and removes it from its original
purpose, which was to be firm in the ground and, there,
invents a determined situation. If, later, Spoerri makes me
that table there, covers the whole thing in glue and situates
it, with a bunch of random objects that weren't specifically
chosen, this doesn't give off some kind of emotion, this is the
point. There has to be surprise in art, there's no doubt. Then
there can be many surprises because they can be . . . on many
levels, right, yes, undoubtedly . . . many characters, expedi-
ent characters, characters . . . Not knowing how to see, like,
when De Chirico paints two chairs with an armoire, he is able
to make a painting that, at a certain moment, is two chairs
in the painting. Oh, this is very important. It isn't simple, I
mean, to catalogue all of this cultural world along with the
world of the masses, anyway, there is a duty to educate the
masses, but it isn't necessary, right. This here is not a reac-
tionary discourse, it's a discourse that's a bit . . . It's this duty to
educate the masses, but the masses, I mean, really, to let them
be educated with photography . . . Let's take a collection that's
huge, like that of Egyptian culture: so, photography didn't

exist, their art was completely abstract even when it was figurative, and they all thought that way, therefore they couldn't find loopholes. You've never been to Egypt but, look, it's extremely important to have seen Egyptian art, and I absolutely do not believe that they . . . maybe the Greeks would have said something like 'I make art' . . . but definitely not the Egyptians. No. Not really, because when they make a ton of objects, following the natural order of things, like making a table, something with a clear function, all interlocking, tied together with liana vines, but a masterpiece of craftsmanship, what do you want, a craftsmanship that . . . Now, they made a lot of them, they didn't make just one, so they thought in that way, as a mentality. On the other hand, they fell behind during the Iron Age, for them, the Bronze Age had already existed for some time, right. Sure, yes, the Iron Age emerged from mountain cultures, thought of as barbarians even by the Chinese, as well. Because they had discovered iron and then they sold it. And therefore, this here is quite important to know because, I think, to be an art historian, more than reading philosophy books, it's important to know a lot about that mythology, about popular traditions. The discourse, in this sense, can be widened a great deal because it doesn't cleanly stop at theory . . . And, sure enough, then, philosophy isn't so useful, in the current moment.

CONSAGRA: All children, at a certain age, have a normal level of activity, satisfying. Then, as they get older, some of them have crises and they're no longer satisfied: intelligence makes them too critical towards what they do. On the other hand, another child, maybe a bit stupider, slower . . . For example, I remember that my mother, in respect to my classmates at school, in the first grade, she sent me to after-school tutoring, so you see I wasn't the best or the brightest. But, at a certain point in childhood, I continued to produce something that satisfied me, while other children move past that and no longer like what they make . . . I, you see, since I was kind of stupid, I still liked the things I could do when I was

little. Even if my drawings from childhood are really ugly, little miserable drawings, without anything beautiful, let's say. Therefore, it's likely probably that these sorts of factors help . . . There are passages in life: as a child you like what you create, right? Then comes the social conscience, so you connect your interests to become a character in society, carrying this weapon, this tool. All of the child's attention, at a certain point, is directed towards mythologising the artistic character in society: he becomes important, makes love with the most beautiful women, fills his studio with girls, everyone says to him 'Professor, make yourself at home,' etc., etc. Then, naturally, there are other modes of conscience . . . one in which, then, he sends everyone to Hell, saying, 'Don't bust my balls, leave me here in peace.' Now, see: is there really an artist today who says 'Go away, all of you, you've bothered me enough, let me be . . .' Is there? I think that there were these types here, but it's a character that has now entered into a crisis. When they told us about the American artist, these guys who did Action Painting, these guys who got drunk, isolated themselves from everyone, didn't want to see collectors, they let off steam onto each other, that is, they created this very antisocial situation . . . If this version is true – historically I mean – then it's a pretty interesting position for an artist. Instead, here in Europe, it results in an artist admired for his Power, officiality, representation, for getting his work into the highest levels of assimilation, of commercial and cultural qualification. But then I think that taken all together, one who has taken up this situation so well can also see the other side . . . Indeed, the artist, for me, is this type who gets tired, is dissatisfied, intervenes, isolates himself. He's one who reacts, that is, one who reacts to various situations.

ACCARDI: Today there are all of these intermediaries, to understand each other: so, there's the critics to understand the artist, I don't know, then the other one to speak in Parliament. Instead, you . . . yes, you brought this up . . . in the meantime to do things on your own, that is, even if one . . . it's not that

everyone has to make paintings. Yes, you were interested in this art that had these points of . . . points of raising consciousness, which gave you many things in life and, certainly, art, of all kinds, is that which grants man the possibility of independently raising his own consciousness, which doesn't come from outside intervention, other occurrences in the universe, outside of himself. Today, however, there is a moment in which . . . or it's me who is interested in other parts of . . . in which it doesn't seem to me to only be art . . . even that seems like a specialisation, I mean, to say things really clearly. So, it can perfectly well not be the way for everyone to . . . See, it seems to me something that borders on utopianism, your youthful idea that through art others should find a way to live their own creative life. It's something that animates us all, right? But, reflecting on it, I think it is so difficult to think of what bonds us to others, to understand them. Do you ever think about it? I, myself, don't know.

LONZI: Rather than being the emissary of society, the critic should, in fact, be the emissary of the artist.

KOUNELLIS: It seems to me that they've mixed up the problems of the signals themselves, which are problems of society, for reasons relating to power, aren't they? Because to be the emissary of the artist means putting yourself in the same condition as the artist, namely as a man who lacks any power at all. So, this here, being emissaries of society, saves the artist at the level of power. In this way, they make the artist assimilate to the social model, which is established. They seek to integrate all of the new experiences into that society with the excuse of helping people to understand the artist. While it ends up that the artist is integrated, in exchange for Power. This is a dead-end street, the road of success, of understanding, and of power. It's an intricate mechanism that's been at work for centuries, don't you think? Even the success of a man.

PAOLINI: A work, such as this, which I particularly care about, is a small reproduction on photographic canvas,

rigorously formatted, identically naturally, of *Portrait of a Young Man* by Lorenzo Lotto. Here, nothing: the painting is the exact photographic copy of Lotto's, except the key to the discourse is in the title: the title is *Young Man Who Watches Lorenzo Lotto*. The portrait is beautiful: there is this young man who watches with intense eyes, really enthralled, the object, that is he looks at Lorenzo Lotto and, in my case, looks at the object, and so I liked it . . . to restore the moment in which Lotto painted this painting and to transform, for an instant, all of those who look at the photographic reproduction, into Lorenzo Lotto.

LONZI: One can be close to artists today also by listening and listening again to them, if you don't understand them at first . . . But, how can you make a gesture like this afterwards, which is a gesture of the critic's absolute impotence, because if you take a recorder it means that, as a critic, you no longer exist in the traditional sense . . . how can you then make the old gesture again 'This yes, this other no . . .' You can't do it. The first time that I used the recorder I said, 'But what's happening?' I didn't really understand, I really felt strange with this device, it isn't something that's so obvious, and then I said, 'Well, it's logical that I felt this way,' that is, I want to be close to artists and to free myself, as a person who may have this academic culture . . . Because the funny thing is that the critic learns what the artist is while at university, he learns about historical texts and then, his own conception of the artist, of the critic, and of culture and then he never questions them ever again, with a recorder or otherwise. I like these works of yours because, when I am there inside them, I feel like any other person, without all of that stuff that a person gets from a culture of protection and privilege, the protection, the privilege, which is useful if I go, let's say, to a Museum. But there, I'm just, I don't know how to describe it. I'm just like a person who goes into a church because, I don't know, he's got a problem that his culture cannot resolve, with nothing, without . . . and very suspicious of that which someone, on the

other hand, has in terms of daily feelings, actually the special-isation of feelings. After these things, everything plays out on a different level. I get to thinking about it when I take action, or when I am distant from action, if I confront this feeling that that has stayed with me, with a life situation that I see as false and I think about that which was true, I don't know, that which flows out of the honest behaviour of a person, you know? It becomes something that you carry with you then, in other moments.

ALVIANI: I'm sectorial, it's true. Because I couldn't be any other way, maybe you know. Sectorial, but knowledgeable also about the possibility of being other, that however . . . not that I don't feel able to pull it together . . . It's my brain that's this way, you know? I don't know, a form: inside there can be a hundred, and I prefer to nurture that hundred, to make space, to make it one hundred and one, a hundred little red balls, and I prefer not to put inside, I don't know . . . a mush-room . . . or else a cube . . . you know? Another thing. Maybe these balls, at a certain moment, will also be judged through this parameter that will work as a filter. But, I don't know, in the brain, it seems to me, that there are many things that just can't fit there completely, especially because, I don't know, if you think . . . so, thinking thinking thinking, you can't get up. I prefer to think of objects rather than to think of . . . See, this is very honest. Or else, like, to think . . . to think of man. Of man in the biological, physiological sense, I don't know, at the current level, and when I will approach this man . . . I have already approached this man as a physiological element or, yes, biological, when I put him there to analyse him. We see what the eyes have to bear . . . I know this well because man sees hot objects in this way, in as much as his retina could also not see them, but there is a sequence of images, he has a speed of x images per second, but, he can see them this way. If he didn't have this . . . he surely wouldn't see this . . . if he had much less, etc. These are the facts . . . because it's made of facts. Obviously, I know there are others . . . and all the others

have always been contaminated, understand? I need to make a clean slate, I need to remove all the literature that's there: intentionally, now, I don't want to show interest, you know? Because they always had their grip on every other situation, emotional, psychological, neuropathic, visceral, sanguine . . . See here, I don't want to show any interest at all. When I'll know, rather, that blood, circulating in a certain manner, because it's accelerated by agents, I don't know, external agents, environmental, so it shapes ways . . . things that are at a very professional level . . . it forms situations of vision, or of absorption of concepts, in a particular way that's a lie, or else, even, that's accelerated . . . All of these are very interesting, what are they called? Hallucinogens, but still, at my level, I don't know what to do with these things . . . I'm not even curious, you know? It's worth saying, I am interested in primary things, yes, to analyse; after, I wouldn't continue . . . In the end, I thought of making these images with only one light: I'd say to the subject, 'Close one eye and see what's taking shape,' like that, but without saying 'close your eye', afterwards that happened ten times . . . Too much stuff, understand? Look, so, in the pitch-black room, you fall to the ground, take a hit on your left side, fall, the light lights me up, a sudden cry from over there. No, here there's still the romantic element, the element of poetry, the effective element, the element of shock, the element that's really of no interest to me. I want to feel how this man reacts to this [loud noise], I don't know, to this [soft noise], you know? Before preannouncing, 'Look, now I bang around,' then without saying anything to him . . . All of the things in one practice. I don't know if these guys who, today, go ba bum bum, ba bu bu bum ba, know this man, zum bam, clap clap, zum . . . if they know them all. If they know them all they are enormous, immense, unfathomable types, I don't know how they did it.

LONZI: I think that, when one is a critic, one should also examine oneself, have experiences, take in everything about this sector of activity, namely have a kind of initiation

– the word came to me and I'll hold onto it – because initiation means that you enter into a thing, get into this thing, absorb it, you transform and live, meanwhile, right? It's not that your whole life, you got to stay passionate about something . . . artists are doing or saying in and of itself and that particular place. It's interesting to you in a free way: in a certain period, it won't interest you at all, and in another period it will. Now, there was a person who said to me, 'But you, in America, did you go to the young artists' studios?' I said to myself, 'How strange . . . I went to Zoos, I went to Museums of Natural History, I saw what I could about the American Indians, I saw the architecture of H.H. Richardson and of Sullivan and also their contemporaries, I'll show you the slides of the warehouses of Minneapolis, I saw friends, I saw the bourgeoisie, or what the Americans call the middle class, I didn't intend to see artists, it didn't cross my mind to visit studios.' I believe that, over the years in which I have attentively and carefully dedicated myself to this . . . now, I no longer have this anxiety, because, let's say, one wants to have the experience of what art is, then the fact of informing oneself little by little about what's happening is another thing, understand what I mean? It's a professional necessity not to

miss a word of what's going on. But, spontaneously, one feels carried in different directions.

KOUNELLIS: You say 'Abolish the craft . . .' but that means that a painter, once the craft has been abolished, can do what, I don't know, can be a farmer or travel or do something else. This is the abolition of specialisation, that there was, in this work, while the critic's work isn't the same, because they start with extremely different assumptions of what they are, they're not the same, right? Because the critic begins from historical assumptions, I don't know, from studies, actually he sees himself as a scholar. And a scholar, later, who becomes a critic . . . what does this mean? Scholars aren't critics, scholars are scholars of real phenomena . . . One understands that this behaviour is very ambiguous, they are really different things. They say 'historians' need to have a wider perspective than that which the critic is allowed to have: if things are very crystallised and you have very fixed dates. While the critic is the mediator of actions, but this is in itself an interpretation, indeed, right? It's a falsification of things, it becomes the interpretation of the interpretation, right? So, what does it mean, in the end, all of this? And who is the critic? A propagator of ideas? Who could he be, right? This isn't it, it doesn't even mean anything. They start with very different assumptions. You talk about it, in an elementary sense, I don't know, about the critical mentality that each of us has, while they take up this mentality in a much broader way and give it more meaning, indeed, to this kind of operation. And more meaning, more meaning, more meaning that also gets to the superstructures, spiritual superstructures of all of the mentalities and, later, one arrives at the excess found today. This is a fact, this sin of presumption, because the artist, the minimum that he makes, he makes something, and the guy there that offers the criticism, he's no one, right?

ACCARDI: You see this book about that school, there, the School of Barbiana . . . there are many things there, maybe also . . . but there it's written, in order to understand what

these kids want, really 'We want a teacher who comes to us, and doesn't automatically say – character development is independent because . . . – that today is the credo of our schools . . . no . . . we want a teacher who, doesn't even make us study the work of Sapegno, etc., no . . . we want a teacher who is passionate, who influences us, who'd tell us . . .' What he was, poor thing, poor Braibanti who was condemned, then. It's right, it comes back to, see, this fact about the initiation that you were saying, it's this thing you're attracted to in humanity, I understood you. In fact, teaching, it happened that I became a bit . . . but instead it opened my eyes, that I can do this. I can, for example, start over leading them to something that's interesting to me. Today, it's a moment in which the accounts of a period have been drawn . . . I see it like that, a chronological period, began in a given year and ended. And, in fact, I am trying to save . . . help save, because I am trying to involve a lot of circumstances, people, elements of life, and this seems very interesting to me, because it's the beginning of something else, you know? I have a problem with the institution of the school, because it's my field, and with critics, certainly, but not as much of a problem as you have. And then I take issue with, for example, with everything that is a surrogate of art, but that was always presented as art. One time I was at the seaside with friends, we were talking about a painter and I said . . . yes, because he was one of those who'd really been hopeless. So, Chiara said 'What are you talking about, isn't he one of the most important painters? Who are you talking about? Aren't you talking about X? But, I thought I heard how important he was in your field, I swear.' I said, 'Yes, it's true.' It happens in all fields, without a doubt, but it makes me angry that even we are stuck and we always get stuck, in the end, in this kind of *omertà* that young people, actually, have a lot of reason to shove in our faces, they really would be right to. In fact, I don't know, one might be modest because he doesn't want to seem like the chosen one out of the whole group, and so he doesn't put on this *omertà*. I don't understand, humans

are always plagued with misunderstandings, as soon as you're distracted for just a second.

FABRO: I'm not sure this is an experience worth telling or if it's of any use . . . anyway, I find that generally, artists have clear-cut reactions to criticism, to anyone really who talks about them. I, instead, I don't . . . I'm unable to be or act as the aggrieved party or the . . . how can I put it? The opposite of the aggrieved party. What I felt, in effect, for a rather long period, was indifference on the part of criticism. The fact of being torn to shreds, or not torn to shreds, of being adored or not, this, yeah, you feel it like . . . limits of the possibility even if you actually know it's part of paying your dues – that is, you've got to do certain things, bow your head or walk like a king, but that's a doorway you have to pass through – until they close the door in your face, and then one feels excluded, really from everything. I see that many artists are deeply affected by this feeling of being misunderstood . . . also of exploitation, but generally it's a feeling of inadequacy in respect to what they do. But, look, generally artists don't have an alternative, that is, they'd like positive criticism that reaches levels that are . . . utopian! . . .

KOUNELLIS: Critics, in Italy, are extremely prepared for exactly that, really, aren't they? I've also seen American critics,

who aren't as prepared as Italian critics . . . that, maybe, is also a part of their intuition-based capability, and also of a stronger scientific education, in respect to others. But this isn't what's important: it's the mindset that doesn't work. There's something in the mentality itself that isn't clear, you know, from a point of view of actual men, I don't know . . . but whoever you pick among the Italian critics, they're better than the French ones. The American critics will likely be diverse also, right? . . . They have more action, more . . .

LONZI: Today, the disappointment in criticism doesn't come from criticism's lack of culture, or because criticism . . . No. Really, it's about discovering an Institution that distorts what you wanted to express with your work. And, this is important because the public, later, bases its own opinion on the criticism, the public wants 'to understand' as the critic does, since they're not interested in 'making' as the artist does. So, standing before the starkest work possible and which directs the public to the farthest reaches outside of culture . . . that wishes to bring people . . . yes, bring them to the point of being able to clear their minds of everything everyone else has said about the world, about things, about life, about how and why. If the critic, in turn, adds other arguments, on top of all that fog that's clogging up people's eyes, it's inevitable that the artist feels, in any case, even if he's highly praised, he feels like he's being mocked by the culture.

KOUNELLIS: It's society that creates these problems. It's not enough for you to feel free on your own, but it's society that continually stultifies everything you do, manipulates it all so much that it turns into something else. And this, though, also gives you a shield for greater mobility: as soon as something . . . and they try to crystallise it, you contradict it, you find others. For this reason, never offer anything solid, it's immediately snatched up: if you offer this here, they crystallise it right away, they create a mountain on top of it, you know?

LONZI: The American critic is a much more powerful man, who can make things happen, has a broad clientele, greatly influences the market, influences gallerists . . . and, in the end, I think he's still worse, they're more subject to their own whims than here. Here there's transformism, there they have stratification, even very quickly, of the things that crystallise. Here the critic tries to hold off facts with ideas, there though, the facts are made of a precise, consumerist substance, for which the critic is forced to draw as much as he can out of every moment and follow the mechanism without trying to disguise himself too much, and so, for this very reason, ends up promoting it. A sense of the critic's real personality also comes out there, the oversized personality of the critic, as they say. This type is presented to society as something pre-structured, like this type which has a consistency . . . while here critics have an inferiority complex that keeps them a bit wobbly. On the other hand, in America, this other kind of character is more recognised, who, I don't know, can become the director of a big Museum, control many powerful levers . . . But, I've heard critics ask artists for their opinions, I mean, at a low level let's say, how they do things here, that is the transfer of opinions, but in an exploitive way, meaning, not a free exchange. Therefore, if you go to look, deep down, there's the same bit of moral misery, right. But socially, sure, they have a different face.

SCARPITTA: When I arrived in New York I was rather perplexed, because they didn't know . . . I mean, they didn't know how to distinguish between painting and sculpture, but because of some strange reaction in '60 and '59, they displayed a lack of understanding about whether paintings in relief could be considered painting or sculpture. And, in principle, when I first read the criticism and they made some distinctions, 'What is this thing? if it was a hybrid between painting and sculpture . . .', as if the painted work was a painting because it's two-dimensional or a painted sculpture was sculpture because it's three-dimensional. They weren't able

to find a stable critical metric, despite the fact there already was the nation of Dada, because there were already people like Rauschenberg, also Johns, maybe some others who were working . . . so Allan Kaprow was a painter, he didn't really see himself as part of the whole world of the happenings, he was mostly a painter himself. So, despite already being in a situation where the dimensions were becoming more open, being considered in a less orthodox way, I had a hard time establishing an artistic fact that in Italy was kind of, not really accepted, in 1959–1960, but it was already something that was no longer discussed in such orthodox terms. Here, one sees that a criticism based in Abstract Expressionism was still holding ground, and in a really adversarial sense, it refused to expand to grant any leeway, even if the country, you know, so-called or, at least, also established out of the events, established then also rightly by the events, of the avant-garde. I want to say: the first wrapped paintings I made, I made in Italy. The first were in 1957 and the first show was at Plinio's, I think, it was in 1958, and then we also, I think, had group shows, but the first solo show was in 1958 and it was at Plinio De Martiis's gallery, after that Castelli came, I believe, and so I returned to America with paintings, but the fruits of Italian labour, and I met these kinds of difficulties. They were the first relief canvases that had been seen here, because they simply didn't exist. Then, maybe, after a year or two, the three-dimensional paintings arrived, but geometrical. But the relief canvas was maybe the thing, filling the space already taken by the wall, which gave, I think, a start to Minimalism, because it invaded the space but no longer in a pictorial sense, I'd say almost, architectonic. But, when one spoke about art that had come from Europe in this way, for example my paintings, one spoke of architecture, while, when they do it themselves, five or six years later, perhaps with other intentions, but some of the same presuppositions, they call it 'Minimalism'. For example, the modules: I also made those there, they were here, I had the show at

Castelli, in 1961. The modules, that is, the formal repetition of one repeated construct, multipliable, in a way that they can be contrasted or in sequence, or anti-sequence, in a near-mathematical sense of 1, 3, 5 or 2, 5, 1 or 1, 4, 6. In this sense, already interrupted sequences, they were already being created in 1961 at Castelli. Yes, how could it be otherwise? But of course, Carla, and I had two shows, one with Leo Castelli and another, same thing, at Dwan in Los Angeles. The show wasn't . . . seeing as how I was always in a rush, I can't . . . I don't even want to sit here and tell you the story . . . and tell you how things were in '61, because I don't care. The truth is that they were paintings made quickly, with a certain intention, that I didn't follow up much with, because it seemed to me, having had the experience myself, that it was enough. I've never had a great sense for putting a product on the market, maybe this is why I was out of line, but as an experience, I did it, and I can bring down, for example, the pieces. And so, like I said, Carla, these modules that I made then, in '61, were based on x, they were interchangeable, in the sense that they could be presented freely. Whoever put these things of mine in their house could arrange them in a numerical fashion, anti-numerical, however they thought best. I had a certain sense of satisfaction because, being a bit enamoured with history from the 1800s, the will of painting, the pressing onward of the will, to impose one's own style . . . it was a rather new thing, for me, to allow whoever was displaying the work that choice, if you will, to arrange these things a bit however they saw fit. Naturally, when I had the show, then, I contradicted myself, because I put them in the sequence I would have preferred, and so with this I once again voluntarily invaded the space, while, maybe, if I had gone deeper into the experience, I would have been able to free myself from this extreme individualism and left things in a sense, I'd say, to a truer Minimalism. Where one would open a chest, a great wooden chest and in it there were some modules which could be placed around the space wherever

one wanted. But no, I don't believe I did this, but, even if undeveloped, even if it didn't expand into the space, at least the detail for this kind of action was there.

FABRO: I think indeed that now, as long as a vitality subsists, something of a vitality, this avoidance is quite natural, that the thing works for as long as you're able to elude it, from our part, from the internal side in which artists do a certain kind of work, and are able to live as long as they, little by little, manage to get out of the way, to move, as if this cataloguising, these registers didn't exist, that is little by little . . . It's the work of the other, that must be rediscovered and re-registered because one realises that the previous order of things is no longer valid; so you pass your whole life re-registering, if you don't have this discerning capacity of . . . working without categories, see. But, I don't know, I see for example that the climate, when we struggle or get angry at the critics, it's a bit like, I don't know, when young people go to the Academy, I mean, they've finished art-oriented high school, and then they go to art school and they start to criticise the art school, you know, 'It's inadequate to meet our needs . . . and this and that.' Actually, what would they want from art school?

KOUNELLIS: Some really clear traits come out when you go to art school, since it teaches you the techniques of that institution. Naturally, not that they care if you change technique, but they do care if you change ideology, don't they? That thing there, they use it to neutralise the creative power of youth, so they don't change things too radically, because this is the method, really, of the art school and of school in general: they teach you an ideology, you have to stay there inside it, because it's impossible to change it, understand? These things I'm making now, I don't think they have any technique, do they? Yes, I don't want any technique at all, and I don't see why anyone is required to have any technique. The coherence of Lichtenstein's style in line with what he makes, at that point it's no longer a technique because it becomes the actual expression of something. So, what technique is there?

There's none, right? Here it arrives as technique because, from an advanced position, it arrives underdeveloped, and arrives as technique, as an outside factor. Painting was never a problem, the problems were born with the art school, from the crystallisation of values, of false values because these aren't the real values. The painter's problems are problems of creative freedom, there's no such thing as a technical problem. I don't know, there's that one who made the *Venus de Milo*: he could have in principle had, in the scholastic sense, a technique in order to be able to tame this material and be able to express himself: another technique didn't exist, that's how it is. But even this is conceived in an extremely western way, as technique. I think that for an African who places four poles or something just so, with extreme freedom, there isn't any technique: he, simply, expresses himself. There is also a technique, that . . . I don't know, a maturity of expression, because one reaches also in a technical sense, really . . . this getting to the precise expression of a concept and getting there so fully, to the point that you become free. Like traditional painting . . . not now because, now, it's a stereotype, but traditional painting, I don't say European because there is always a technique in the technological sense, but in the folk culture, I don't know, in Arab folk culture, in which one expresses oneself with a real great freedom, right? There are things that express themselves perfectly well in every sense. There is another technique, in principle, but in the scholastic sense, like how one learns to speak, it's minimal, it's not a technique as we think of it.

FONTANA: So, technique, for us was clay, marble, bronze, and you really needed to know how to use them because you would have to mould them, and you gave all your life to those moulds and all your form . . . For bronze, first you had to work with clay, then move on to plaster, then . . . three or four different elements that transformed you, also, in a certain way. The most logical material was ceramic, that you would model and then fire, it was totally direct like working with marble

that, if you sculpt it directly, marble . . . but there are very few exceptions: Michelangelo . . . Today, there are infinite techniques, it's almost like they want to take advantage of techniques in order to distance themselves from the pictorial reality. Now, see, the hole: I didn't worry about a technique because I was interested in the idea, and so I poked holes in the canvas and I didn't think of poking holes in a sheet of metal, but the value would have been the same, right? Later, I also poked holes in metal to rebel against the canvas, but then, I thought, the material didn't make much difference. And for *Ambiente spaziale* ('Spatial Environments') . . . naturally, thinking of an environment, the technique also comes to you, if you had a concept to say: the environment is the sign of emptiness, the end of showing in galleries with paintings on the walls, the little sculpture, the big sculpture to sell, the art that has entered into a general social construct, that would be more of a thought than an artwork for sale. And you say, 'How can I represent this?' Take the elements, then, that give you the technique, not 'approachable', but that you think could be most convincing for the public. Look: the all-black room, the black lights, with fluorescent colours that gave this feeling of emptiness, a feeling, a completely new material for the public, and so there comes the technique. I don't know,

this is the most important thing: illuminated sculpture . . . you can't illuminate marble, you can't illuminate bronze, so there were neon tubes, you can also make a work of art, I picked up some neon. What's the technique here? Working with neon? It would be difficult for an artist to work . . . see what follows, later, co-operation with craftspeople, because it's also the guys making electronic music, today, they use electronic engineers, who are well-trained, great men. They put out some ideas, paltry ideas, that become formidable only because there's the machine. Understand? It's always man's creation that starts it, and the technique you do yourself, trying to arrive at the point closest to your idea, and so, you go to find it immediately. And then, the techniques . . . someone discovers plastic, another light . . . so comes the lighting technique, the plastic technique. But, you always need to go to the source, because Lichtenstein is a revolutionary and didn't do anything besides paint comics, anyway, with his own technique, exactly, it's the technique of printing, inventing those things there. Your question, 'How is it important for you . . .' I'll ask you the question. Technique is important for the display of the skill of the artist, right? Because the artist is already a creator who creates with whichever material, then there is the practice and the perfecting of the practice. But, you insist that technique is important? To bring material that almost doesn't intervene in your creation . . . That, moreover, even Michelangelo, who at twenty-three sculpted the *Pietà*, a form and a technique, well, out of polished marble, and when he gets to be eighty, he rebels against this material, he almost wants to destroy it and he makes the last *Pietà* as if he almost wants to shape a spirit, and mould light. You see, the material is always a compromise for the artist, and yet, like I told you, a documentation: you can't rebel against that. It's an important part, because technique is like writing in the end, isn't it? Once upon a time it was an issue for writers, I remember myself . . . I'm old now, so I can understand . . . they wrote with a feather or a quill, then the fountain pen . . . I remember the issue,

even with D'Annunzio, who said it was impossible to write with a fountain pen, it was necessary to dip, because while you dipped, ideas matured, like that. Then, I won't even get into when they came out with the typewriter . . . there were, seriously, writers who totally lost it with the typewriter. So, see, that in creation, technique has a secondary importance, right. Unfortunately, there are stragglers who are overly concerned with technique.

ALVIANI: In industry, in technology, one can be attracted to everything the machine makes. The machine produces marvellous forms, strips are cut and come rolling out . . . take them and carry them off emblematically just so, like products made by machine, it would be the easiest thing, the most tempting thing, the most curious. On the other hand, I think the machine must serve the realisation of the idea. Once upon a time, one walked through fields and found beautiful stones . . . today, one is in the factory and finds wonderful wood shavings, but the spirituality, if we are to behave in this way, would always remain the same, the spirituality of found objects: today, a bit more technical because it is produced by machines . . . yesterday, more naturalistic, more poetic because one found it in the forest. But the spirituality doesn't change. The spirituality, however, changes, and for me, the most important thing is this very spirituality, in the increased power that these machines have given us: above all, powers of investigation, and therefore of verifying ideas of mentality or of helpfulness, even certain ideas that concretise in the mind in a certain way and there, in the machine, you have the possibility of making them a reality, of proving them real. All of the things that the machine can give you and that I, without it, could not . . . But people aren't familiar with plastic, they discover plastic and think they've discovered the world. It's, really, at the level of a found object, isn't it? And then, it isn't problematic, understand: I am interested in the problematic in things, I've always talked about this question of the problematic. Inside there have to be real problems and

not surface charm, also it's wonderful poetry. You see: from
the expanses, that are these shapeless forms, to the metal bars
that come out of them, extremely shiny . . . they're fantastic,
and it would be enough to bring them there, I don't know,
into a place suitable for worship like the Galleries . . . what-
ever enters that space turns into cult straight away doesn't it?
They would become great things. And this here doesn't cor-
respond, you know, it isn't in the problematics. I also imagine
that . . . I don't know, comparisons are silly . . . to chemists who
create reactions between one thing and another to find a new
resin, let's say it results in bubbles, or else some crackle . . .
Say, 'Ah, what beautiful crackles! Instead of making resin let's
make crackle.' It doesn't hold up, does it? I need to do other
things that I sense and have to research. There is, undoubt-
edly, every time the suggestion of a product, of a material
that indicates possibilities, but these, then, they have to be,
besides filtered, because it's too little to filter them, they have
to really be made. To truly acquire consciousness, to have a
consciousness. Therefore, to be spiritual, to be expressive
objects. I've never had enthusiasm for the found object, like
saying, 'Yes, look what a beautiful result the machine gives
me, let's try and do it.' I needed to develop some problems,
I approached the machine that I thought most appropri-
ate, the most relevant for giving me the problems I needed,
the machine sometimes encouraged me to give even more,
even more perfect than, let's say, embryonically, than I could
think: obviously, an interrelation.

NIGRO: I employ painting techniques in as far as I've
always considered my work to be projects to be realised on a
large scale. Therefore, I give maximum value to methodolog-
ical research that has design as a first step. For me, the actual
creation has a marginal importance, it isn't essential. There
are many lines of research that have expired in time that are
later proposed using new media . . . this doesn't matter to me.
With this, I don't mean to say that if artists use other materi-
als they can't turn the object made from those materials into

pure research. But, as a point of departure, there is always the element of planning, that is, of methodology. This is the problem that has racked my brain for many years and that I've followed relentlessly. Even if I might be mistaken: every philosopher, every scientist has his rights and wrongs, therefore, I will also have rights and wrongs: in my time, because a hundred years from now I'll surely be wrong. But, I do say, that twenty years ago, I had some good points. When they claim that painting is exhausted, I think it's an erroneous discourse, because one cannot talk of painting, but of plastic language: painting and sign. Whether this plastic language is realised on a plane, as a plan, or in three dimensions, while it may alter its appearance, it absolutely does not change its meaning. Because, if you like, in the beginning one doesn't even need to create a plan with a pencil: when it's thought up it's already completed. There was Malevich who said, 'You want a painting, call me on the phone and I'll tell it to you.' Not in a Dadaist sense, but as the utmost level of research freed from any material. It's beautiful that one tells a painting, it's gorgeous. In this respect, Malevich got to the bottom of this problem.

PAOLINI: The fact itself that a work of art exists is because, through a certain technique, it effectively manifests itself, right? It isn't of a second order, then, this fact of seeing this work through the use of certain materials or others, it has a discreet importance. The technique, therefore, is the means that allows us to subtract, from the space in which we are present, the other part of the space that is the work of art, and which nullifies itself, precisely through this technique. In the end, art is technique itself which is used towards a certain end. Technique allows the work of art to exist in as far as it subtracts from the space in which we are, namely the environment in which the work of art is present, that amount of space that is constituted by the work of art itself. If we have to pass from our everyday space to the space of the work of art – I mean, the actual physical space – we need to cross

the membrane, internalising a technique that allows us to take this very leap, right? Exactly for this reason, technique shouldn't prove itself in its own strength, but only serve us, it should prove itself useful like an invisible membrane, innocuous, to get to the other side. For this very reason, it is of the utmost importance and of the least importance at the same time. From the utmost importance, let's say, abstractly, as a problem, and of the least, possibly of no importance, as an entity. When technique weighs on the thing it means that it is undoubtedly an obstacle, a restraint: if the technique is appropriate for the work that one wants to do, it eases, promotes the passage, the function of the work. In this sense, all of those creations in which the technique becomes the focal point, when one is more taken by how a thing is made than by the thing itself, I think it's a tone-deaf situation, an embarrassing mistake. Given that my work isn't so much about propositions, but rather work on the very language of making, I've never chosen one technique over another. I've always chosen the most invisible, the least bodily world to grant evidence to what I wanted to create. It would be absurd for someone

to choose a technique as one chooses a suit or a uniform and that would work indiscriminately for every circumstance. Every task requires a bit of thought about how it will be carried out. It's my opinion that the material of the work of art should be – but it's always been – modest, in the sense that it has always been overpowered by its function for which it has been used. In this sense, there is not a stylistics of simplicity, but a 'rule' that establishes that the technique used should be as discreet as possible. I find myself annoyed when the simple, not to say banal, reality of a process, appears – I think – weighed down, by a mechanism of its making, namely, when technique presents itself as a gratification beside the idea. The danger is that, more often than not, in certain research there is an inversion of terms, indeed, between technique and idea.

CONSAGRA: My sculpture is frontal because it comes from technical considerations of simplification from the constructive point of view and of the materials, but above all because it comes out of the concept of Different Space. To differentiate the frontal space from the central space was, for me, a raising of consciousness of social problems, of my way of saying that I didn't believe in anything. The plastic elements reduced to the flat surface, the simple overlaying of levels was the technical consequence of my refusal of modelled plastic, resolving it with minimum costs, a sculpture made in light metals, strips of wood or iron.

CASTELLANI: Current technology is so rich with possibilities, with various materials and disciplines, that one risks losing sight of what one wants to do, the reason one sets out to experiment in the first place. It seems to me that experimentation as an end in itself could happen on a technological level, but then really within an ideal of craftsmanship . . . also with new materials, naturally, this doesn't change anything. While, in our field, experimentation has always been understood as something to enrich language, it has always been subordinate to the language of the artist. My things can be made with all kinds of diverse materials, but there is the

labour of technological and organisational research that, at a certain point, one realises is no longer worth the trouble. There are much more direct and immediate means that eminently serve their purpose. Yesterday evening, you spoke of a fundamental difference between what I do and what Fabro and Paolini do, in terms of a poetic methodology, let's say: for my part there is a constant monotone and in their case one moment is very different from another. Therefore, thinking of behaviour, we are at two opposite poles, but it is very strange that, even they, when they want to create their works, they get there using the simplest technology possible, a traditional artisanal technique, without resorting to advanced technologies: for immediacy's sake, even them. There are halfway points between these positions, there are those who, having nothing to say, cling to technology, those who want to prove their worth at any cost by using the most up-to-date technology to show how much they're able to legitimise it. Why did I say halfway points? Maybe to place them somewhere . . . No, the fact is that I put them in the middle without thinking too much, also because they're amenable to anything: they have little machines in their hands, they have plastics, they have the ways of shaping them, of giving them their look, and they can also be here or there, they can make my things, or Fabro's or Paolini's. But, they also make an ideology out of

their position, don't they? They idealise, rather, the problem. I've had the incentive to experiment with different technologies, to build what I already make in a different way, but in reality, it ensued from a contamination of these ideologies. I remember my first show very well, 'Think how beautiful these paintings would be in a thousand plastic specimens': you have these elicitations. Then, there, there is the rather abhorrent speculation of people who say 'I make work that costs very little . . .' But, then, they want to put it in a worker's house, who would rather spend his precious 2,000 lira on a football which makes him . . . happier, doesn't it? . . . it's more emotional than keeping a piece of plastic in your house, that, if anything, tickles his petit-bourgeois fantasies. Therefore, their declared socialism, if you analyse it, is . . . an arse-licking show. One, at a certain point, when he makes something, has already chosen the most suitable technique to carry out a given idea. If I make things with canvas and nails it's because canvas is the most elastic membrane that, however, also has a guaranteed resistance. One can think that, relieved of the pressure from the nails, it will return to being completely smooth like at the beginning. The relentless push to find new techniques is always frustrating. The more obvious the material, the more traditional, the less likely the product becomes an object of contemplation. Because whatever you make could become an object of contemplation – the ashtray, the drinking glass . . . but, if you make something that's the most simple configuration of an idea, that object remains truly the minimal means, not susceptible to becoming a fixed object to contemplate, and that's all. I don't believe in technique as the yeast for new ideas, as provocateur of new things: it will always be subordinate to the ideas of the artist. If I had a project in mind that could be an invention of language, in this case I'd also find the right technique. The technique comes automatically after the idea, but as a spontaneous element: technical research, for me, is at such a normal level that it's not even worth talking about.

FABRO: If one is a critic by profession, one who has to review shows, one who publishes books that give context to a given moment, another who has, I don't know, a teaching position in modern art, so when he stands in front of his students he has to create frameworks for which this one is understandable because it's got green, this other is characteristic because it has red with a blue point . . . it's something that doesn't . . . that has nothing to do with us. Criticism has nothing to do with us, in as much as art school has nothing to do with the formation of artists. Criticism, as it is conceived, cannot be, I don't think, different or better: or it's something else . . . Something that's useful to some people, how it has been useful to me, I don't know, like *Garzantini* pocket dictionaries from a long time ago where I saw paintings, Picasso and maybe Morandi and Braque. However, it's that intermediate phase of culture of which you cannot ask more. As soon as you ask for more, criticism does not exist, those personalities do not exist, while we continue to require things from certain people, people who have clear specific functions, of things that are not for themselves, that they aren't able to give us because their lives are arranged in a certain way, they didn't want more. Their willingness to get to work is already quite a lot, when it's done honestly if, when writing a review in a newspaper, they attempt to understand something. I'm not sure I'm being clear. You can't pretend . . . from the Little Professor, at a certain point, to get inside yourself: he has his own little problem. I bring this discussion to you because it's the painters that do it. It isn't your discussion. You do completely different things . . . you don't come in like this, with predetermined tasks. I want to make this distinction: the critic who has assignments and the other, who is neither a critic, nor has assignments . . . who does things, but, independently. When I talk with you and you talk with me it's not like you're carrying out criticism about what I say . . . or now I am speaking with you, I'm your critic. I don't have assignments: I speak until the moment in which I don't know how

you could respond to me, or until I want to talk because, like this, I have things to say. That which, on the other hand, we need to distinguish, yes, in criticism, it is the critic who feels the need to teach, who has decided that for him it's important to teach. Perhaps to get to the point, I don't know, that he has to teach others that Italy, in this moment, is a very particular situation, characteristically, in respect to the rest of the world. So, he will find all of the loopholes, all of the ways of characterising it, like someone would characterise a car, he starts at the bumper, but instead, by doing this, he does it pointedly because he is interested in characterising that thing there. Yes, you can't ask for more. The danger begins as soon as the artist, on the one hand accepts the elements of characterisation or captions, because more or less they're captions, on the other hand the artist refuses and gets mad when he sees limitations in these elements. He doesn't get mad so much about the characterisation or captions, but about the limits that come from them, and that's absurd. Yes, because, see, he says, 'But he didn't understand anything! . . .' or, first says, 'Ah, yes yes, but he's really good, look what he did . . .' Then, when he talks about something in particular, he says, 'Ah . . . he didn't understand anything.' But, what the heck do you want him to understand? He has a completely other job, he creates a kind of connection, I don't know, like my wife when she's able to explain a certain author at school: it's obvious that what she explains is not the author, but, within the limits in which she is able to create interest around the author . . . it's quite important, it's the most one can do, because then, she cares about the author, that's what I take away from it. I sense that the critic doesn't care about the artist . . . and even the artist . . . and it's completely fair. Why shouldn't the artist have to accept that, at a certain point, a person doesn't give a shit about him? Despite not caring, they have an exchange beyond that, okay, but you can't put on this prima donna role, where you suffer a shock when you go to some little town and no one there knows who you are. I often sense this . . . the imbalance,

here, right, in the artist and I see it as a limit of weakness. Because, then, I don't find it in everyone. You find it in some of them and they are the ones who start up this problem with criticism. Eh. In others you don't find it, you really feel some artists thumb their noses at criticism.

LONZI: There is also the reflection on the elements of Power that this criticism wields. Because, yes, what, afterwards, disturbs many is that, a fact that the artist considers fundamental and educational, then influences his life as if it were a decision handed down from God Almighty. And this becomes tragic because, if you think of someone like Nigro, you know? . . . Someone says to him, 'I consider you a mediocre artist.' Nigro might not care that this guy considers him a mediocre artist, but the fact that he does consider him a mediocre artist influences his life, to the point that it makes him into a person conditioned by the persecution of these negative judgements. Which then, at some beautiful moment, become positive, when a series of external circumstances align and mature.

FONTANA: Laughing for years and years, right? They said to me, 'But what are you doing? But Lucio, you who make things so well, you who . . .' so I was good before and then an ass after that. And I managed to get into the Biennale by tricking the Commission, because I was invited to bring sculptures, wasn't I? I didn't say anything, and I swooped into the Biennale with twenty hole-punched canvases. So, you can imagine, 'But this isn't sculpture, it's painting!' . . . and 'No, who told you it was painting? Holes are painting according to all of you? . . . For me they're hole-punched canvases that represent a sculpture, a new reality in sculpture.' And also there 'Bah, we don't want it' . . . 'I've got the hall, I'll leave it empty, okay.' Afterwards I was sorry, at the same time, to lose such an opportunity, so they forced me to put a piece of sculpture in there, and I put a piece from '34 or '35, *Le amiche* ('The Girlfriends'). Look, you can imagine that Biennale, you know, with the holes . . . But, see, criticism to me, didn't . . . Even

Argan, who was interested . . . he was interested, but hadn't really understood me. Argan, perhaps, still understood me as the old Fontana, these sculptures, and such . . . Then, he interpreted me as a gesture, gesturally, more as a sensual reality, something having to do with the materials. But really, it was clear: 'Spatial concept', it was a whole space that . . . But, I, I also had many friends, I can't . . . I, about criticism, I can't . . . except for rare exceptions. Naturally, some came at me, on the other hand today it's all very positive, right. It was the same question when I moved from the holes to the cuts. They said, 'Well, the holes were so beautiful, but the cuts . . . uh, but that there . . . you made a mistake, there.' When they don't know what to say, they don't understand, so they grab what they can, excuses. It's like the Biennale, the same thing, isn't it? The Biennale now, with this oval shape . . . And there, everyone, 'But what, you're not showing paintings . . .' Everyone, even a good number of the critics I admire, they suggested showing the *Teatrini* ('Little Theatres') or a retrospective. Afterwards, however, my critic friends, just like that, they understood that, maybe, the oval was more important than having an exhibition of paintings. My Gallery wanted paintings, naturally, in order to sell them, for commercial purposes, and I didn't accept that. But, I'm very happy with what I did do because that is a spatial environment . . . since at the show in Foligno I heard a lot of criticism suggesting set-ups to the Biennale, not mentioning the fact I actually made that, that surprises me. Suggesting – 'but' I say 'Actually, I made that show. I did not suggest it.' For me, that was an environment, it was an action on the environment, wasn't it? Eh, you know? In fact, I had this courage, the strength of spirit more than the courage, to resist, you understand, with the holes, all the collectors and so much of the criticism, even the friendly criticism, I didn't accept it, but I was so convinced . . . After, you know, there was a stroke of luck because, for us, it was a bit tough, not only for me, a whole series, from Capogrossi to Burri . . . Burri was also lucky because he did something maybe . . . because you also

need some luck . . . I'd almost say, more understandable, in
the brutal sense, really. Then we had support from Cardazzo,
moral support, because we paid for all of the shows, books and
everything, all of it a sacrifice, but it was really worth it because
he held the whole group together, did shows abroad . . . Well,
in the end, the life of an artist, this struggle, back then was a
bit more difficult than now. I mean, to be honest, young artists
are more understood, this particular problem with painting
has come to an end, and so they already have this freedom in
making things. For us it was extremely difficult. You see, also
the spatial environments: I remember when they came, in
'49, they all fell over laughing; after two weeks they all forgot
about it, didn't they? I didn't insist because I didn't have the
means, the neon lights: I made sculptures out of neon, two or
three. After I didn't have money to make them and I had to
leave them there. Today, any young artist might make struc-
tures with neon, with lights, because everything has its mat-
uration period . . . they might make a spatial environment,
which today are in fashion, and maybe they don't even bring
up my name when they talk about it, because now, it seems
like everything is invented by certain critics that appear
now, and they've made an evolution accordingly, they're like
Vedova, they invented everything themselves, like that. And
they're also afraid of naming me, because, if they name me,
you understand, someone can say, 'No no, Fontana did it first.'
So, they say, 'We, by now, space . . . environments . . .' They
change the name, instead of spatial they call it imaginary, or
philosophical or whatever, but it's polenta with fowl, polenta
with stracchino cheese, polenta with milk, in any case, it's
always polenta.

NIGRO: I as a painter, usually the critic, as such, I see him
somehow like a foreigner . . . barring some exceptions of
course, right? Look, for example . . . haha! . . . did you get it?
You're an exception, yes, because you establish contacts that
aren't based on arid criticism, look, maybe this is a funda-
mental fact. Because, when you are criticism, you come to

my house, you see my paintings and then you casually quip,
'Uh, but this has something to do with Neo-Suprematism!...'
Yes well, what can I say to you? It's not like that for me! Buh-
bye, you know? Speaking of Suprematism: you know how
many times they said that to me? Now, there's nothing like
Suprematism that I had to get around, rather, I'll remind
you, in my writing from 1954, I said exactly that my *Spazio
totale* ('Total Space') was a break with Suprematism, it was a
break with Neo-Plasticism, with all of those movements.
Already, my abstract panels were a break with Neo-
Plasticism, because Neo-Plasticism established relationships
between spatial research in the support and the perimetral
limits of the support itself. Instead, my abstract panels had a
continuity, they had their own autonomy, with optical,
rhythmic consequences, for which, by now, the relationships
between that which they represented, the so-called composi-
tional relationships, by no means had anything to do with
this. This could have been a problem for the Concrete artists,
certainly not for me. Therefore, when I write there that I am
no longer interested in the portrait of the abstract object and
I no longer accept the bi-dimensional problem, I have a clear
idea of what I am doing in that moment. I have the impres-
sion that up until now critics haven't understood me on this.
Or else, it's me who hasn't understood anything, it's clear,
isn't it? Either I say something that isn't that or it's the critics
who haven't understood my research ... because, when they
put me back into Concretism, it shows that, effectively, they
don't know what Concretism is. What is Concretism? A still
life with geometrical representations. The portrait as square
is already Suprematism, thus superior to Concretism.
Therefore, Italian Concretism is a very superficial way of
thinking, end of story. Very courageous, but it has nothing to
do with ... while on the other hand, my research moves for-
ward. I follow a line of research, whether for aesthetic rea-
sons, or more related to content, the demands that organise
my motivation, I don't know, or social questions that tie

them to the interpretation of art. Certainly, they couldn't be tied to other movements except the Neo-Plasticist movement, in my opinion. Naturally, they were unsatisfied, they didn't come, precisely because of that obsession of still making . . . a Marxist obsession . . . of making art utilitarian. While, instead, I believe, art should be carried forward as pure research, like the mathematician carries out a pure science. I don't know . . . Einstein . . . he carries out pure mathematical operations, he doesn't go and construct rockets, those are the technicians. For this, the question of use comes as a reflection, at a secondary moment, but the researcher shouldn't have to worry about this. Look, between me and the critics, an ideological tension has emerged, and as a consequence a practical one as well: when the critics, in 1968, gave me a hall at the Biennale, just because they had to save their own face, despite the fact that I had clearly reported, on the notification card, the dimensions I needed, they gave me a room where my work was spilling out, it didn't fit. Why all of this? It's obvious: according to them I was one of those idiots that got invited to the Biennale to get a handout and keep out of the way. Yes well . . . in the end, those who did it are

stupid because, actually, I'd prefer nothing at all. On the other hand, if one looks, I don't know, among the older people, those they invited, the standard is really so low that it was only the protest that saved the Biennale. It's clear, at the very least, the most important things were circumvented. I could cite another example: in 1952 there was the show 'The Movement of Concrete Art for a Synthesis of the Arts' where there was an investigation in order to construct forms in a space, forms out of new materials, plastic materials. Remember? Now, there, there was a rather precise ideology. Then, fifteen years later, they did a show on images and space in Foligno, then they did another show in San Marino on new materials in art . . . so, they are two shows that really hark back to . . . sort of exactly back to that paltry little show fifteen years prior, but . . . actually, really, I wasn't invited. Why? Aside from the fact that I, in 1952, I had made a cube and a rectangular prism to arrange at will in an environment, right? The viewer could arrange them, okay? I made a project, I hadn't constructed it in the natural order of size because there weren't the means, there wasn't space, nothing. But, in the end, the project was what it was. So, for Foligno, I had actually made the images in space fifteen years earlier and, as myself, someone else. And also, then, aside from the phenomenon of 1952, I, you remember, in 1965 and '66 I had made modules, columns, so all images in space. In Foligno, they had invited artists who had never made things in space, right? But just paintings, right? It's true isn't it? Therefore, decide for yourself: why should I have anything to do with criticism? Okay, enough. The result is that, given that the old critics didn't understand what I had done, I mean, they didn't want to acknowledge it, they didn't make an effort to inform themselves, etc., they don't even want to give me the satisfaction now, this obscurantist routine continues, so they save face, their tenure and everything, and I am condemned to have family issues, etc. etc., precisely because of how they behave, understand? Look how much the critics' actions can

really influence things. But even if I hadn't done anything important, even if I had been the last of the painters, evidently the actions of the critic and the actions of the market bring the consequences they bring, and therefore . . . yes. I think that the critic can exist in another type of society, in this type it's, if nothing else . . . there are many difficulties, you need a particularly sensitive person who, at a certain moment, doesn't function as a critic because, in the type of society in which we live, the figure of the critic can't change much, you know? Isn't it true? A person, yes, a critic can truly understand me . . . not only me, but others as well, right? If he sets his mind to understanding my work as if he were inserted into a different society, in which there would be no form of Absolute Power and, therefore, there would be no danger of commodification, of mystification, no danger of speculative consumption. So, I truly think a communication could emerge, a discourse. But if the critic reasons within his own type of society he will never be able to understand me because I have always acted as if my painting ought to belong to a different kind of society, and not this one. It is for this reason we see this discrepancy. Don't you think it's this way? The critic should change his own structure, he should put himself in the shoes of a person living in an ideal society, where the job of the critic doesn't exist, but the critic himself exists . . . we're all critics. We are all artists, and we are all critics, in this world, only in this society are we not all critics and artists, but in an ideal society we are. It's natural, it's not like we're artists or critics because of divine grace, right: all of us have the qualities as long as we have the possibility to love because, in the end, art is an emanation of love, it is an expression of love. So, it's clear that, at the same time as we love, we are artists, or rather the best art is love, in my opinion. But . . . I think that's how it is, for God's sake. It's like this, believe me. This business of fixed roles is the famous alienation: if I do the job of the painter I am alienated, if you do the job of the critic you are alienated, right? Eh.

FABRO: It's what needs to be ended, this . . . this Power, it's necessary to disconnect these people from the levers of Power. And for sure it's a difficult thing . . . I don't know, I think that this may come naturally . . . if things continue to go as they are, there will be such incompetence . . . Because the rhythm is becoming, it seems to me, kind of . . . fast, yeah, I wouldn't say frenetic because it's a word that frightens me, anyway, fast, and for this reason, only those who stick together are capable of coping with it. It's something that I've found often enough in my own experience, yeah, to see how tired people really get when you push them, their capacity to endure. So, there, someone ends up out of breath and they're cut out . . . that is, not cut out because we're not up to the task, we don't have the strength or the will or the interest to go against. I think this work of continually avoiding, of escaping from that which might be considered a cultural configuration, might be a tactic and the only tactic that truly brings us towards . . . towards dismantling the culture. Even if we

were to have the very same people, but, these same people, little by little will do it and with some brainwashing, and what these people gobbled up until they were twenty or thirty or forty will be purged, there will be nothing left: they changed blood, a little bit at a time . . . or they destroyed their livers. It's the only thing we can do. Don't get us confused . . . the artist doesn't need to have lots of traumas. Yes, it's logical enough that the artist feels the limits that a certain situation in criticism imposes, but, at the same time, it's just as necessary that he doesn't feel dominated by it . . . Eh! Because for example, look at Turin's critic–artist–gallerist connection. And I see that it's also pretty similar here in Rome . . . I feel, in this, a bit outside because in Milan there isn't this critic–artist–gallerist bond. Ahhh . . . Ahhh . . . Which is why, when I am in these places, I really feel like, like someone who comes from abroad, looking around serenely . . . more or less pissed off . . . look, these things. But . . . yes, everyone has these discussions against inept criticism, criticism that says this, and that . . . but, as soon as they find someone who tries to defend them, their behaviour changes. In such a way that it becomes quite clear that you are actually waging war on those people, just because you think they're not on your side.

TURCATO: After all, artists, or certain groups of artists, are still the actors, the protagonists of a certain judgement, more or less critical or efficacious. On the other side, here, society still has not, especially Italian society, but others as well, but especially Italian society, has not yet learned . . . the taste of Italian society is still backwards. We have the example, I don't know, of a great artist like Balla who, then, was forced to do portraits: at its core, what he did for himself was utopian. We also have a current example like De Chirico, who, effectively, has done great things – maybe he is the most contemporary artist of this century, more than Picasso, more than many others – he who said 'I don't want even be the victim of myself . . . I also make paintings for bourgeois taste.' Then, that he resolved it, this, with philosophemes that are

more or less sporadic, phoney, that mean nothing. But, when they ask him about his work, by and large, despite his being eighty years old, he knows very well how to defend it. Now he, eventually, what satisfaction did he have? In Italy very little, his paintings are in the most important Museums abroad, the young imitate him, cinema has imitated him, sculpture has imitated him . . . he didn't have such glories, let's say, like Picasso did . . . And we need to understand . . . he is also a man, because, to be an artist, doesn't mean that . . . to be an artist like De Chirico, great artist, but he is also a man and has reactions that are undoubtedly, even banal at times, but it is only human that it's this way. Eh. Because there is a part of him that can expand, and can see further beyond than many others, then there is a fact, that's also consistent with everyday life, for which one can be, like that, not a man like . . . It's the idea of criticism that wanted to make the artist into an apostle, a prophet, and show it, also, that he had to be a hero. But this isn't true! It doesn't exist. No way really, look. This

is a seventeenth-century idea, that unfortunately our critics still carry with them, ringleaders of so many things, but no way. Yes, poor thing, he also has to eat, he has to do the things all mortals have to do. Now, really, I say . . . no, because, no, because then we inherit, in the world of artists: we inherit an artist like Wagner who undoubtedly also had . . . I don't like him . . . but, anyway, always had a great German prosopopoeia inside, anyway he was one that conceived of the world hero-ically in that sense here, and then there are others, obviously not only Wagner. But, this, we should no longer care about this, we can't have this dimension, really because this is a con-sumer society: one can't consume heroism. Eh . . . no, you can consume it, but only if you go off to get yourself killed in a war, it's all there, unfortunately this is the fact, the mis-take of current society: that on one side there's . . . Eventually, even a communist society, what is it there to express? It wants to express a heroic fact, the congregation of the eagles of Russian literature, it wants to show sublime states, which is absolutely banal, aside from the stupidity that supports these things and the slogan, made for use and consumption *pro domo sua*, aren't they? Then, according to the theory, there needs to be a new criticism towards this whole strong appara-tus, to show reality . . . But no, things must be born and go on for much longer.

ACCARDI: Before, I used to say, 'This about maturity, about prestige, about power, it annoys me.' But, now, I've changed a bit over the past few months, I'm not sure if it's interesting but, I say, 'What is there to be so pleased about?' I, four years ago, I had a crisis, I let it be enough. That was a much too sentimental crisis, in a certain sense, when I said, at the Biennale, 'Uh, but I want to stay young, I don't even want to be the one who's had a show at the Biennale.' A strange feel-ing, you remember, 'I don't want to become important.' But, important I am not, nor am I powerful. Actually, it bothers me when they say to me, 'Uh, are you Carla Accardi? Ha! . . .' because I, here in Italy, I became almost too much of a name,

understand, while outside of Italy, nothing, no one knows me. Now, if I do something, I really want it to be done to become known abroad, not to a handful of people here in Italy that, by the way, it's been a while now, here in Italy, that I am so sick and tired you can't imagine. Ten people aside, who are the ones, also, who always see my work, it's unclear why I should keep doing this job in Italy, still. If I do it for Italy, it would be better to stop really. I was talking about it with Samuel, a while ago, and I said, indeed, 'So, I set about carefully to do my work, then to have it photographed well, to see if I can get it out there, so that it becomes something at least . . . at least towards an audience, I mean, a meeting point because, otherwise, it stays here in Italy and . . . the meeting point is missing, gone, gone.' You know where this came to me from? After the show in New York, I had this reaction, this feeling. Because, you have a show of Italian artists in New York . . . but the show that one should manage to have in a lifetime, wouldn't be an Italian show in New York, but a show where

there's someone French, someone English, an American, and then there's Carla Accardi, I mean . . . let alone, a word, right?

FONTANA: Because, see, now we're influenced by the Americans. You go to America and they say that there's nothing left in Europe, and everything that they're doing is still a European education because, when Signor Manzoni did the line the Americans, with all of their glacial art, still hadn't risen to that level. When they talk to me about Pollock, about Spatialism . . . Pollock is such an ape, that we Europeans invented, because Pollock is a bungler who didn't do anything else . . . who made Post-Impressionism, and of Spatialism and of the measure of new space he understood nothing. He wanted to get out of the space of the canvas, but he only dirtied it, the painting, there's a gesture of rebellion and that's it. Klein starts to become valid when he makes everything blue, there's a dimension . . . He, he intuited the space, but, let me tell you, the ones who really understood it are me and Manzoni: Manzoni with the infinite line and, until now, no one has reached him, look, with all the experiments that they're doing, it's the greatest discovery there is, and myself with the hole. And the Americans still haven't got there, with the connection to cinema . . . all stupid things that will fail in six months, they invent forced discoveries, they think they're making art with their findings. Art, it is not a finding: even modern art needs to have an infinitely valid conduit, otherwise it dies right there. Pop Art is a gesture of rebellion towards figuration, it's something very beautiful, very American, very acceptable, but, with billions, they launched it in a form that . . . But Rauschenberg is derivative of Duchamp, a bad derivative of Duchamp, because he didn't get him: in Duchamp there is mystery, in Rauschenberg there is a mess of colour and nothing else. Conversely Lichtenstein, Oldenburg, they made something truly American and they made art, in the end, that is a figuration, but they got stuck there . . . Conversely, you see that another idea pushes ahead, there's another opening in another sense. And now, they make

films: cinema is an old thing, you have to go there, fix the reel, project it . . . What is cinema? Cinema is like painting something from the fourteenth century, today. These artists think they've discovered cinema, the art of cinema, it's the stupidest thing there could be, it doesn't have dimension, it only has movement, it doesn't have volume. Now, in America, I read that they already project, for television, forms in space: so, I could already do something, not that I would transmit figures, I would invade environments with colour, I would do big projections, I would do what I want, but you arrive across a space and you arrive through some really new elements. But doing cinema, in art, is a really idiotic thing. And now Pollock . . . they say, 'It's us . . .' But no, they haven't understood anything. And us, here, saturated . . . Pollock is my contemporary, sells his paintings for a hundred, two-hundred thousand. He has paintings from '50, from '52, '53 that are smeared with colour, I was already there with the holes . . . My discovery is much more important than that of Pollock. Since we don't have the

billions they have to launch things, we're always a by-product of the Americans, and they still didn't get to Manzoni's line and cold art, as a gesture of freedom, this way. What is a more profound discovery in art than Manzoni's line as a philosophy of art, if we pick it up from there? And then . . . if they do it, then they forget about everyone, say that you copied and they gave you the idea . . . And we, unfortunately, are provincial, we tell them they're right and they do everything, and so on. And the Italians . . .

PASCALI: The space of Europe is very different from the space of the Americans, more than belonging to action it pertains to the reflection upon action, understand? The Americans can allow themselves the luxury of taking something and nailing it to a painting and it works, of taking a comic and redoing it and the painting is a painting because in their gesture they historically summarise that which is really their culture, the most advanced from a technological perspective. Our civilisation is, on the other hand, a civilisation that, in terms of technology, is behind the Americans, for which a direct action between man and material is crazy. Already, time moves at a frightening pace in America: if you go into a chemical research lab in America you will find incredible materials, there's actually a click between those materials and the American artist himself. In the end, by now, artists have to use materials made by scientists because nature has been exhausted, a new nature has been born. Never mind here, in Italy . . . here, another space exists, there's a mental factor of selection, of not getting too much involved in things. The problem of the average European is to be a lonely man, but self-sufficient, a man who is able to create an autonomous civilisation: however, in America it's not the case, even if Americans are very individualist and they don't even look each other in the eye, they are inside that American space, that American civilisation and, even if they don't look each other in the eye, they are bound together, understand? A comic is a bit like their palate, what can I say. Instead, I see

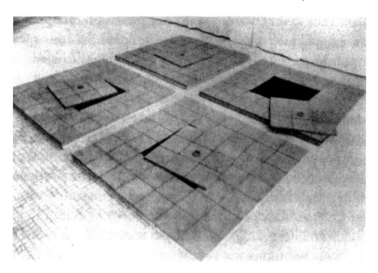

things, not in a detached way, but I see them. What I see no longer belongs to me, and what I have, or what the Americans have, doesn't belong to me either. I don't belong to one world or another. We are born here and we have that heritage of images, but to really overcome these images, we have to see them coldly and, really, physically for what they are and verify what possibility they have to keep existing. If this possibility is a fiction, one accepts the fiction . . . if these things are old, dead, they no longer belong to our patrimony, one can no longer take them seriously, you know, and believe in the problems of Mediterranean civilisation. I, practically, to feel like a sculptor, have to make fake sculptures. Not even . . . now I'm going to end up on the level of . . . cunning. Nothing, there is a type of invention of civilisation in this sense, that one really looks for . . . not even 'looks for' . . . I don't know. Behind us, we have a kind of archive in which certain facts are catalogued, the Museums in which there are certain sculptures, materials we have used and, around us, there isn't a world, there isn't a civilisation we can take responsibility for with our own gesture. What I really believe is that around us there is nothing . . . now I'm not able to specify what I mean . . . but, I

know that around us there is nothing and one is at the centre of this space in which there are things at the edges. One finds oneself in this place and, since this is one's own place and there aren't other places to which one can belong . . . that is, you can go to another place, but you come from that place, understand? You say: but if all around it's empty, what place is it? It's a place in a void . . . but one stays in that place in the emptiness even if one goes to another place. It's not that I am in Italy and I am Italian and if I were to go to America I would renounce speaking Italian: no, I am not in Italy because Italy doesn't exist and I go to America and I am no one. But, in this place, there are lots of soap bubbles that pop every once in a while, then another is created . . . these soap bubbles are full of emptiness, but I created them and I hide inside them. Perhaps, there will be a soap bubble in the end, but I knew it, you know what I'm saying?

TURCATO: To make a comparison between Europe and America is also difficult because America has more precise things, that are, however, all falling apart, this here is the matter. But yes, this idea of defenders, the Americans – I, indeed, I hate the Americans for this – defenders of the world that, then, they don't care about, Europe included. To be protectors of a world, in defence of a world, that you then treat in a commercial way, this here, look, it doesn't hold, you know. It can't. I've been to America twice: once when there was Kennedy and now, when . . . Now it's got much worse, with that never-ending jingoistic attitude. And what do I care about returning to America, look; rather, I find it useless in the first place, to be honest. No, in terms of knowledge, very useful . . . But I can't participate, not in the struggle of the Negroes either, what do I care. I absolutely don't care at all. For now, the Negroes lost an opportunity and had to put down their weapons . . . like we did in the last war . . . to go with the Viet Cong: that was the great rebellion, so you saw what happened. But then, these family issues . . . but, no for God's sake! The Kennedys are a huge family that, however,

wants to reinstate the entire progressive movement by them-
selves. You know, these ideas are also . . . this is a horrific idea,
I promise you, there isn't, they won't ever be able to win. Why
the Kennedys have to follow this idea, I haven't figured out.
To keep making martyrs? But no, this thing is foolish. Really,
you can't encapsulate everything in one family, this is the
fact. Eh. America has now blossomed, because before there
was an America that, according to us, given that we had fas-
cism, Nazism in our house, Franco, the conservatives . . . But
there was an ideal America . . . however, the real America is
this one here. But, the young people, they understood that
there was something that wasn't quite right in this society that
seemed, even, rather perfect . . .

KOUNELLIS: There is the need to be so amenable, today,
I don't know, like an actor who is amenable to a wide range
of expression, who doesn't only become formal, but is capa-
ble of much more. For example, the difference between
Twombly's paintings and Lichtenstein's: the one by Cy lasts,
because there is a training in his gestures, while the one by
Lichtenstein doesn't hold up for as long . . . but, in Cy there
is something intimate and extremely intimate, while the
other has a much more external quality that brings you to
have an experience also in a critical sense: so, it can work.
It's only that, since American society exhausts content, form,
everything, and very fast, so finding other ways to be flexi-
ble, amenable, is necessary, otherwise what do you do, shoot
yourself, what do you do, right? A friend of mine was telling
me about how when she went to Persia, near Abadan, there
were some villages in the desert, but villages with very very
few people. Each village was closed off with greenery and
inside there were some little streets, that went from house
to house, and above them were sheets to cover them. And
in the village, there was the scent of roses everywhere: when
there aren't roses they spray a water that's perfumed with
roses and they also give it to people to drink to refresh them-
selves. But every village has its own clear-cut physiognomy,

social customs, laws, everything: it's maybe millennia that these people live in this same way . . . but there, it is possible to live. I would very much like to stay in this village, and for Cy it would be great as well, he could remain intact for his entire life. But, for a society of great metropolises, one needs to see what the painter is capable of doing: the openness, here, where things get exhausted, I think it's indispensable. I don't know, I am thinking of a painter who doesn't have lots of knowledge stored away, doesn't have anything, and in each place, he finds new experiences to develop . . . Really, this way, he is much freer. I think of a possibility that is less and less tied to the structure of painting and always freer, like one who, little by little, as time goes by, becomes freer and freer and freer, so much so that he becomes a bird, something like that, that doesn't necessarily make sense, but he's more and more wonderful, right? Because, see, this is essential: that one shouldn't impose oneself, one has to manifest the possibility. The work of a painter is to free something without enforcing it because, if he forces it, he has liberated a Thing, but not a person. Whatever the cost, the artist has to remain firm and not give it away, then, with any violence on top of him, otherwise it might be accepted, maybe, but it isn't understood, or it's understood in a vague way . . . It doesn't become vital, while a painting has a meaning that is truly vital, extreme, and this needs to be understood. The depth of the painting needs to be understood: to help to free and to comprehend. Otherwise, what sense can a painting have?

FONTANA: But you see, however, what we're now reduced to? That everything produced, by now, is influenced by the Americans. If I say that I did neons, this guy who is now doing neons says that I'm a by-product of the Americans. And they will never accept that you did neons twenty years earlier, not me, but also Vantongerloo did them already as well, they will never accept such things. They accept the latest things; they never accept a Manzoni . . . where do they have a Manzoni? They take up Stella: Stella is structural, sure, there were some,

here, who made structures . . . It has to be said, they do it with a more violent, more modern spirit, maybe, with a sense of . . . but, it isn't true that everyone here is copying things from over there, it's not true, because Gruppo N, Gruppo T, they already existed before these others with their little machines existed, right? It's just that we didn't have the propaganda, we didn't have the millions to pay the magazines, and have them write those articles that are ten, twelve pages long. But Gruppo T and Gruppo N were born before what happened in America: there was no such thing as groups in America. You tell me what they did before Gruppo T. But, how is it that no one has tried to publish a book and put these things in there fully developed . . . I'm not saying anything against it . . . It's what they did in Europe, Yves Klein and all these people here . . . Afterwards they're confused, they mix everything up . . . That Restany there, who believes himself a genius, got there ten years after Iris Clert had already got the Kleins, the Armans, and all those people, for ten years. When they became famous what did he do? He made a mess . . . A new reality of art, wasn't it? Clever. He took these famous men: César with Klein. What does César have to do with Klein? Rauschenberg with Tinguely and Klein . . . That is the mistake: in the research: not that anything differs much, but one had nothing to do with the other. And, so, he called it the 'New Reality' . . . and you take Klein . . . with Tinguely or Arman: but they have nothing to do with each other, they are two completely opposed sets of research! And so, he made himself into the discoverer of a new reality. No: you were sneaky, and you took seven or eight painters who were already famous, and you want to make a name for yourself out of them. Why didn't you choose them ten years earlier, why didn't you go to discover Klein when he was with Iris Clert or Soto? Go, now, and make a confused group and create even greater misunderstandings, because it isn't that a César is worth less than a Klein, but César has a research that is the opposite of Klein's, valid, but the opposite, right? The Americans did Pop Art and we did Spatialism: but,

for me, Spatialism is way more important than Pop Art. Pop Art, maybe, carried out by the Americans, had this sense of vitality, really, but if we take Spatialism, Kinetic Art and we give it a zinger, it takes on an importance just the same. In fact, now it falls . . . you already see people who already go around . . . spatial or, I don't know, cosmic . . . with clothes . . . Fashions change, right? It's just that, if we had money, there'd be a general launch and things would be valued.

TURCATO: In Europe there is a particular fact, the fact is in the very landscape, in how it has been changed over time. Because, if we go by train or by car through Central Europe, in Western Europe, we see that the character is still Gothic: therefore, this has an influence. That civilisation has undoubtedly influenced the way of thinking, the way of being. In America, on the other hand, one starts with a neoclassicism, then there's Art Nouveau, and then, slowly slowly, things move to something new, even more naïve, and, therefore, also more natural, at times, than that which . . . In Europe, really, there is still this sense of mastery, that will probably disappear because it won't be able to stand up against the scientific reasoning of new techniques. In comparison with the American artist, the European gesture is always critical. In the American artist there is more spontaneity than an amalgam of new things, the dynamic succession of novelty. In the end, we didn't have this éclat that then saved the United States . . . Not for nothing did Pop Art take the tomato can, the thing that saved American agriculture after the Civil War, which must have been a very dark time, and, where they save themselves by coming up with, exactly, the famous tin can with preserved food inside, meat in a tin . . . By now, it's something so incredibly inserted into the daily lives of Americans, that you can't think of an American outside of this food storage system, for the whole apparatus. We, on the other hand, after all, are still tied to natural products, therefore we don't know how to adapt to this situation. But, in fact, nor does Russia . . . because, on the other side, communism should have resulted in, yes, in a jar-like

state. While, instead, it seems to me that hasn't happened yet. No, that's a very important aspect of American life . . . the uniformity of American artists, I think, have had great intuitions, especially in the years after the most recent war. Now it seems to me that even they have entered a bit into chaos. The two currents are: either Pop Art or, yes, the other . . . Morris Louis. Anyway, they have their own arrangement for their environment and, therefore, it can be articulated in a certain way. Well, I don't see how, here, one can blend their way of seeing with ours. This is a discussion, however, that is too demanding and too prophetic, undoubtedly, one cannot make such predictions, right? It isn't that simple, in the end. Then, certain things came out of the same mould because the Americans looked at the Impressionism of Monet, then they looked at the Futurists, then they looked at the Dadaists, the Constructivists . . . The Futurists have a huge influence on American art. Therefore, when the mould is the same . . . Naturally, then, things happen . . . just as a French artist can be different from us, or a German, I mean, they are. Well, there isn't some kind of immanence of one nation or the destiny of one people, compared to another. Psychologically, however, there is a pushiness, because they, actually, they have this matter of self-promotion, a way of being able to amplify things that to us, here in Europe, in any European nation, including England, is unknown. We don't have that phobia of launching a product, even a cultural product, like they have. Or even a song . . .

PASCALI: The only means that a painter or a sculptor has is painting or sculpture. Now, speaking of painting, one speaks of a fact that is already traditional, already not experimental, a limited reality, already catalogued, for which there are already conventions that, maybe, could not exist at all, could be something else, right? I think that someone who is a painter has to use this medium politically, precisely to resist in the emptiness. When I was talking about this, in the emptiness, I wasn't saying: me alone in my house. I was saying: me,

and my surroundings, that emptiness was my city. Not: me isolated in the ivory tower, understand? It was really the city. So, that soap bubble happened, I don't know, in the Gallery, or this Gallery became a soap bubble itself . . . But, I say like a means of false morals . . . the painter should be, almost, like a moralist, he is a moralist because, like this, he has his moral idea of life, negative, positive, false, however you see it, but, if he's aware, he has his own moral identity. In this sense, he's on an exemplary level. It's the only action that's truly . . . If someone wants to try and make collectives, I think they need to set off right from these small soap bubbles that make foam, and they can carry out all of this false act, maybe, but something false can also be light, something false can also fly. On the other hand, I don't know, to construct fortifications of cement no one can enter, but which are resistant over time, maybe you die suffocated inside, understand? And, in this sense, I think that someone who deals with new realities and new phenomena is also a moralist. Look: the sculptor, the painter, anyone else, the musician, what can I tell you, everyone, writers, they are people who stimulate phenomena. If you chose a phenomenon and identify yourself within a phenomenon, I believe you deny the whole idea of progress that you've previously put forward. Unless, this phenomenon, it creates a sort of chain reaction that produces other realities. In the end, the phenomenon always has to be stimulated, the phenomenon has to stimulate the phenomenon: the only limit, of this sort of chain reaction, is death. There aren't any others, and for this, so, at a certain point, rationally, one rejects it. It isn't even that you refute it, you don't understand it. Death is one of the most monstrous things that exists, really. It puts an end to the continuous stimulations of these facts, doesn't it? and concretises them and, after, re-stimulates. This discussion is stimulating . . . I don't know, after a while it gets rhetorical.

LONZI: Without specifically turning our attention back to Renaissance art, one can think of those kinds of Greco-Roman antiquities, scattered around the streets and in the gardens of

Rome, could be a reference for you, not so much in terms of culture but of life. That is, that the scattered fragments of the Greco-Roman civilisation appear to you as symbolic of the innumerable mishmash of the phenomena of the world. On the other hand, certain architecture from the American South, with its classicist desire, could give a similar impression. Do you think you could speak about what interests you about living in Rome in relation to your childhood memories of the American South?

TWOMBLY: (silence)

KOUNELLIS: That other time I said that in terms of language, that there is a great contradiction right there, indeed. No one thinks that Warhol or Lichtenstein or Pollock wanted to do something different, really, right? That is, it doesn't come out of a process or something like that. The speech is not separate from what you say, you understand that it comes out of a unity, the unity is in the expression. In fact, speech is an expressive fact, it's the only way, really, to conceive of,

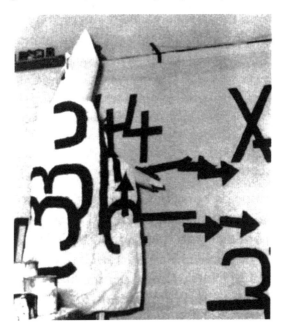

also in a logical sense, language and the sense of expression. That you express something to me. When, Warhol wants to make, I don't know, the electric chair, it's natural that he would express it through those particular means: no one thinks that he would make it like Rembrandt would, right? The means cannot be otherwise. The means and the electric chair have the same origin, understand? I don't know, in Africa there will certainly be different problems: in a tribe you can't find someone who wants to photograph an electric chair, it doesn't exist, everything is born out of an extremely different experience. You make a thing, object-like and, of course, you can't put all of these things away, it isn't possible, it never happened to anyone. The lesson you carry out is a sort of diploma, in some way you undertake an operation . . . Yes, even when you arrive at the height of freedom, you always have this control because, when you lose control, you also lose purpose . . . Yes, you become something that goes by itself, but freedom is reached when you have a goal to achieve and, with the struggle one faces, you reach freedom, it all makes sense. If you completely lose sight of this goal, well, these actions here, they are free actions, but they lose any meaning. It could be that someone, one day, arrives at those things there, to close a circle. I, when I say maturity, I mean just this, not in a formal sense that I try to do one better, because that's not how it works, but to reach, really, a moment in which these are extremely free, like placing something, up there, without any . . . For me, this means 'to reach', in this very moment, because, afterwards, the terms shift, and what I want shifts as well, but for this moment, I believe it's fine as it is. I didn't make many attempts, really, to reach it, it isn't possible to make many attempts. With the old paintings you did that . . . afterwards, I don't know, a part was covered, then another part, and, in the end, only the essential thing remained, right? Only the operation was all done on the painting, because the painting was the ideal space for such an operation, while, now, this shifts to the inside, everything

close-up, let's say. So, you – one needs to arrive at this thing here, otherwise you can't undertake this operation: like with dancing, first, you would start with gymnastics. It's something essential, otherwise one can't dance, not really, right? You do something else. Otherwise, the action, this action, is completely confused with life.

SCARPITTA: I think that we are all, more or less, captured by or slave to our experiences . . . And, as a boy, I lived amidst racing cars in California and then, returning to Italy, I spent lovely days among artisans, caring mechanics, who carried on this world of races, race tracks, garages . . . I am someone who loves fetishes: for example, a motorcycle, if it's called 'Saturno Sport', for me it has a cacophonous meaning . . . not only that, from there I could bring you to other facts . . . so, not to be metaphysical about it because Saturn is a planet, but Gilera Saturno Sport, for me, means as much as American Miller Special. It's a world that lives here and also lives elsewhere, it's a strangely international world, in which there are different aesthetics, but the motivations are very similar, almost the same. Where men chose a bit of their indirect way of feeling alive, not racing themselves, but, sometimes, building or, sometimes, only watching, participating, as they can . . . As a boy, I participated in so many dreamed-up ways and I found a way to re-enter that world there. Coming away from America, as a kid, I was able to return to being a kid a bit here, to be able to reconnect to a certain continuity. Seeing that I had lived for many years in Italy and seeming to me, that there wasn't anything I had learned in Italy, that here what I knew wasn't worth shit, I thought that if I wanted to stay here, I should go back to where I had caught a trout when I was twelve years old. And so, without much shame, I put myself back in that way of thinking, only with fresh eyes and different experience. And, in this sense, I was able to do things I couldn't have done at seventeen, when I left America . . . for example, I couldn't have built an automobile, but I was always looking at cars, back then. On the other hand, now, I can build a certain

car and . . . they are dreams from back then that are now come
to life, but that, without the years in between, I wouldn't be
back to doing it, like that, I wouldn't have any of the technical
skills to do it. I was also lacking the means, because a young
kid, maybe, could do a lot of what I do, but he doesn't have
the means: so, I am his tyrant. He has a little electric train, I
have a racing car, I invented the means to be able to do it. In
1964, I painted the last painting in a certain way. I was very
disturbed, at my last show at Castelli, because someone that I
heard, a young guy, looking at my paintings, he turned to his
friend and said 'Look at this guy, he is still interested in sto-
ries, tragedies . . . one can still feel, in here, some reality from
the 1950s,' he says 'Here, one can still feel human tragedy.' And
this disturbed me because I don't want to bother anyone with
tragedies, and I thought that a lot of people can make a tragic
painting and only a few, maybe, can make a happy painting.
I preferred to take time to understand this point here. So, I
set myself to making automobiles, because it seemed to me
to run directly to the source of what was the content of my
paintings. Instead of applying an exhaust pipe to the canvas,
I put it back where it was before: I made this journey towards
my content, precisely to render it as clearly as possible, so
that everything that could be part of the emotion of changing
things, could finally disappear. Without killing the motive, to
kill the literary superstructures that I could have had. Which,

according to me, were those things that these young guys were criticising without knowing that I was listening to them. FONTANA: It's serious, but, unfortunately Italian and French criticism do not know how to rebel, not in a stupid way, but really in a positive way. When they write they mention a thousand American names . . . and when one speaks of Spatialism, precursor . . . But, you, now, did you truly believed that Pollock was a precursor of space? He is a man who wanted to rebel, but he is a man who threw down some colours, and what is that? He wanted to leave one dimension, but he didn't understand what it was, as I hadn't understood in 1934 what that was: I was working with threads, but I hadn't arrived at . . . Yes, it is documented, because in the end it isn't just chit-chat, there is clear documentation and there's no escaping that. But, you know that in American manifestos I've read things that are the definition of the *Spatial Manifesto*, in full, with some variation, just like that. Look, I once spoke with a critic, such an idiot, American, Vedova was also there, who before anything else said to me, 'Hey, you're a Spatialist, what do you think? . . .' And, in the meantime, he knew that I was spatial, he meant that I was nothing and, meanwhile, he knew what I did, he began with the knowledge of who I am and what I do, 'That if you tell me that I didn't invent Spatialism, it means that you know me, that I'm not an unknown.' He says, 'But yes, but you . . . space, but what do you want, you're Italian, space . . . we Americans, the deserts of Arizona, there' . . . 'Ah,' I say 'that is, indeed, space? . . . because well, look, I am not Italian, I am Argentine and I have the Pampas which are ten times as big as the deserts of Arizona . . . but space is not the Pampas, space is something else, it's in the head, understand?' He got up and left, there was Vedova, there was a bunch of people like this. That guy there is enemy number one: when an idiot comes up to me to say that I, an Italian, don't have the deserts of Arizona in order to understand space . . . he believes that space is a dimension, like that, earthly. Then, later, he says that Pollock is the greatest precursor to Spatialism, not referring to my

Spatialism, but Spatialism of a new form, of coming out of the canvas . . . No, you should make them disappear. Eh . . . no, there are some, but they're rare, right, they're worse chauvinists than the French, now: first it was the French, now, it's them. They're good, I'll give them that, they're good . . . Yes, yes . . . money, powerful Galleries . . . unfortunately, we know all too well that someone who pays a million lire for an article in a big magazine . . . or two, or three, to have twenty reproductions in colour, the critics . . . unfortunately, that's how it is, the articles in the magazines aren't spontaneous, they're paid . . . Eh, someone pays, maybe it's worth nothing . . . But Manzoni alone was an extremely important character, then you can also take Castellani, all of these people who worked before they did, the cold work, that . . . that cold American art or, at least, contemporaneously, they are two different things, but valid without any American reference. Now that the young people have taken the lesson from Pop Art, that is, of the structure . . . but they took it with class, with some invention. A Pascali could be Pop Art, nothing is true, nothing, nothing, but they mistake everything for Pop Art . . . And their inventor of Pop Art is Rauschenberg who copied from

Duchamp in a scandalous way, really, and it's done badly because he didn't understand Duchamp, so he's the inventor of everything and I dare you to tell him . . . And, so, they forget about Duchamp and lots of people who made that art. For me, the greats who did something American, valid, are from that particular group . . . Lichtenstein, Oldenburg and the other one, that sculptor who makes the figures . . . Chamberlain no, he's a bit of a bastard . . . Segal yes, there are five or six . . . He's really American, no one can take it away from him, but it isn't true that he influenced the whole world . . . in Europe they respect them. I have them, in my collection, Lichtenstein, Oldenburg . . . I have them, from the first works that came out, but they, they kind of got big heads and think that they invented everything on earth. On the other hand, they need to understand that they had a European education and, at the same time that they had it, in Europe while they . . . there were other things, valid in a different way. They think they have discovered everything; they don't accept anything because they aren't interested in accepting it . . . really because of plain and simple chauvinism; while in Europe there is another kind of education, more culture, and all movements are of interest. I would like, tomorrow, to hold an international congress and do an update of thirty, forty years of painting and show the Americans that they are not precursors at all, nowadays, of European art, that they say Europe is over. I can assure you, that I would leave them there with their mouths hanging open. It's not that . . . they're really good . . .

TURCATO: Meanwhile here in Italy, to get to being somebody you need to get to be eighty years old, because . . . No? Look at us, right. Oh. Now then, these guys like Moravia who haven't even got there . . . Well, the shrewdest one gets there, Argan, he'll probably become the minister of education. But, you know, Moravia, he will never get there. Yes well, no: young people booed him. Ooh . . . they did me a huge favour, it was a pleasure, but what, are we kidding? But he changed, when he started off he was better, wasn't he? Then he became a populist,

then communism was useful to him only as a springboard to get in the *Corriere della Sera* . . . There is all of this . . . As for the rest, Garibaldi had understood it, unfortunately . . . Here, look, there isn't much to be done . . . amongst ourselves we should use our common sense, look, and continue with our work and then, maintain a certain purity, indeed . . . Eh, since we have chosen the honest road, but, on the other hand, it is the only road to take, what do you want? Then, you can . . . I can go to whores, to do . . . but, anyway, that doesn't even . . . because it has nothing to do with it. Here they have really made a slum, a towering mess . . . Pasolini would like everyone to have his same ideas, he thinks of a situation, that is absurd . . . but, after, he wedged himself into the Communist Party, then a film here, a film there, okay. He also said things, in vernacular, in jargon, he also said things that were more or less right, then he managed to make this *St Matthew*, so they even brought together the Church Councils . . . Now they annoy him, naturally, he is also petit-bourgeois himself, he's pissed off because, it isn't as if he can always go on adventures. That's the biggest adventure he could have had by playing the opportunist, isn't it? So, now they bother him: he says 'Where can I go?' Eh. And now, a resignation here, a resignation there, he says 'The police force is made of good young men.' Understand? But this is unacceptable, because not everybody is like him, this is his own personal adventure. And he could be a joker and describe it like Peyrefitte does, but Peyrefitte doesn't lack good taste, but Pasolini on the other hand does lack good taste, understand? And therefore, you know, the ruling class lacks good taste, so do the intellectuals like Moravia. Moravia really became boorish. No, because, at least, the French reaction aligned itself with a baser sort of men, who de Gaulle then put in jail, but he showed himself for what he is. That same de Gaulle before this wave . . . because he is a conservative, a radical, an autocrat, okay, and at a certain point he had no other road to take, in terms of his mentality, you know? So, that's it. Faced with this bunch of young people . . . the

Communist Party screwed them over because they let themselves be screwed over. For me, things are quite clear. The, the young people said, 'The Communist Party – no,' here, on the other hand, everyone voted for the Communist Party, understand? If then, we are under the Communist Party, we will never move again, right. But look how the government was made by these guys here, right. Okay, they will have some problems, but the only opposition to these problems would be the socialists, but you've seen what shits the socialists are. Well, we still haven't arrived at inflation, but there have been sacrifices . . . But look at what kind of government they have made: there is truly a clerical right . . . Eh no, if Garibaldi were alive, he'd occupy Rome. Ah, yes yes. No, but I, at the moment, I am reading Garibaldi's memoirs. You haven't read them? He has an ancient sense, that is, a bit like a general, but . . . as a general, a bit like a General Giáp would write and, in the end, he was a General Giáp . . . but he, he observes the Italians, Piedmont and then, really . . . the tricks pulled on him . . . No no, he really talks about the mentality of the Italians, and with Mazzini . . . he's got more problems with

him than with the king. Eh yes, because he took all of his volunteers, understand? Mazzini, with this false story of the republic, that was impossible to realise, speaking honestly, he said to young people 'But no, don't go with Garibaldi, because he's a traitor,' understand, and therefore . . . No, but . . . the history of Italy is rather interesting in a certain sense . . . Eh, now is a moment in which, you know, everything is at a dead end, but, undoubtedly, a dead end where one needs to see then, what comes out of it . . . So, what are we hoping for? Here, the cultural environment is in the hands of . . . Now, though, try to have this book come out soon. No, because it seems that here, everyone, communists, Christian Democrats, all of the cultural enthusiasts in a general sense, shared the same ideas. Eh no, it isn't true. They say 'No, Informalism is over, then it will be the turn of . . .' and now they'd get over everything . . . I have to tell you the truth, I do not understand how our friends Dorazio and also Consagra, because Consagra as well . . . so, we go to America, and okay, but we also think about things happening over here, in this country . . . Anyway, look, in America they're chauvinists, they don't let them through, there is nothing to do. On the other hand, when they tried to make things happen, nothing ever happened here. No, we have a disproportionate idea of what the Italian possibilities are in regards to our own country, because, I mean: on the one side are the communists who toil in every way . . . they, really, when they have to do something they do it, that Guttuso and that Carlo Levi, and we, on the other hand, so . . . And on the other side we have, then, the Christian Democrats who are for Quaglia, these here, so . . . Perilli, Novelli, Ponente were in the Socialist Party and wanted to do the cultural thing, then, at a certain moment, they ran up against Purificato, Miele, Cesetti and that lovely company, and nothing. But this was known, with Nenni . . . that if Perilli shows him a painting he doesn't even know which angle to look from. This is the matter, you get it, right. Because Bottai was way more attentive in that period there, there is nothing to do about it. These here are

old, old, they were born in 1870, are we kidding? How can that be? It bothers me because I was a partisan, even if I don't give a crap. Then, yes, the place was left to these guys: and these are the results. It's that, then, even the Christian Democrats are all keen on resistance, but the communists go with the Party Line. But you, what did you think about America?

NIGRO: A person who lives a simple life by choice, arrives at the ideal of serenity that wouldn't be possible otherwise. Beyond the turmoil. Look, *Spazio totale* ('Total Space') represents a tragedy to me: when I come up with an intersection it is a tragic matter . . . sometimes I content myself with it, sometimes I don't . . . anyway it's a tragedy. On the other hand, in *Tempo totale* ('Total Time') it's as if I were frozen, isn't it? But frozen in the sense of ascertaining a situation and of ascertaining it with a rigid mind, not giving in, of not getting involved in a drama, of witnessing in this drama, of being able to propose a remedy and, in my opinion, it's impossible to have a remedy for a drama when you're involved in it, but we can only propose it when we are a bit above it. I don't know. Yes . . . In his struggle against time, that is, against death, man instinctively looks for something in which he can find evidence of eternity: the best, most pleasurable moment in life, to be able to eternalise it. It is a romantic position, of desperate desire. Like once upon a time man created religion in order to have a foothold on eternity, I don't know, and so man said 'Okay, I will die, but I will live in eternity afterwards.' In this way all religions are at the same time a desire for justice, or better, for revenge, and a desperate desire to be able to achieve eternity, the best version of eternity, because to achieve eternity on earth . . . I think many people would get bored, go crazy. You can't think of eternity on earth just as you can't think of living many lives and recalling those different lives: it's fair we don't remember them. I, for example, once saw a tree with grass on it, this tree . . . I thought 'Well, to be eternal like this tree, if I could, would be wonderful.' Namely immobile. At a

certain moment eternity gives you a definition of immobility or, at the most, like a cloud in the clear sky, so I say 'Yes, eternity can be explained, because a cloud has no active form, therefore it lives in eternity and it's okay . . . time passes, but, really, it passes in eternity, one doesn't take notice of what has happened or what is to come, but lives in continual happiness.' And so is never desperate, never bored, life never causes nausea. Now, this is a purely romantic fact. In respect to time, like I said, time in these patterns appears as hypothetical verification of a scientific fact, that is, time can be freed from the dimension of space. The episodes in life that make you regret the past or, on the other hand, to repeat the same life every day is terrible, to repeat a different life, I don't know . . . Everyone desires something that they already know to be unachievable and so they prefer to stop desiring it, and desire, rather, something ideal because the ideal thing is always achievable.

FONTANA: Do you remember the paintings *La fine di Dio* ('The End of God')? There was the hole that is always nothingness, right? And God is nothing . . . it coincided with my idea as well: I don't believe in Gods on earth, it's inadmissible, there can be prophets, but not Gods, God is invisible, God is inconceivable, therefore, today, an artist cannot present God in an armchair with the world in his hand, the beard . . . Look, even religions have to update themselves with scientific discoveries . . . man who goes into the cosmos and sees that there is no Paradise. But, ancient man, he could think that Heaven was there, as part of a human reality, naïve, in fact, they made angels with wings to fly to Heaven. Now it's inconceivable, today, that an artist would make wings . . . the fact of believing in Paradise or in Hell is really a fact of conscience, of faith, that one believes, but as aesthetic representation . . . Let's take Manzù who makes the Doors of the Duomo portraying the Pope. The Pope is also behind everything when it comes to his conceptions of modern discoveries, because the cosmos shows us that it is infinite, the infinite is nothing and

eternity doesn't exist on earth. Because the mentality of living man, up until now, was: to be great was to believe oneself to be immortal. But eternity before nothingness, before time . . . doesn't exist, because, in forty, fifty thousand years, neither the Doors of Saint Peter's nor the Pope will exist. So, it's clear that men on earth need, before all else, to rid themselves of that materialistic ambition of being represented in materials, marble, bronze, believing that they will be received by future generations. That is a human ambition, and it amazes me that the Church still chooses Cardinals and Saints, to have them depicted by modern artists . . . I admit: well, it was a thing, it was valid . . . And that Manzù makes angels that fall from Heaven, 'death in space' . . . one who falls completely dressed, it would seem that they'd break their necks falling down the stairs. A modern artist has to conceive of death in space as a completely new structurisation, no? And so on, all of these things . . . *La fine di Dio*, when I presented it, they said to me 'You present the end of the Gods' . . . 'No, the Gods is one thing, this is the end of Gods on earth and then it means: the end of these Gods, but the continuation of a God . . . what is He? Nothing!' Who knows what God is, right? And so, I made these holes . . . Like I did in another piece, that I presented at a show of Catholic art: there were two cuts, all in blue, and I said, 'I believe in God.' And they came and asked 'But what does this mean?' . . . 'It is an act of faith, the single gesture I make is: to believe in God.' And I said to them, 'You tell me: how is God? how is He made, if you are true Catholics, true believers . . . not even you know . . .' So, I make a gesture, I believe in God, I make an act of faith . . . Therefore: God is Nothing, but is Everything, right? This is a fact, a bit moral, a piece of advice . . . Before, they painted war, the general was victorious on his horse, or the Church used the Virgin, used the Saints that went to Heaven, in order to educate, to make understood or to convince the people that it was as it claimed . . . it documented everything in order to confirm, through artists, to convince the Catholic to believe in these

things. The fact that I am ahead of time, I said, 'Man in the cosmos is in the cosmos in all of its new dimensions,' and the *Spatial Manifesto* talks about a social transformation that will be essential, because one sees that the world is already uniting, one already goes to other planets . . . it means that, even socially, things change. I can no longer accept things that man on earth accepted who, back then, was everything. Conversely, man in the cosmos is in space in all of its dimensions. And so, even in religious matters, all the allegories come to an end because they have to fall, so that I make a symbol 'I believe in God,' I make two cuts. And God is that thing, or can be any other thing, but I cannot portray him, He is so great, if I have faith, and so I make an act of faith, like someone else could make a black splotch. And in fact, a month ago, I saw a manifesto affixed to a church, here, in a neighbourhood in Milan, that says: 'You will never see God.' Like I said, and there is a white splotch on black. So, you see that, in the end, lessons aren't given unnecessarily, they receive something, right? And they had done this, not me.

CONSAGRA: Your book, this one that you're making, it seems to me that one becomes aware little by little of how, really, to do this thing, it's a sort of collection, as far as I've understood, of everything that goes through an artist's mind and that people don't know about. The technique of art criticism has excluded this direct relationship with the artist, right? The recording is a new element in this sense. For example: Argan, we don't see him going to interview Castellani or Turcato, say, or Kounellis. He would never do that, because he's beyond, artists for him are ponies and he's the one who says how these ponies should move around and where they are born and where they will go. He already knows everything. There's an attitude, with the Argan type, with theoretical types, with these theoretical matters, that are exactly the opposite of and still, technically speaking, prior to the artist interview. Now, the artist is also quite satisfied at being able to participate in this sort of thing. Why? Because he sees it as a method that is also his method, to express his thinking, and really, it's a pleasure because someone, when they're talking to you, tries to understand, as well. One is compelled to talk in the most candid way possible, spontaneously, and also, verifiable.

CASTELLANI: In the case of Argan there is an ex-cathedra enunciation, the enunciation of authority of that which he believes to be artistic, perhaps supported by a historical analysis of the phenomenon. But he never tests what he claims . . . Actually . . . actually, because then, when he is faced with reality, he constantly contradicts himself. When he has to give a prize, he gives it to the one who deserves it the least, in respect to what he's said five minutes earlier. But this could be a matter of, how to put it? It could be a biological fact of Argan, that he is unable to understand what makes a painting and what makes a bottle, that is, he has absolutely no critical sense, but rather the capacity to theorise. But it is an extremely false position to theorise a priori and outside and above and without . . . I'm referring to Rimini, when I suggested that a prize

was incorrectly given. So, Argan said, 'The single artist is an alienated being, one destined for madness, for suicide . . .' He also brought up Hitler, I mean . . . 'While the only possibility is the group, the team.' Five minutes later, he presided over the prize commission and who did he give the prize to? Not the guys from Padua, who had already declared those very ideals, the guys from Gruppo N, who worked as a team and above all in anonymity and did what they did. Instead, he gave the prize to a very ambiguous group like Gruppo Zero, that didn't work as a group, each did his own thing, then they organised shows together to have a bigger impact. All this to say that he didn't give the prize to the only artists there who embodied a reality close to what he had just been talking about.

PASCALI: If someone says to me, 'I like your painting,' I feel wonderful, but also really negative. If someone says, 'I don't like your painting,' my pride is damaged, but especially if it's just a single offensive phrase and nothing else. But if someone says to me, 'How beautiful,' one thing, I say, 'Oh, dear, okay, very beautiful,' but I promise you, in that moment I feel nothing, it doesn't mean anything to me, I

don't get anything, you know, I only get the negative side, of the lout with the feather in his cap. Nothing else, because I never thought things could be beautiful: paintings are neither beautiful nor ugly. The only audience I care about is other painters, sculptors . . . Unfortunately, I have to say. The others don't concern themselves with these things: the man who comes into the Gallery comes because it's fashionable to go and see things in the Gallery, because he wants to put something above a chair or the couch, or else because he wants to feel extravagant sometimes and other times he wants to feel serious and traditional, but nothing else. But, if someone says to me, What a wonderful thing, this painting makes me think of . . .' that interests me, it also makes me laugh, it's only that they can say things to me that are really . . . Yeah, I don't accept aesthetic judgement at all. If a spectator manages to say, for example, 'How stupid of you to put that colour on that thing, look how that thing is no longer there,' so automatically, I test if this contradiction really exists. They can say to me, 'This shape looks like a phallus,' it's really helpful to me because, 'Damn, this looks like a phallus,' with all of the consequences that can come from that. Or they can say, 'There aren't dinosaurs,' so it helps me to think how this phenomenon gave rise to another one and I can verify whether it is of interest to me or not. Namely, I'm interested in the simplest things. If someone says to me, 'These here, for me, they're real cannons,' I'm really happy because they are real cannons. Or someone says to me, 'This doesn't look like a cannon, it doesn't look like anything' or 'It looks like an antique sculpture,' so I know I really failed there. If, on the other hand, someone says to me, 'This is a road to destruction . . . bippity bopbopbop,' this really bores me and frankly, I don't even grasp what conclusions to draw because it's something that doesn't make sense, I can't take it. It's like when you read something that you don't care about and think about your own business, or when you hear something so interesting that you forget what's so interesting about it because there was a little point that sent out

two thousand beams of light in different directions from the initial thought . . . You follow all of these rays and get lost in the end, maybe, right?

CONSAGRA: At the first conference that was in San Marino, I think, Argan dreamed up the idea of awarding young artists with works of artists from the previous generation. So, I refused: I didn't want to send my work to be awarded to a young artist. I don't know, only Fontana and Capogrossi, the oldest ones, sent something, flattered or not, right? Anyway . . . What does this mean? That, at a certain point an artist of my generation has already dropped these things, or rather, has avoided them. Now, the one who's most keen on falling into these traps is the young artist, I mean, today, Argan is more esteemed by a young artist than by someone like me . . . we've already passed this phase, it's useless. Instead, we see that Argan is someone we don't identify with, while he is able to absorb the young through his power. But, today, things are at a point in which young artists are forced to realise . . . because now, it's quite clear. To go to San Marino . . . it's too brazen, it's a neurotic exploitation of all that's going on.

LONZI: Many things re-emerge from the past and are justified in the past, in the sense, exactly, that after the war, there was this fight for modern art, so-called modern art, so artists felt an obligation to rely on anyone who didn't claim as a precondition, that this kind of art didn't exist, or wasn't being made. Therefore, there was a moment in which the door was open to whoever wanted to say something positive in favour of this art, in order to allow it to exist. In this sense we can understand many manipulations of the post-war period, right? Now, though, the situation has changed, and it seems to me that there are the conditions for a reclaiming of autonomy. There's no longer the need to have a crusade for modern art. If Argan doesn't support you, if he doesn't theorise the reasons why your artistic approach is historically contextualised, you exist anyway, I mean, 'you, artist in general'. For me, this contestation is an absolute, complete point. Already

in 1963, I had written an intervention talking about the 'anxious and anxiety-inducing gestures' of Argan's cultural power, something completely in favour of the artist's freedom. So, some critics accused me, and my position, of discrediting modern art in Italy, damaging one of its official defenders and enforcing the power of Guttuso. They said, 'It is necessary to stand with Argan because he defends modern art, if it weren't for Argan modern art wouldn't be defended.' This reasoning, in my consciousness, wasn't acceptable. In fact, the problem was overstepping Argan's position, of taking myself out of the blackmail of the ultimatum: Argan or Guttuso.

ACCARDI: In many books there is this anxiety man has, the scholar, the sage, the philosopher, of non-resolution, of not being able to give definite answers. This is something that I consider, certainly . . . something I bow to, in the end, natural, something extraordinary. He has it on all levels: so, the man wants to have a definitive career in such a way, or wants to definitively conquer a people, or else he wants to arrive at a reasoning that definitively explains a problem . . . And, for this reason, he suffers, if he is unable to achieve what he wants, he arrives at the edge of madness, or he arrives at that wisdom that many possess . . . The real sage, the sage who is detached from everything because he had to renounce everything, there's always that element of renunciation. This, in woman, you won't find . . . Vitality, naturally until now, has kept woman at a level somewhere close to the floor, I'd say, wouldn't you? Scrubbing floors and cooking, because poor thing, she does it instinctively. But, if a woman sets herself to thinking . . . if man wouldn't get scared, my goodness, because a woman who thinks also has a pair of legs, a pair of eyes, lovely eyes, soft arms that are nice to touch, so, because if not, if here the man has to be afraid of a woman because she has some brains . . . they have to get rid of, right, a little, this fear of the thinking woman . . . You have to talk about this, Carla, right? Actually, you get a bit distracted. So much so that today women, as it stands, we can't say 'I am more important than men,' we can't

say it because there are millions of us, among us there are
lots of women, poor things, who are living under repressive
conditions, it's woooo! incredible, and who looked for solu-
tions to their oppression that were so neurotic, petty, that
they were blackmail, that maybe they're actually worse than
male behaviours . . . In fact, when I hear people say, 'Oh, you
women are . . .' Yes, they're almost right because I see that, in
bourgeois families, it's not like women are such a great exam-
ple. But a woman, if she takes care of this strength inside of
her, if she brings it out . . . I've used my female instincts often
to then think about it all . . . so, reasoning brings me to seeing,
for example, how the anxiety of needing a definite answer is a
more male matter. Now, last year, I was in Florence, I told you,
'Oh God, what a feeling, I'm having a day, a moment . . .' Your
brother was also there, 'Terrible, because I think I see . . .' you
know, that I was sad because Edmondo had recently left, 'My
eyes are too open, I see how old age might be, what wisdom
is . . .' You know, seeing that in life you can't become attached
to anything, that life resolves nothing for you, doesn't give
answers, leaves everything open for you, but with a persistent
cruelty, so that when they speak to you about divinity, you feel
like a person in a cage, in a prison where they tell you 'Stay
there.' You don't have anywhere to sit, if you sit on a chair with
nails you have to get up, if you stretch out – it happened to
me, to have this feeling – there's water on the ground, you get

all wet and have to get up . . . Freud, in fact, said, 'God made many obstacles in human nature in the way he fashioned it, so I cannot understand how he could claim, then, even veneration . . .' It'd be better to find Freud's exact phrase, it's wonderful. These moments of lucidity seem terrible to me and, if I had to continue on this plane of lucidity, there would be an abyss for me, I think woman would arrive at her own suicide, I mean, more than man, because man, even there, continues to reason and then he arrives at old age without illusions and becomes one of those really, I don't know, kinds of people . . . Once I heard a great comedic actor who had become like that, so scary . . . On the other hand, we women, we have to realign ourselves with nature because it's not like we don't notice, we certainly notice that the world doesn't give you these answers, it's not like we have a lesser quality of intelligence like white men always believed, 'Woman has a lesser brain, the Negro has a lesser brain, that other one has a lesser brain . . .' None of this is true, it is a conceit of white men, who've annoyed everyone enough, really, sorry. So, I, you know what I do? At a certain point I interrupt, and I say that the satisfaction of the wise man is not mine: I recognise it well, but if I feel it, I distort myself, I destroy myself, I . . . yes, I kill myself. I find that the position of the mature man, today, is sad, is a bit too sad, it is too close to nothingness, because I read the thoughts of important writers, always white, but I am always talking about race, here European or Anglo-Saxon, because they've arrived a bit at the point of burn-out, really. Because then, they no longer concern themselves with vital problems . . . now they've arrived at democracy . . . In fact, it's not like I invented democracy, historicism invented it, the kind created by white men, I mean, right? I recently read that democracy is dead, this discussion between Mailer, Schlesinger and Marcuse and I wanted to arrive at, by any means necessary, some opinions on this issue, that I wasn't much interested in reading about, I wanted to read it to see what I could extract, but I extracted nothing, I don't even know what thoughts I

had. It seems to me, this determination that you say, 'I don't want to rant about something' and they got together for the very purpose of ranting, ranting . . . This is specific to the man who is a bit emasculated, that he rants. In fact, Mailer is one who, when he has to explain why he loves a woman, says it in this horrendous way, that every evening he has to love a new woman to prove his virility. When a man starts saying things like this, I say, 'Enough, closed, not interested.' See, I am interested in the problem of the other, the other in relationship to the white man. Who is the other in relationship to the white man? Woman. I, sometimes, meet women . . . my friends, for example: it's a kind of search, for treasures, you know . . . it seems, here, like a treasure hunt, they are extremely interesting to me. Sex or race. Race, for example, Negroes . . . Someone says, 'Why do you care about Negroes?' I mean, I leave these issues around Negroes alone because I have nothing to do with them, just think, as a white woman, but that's the thing that interests me more, you know? Because I feel like I'm more on this side, the side of the other, when you say 'other', honestly. I want to take a step backwards: they have taken a step ahead of me and I do not occupy those positions. I take a step back, for this reason I always repeat to you – look, in this conversation I'm finding lots of points of contact – 'I'd like to go to a country . . . I'd like to go, for example, to Morocco.' What is Morocco? Who knows, maybe I'd like to go there, because I'd like to be in a society where there are still problems to solve. But this is a mistake, because the problems that need solving are here and there are always many, I'll tell you, always surrounding this woman–man issue.

ALVIANI: When there was the American exhibition 'The Responsive Eye', in *L'Europeo Ruggero* Orlando reported that I was talking shit about painting, the paint brush . . . Still now he keeps repeating this about me, 'This is Getulio Alviani who says . . . that his generation never touched a paint brush.' In the traditional sense of a paint brush. Even now I don't use a brush . . . it's clear, it's a bit something else: when I deal with

colour, it's colour in the sense of colour, not in terms of paint-ing. What appeared there was like an affirmation of nonsense of an attitude . . . of things that have nothing to do with me, it was the feeling of something else, understand? Look, I'll give an easy example: means of transportation. There were horses, and then the motor was invented, both means of transporta-tion, but the veterinarian didn't become the mechanic: the veterinarian continued to care for horses. Obviously, inter-ests changed because horses moved carriages, then, on the other hand, the motor revolutionised the whole situation and they didn't put the motor in the horses' bellies for them to run faster, but they did something completely different, therefore it's obvious that the person who cared for horses, groomed them, brought them hay . . . with the car, it is a com-pletely different thing. Not that it is an antithesis, nor . . . it's something else: it becomes a different matter, it has another function. Look, this above all else: it has a different function. Indeed, there's always this big need to want, especially when speaking about ourselves, because obviously . . . now, sorry if I speak to you . . . critics are always inside everything . . . you are a critic, but you mostly fall outside of this thing . . . anyway, they look at you in the same way they looked at anyone else.

We got involved in this situation, meaning that we used the same vehicles, the Galleries, the Museums . . . but now, we're already . . . Also, I imagine, motors were put into stables at the beginning; afterwards, however, they made garages, following other principles, different from those needed for housing horses. It's obvious: also, we, today, we are introducing different vehicles. To us, who are alive, it doesn't seem like there are a lot, but there are at least objects in series, production, different techniques like graphic design, like transformable objects, mailable objects . . . I don't know, today, with these E.G.912 editors, who are pioneers . . . or would like to be. In fact, I know that we will produce boxes that will be sold in bookshops, and, inside, there will be plastic objects for 1,000 or 1,200 lire, something like that. But, as a vehicle, it's all different: if people chose it on their own, see it for themselves maybe they won't like it any more at all, tomorrow, the name and finally they will be interested in the demystified product, something legible, more rightly so. Because, today, innumerable objects are read in a certain way, then it's known who made them and, immediately, the psychology gets a hold on you, and so you say it's either okay or not so great. While instead, in the thing itself, I believe there is communication. I make things in order to create things, obviously I also identify myself, since I make them I am also there, but the things, they don't have to be influenced by anything besides what has allowed them to be produced, not by the whole world of literature, by the stories, by the character who's more or less good, who has more or less of an entourage, whether he holds salons or not. This, it seems strange to me that I should even have to say it, it's so obvious, but . . .

TURCATO: Let's take Romanesque art. Romanesque art seems like an art of its time, universal because it went from southern France to Sicily. And Romanesque art is made by anonymous artists, mostly comprised of pieces that are signed by no one. Try to say, now, to an individual artist that you don't sign a given thing, if it was placed on a given

monument, like a cathedral . . . San Martino in Lucca, I was there, but nobody knows who made it: the door and the statues, you don't know. Actually, many works are anonymous. So, I wanted to say that in society, the nucleus of society, that it could have been composed of an elite made of different expertises with diverse intelligences, but it was instead in this state of anonymity. But even Roman art from the last empire is anonymous, because Roman art didn't even want to be making art. And yet, the craftsmen made lots of those monuments, many have disappeared, but, in the end, the sculptures are mostly . . . they're comics, actually, they're descriptive, like Trajan's Column, with more or less technical ability. But this is also found in Egyptian art, these stories about the dead, the afterlife that covers entire walls, it's not like they're all so well done, more or less, depending on the hand . . . Eventually, art is an attitude one has, then there are those who have more, who have less, but that's how it should happen. An attitude of dressing in a particular way. In Romanesque art, anonymity is imposed by Christian humility, during a time in which people believed, that is, it was merged with society. And in the late Roman empire it was due to consumption, because there was a town that was dedicated to Bacchus, another to Venus, and so statues were there for that reason, but it isn't as if they had to be perfect. But, maybe, this hadn't happened even in Greece. It's that, later, this idealism came about, this way of the . . . that, then, in the end, it's the idealism of the supermen. So, there is a whole situation to change in terms of our understanding of the historical, historicist side, to scale down all of art history, how it was made and how it is seen. And the error of contemporary critics is exactly this, to think that you can preordain, before anything happens, the expressions, to preordain who will be the best. It's like this all over the world now, there's the tendency to follow it as it is. Also, in America they've gone mad for this sort of behaviour. Yes, geniuses are preordained, because they think that whoever it is is closer to a determined aesthetics that the critics like. And then, again,

there are critics who want to have power through their role as critics, which seems absurd to me. They want to be the record keepers of a certain situation, that, then, they don't know if it will come to something or not. The contemporary critic wants to be more like a philosopher, so he isn't particularly interested in inquiring into what's happening here or there, up or down . . . For this reason, in the end, he isn't very interesting or interested, because he thinks that, through a philosophy, one can arrive at an artistic expression. But, here, there is a philosophical fallacy because philosophies also come after a particular form of civilisation. Greek art came first and then, later, came the philosophers: Plato and Aristotle come later. Already Greece . . . oh no, historically I think it's exact . . . already Greece no longer existed, yes, that's right. Reflection came afterwards. No, the Egyptians, in this sense, remain more closely tied to a natural situation. In fact, the Egyptians invented the idea of preparatory education and statistics: before making a judgement, they calculated the statistics of repetitions of events from a given century. And in preparatory education, then, they calculated the various philosophical movements that had emerged. All this to say that their civilisation was on top of things, very advanced. But, anyway, I find that there is a bit of dilettantism, yes, in this trend.

FABRO: In Rome, they're done with criticism. For me . . . well, I don't suffer from this particular form of nausea. I can, I don't know, I can badmouth them or I can call them idiots, but I'm not sick about it, when, I don't know, I go to Jamaica or to an exhibition, I, let's say, to Deflores I say, 'Good morning' or 'Good evening' or I say to somebody else 'Hi, how are you?' and that's it. While they spend days, nights, evenings, afternoons and early mornings with critics, they always have one around and they're always talking to each other . . . because there's also this aspect, that the Roman critic is someone who talks a lot to the painter, or he has the habit of explaining certain things to him . . . at least that's how I've understood it. They have a different kind of relationship, that really makes

you annoyed. It's a bit like, I think, a bit like the complex of the father . . . ahhh . . . the complex of the Romans towards critics. Someone you've always had hanging around you, at a certain point you begin to hate him, you want to free yourself from him . . . while, I don't know, elsewhere . . .

KOUNELLIS: Art . . . today, many feel it's didactic: it isn't, is it? But it can help man live. Without becoming his hobby or his programme, exactly. Hold on, now I have to say something to understand it. It's strange that Piero della Francesca lived during a century that was all about intrigue, things like that and he's so clean, idealist: he was the opposite, he offered the opposite of the reality that surrounded him. I don't know, Pergolesi said that all boy sopranos come from Hell . . . Now, it's not that you want to give the opposite, you simply want to give a measure of life, that's what it is, isn't it? Even what occurred already, I don't know, avant-gardes, the first avant-gardes: while everything around them was immobile, they gave a sense of movement. But, a sense of movement, always, because it's connected, the idea of the artist and of art, to previous frameworks. The artist can't have this sort of role, he has to have an extremely different role, this is also, I don't know, the destruction of the monumental, the destruction

of the rules around something that keeps everything crystal-lised there and he brings them all towards painting. The first time that I put paint on the canvas, it wasn't to pull people in, because painting has a quality, it may be that it's a part of it, of drawing people in. In fact, I think that perspective was created to attract people and enclose them in this ideal space, that goes inward, and everyone absorbs some of these problems. While painting . . . it wasn't that other rules had to be found, but its true essence is participation towards others and not tricks, really. Naturally, there were exceptional artists that have . . . look, and here is a personal matter, of person-ality, that one is also able to give great value to these things there, right? And, later, everything stands for this very reason. But, in any case, for our line of work it has to be something extremely, I think, extremely different from all of that which made up the perspectival world.

NIGRO: Perspective is created in this vanishing point of bands of iterations – today, they're called series – perspective originates from the simultaneity of these progressive series, a

perspective that could also be defined in the third dimension, but, for the same reason that these series go on ideally into infinity, beyond the limits of the canvas in a bi-dimensional sense, forming an infinite continuity, the original perspective takes on an infinite value. Since I'm mentioning writing from 1955, you can't measure this difference in perspective, of intersections between various series, which ideally originated from one point and extended like many rays and have an end only when they meet another series. Now, perspective, namely the distance between one overlying serial band and one underlying serial band, can't be measured because it doesn't pertain to figurative objects. This infinite perspective grants itself to what I call *Spazio totale* ('Total Space'), in as far as it's relative to all directions not only existing, but also imaginary. We can imagine any dimension because, without the tools to measure it, these dimensions can multiply without us knowing. We cannot claim what we see as real or imaginary, this doesn't even interest us, we are interested in seeing this escape from perspectives that move towards the infinite, and therefore, the spectator's fantasy is also enriched. Otherwise, we return to the limits of Suprematism, which conditions the spectator to a bi-dimensional surface and that's it, aside from the negation of every iteration and therefore every rhythmic. Rhythmics and perspective represent the fundamental values of this *Tempo totale* ('Total Time') research.

ALVIANI: On these surfaces, absolutely flat, there was always my idea, of concave and convex; here, instead, it becomes truly volumetric, besides concave and convex. Because these, since they are made in a determined way, all of the lines move, they go here and others go there, there is a hole inside. Photographically it isn't true, photographically you can have a single idea; this, you have the idea that it's a solid . . . this, you have the idea of a cube, of two cubes. It is an illusory quality of perspective, look: this comes forward and this comes forward as well, but how is it that this moves back, also that. And this way the situation is created, by virtue of

this line that also, how it would move, they all converge at one point and at another, and they are in diverse movement. With one movement the close-up is on the top, you say 'Ah, the top is full, the bottom is empty'; then, you move to the other side, you say 'Ah, the bottom is full and the top is empty.' I mean an interior property, that I no longer call research, I call it 'interior possibility'.

FONTANA: The cuts are the thing . . . I'll never leave them. I maintain that they still haven't been surpassed, like . . . I don't have to worry about having been left behind, really, the thing is I do believe in the cut and the hole, the other things are artist's fantasies. I made the *Teatrini* ('Little Theatres'), as they call them . . . Because then, I called the first paintings *Concetti spaziali* ('Spatial Concepts'), they called them 'holes', then, the *Concetti spaziali* cuts, they called them 'cuts', the spheres were the form they were, so they called them 'balls'. There is even . . . here in Milan, I've heard, I don't know if you . . . I'll tell you, then you'll erase it, '*Fontana, prima el faseia i büs, adesso el fa i tai, e adesso el rump i ball,*' 'Fontana, first he made holes, now he makes cuts, and now he breaks our balls.' But it's others who call them 'balls', I call them *Nature* ('Nature Sculptures'), these are called *Concetti spaziali*. It was already the end of painting, so there was already the intention of the object: I didn't call them objects because it seemed too materialist, I called them 'Concepts' because it was a new concept of seeing mental matter. Now, I make the cuts because then, you know, there is a market to which we are unfortunately subject, still, because there are merchants . . . collectors look for them and I make them . . . Then, once in a while, I make the *Teatrini*, and *La fine di Dio* ('The End of God'), these ovals, that don't arrive at anything, it's a variation, that's almost for fun, not for discovery. My discovery was the hole and that's it: I am happy to die after that discovery, too . . . while, at first, I didn't feel anything, I was never able to . . . All of these lines of my research, 'Fontana jokes, mocks us,' there was this discomfort, right? to find something that was always in my head, also

from 1931–1932, I was already into sculptures with thread, not volume, I had a discussion with Brancusi and Tristan Tzara . . . I admire Brancusi enormously, but he's always about form, and I told him that there were stupendous things within an epoch, but that there was already Boccioni with *Muscoli in movimento* ('Muscles in Motion'), which I considered a more important discovery than his own, while he valued material in the sculptural and spatial sense, in Boccioni the matter was secondary, light entered into the material, so no more worrying that it had to be made of marble . . . Because people, maybe today, one day, understand that they are doing these things because Boccioni said 'Material is no longer important,' the matter of gathering light inside . . . while on the other hand, before, the material was polished, it was the base for everything, in marble . . . Today, you can see that the material can be anything, can't you? And so, it was all about this obsession with research . . . painting, the colour, the all-black statues, all blue, to actually destroy this material, not in the sense of destruction, but to create a new form, until *Manifesto* . . . and then *Manifesto* was theoretical . . . to find something that could correspond to the thought without resorting, maybe, to tricks. And so, given that the painting is in three dimensions: the foreground, the second and third, ideals, from Paolo Uccello, about perspective . . . beyond perspective . . . the discovery of the cosmos is a new dimension, it's infinity, so I put a hole in this canvas, which was at the base of all of the arts and I created an infinite dimension, an x that, for me, is the basis of . . . of . . . all the . . . the . . . sorry uh, of all of contemporary art, whoever wants to understand it. Otherwise, they'll keep saying it's a hole, and whatever. Yeah. On the other hand, the idea is really that there, it's a new dimension that corresponds to the cosmos, the space rocket still hadn't been discovered, the cosmos I mean, right. Because look, man has always been on earth: base, height and depth for millions of years . . . When architects say they make spatial architecture standing on the earth, it's an enormous mistake, because they create elements

in space, but never a spatial structure. The spatial structure already exists in this capsule that was sent to space, and it will be there when the interplanetary stations are set up, that are forms in space in all of its infinite dimensions. There is no longer foundation, point of view, vanishing point, it's really free, isn't it? So, we will see how art will transform, what necessity it can have for society, if it will still be valid or not. The hole was, exactly, to create this emptiness there inside . . . and then, mature in some form or another, but, it was important to say 'A form like this is over, I'll go beyond, I want to witness it.' Because, otherwise, I would never have made the hole, I would have brought out the *Theoretical Manifesto*, instead, certain things have to be documented: 1+1=2. You can't say 1+1 and not do anything, you have to say 1+1=2, it's a mathematical operation, isn't it? Also, when they say 'Fontana makes a gesture,' yes, I make the gesture of making the hole. And those who make little machines? the little screw, the little wire, the car . . . they have to make gestures in order to make these objects. So, they also make gestures: that's the stupid part, they think that one makes an informal gesture of making the hole . . . It's the thought that you need to document, to write a book, a philosophy, you have to document it to get past it . . . It's a formula, like Einstein made a formula ta-ta-ta-ta, and he discovered a new mathematics, the formula of space, actually almost of the cosmos, helped in new discoveries. But I am not a mathematician, I used my instrument, my medium . . . Man, on the earth, made the first gesture, made a dimension in sand, he didn't put himself into drawing or painting . . . then, the Assyrians, they already started with the second dimension, the profile, movement in marble, in colour, so . . . then Paolo Uccello discovers the third dimension. They're all ideal, right? Foreground, background and perspective, which is the third dimension, and which is also parallel to scientific discoveries. Those were the great new events of their time . . . then that the world is round . . . it's nothing for us, but then, it was a huge discovery. Einstein's discovery about the cosmos

is the infinite dimension, without end. And, so, look at that: first, second and third planes . . . to go beyond that what do I have to do? Nothing, if I take up the camera, I make light and I make light, rather, ideally, as a documentation, as a formula, it was saying 'I make holes, the infinite passes there, light passes, there is no need to paint.' I wish you could understand, because, instead, they all thought I wanted to destroy: but it isn't true, I constructed, I didn't destroy, that's what it's about. Later I gave them an aesthetic structure, because the canvas is good as it is, it's a matter of, that is I mean, aesthetic taste . . . There was a time when you didn't see panels with holes, when you had to make a hole in a panel . . . a tragedy, you had to hide it with a lamp . . . now, look, they put holes as big as a square metre in cinemas and everyone looks at them, without . . . And, so, you see that it's also a new aesthetic, it isn't necessary to paint figures on panels, you can add holes . . . but it's over, really, saying 'I paint the wall.'

CONSAGRA: Let's suppose for a moment that the artist realises that everyone is an artist and he lives in a society of artists: what does he do? He stops doing anything, he observes others and enjoys the situation, in other words he will create another product that isn't visible because everyone will

create visible objects, right? That, then, is the same. At the end of the day, the artist personifies a worker, personifies a sufferer, personifies someone happy, personifies someone in love, personifies a sailor . . . and imagines all of these roles as artists. So, he sets about to do a specific thing that allows him to understand what's going on around him, am I explaining myself? What if, instead, he was able to see all these characters that actually do this fictional thing . . . I mean the artist is like an idiot, actually, because if he were more intelligent, above and beyond, he could avoid making these objects, imagining that all the others are already artists on their own. But the artist makes this object, does this other thing, puts together the mechanism of work . . . So, I think, the most moving part would be discovering why the artist works, what is the mechanism according to which, for him it all comes down to in order to work, he doesn't try to move away from it and penetrate the others, without producing anything himself. Instead, he wants to produce, there is this pleasure: what is this pleasure in speaking, in making sense through this thing that he does? So, what Castellani says, to do it in a way that there is full absorption, permeation with the process of the work, it's an emotional side that you can put in communication with the others, but, I don't know myself, the most important thing, from another point of view, is something that you cannot actualise, that cannot be actualised . . . Then, actually, the artist also would get tired of this, I see that he is the type who gets tired of things, gets tired of everything, so I wouldn't ever start to think of something that will go on . . .

ROTELLA: As far as the evolution of my work goes, I have to say that the past two months, that is since April, I was inspired by new sexological images, by biological images. From which I began to appropriate things, some illustrations found in 'sexology' books, to then make paintings or designs, reproduced on paper, that I mounted on framed canvas. One was the double image of a vagina: the first in the state of virginity, the other no longer virgin, with various biological

words, I don't know 'labia', 'hymen' . . . Another image which I also appropriated and made a painting from, was the effect of the birth-control pill in the sexological apparatus of woman, with various words, of course. And then another was a section of the man's sex during an outbreak of gonorrhoea, of an illness we know is called gonorrhoea. These are the new things America inspired. I actually thought of them during my time in Paris two years ago; then, in America, I saw a more fertile terrain for making these new works. I also continued to work on some portraits, because I think that at a certain point, the painter must also change, in the sense that he has to put an end to whatever his habits are, to find things that entertain him. And so, these portraits of personalities and friends entertained me . . . I worked a lot on these portraits, with this photo-mechanical technique, always first taking a portrait with an old Polaroid and then projecting the negative onto a sensitised canvas and colouring it with chemical solutions. I had a lot of fun doing this. The portraits were of colleagues

like Claes Oldenburg and his wife, of Roy Lichtenstein . . .
Some were commissioned by collectors like Mrs H. Solomon
who is a collector of portraits by various artists, various Pop
Artists, naturally . . . she commissioned a portrait from me, I
think the result is quite fitting. Then, the big publisher Harry
Abrams also commissioned a portrait from me that came
out quite well . . . This was a lot of fun, in the end, really,
along with all of the other things I was trying to do. A sort
of entertainment, but at the same time, something serious:
the painter who, at a certain moment, needs photography to
express himself, let's say, a language, and therefore . . .

ALVIANI: Another situation that interests me a great deal
is: colour, the phenomenisation of colour. I made three sheets
of silk-screen prints with phenomena of colour, it's also a
primary phenomenon, because you need to start at ABC. I
always say that our research is ABC and will continue to be
DEFG until it forms a new language. The success of Optical
Art caused a lot of damage to a lot of people, which was – at
the core, to we who did it – at the very beginning, you know?
We try some white lines on black, black on white . . . the first
markings, the straight line, which would become round, then
it would become square, then a circle, then a cylinder, then
a cube to eviscerate all possibility of the notional order, in
the order of knowledge. And this was our beginning, because
we wanted to start from the beginning, the world mistook it

as style and, therefore, many stopped at that style and they make little squares in that style. For me the squares were the letter B. It can't be that you do BBBB all your life, right? Look so, obviously, some will do it more quickly, others more slowly, in order to make a new language ... this is what I think: by now the differences are minimal, you know, I don't know, another small thing that's a bit different. About studies of the tension of lines, I'm working on ten or so, all of the possibilities of a space of identical surfaces that you can stretch out in a determined space. You could spend your entire life studying this, I mean, to analyse it. These tensions are only one letter of the new alphabet and, so, I think for just one colour, for blue, for yellow, a lifetime, I'd say. Now that I'm seriously studying colour, I see what enormous, enormous things we can investigate and therefore become aware of. Therefore, it's an ever more specific analysis and always more particular, particular, particular.

FONTANA: White has no importance because my paintings, the first ones, had no colour, it was pure blank canvas, or a yellow stain. The first ones had nothing, I still have them there, right? Then I gave them some colour, really to decorate them, because really there's nothing bad about saying that I decorate a wall, because Michelangelo decorated the Sistine Chapel. It's only that, later, its meaning was considered decadent, 'decorate'. But, how do you say, how would you say it? Michelangelo did what: he painted the Sistine Chapel? He decorated it, didn't he? I think that's how I'd say it in Italian. But great decoration is pure painting. On the other hand, say, 'You are decorative', if now, you say it to me meaning shoddy, that is, to say that I'm a bad painter, okay. But, that painting, why isn't it decorative? It is decorative, because the structure is studied exactly for the purpose of pleasing the eye and everything, but you have to understand that it's a new dimension. So, I give it red, I give it yellow, so ... Then, when I put the rocks in, it was to see what I could overcome, but instead I took a step back, you know ... because you also make

mistakes, thinking that you're moving forward . . . thinking that light would pass through the rocks, that it would create movement, and all that. But, I understood that I need to stay with my own pure simplicity, because it's pure philosophy, more than anything else . . . you can even call it spatial philosophy, you can call it cosmic. I also used white a lot at the Biennale. But it could have been black. I wanted to make shocking pink, pink, from the world of fashion, I wanted to make it black, the colour wasn't important, I did white, just because . . . maybe, because it is the purest, the least complicated, the easiest to understand that this hole in white is more logical than in a colour, but it has no importance, on the effects of my thinking, white or red or yellow . . .

NIGRO: As far as the psychological aspect goes, it seems to me that colour, referring particularly to the period of 1953–1954–1955, would be transparent colour. I make black and dark blue grids, two types of grids, one on top of the other: underneath there is a varied background of green that shifts to yellow that shifts to red. I'd say that psychologically, actually expressionistically, it's similar to the feeling of having a fence, of an impediment that blocks man from a free immensity. The lattice pattern, aside from its rhythmical necessity, and therefore methodological necessity, of identification of the poetics in a plastic language, it really creates the feeling that man has a fence in front of him, like he's a prisoner: beyond it is freedom, pure colour, more lively colour, more violent than one can imagine. Structurally, the background colour gives value to the various parts in that they stand out in contrast as variations: each series acquires a chromatic timbre that is slightly different from the one adjacent to it, right? And, therefore, it acquires a more defined structure and, at the same time, a kinetic value because of this variation in colour. Ultimately, it's about a monochrome variation because the painted lattice pattern doesn't comply to colour, the colour is filtered, therefore the impression of the painting, at first sight, is a monochrome impression. Then, this monochrome

impression, whether because of the variation of colour, from green to yellow to red which occurs gradually, or because of the difference in distance between the stripes on each iteration of bands – the colour becomes darker where the stripes are more crowded together, and lighter where they are more spread out – it appears as a double variation. One in the background, uniform, and one on the surface, episodic, formed by this alternating between light and dark of the perspectival intersections that give exactly this, the core of everything in this dynamic composition.

TURCATO: Well, now I do these things on the surface, as for the rest, I began with the Biennale and, exactly . . . I think I told you about it that other time, as well, that my obsession was with making a colour that was different from that of the spectrum and then, yes, also to invent a colour, which isn't a simple thing. Up to now, I was able to make violet, for example, blue, as a given of some reflection. Well, I was a bit shocked because I saw that Olitski, even him, after the Biennale, started making violet paintings. Anyway, since this attitude, today, you breathe it in the air, it means that things are more or less coherent. Bypassing Olitski's intercalations, I think that today one could even create objects as well, but objects that are not the result of an exaggerated programmatic rationalism, like the Triennale . . . The objects need to be a bit fantastic, a bit poetic, objects large or small, or structures, too . . . Because, at the last Biennale, more than paintings, many had charts, so these drawings were better at the Triennale, so it was a mistake, geographically, where they were placed. I didn't see the Triennale, I know that it was 'The Big Number', somewhat ambitious, as an idea, but . . . Now, I think, these things are too flashy . . . there needs to be a bit more simplicity. Too many mirrors, too many . . . too much cinematic scenography, all in all. Too much advertising, yes. In the end, it takes little to do something well, in principle. Undoubtedly . . . Europe has different dimensions than America . . . there aren't these massive showrooms, or banks

or . . . housed in skyscrapers, it's always a more modest dimension, too. It could be that some things don't work so well for them, they work well for us. There isn't, this dimension of representation, because then, we're still not at the mammoth of advertising, of propaganda . . . Maybe, probably, we believe in advertising less. Now, I don't want to judge if this is good or bad, if we're more or less advanced: anyway, we need to be in the dimension in which we find ourselves. With all of this, the Americans have respectable things whether in architecture or . . . actually, in a certain sense, they are preferable to the imitations that they make here, of certain American things, I don't mean just Italy, but Europe in general. Therefore . . . everyone has to stay in their respective dimension. These are judgements that I make, like this, because it isn't like you can predict what's to come or what you should do or should be done. I would take the European dimension as a template, but as a model that ought to be studied thoroughly. Of course, also a prefabricated model, but . . . a model that

would also have a coherence with a specific proportion, that Europeans also have in ancient monuments. This not knowing how to design, in a façade of a building, windows with proper proportions, I find it really . . . I pity them, because it's impossible not to be able to do it. Until now, even in low-cost, let's say, buildings, or also in housing, instead . . . or in skyscrapers, things are, like, half copied, or half cobbled together or half . . . There isn't, in the end, a proper expression, even incorrect, I wish, in which one says, 'Look, we are here in a certain dimension, that could go well.' The difficulty, yes, of decorating a bank or building it in a way such that the bank has the possibility of being decorated, because effectively, an act of architecture can also hold without any instrumentalisation from painting or from sculpture. There are examples of this in ancient art, it's not that, like that . . . I, meanwhile, I want to go beyond . . . rather, I believe I've already begun to do this . . . absolutely, the rectangle of the painting, the square of the painting . . . For me, the quadrangular dimension is a mistaken idea, because . . . everything that comes from the golden ratio, that is, it's a bit about fitting into a certain geometrics. Then, we, we have round heads, I don't know why we need to think within square rooms, or inside square cities. And this, naturally, will have its consequences when you make something, even an object, or also a painting, that should undoubtedly be in another dimension. The painting, that is the quadrangular canvas . . . is the corner that continues to annoy, above all . . . in the end, it's a dead end, it isn't true that the square is an exact form. Up until you hold your glance at the centre of the painting, it's okay, but then, when you arrive at the corners, in the end they're annoying. Isn't it true? Well yes, while something that is round is already a bit, uh, a bit more soothing, more . . . yes, actually, more in tune with our way of thinking. Then . . . who knows, it could also be that it wouldn't be possible to do anything, right. And then what is this damned form of expression that should also become a new form, but, naturally, cannot be planned before

the work of art is made, or so-called work of art. It could also be that there is no need for this thing . . . but . . . anyway . . .

NIGRO: I, as far as my character, naturally I am classicist and romantic, I'm both of these things, unfortunately, for outmoded reasons.

LONZI: I see with pleasure that you haven't considered at all the fact that I said you could be like a mannerist. I'm happy it didn't even cross your mind. Mannerist in the sense that . . . I don't know, the essence of mannerism is an extremely controlled form to express dramatic content. You have a completely planned, not effusive, form, not gestural, for expressing, in fact, very dramatic content.

FABRO: You're a mannerist, Mario, she's right.

LONZI: I have the broadest concept of the mannerists, I'm not saying it in the sense of, you know? . . . You didn't get it, this thing wasn't teased out of you, as I see it. Because you say 'classicist', 'romantic', but, there is a different phase, this one is, I think, mannerist, that's the most disoriented, if you will. All of those paintings with that drab green, you know, that green, that then becomes a jarring feeling with the lights behind it. You remember those two-tone drapes? . . .

FABRO: Mannerism is a very interesting juxtaposition. It's a juxtaposition that's very difficult to imagine, just like that, but, once it's thought of, it seems to me . . .

NIGRO: I never asked myself . . . because, now, I should clarify mannerism for myself and, then, I could talk about it. Anyway, I'm not offended if you call me a mannerist, if you call me classicist, if you call me romantic. If, especially, you make objections, 'I think that in this moment you're mannerist, or you're romantic, or you're classicist.' It's in my nature to alternate these classicist and romantic moments, naturally I always try to valorise the classicist moments. Because, I mean, that way, it's a fact of nature, of education, I don't know, of conviction, maybe above all, yes, of confidence, isn't it? I don't deny that there can be romantic moments, but they're very dangerous those romantic moments, I think.

FABRO: To me classicism seems . . . we say that an author is classicist when he has the perfect identification of the ideal with the real. While, when we talk in abstract terms, I don't think it's possible any longer to talk about classicism . . . Maybe you mean classicism when a school has become, over time, part of the common culture, but, I think, in very arbitrary terms. Mondrian isn't a classicist, as long as we are talking about mannerists, Mondrian is a mannerist, I think.

NIGRO: No, for me Mondrian is a classicist because he develops a precise problem and so, there, he's classicist.

FABRO: I don't believe classicism has . . . you studied art history, you probably have more understanding of this. But it seems that it's also the difference between Pontomoro and a classicist . . . also Michelangelo is a classicist in the *Doni Tondo*, but why then, later, do they call him mannerist? Because there is no longer that exact identification that, on that other hand, you can find in Raphael: that peace that is classical. Classicism is, I don't know, Phidias and company, where what

is said is said, it's there, it doesn't have any . . . For example, we have a literature, in the sixteenth century, that isn't classical at all because its problem is to create this union of the ideal in the real as a mental factor, while we have painting in the sixteenth century that is classical because this union is alive. It seems very different to me. Instead, Rosso Fiorentino becomes Neoplatonic . . .

CASTELLANI: The artist would like his work to be consumed immediately, and then he doesn't care the least bit if the object persists, occupies a space in . . . in the world. And this, maybe a bit paradoxically, pushes me to believe that the expression, the materialisation of what a person wants to say, is extremely disproportionate as . . . as the mass of material that he uses, always so disproportionate to what he has to say, what he actually says, there is such a waste of space, of weight . . . that I think can be attributed to the fact that we are at the beginning of our brain development, very likely.

CONSAGRA: I believe in the history that . . . for me, the artist is he who . . . is the man who is most impressed of anyone by the fact that . . . that he has a body that produces poo-poo, okay. And, so, he wants to sublimate . . .

CASTELLANI: . . . that his body creates something, that he considers the most filthy thing, while the others don't take much interest . . .

CONSAGRA: They do care, they're interested to a point . . . to the point that it's, let's say, any old job. But the artist doesn't want to do any old job, he wants to do a job that is something beyond, that would be something much more elevated, that . . . that makes him forget as much as possible this product of his body. Now, we need to see if art will manage to . . . to surpass it. Otherwise, the artist would be happy to think of a creative fact, he'd be happy, yes, to be that really intelligent artist that I was talking about, who knows that all the others are artists, too. Instead, he cannot be happy with this, because he needs to counter with an object that is produced by the mind, to contrast with another version of himself.

LONZI: But there is a variation, now I want to record it, since it's already come to mind: exactly, one can think that woman doesn't have this creative stimulus because woman, already, is producer of life, that is, a woman makes babies, so this business about excrement is obfuscated in the conscience, this debilitating figure for humanity. Therefore, when woman sets out to do something creative – this is a button I'll barely touch, but that I like a great deal – she behaves differently from man, she doesn't need this sublimation, to completely detach . . . but it is something kneaded into her very self . . . This is a possible hypothesis, now it is necessary to see if women will create and how, in a system much vaster than the one we have now . . . Of course woman had difficulties accepting creativity according to those very sublimated masculine terms. There she feels unnatural, she feels pushed by a heavy force. This, like this, to bring women a bit into this business. Then, we will see if the problem is about forgetting, right? Maybe, who knows, it's a way of placating, of maintaining a strange contact . . .

CONSAGRA: No, no, it depends though, this dialogue . . . There's Matta, who's obsessed with these things here, he always talks about anal matters, about the creation of . . . he always has paintings that are, like this, something to create . . . Then, he once made a little book of comics where there's the figure of a man as a dick, a dick with eyes . . . exactly this, he had done this inversion, this terrible synthesis. Because, so, what would the problem be, to test what I am saying? To accept poo-poo as, rather, a good product, as a beautiful product . . . that is to stop with this obsession that poo-poo is a bad product. I remember, once, that Turcato said, 'It'd be enough to add some sugar and you could even eat it, in the end.'

SCARPITTA: After those two shows with modules, I found myself, again, in my usual situation between the organic and the geometric, again a contradiction, that once again pushed me . . . because only one thing can resolve, I believe, the conflict between the organic and the geometric and that is the

matter of the content. And so, I went in the wrong direction once again making those bandaged paintings, based on a precise content. That would have been visual content from a certain world of the American mechanic, covered in dust, in the garage. Where things live in a certain domain of use. I wanted to cut out the hermetic, to cut out the hygienic from my work, and to turn again towards a certain intimacy that one has in coprophagia or in playing with shit – as contrast, really – or, in my case more specifically, bitumen, oil, bandages dirty with oil, dirty things from an organic world. Without entering into the psychological like Burri, but always keeping it in an explicit field almost, I'd say, illustrative of a certain visual world, almost an objectivism. So, I began again to try certain things on the canvas like seat belts, tool belts, parachute clasps, aeronautical or racing-car-type ties, exhaust pipes and I inserted these things into my canvas, a bit to bring me back towards a world . . . more . . . that would be more reassuring to my presence here, in America. I'd say maybe, to concede a

bit to the world that surrounded me, because I believed that I didn't have anything to give in an axiomatic or corollary sense, I didn't have any theorem to succeed, I only had the experience to be carried out. And, so, I employed a bit of my environment that I was looking for, a human environment in an organic-mechanical world, like this: from the seat filthy with sweat, to the steering wheel, to the exhaust pipe hot with fumes, hot air . . . like this, to give a setting to a painting. In this sense, I returned to a fact, I'd say, of material order.

CASTELLANI: The beginning phase of my work is very far away, but, if you're talking about technical innovation, that is without a doubt what brought me to discover the possibility of language that I was chasing for a long time. What I had done before was a research into origins: by reconnecting with the experiences of pure painters I was trying to understand . . . In the end, I was influenced . . . I liked . . . I had Tobey in mind, because I thought that he arrived at a point of such purity of language that could be a kind of departure . . . that would

have eliminated every expressive desire. I worked in this way, in '56–'57, returning from Belgium: I was trying to cover the canvas with markings that were progressively more cramped together, progressively more depersonalised. In that period, others also worked that way and especially Dorazio, I met him with Carla Accardi and Sanfilippo. Then, at a certain point, I realised that, working in that manner, the only possibility that I had, the only way out of this research of mine would have been the completely white canvas, and I didn't have the courage to get to that point. Not because the leap would have seemed too vast to me, but because I realised that, at this point, the discourse became terribly different: a white canvas like the one you find in a shop is like renouncing the . . . Not even Manzoni got there: when he had gone very much in that direction, he made a stitch in the middle. Yes, Paolini worked the canvas and, in fact, he is on his own, really. So, at a certain point, I found a technical means that could resolve my problems, from giving the canvas a different dimension from what I could do with the brush or the mark, the traditional means of painting. At that time, more than being interested in any given artistic direction, I was really bored with the things others made. There were trends, Post-Expressionism, post-realism, all of these movements, where painters dredged up the bottom of their conscience and dumped it onto the canvas proposing it as the true unconscious; they claimed it was artistic material, remember this? Everything that was the history of these people's personality, really, that they hadn't been able to purge, let's say, to flush out by other means, either sexually or any other way, they insisted on dumping it out, with the presumption that the canvas should be something of a gym for their psychic liberation exercises. So, I thought that it was not the suitable gym, the white canvas, for these sorts of exercises . . . if they weren't exceptional.

LONZI: Speaking of the fact that you so often use words, that is writing, and signs in your painting, seeing as this began at a later period, it implies that, from a certain

moment, your mark-marking developed and differenti-
ated itself in a such way that it could be understood as the
equivalent of words. But, also, that words could have been
written as diagrams of psychological forces, and not in the
calligraphic sense, but a sign–topological sense. Does this
explanation seem to you to be true?

TWOMBLY: (silence)

KOUNELLIS: The last letters that I did recall a very old
period, they aren't actual letters, I think that they're from a
period around 1960. In order to say something and to have
it remain without taking on the experiences already implicit
in what you see today. Like something heard and written.
First, the letters always had the same length because I didn't
want to absorb the eye with a mere formal question, but with
something that is said . . . it was to create a discourse, also
with few letters, in a hermetic manner, like someone who
has to write about things and then, maybe, the letters don't
reflect that discourse, they become something else by read-
ing them in a logical manner. While now . . . when you say
a name is a name, complete, but I don't want to write in a
way to make a new object. Jasper Johns's flag is a flag because
it takes a space, it ends in there . . . No, I mean only to hint
at. One wants to make, maybe, some things that don't exist
for him, but he believes in them so strongly that he makes
them become truly existent. Like that guy who was missing a
leg . . . so, he wanted to dance, and he danced with only one
leg. He shouldn't have been able to dance, but he danced, you
know: he wasn't in the physical condition to be able to dance,
and he danced. Yes, I say this in respect to doing an activity,
to inserting it as a possibility in life and, afterwards, as a pos-
sibility of painting. When I made moons and the other things
from that period there . . . so, when there is nothing more,
not even to see, not even of other possibilities that many oth-
ers have, you can even arrive at the point, like that, the essen-
tial point, but in a way that isn't dramatic, rather it's joyful,
in the broadest sense of the word . . . So, to find a calendar,

but also a mental calendar: each week there is a moon and practically you paint that there that grows, grows. It's that same thing as when you go out and continually see the same writing and 'bar', and 'barber' . . . and you paint them: every day you make one. So, you create an inexistent activity. I also made a painting that's 'Monday Tuesday Wednesday' . . . Consequently, 'the moons' came after because, at any rate, you had to wake up every day . . . One day there was Monday, okay . . . after, I don't know, there was Tuesday, but, together, also the full moon . . . so, I made a painting of the full moon together with Tuesday . . . and, after, I don't know, you go out and see writing: you also make the writing, right? It's like this, you start an activity and from there it's not possible to think one just starts painting.

LONZI: My sister told me that, during a lesson, Jakobson, the structuralist with whom she studied at Cambridge, read a paper with this observation: it was revealed that people affected by aphasia, that is, the incapacity to use language in a structural sense, if they were painters, their painting was subject to disastrous results. Jakobson used this very term. So, it seems that these two sectors, language and image, contrary to what was believed up until today, have a relationship between them that is functional. In the sense that if the function of one sector is disturbed, the function of the other sector is also disturbed. Instead, one thinks habitually that if one works with images, or anyway, in a sculptural practice, if one is unable to use language as a structure, he can make the structure of pictorial language operate in the same way. This doesn't shock you, Giulio Paolini? It shocks me that it doesn't shock you! Because you use letters to express the image: for example you make *Lo spazio* ('The Space'), right? Anyway, you associate these two sectors in a way that isn't parallel, but, let's say, functional, to get back to Jakobson's concept again.

PAOLINI: The necessity of putting a certain idea in an image, rather than writing it down or talking about it, requires a more lucid application. Until, indeed, one speaks or one

writes, there is always this margin of possible correction or further clarification; when, rather, you have to picture something, you have to be extremely certain of what you're doing. So there is less of an ability to put ideas into images, in people affected by aphasia, because of this lack, yes, of a lucidity that could declare, once and for all, what they wanted to say. The condition of the image probably suffers, in respect to other forms of expression, from a certain dose of drama, in the sense that dramatics, in this case, could be steadiness, definition, and that, therefore, this leads to a certain condition of internal terror; you could place it, exactly, in the impossibility of realising a structure of the image, differently from other languages or structures.

LONZI: This relationship between the two sectors is not so obvious from the moment at which, for example, someone who is mentally ill, but not affected by aphasia, can develop some form of painting. When I learned of this objection, reported by Jakobson – I don't know anything about possible conclusions, I think that it's a problem specialists are studying

at the moment – your work came to mind immediately. So, I asked myself how it could be, that out of all the artists who use words, I thought of you in particular. And later, upon reflection, I realised that, while the others use the word and the image as two distinct channels of communication, in a way that the word serves to confirm the image and the image to confirm the word, in your work one manifests the other and vice versa.

PAOLINI: I, at this point, I would complicate this even a bit more, I would overlap this argument with that of technique. When we see a painting that proposes an image to us and, confirming this, we have to read a word that is there nearby, it's clear that the operation hasn't succeeded, we no longer distinguish whether the word is to be taken as an object or the image is the object. Therefore, the word and the image can be, at the same time, the technique and the meaning of the painting, right? And this crazy interchangeability of the two elements, this possibility of intending them to be two, means to say one thing that isn't there, or vice versa as two connected and coherent meanings, when one of them would be enough. Therefore this rhetorical form of expressing only one thing with two instruments leads to charging the work, at the very least, with one additional element, or it can even ensure that the two things could have an equal weight and wouldn't even constitute a unity. No identity is possible, since two parallel elements exist in compresence. Now, I sought to do things in such a way that the word would become the image of itself. When the word assumes a particular spatial position, it can become an image, in its way.

LONZI: Kounellis also looked for a relationship in this sense, first with letters, the telegraphic paintings, and then with words, *Paola, Come, Night, Yellow* . . .

PAOLINI: It was probably the desire to touch on, indeed, an identity between words, that after all is what we think, before we can see, and what is seen. In respect to Kounellis, I gave the operation a more rigorous aspect . . . but, at a certain

point, it could also be my own deficiency, that is, needing to verify the thing in terms of a geometry of space; it could be that, on my part, some kind of superfluous verification. In the sense that, for Kounellis, as for me, I think that these works represent the need to speak those specific words. Now, that he'd write them on the canvas or that I'd look for a 'solution' to these same words are two different aspects, but, in the end, if Kounellis renounced the observation of the space around him and was simply contented with writing them, he was quicker, wasn't he?

CASTELLANI: Mine is an essentially political discourse also in consideration of this fact: it's true that among men some are creators and others are just not, but I don't know up to what point this is a question of conditioning . . . of social conditioning, right? Because, for example, I think, that all men are . . . are creators, that they're inclined to creative work and not for repetitive work as they are conditioned to do now, except for artists who become privileged members of society. But if . . . if you'll admit, it isn't even that science fiction, this fact, that one day, and it could even be quite soon, that man will be relieved from this repetitive work, and will have the chance to dedicate himself to creative work. We are part of a civilisation and of a society pre . . . pre some other thing that we are catching sight of and, therefore, ours can be considered . . . how to put it? like an archaic archetype of what man will be. I mean, the artist today is what man will be tomorrow. I, a political man, seek to accelerate this process.

PASCALI: I try to do what I like to do, in the end it's the only system that works for me. I don't think a sculptor does difficult work: he plays, like a painter plays, like any person who does what he likes, he plays. It isn't that play is only what children do, it's all a game, isn't it? There are people who work: later, childhood games become adolescent games, adolescent games turn into adult games, but they're still games, aren't they? At a certain point someone is in their office, if the work is unpleasant, he wants a powerful

automobile to go for a ride in, you know, really because
he does a job that he doesn't like; instead, someone who
likes what he does, plays with the work that he does, puts
everything into it. Not in the sense of playing for playing's
sake, that's something else, but in the normal sense of man's
activities, right? Even children play seriously: it is a cognitive
system, their games are made to try things out, to under-
stand things and at the same time to go beyond them. But I
don't know how to define children: they're men from a cer-
tain age until the end, you know? Later, if one whacks his
own head with a wooden spoon, he's an idiot, that's clear, but
if he is able to live as he pleases, like, I don't know, the boy
who makes school feel like a party, like that.

KOUNELLIS: I believe that you produce freedom, it isn't
something fixed, that, once achieved, is always free, but it's
something to continually reach for. That demonstrates that,
every day, there are also different conditions for getting to
this freedom and to achieve it in this measure, because this

changes everything, right? Not only, specifically, from coun-
try to country or from civilisation to civilisation, but, like that,
also at the same . . . And, also, you produce things that are
even contradictory, but these contradictory things need to be
accepted because it's the only way to achieve this freedom.
This freedom is also to do other things, isn't it? Before, there
was that kind of work . . . everything was typical: for an artist
that's the typical way, isn't it? . . . While I believe that, beyond
this, now we're getting, little by little, to a greater maturity,
we go away from the trade . . . We have done everything to
get rid of the artist's trade and, once the trade is gone, not
to do another trade, but to be a different man. So, today you
can make an object and tomorrow it might be important to
paint a painting, right? You have to have a precise reason
for doing these things. So, this is a sign of freedom, also of
maturity, really, that we move forward also towards things
that are, actually, contradictory. Here, society has produced
this division between life and work, and created specialisa-
tions, and now it has become once again unitary, in the sense
not of fitting to life, but of fitting to the image of the office.
I don't know, things that divide life don't feel right to me,

really, right? I mean, to be unitary, to have a life, I don't know, coherent life . . . what you do is coherent . . . to find a unity, if possible. You say to me, 'How is it possible to create a kind of unity between you and the outside world that really doesn't give a damn about unity?' In this sense, a sort of closure could have been made, for the artist, to create a world, that doesn't exist, but it is unitary. I believe that today, as I see it in this moment, I believe that it is possible to create this unity . . . to expose it, because you don't only create it for yourself, really. There is also this aspect of bringing it out, it's the only way to show it . . . it has little to do with trade in the traditional sense. Because the Gallery, see, this is all a complete circle where, anything you do, blends itself into the common mentality of the surroundings. If you make a free action, like that, from the moment you show it, because you have to show it in some way, then it is instrumentalised and becomes trade, right? And so, you need to continually move, to be free from those instrumentalisations that are cast upon you when you show things. And, afterwards, how your opinions of the world change, it's not that you formally change in order to leave things . . . you always solve problems according to certain situations, right? One reaches that unity he wants to create, afterwards he abandons it for something more detached, and it has to do with it. To not isolate oneself, to not create an ideal, something nostalgic about a lost unity, really about a happiness, even, that's been lost. That's always a possibility, and you have to have this rigour since you propose something, and continually . . . And also it leaves tremendous traces inside, to want to . . . I find, however, that this is not for an ideal world, but for a world that man is able to live, I don't know, a life that's dignified enough and everyone can have that unity, really, of things. Only, this system, doesn't allow it. I believe that the realisation of socialism can produce a unity of this type, but it isn't because, I don't know, I say that socialism . . . Because, in another system, it's very difficult, right? Socialism meant in a certain sense of course, not in the sense

of the Russians, because it's very different: as in restoring activities, and restoring freedom, as well. But there are other problems, later, that come out even there, because it isn't stable there either, it needs to be continually shaken up, really, this thing. It's this sort of thing, that has a long-term objective itself . . . so, it allows them to do a lot of work and have many, I wouldn't say experiences because, already, it's too compromising, isn't it? You can't reduce life to experiences, it needs to be that life . . . Today, it's very difficult, I don't know, to even talk any more . . . now, we're talking, even this is extremely difficult, because you don't know precisely what you have to say: in five minutes or in ten minutes I will have, not different ideas about it, but I could have different opinions, you know?

NIGRO: This *Passeggiata* ('Walk') is a logical development of the painting that expands and needs a new dimension, rather, more than a new dimension, it needs continual revision, which is why it's necessary, at a certain moment, to get out of the traditional outline of the painting, not to get out

of the painting, but for a more immediate legibility. This *Passeggiata prospettica ritmica* ('Rhythmic Perspective Walk'), I could have executed it exactly within the limits of the canvas and in substance it would have been within those limits, because it's the same. Okay? So, for this *Passeggiata* to be more easily perceived, I need to carry it out on these terms, as indeed it would have been necessary to also create the experiences of *Spazio totale* ('Total Space') in different terms. When I carry out these rhythmic perspective projections, I have already exhausted a theme, I can always consequently develop this theme and, little by little as I develop it, I identify the base element of the plastic language. At a certain moment, once this identification is made, I make another and so on, progressively, there is nothing still, inevitably it must be progressive. It's absurd to say, 'I've identified art.' Art in itself doesn't exist, it exclusively exists as research, as artistic research. Little by little as you do this specific artistic research, you identify the plastic language. Definitely, one cannot talk about Optical Art, socialist art, religious art, it doesn't make sense, as far as there is an existential situation that points you towards a concept to call art, but in and of itself nothing exists, right? You can call it 'salami', just the same. You make this thing: in the moment that you make it, it becomes this thing, it's obvious. So, when I dreamed up these prospective progressions, at a certain moment . . . look, here is the unexpected element, in a nearly symbolic coupling, that is suggested to me not only as a rhythmic conception, but as chromatic counterpoint. For example: in the grey comes a yellow surprise, then in the other grey come different surprises in different colours, in the end in the last black one comes a pink surprise. All of these surprises can suggest a symbolic significance that, in the musical sense, could be identified as a 'suite', a 'fugue', an element from the background comes to the foreground, maybe just for a moment, then it stays as background, disappears. These chromatic timbres have a determined colour, and in

contrast with closer colours, assume an emotional meaning. That's how the surprise comes, in the emotion of these chromatic notes. Naturally, being four poles, as symbology, I think, I don't know, of the four seasons – winter, spring, summer and autumn – or the course of life. It could be something a bit autobiographical, in a certain sense . . . and where this is a larger chromatic surprise, maybe it could be compared to summer, but clearly it isn't that this is a main problem of existence.

PAOLINI: Then there is the painting composed of two big canvases beside each other, like two big open pages, on the same module, on the same positioning of the subdivision as the space that I had used for the painting *Una poesia* ('A Poem'). I arrange things according to this plot, along this pattern, one by one all of the corresponding letters to the writing of all the names written in my notebook. The title of the painting is *Titolo* ('Title'), if for title I can mean the argument, the context in which a certain work is developed . . . namely that the title should allude to the environment of things, to the identity of things in which the work comes into creation. Therefore, in this sense, the names that come up in the painting are a bit like the frame of my working space, the frame of my everyday life. I'd like to make an edition out of this work, that is a real, true edition, a book, that will be made of a certain number of pages of white drawing paper on which, page after page, I transcribe these names, always according to the pattern grid, like this . . . The title of the book, that is the title of the painting entitled *Titolo*, will be the encyclopaedic voice corresponding to the word 'Infinity': it's a phrase that now I don't remember by heart because it's a bit long and complicated . . . If I do elaborate on this painting from time to time, without fixed deadlines, in the arc of my life, other exemplars, leaving the dimensions unchanged and narrowing the lines in order to keep inserting new names, the book will remain a fixed point, it won't undergo further elaborations: this is the difference, the opposition of two titles for the same work.

CASTELLANI: What I say, naturally with a great deal of reserve, that I think it's good to let the creative process be known in its dynamic phases, on the one hand, demythologising artistic work conceived as the critics do, and on the other hand it seems to me very, how to put it? demanding of certain reflections and then, at the end of the day, didactic, also a way of working that is different from a way of working that's repetitive and alienating.

CONSAGRA: To transmit the way the artist works, yes . . . that, for now, is mythologised, let's say, that's the contact the majority of people have with the work of the artist, well there is no contact, right? Therefore, an artist, in the work of demythologisation, has to do what Castellani is talking about so that everyone can realise the simplicity of things. But, it always remains . . . this fact will always remain that, once people have learned, have seen, they will come back and do something else.

LONZI: Now, I think that there are a lot of people who have had the possibility of this experience that he is asking for, and haven't been interested, okay? These people, who didn't get close to something because it was unknown or because they considered it impossible to get close to, it isn't that you can get close to something in the moment that guarantees are made, those cultural guarantees that the artist, conversely, didn't have, right? Now, in the United States this art has become a thing . . . let's say . . . why? One knows that it has a cultural guarantee, the artist makes it like the automobile manufacturer makes cars, therefore, why not do it, from the moment that they guarantee to you that it gives pleasure, that you are considered an intellectual, etc. In the end, art is interesting in that one faces it, really almost doing something he isn't even sure if it is art even . . . namely that vital moment in which you don't ask for guarantees. When culture gives the necessary guarantee, it presents itself as an institution in which processes are explained, in which things are displayed, it's understandable that it will be more tempting for those

who have up until now thought in this mythical mode, but, at the same time, there is another mystification, if you like, which is that of giving it a social face. Of creating the trade of the artist, which will no longer be that of the Academy of Fine Arts, of the conservative school, but of an extremely up-to-date school and of the creative processes that weren't followed by those authors of the past, but are followed by the artists of the avant-garde, and all that. This can have a cultural-didactic value, it can elevate the culture of a country . . . naturally I think that it's better if the schools are better, that everything would be better . . . more modern, more informed . . . But, the problem of art is always a problem of life, it's not a problem of culture, am I being clear? It doesn't concern the University. People no longer want to be part of the public, nor to be pupils, they want to enter into the thing, that is, they feel that they're already inside.

KOUNELLIS: The closest, really, is the person who lacks the mental, cultural superstructures that have come, to everyone, from the consideration of art also in the historical or ahistorical sense . . . Because I, many times, have heard, say 'This one is a poet.' So, poetry had to be something so idyllic, in the eighteenth-century sense like someone who was up in the clouds. It isn't true, history is made by everyone, but history shouldn't be considered only in the western way, because history is much broader, there are many ways to conceive of history. Because if you go, I don't know, to America, there is really a thread of history which is made of events and things that are also logical, within a system; only, if you move, even within America, into another mentality, you see the defects of this whole takeover, which as it is isn't very convincing, today, this story here, right?

CASTELLANI: In the end, all of my reasoning about the need to let things seep out, to allow the perception of the moment of the formation of the creative idea, is really to involve other people, a large swathe of people who, before everything, weren't experts. Because, actually, the finished

product, ours, is perceivable only to those who are experts, there is a matter of techniques that whoever isn't aware isn't able, through the finished product, as such, to fully enjoy, he can't assess what technique prevents him from saying or doing.

ALVIANI: I always use lots of examples. It's very difficult for me to talk, by now you will have understood this, because these things, I think of them, like this, without . . . and later, maybe, I get going and I say . . . Ha! so to speak. Now, my situation has passed, in the progression of the action of things, by levels, like this, of phenomenal presentationality . . . to, instead . . . In a phenomenon there are many things, I now essentialise more and more, I mean I am seeking really a fact . . . that could be the vibratile texture of a time, one of the first, one of these situations that, indeed, has served me a great deal because they were really a propaedeutic object, in the most total sense. I began to fabricate something really out of nothing, and besides starting from nothing, I had to look

for everything. I was very young, a child really, therefore, to
know the word supplier, that you have heard . . . and, instead,
the supplier became an important part, an asset, once I knew
that a given industry produces this, produces that. Therefore,
it was really an object of investigation: how to fabricate an
object. Now, how I fabricate this, I'd say with the same pro-
cedure, I could fabricate, I don't know, a vehicle or, I don't
know, a needle . . . There are raw materials, manufacturing,
transportation, dozens of things, utensils, machines . . . so
many. The whole procedure: you have to pay for the electric
energy, remember the bills, the accidents that can occur, I
don't know, to have a notion of time, defects, merits, to reject,
to add, what crossed your mind . . . An object that served to
lay out as such this research. It was really a total research into
every single component of the action, therefore, it's an asset,
really, that . . . Obviously, there was researching . . . now I've
perfected it: I found a new system, there's a new oxide that, I
don't know, makes it more lucid, there's a new machine that
makes these things in less time, 'Ah, look, it heats up,' so you
need to make it not heat up, 'Prepare a machine to cool it
down,' etc. etc. etc. And this was . . . how would you define
it? A propaedeutic object, right? I mean almost, you know?
It allowed me to know a bit of everything. With this asset of
knowledge, I, like in that experimental period, today I can
transfer this to plastic materials, to glass, to pneumatic mate-
rials, to . . . to anything. Obviously searching, as I searched
back then for the native elements of aluminium, today I look
for them in glass or in plastic materials, but the knowledge is
always that same one. Today each time I deal with other prob-
lems without fear, without needing to waste time: the research
is in a pure operative sense and, therefore, into those prop-
erties that that material can give, into what I can, maybe, give
to it and enrich it with . . . It was a kind of, see, an operational
model. They are all things that are there on their own, but I
was able to give something to it, and it gave to me, I analysed
everything it could give, it made me understand everything

that could be obtained, and today, obviously, I do these same things with other things. And this is my spirituality, right? In creating a constant interrelation that I seek to make continually progressive. Interrelation with the materials and . . . my spirituality . . . all the sense that I have.

LONZI: There was talk about creating a kind of pedagogy about the ideational moment of art. Now, this form of pedagogy . . .

CASTELLANI: The term is probably not acceptable in and of itself because it recalls the concept of imposition.

LONZI: Apart from the concept of imposition, it implies that, through a sum of information, you arrive at a result that is the experience of art. Now, I think that this is very dangerous because it's clear, and the University is there demonstrating it, that people can become very erudite about certain facts, know things very deeply but, for their own reasons, for closed personal reasons, in life, then they don't experience the value of that thing, the sense of the thing. A sum of information doesn't give us the experience at all.

CASTELLANI: It's actually because, maybe, the information was poorly delivered, in a biased way . . .

LONZI: I am unable to think that a piece of information can . . . can open the path to more initiation. Because all of the particulars that the subject receives are interesting to the extent in which they are needed to deepen his particular use. I really believe what the Gospel says, that there is a concomitance between a word that is spoken and a person who awaited it. Otherwise, the person doesn't move, you can tell him anything. Now what are we waiting for? We're waiting for criticism to get out of the way, I don't think we're waiting for anything else. That Signor So-and-So steps aside, him and his cultural techniques, and that he finally sees the artist behind there. Because, if someone shuts up, and a void of information is created, the artist would move ahead and probably lots of people with him. I have this precise conviction in my head. They were all the accumulations of exegesis aimed at

specialisation, of advertising, of neurosis, and of appropriation on the part of critics of artists . . .

KOUNELLIS: I spoke with you, I don't know, about the one about children, right? Because I believed that the child had . . . they aren't the kind of situations . . . a much more direct contact, because the critic was conditioned by his experience, culturally conditioned and, so, he says everything from a cultural-historical angle. The child, who didn't have this, truly got close to things. That position of the critic, with all of the experience, was an extremely backwards position, it demonstrated his backwardness as he stood before things . . . while the child, I don't know, touching, seeing . . . what he says, also things that don't make any sense, that is, illogical, but have matured from contact. With the parrot, the child develops a discourse when he says 'That there has green hair.' And, later, the parrot speaks to him, responds to him . . . a strange thing. Many critics came, and so one saw it . . . because behind it there's a metal sheet, with a perch, and above, there was the parrot . . . the child saw it as a juxtaposition of colours, even. It's an absurd thing how thought is tied to certain forms of

reasoning that are really conditioned, because you, like that, are unable to even see that there is a parrot there, that it isn't a juxtaposition of colours, because a parrot is a parrot, right? There it was a bit more structured, the thing, to even take a contrary action, in order to give it a shot, while now I'm for doing one thing, how do you say this? more anthropomorphic, yes, anthropological, even more, more contact. While, before, the brain was used more to do an operation, now, that operation, I try to live inside it, really to spread out, to think a lot about that thing there. Of having . . . of arriving at . . . of using all of the fluidity of gestures. There isn't the idea of collage or of accumulating objects, but of finding gestures that are, like that, quotidian, maybe instrumentalised, because that freedom is instrumentalised from the moment you've made it. Even when you toss a white sheet on two poles, you instrumentalise, after, the thing, because it becomes a sort of object. But, this isn't important, it's a stage that later becomes, actually, instrumentalisation, it doesn't happen as soon as you make it. Yes, it's instrumentalisation because you do it for an end, but, at the moment, in that very moment, it's truly lost, this end, it becomes a continual finding, like this, also the lightness of certain things. At least for the moment, understand? Because it's this: that the limits cannot be imposed, but it's important to find a dimension, the dimension of a man who lives each day and produces these sorts of gestures, right?

LONZI: Given that there was talk about how everyone is an artist, and some are not because of circumstances, the problem, I think, is demonstrating that art is a symbolic matter, that, in a society where everyone is framed, all along, out of life's necessity, everyone is framed in terms of productivity, in terms of social utility, the artist makes a product that is symbolic of another human condition.

ALVIANI: Light is the reason why one can see all things. This is very obvious. In my first research light was crucial, it was the fundamental element of a phenomenon and so, since these things became famous, I fit under the label 'light', right?

It's like this, okay. Effectively I am interested in light, like today I am interested in colour . . . it would be trivial to say 'Colour itself is light as well': when I'm interested in making a colour that is the negation of light, I'd do that, maybe. An object, here it is: in fact, it's really the decomposition of light, I'll show you, it's in your catalogue . . . uh, because, eventually, I've made many objects . . . Like I created the increase of light, this is the disappearance of light, see, through a set of mirror passages: the more mirror passages there are the more the light disappears; here it became black because there are many passages. This light is absolutely white, the plane is white, very strongly illuminated, there are two mirror elements which begin to play with the light and annihilate it and, here, it's fully annihilated. These were objects of pure research, a problem as well as another problem. For me, everything I face, is problematic . . . in this resides, really, my desire to work, my direction: to have problems that I would like to get to know, which materials they suggest for me to investigate. If then these objects are new, people might get interested in them . . . I don't know if they will be read clearly, maybe . . . if others made them, it's a shame I didn't know before because I wouldn't have made them, honestly.

CASTELLANI: Art cannot be considered only symbolic because, otherwise, the one who made the first line on the wall would have even been enough, and so, from that moment forward, we would have had this symbol. While instead, each single artist has a supply of knowledge, contributes with something . . . The fact is: I don't want it to be considered after fifty years, but, if possible, immediately . . . and through what? Through the recovery of the mental process that allowed the artist to arrive at that result that, for the moment, presents itself as the result, end in itself, immutable, and therefore, already partially, how can I put it? partially dead, really. That it isn't effective, because it went beyond that moment of creative virulence . . . I, then, I'm using terms that are very . . . It could be that it isn't even possible to create something like

this . . . to create, to stop this moment in respect to a single work, a single experience, a single individual, but it could be that it's recoverable through the confrontation of various experiences, of multiple singularities. I reconnect with what I wanted to say in regard to a Centre of this kind where . . . where everything is put into question on such a dialectical level that this moment is recovered.

CONSAGRA: The work of art, as it is part of our experience, has a side that let's say only has to do with the artist: the artist knows that people know that he exists and he does a given thing that attends to his experience, okay? That, then, he is understood, not understood, followed or destroyed . . . is a fact that can be . . . up to today, it's secondary. This . . . this still secret sense of art seems to exist in artists: the artist isn't very content, maybe, when his work is read as much as possible, as much as possible still . . . one then feels, then, instrumentalised by what the people want to understand. For me, the artist is still hanging in the balance between wanting to make others understand and, on the other hand, to conceal . . . I still believe there is this confusion in the artist . . .

then, of course, the artist also has . . . Because I see that one, to be an artist, has to have a split in the middle between two things that make the dynamic and I believe it's this: on one side, the secret element, for him only, useless . . . on the one side, this tendency to want others to see how he does it. And, in the middle, there are glimmers of this thing here, that is the relationship, indeed, the chaotic relationship, that comes out between the production and the work of art. I, an open faith that people need to come to understand, this open faith, really, I don't have it. I long for it, it's like a libidinal entice-ment, but, then, I say, 'Oh God,' then, I see darkness, 'But can this really happen? but would I really like it? but is it really interesting?' Look, I say, I have these two fears, also from one point of view the fear of remaining alone, of doing something useless, that no one understands, that I build and, then, I can also destroy. That is to not even make the object, to not even realise the object, that could be like that kind of manifesta-tion, yes, that you build for yourself, in your studio, and then

you burn it. People know it, they are informed that you made something only because it is the gesture of work, the gesture of research, the gesture of activity, but the object is no longer of interest to you, and you destroy it.

PASCALI: I think that these things really serve themselves, they don't serve anything else, I don't think people can keep them in their houses . . . actually, I want them to not keep them in their houses, you know? And yet, sometimes I think about it and I would like to see them, I don't know, in a garden, in a grand hall, in a Museum, but I have this thought because I have a kind of negative infantile thing, namely the fact of being a sculptor, and to be in a garden organised in a certain way where it creates its own space. But I don't know about this, because afterwards, it's not like these sculptures are magical, they're things that stand there and I want them to be seen, that's why I make them, sometimes, very big . . . it seems ridiculous, yes. It's like, I don't know, dressing in yellow: it's a factor that can also seem negative, but who knows? . . . I don't know . . . The essential thing is that they give me strength, they demonstrate that, in the end, I exist, right? Also, in this sort of fiction, I'm able to demonstrate to myself that I exist, precisely because I believe in this fact, understand? But who knows? It could be that even this is another excuse . . . But, like this, I'm sure that doing this work I truly manage, yes, to exist, and to see myself in the mirror.

KOUNELLIS: The other time I met a Canadian painter who had had a show here, at the Gallery of Modern Art. He was an Abstractist who made . . . you know, the ones who make the lines? And so, he said to me that there was an American painter who had made, one of the first, also big, I don't know his name, but he had made only a single line in the painting. Newman, yes. So, he said to me, 'You know,' he says, 'everything else is Cubist, while he had found something more . . . perhaps the best one you can find, really, a painting: there was everything.' And I still don't understand: if there was everything within, what had he been born to

do? It's like that, isn't it? No, because it's no longer possible, to say something like that is impossible. So, there are other things, I don't know: there is life around and the painter is part of this life. There are no longer rules and this guy here had found something that was . . . maybe, was a thing . . . I didn't see it, I don't know his paintings . . . but it could be that I really like them also, but, for me, it means absolutely nothing, right? Like millions of people mean nothing; they mean very little. But, to say this here, to look at a painter only though the painting, is really madness. The painting should be something that you . . . to communicate . . . meaning to love people, the painting is an expression of a person with the means that person expresses himself with, right? So, the painting, only has this value here and, afterwards, it's very provisional, because this person passes by . . . That there shouldn't be values, so, abstract, that there aren't some *Mona Lisas*, even especially, here, right? And there shouldn't have to be, it's an absurd thing, it's a fantasy of our world that continues, like this, with the idea that these *Mona Lisas* where everything is crystal clear. Consequently, this that I do, and that I attempt to do, at least . . . attempts to be the opposite of what my Canadian friend was saying. There are things with a great fluidity that disappear, like someone who paints water, that is nothing, that is extremely fluid, but, in itself, you feel like continuing, continuing. And, to continue does not mean that you always do the same thing, it means that you are freer, you don't have properties. The painting is a property, it's property of something, you make it and you have properties, I don't know, materials, of all kinds. Yet there, you have nothing, you only have an action. Now you say to me 'It could be instrumentalised very well, that element there, to become anew a property and everything.' Okay, you do the impossible not to have it become that sort of action, but if others . . . The ideal should also have been a society that has the same spirit, really, of revolutionising this situation, of the will to find the things that are connected to life, that give it meaning,

right? And if society doesn't do it, it isn't the fault, really, of the painter. Also, as a citizen you do everything because society changes, because it includes this dimension, not only yours, it includes this dimension of life, but if you don't succeed it's another issue, I mean. Today, I don't know, even the novel and all of that are in crisis, but it's in crisis because it represents these very closed values . . . it's everything that goes inward and never expands outward. Also, the book that is an accumulation of words, of sensations, of ideas, it's all up in there, writing it in there, and you construct a whole sequence of events that are really abstract, ideal . . . ideal also when there is a great violence, but it's always in this order, really, isn't it? It should have been much more direct, so that it makes the dimension and the figure of the artist change. Today isn't very nice to say 'Art is over.' No, it's the figure of the artist as he was conceived that's over, and it's been over for a long time, by now we know this. It's useless to still think of the artist as that courtesan figure, as the shoe-shiner he's always been, the one who, yes, was there to satisfy everyone's interests, a really absurd figure . . . I don't say this out of moralism, because there are some things you don't do, but because it isn't possible, it's inconceivable today, that a man should have to live in that anachronistic state, to endure such a wretched existence. Because he, often, did everything to be able to have that thing that, also for him, represents the ideal, a thing that didn't exist . . . Like a slave that sings of freedom, really a strange thing. While, today, there's a need to be aware of this, to face it in every sense, and therefore freedom will be achieved, really, right? And to achieve it means free-being, not free-painter.

PASCALI: Mine isn't a formal research, but, to verify what others have made with another system, to verify this system by juxtaposing it with others. Not because I want to arrive at the plasticity of Brancusi, but only because I am interested in seeing, but not even . . . maybe because I'm interested in filling some place with these things, I don't know if later I am

interested really in also seeing them again or if I like them. I think that I don't like them in the end, do I? Really. It's not like I become attached to these things. It's a process that once it's exhausted no longer interests me. Maybe I am interested in seeing how others see it, a sort of spectacle surrounding people who watch, who inquire, who act, about a thing that, in the end, isn't there: these here, for me, are fake sculptures, and so I am interested also in seeing this kind of farce that the show is. For me these things die . . . once the show is mounted, for me already they're almost over . . . after, they stimulate certain reactions in others, but then it's like I almost see myself as a sculptor. I think I am not a sculptor; I have this impression of myself: it is something that could also be harsh, who knows if it is harsh . . . for me, even that is fun. When I made the cannons I said, 'How beautiful, to put a cannon in this place of sculptors,' to be able to really put it in that world that is so sacred, so fake . . .

FABRO: Have I ever talked to you about that thing called 'object without a name'? No, you were in the United States. When I was busy with the tautologies, at a certain point I had thought of taking a fan, you know the kind for the kitchen, the ones that are a bit pear-shaped, those . . . to put a bandage here, a bandage there and then, wrap it all up in a baby's swaddling bands. It was turned on, and it went fu-fu-fu-fu-fu-fu-fu-fu-fu-fu-f . . . I didn't make it because I wasn't able to find the swaddling bands for a new-born.

LONZI: Oh, I can give them to you, maybe. Yes, I still have some.

FABRO: Now I've found them, now I'll do it. Many, many bandages, one over the other, one over the other. But I was a bit unsure, because I already had that . . . that *Dispositivo per ridurre il peso* ('Apparatus for Reducing Weight'), this was perseverance. Yes, then I didn't find the swaddling bands and . . . and that's it. Anyway, like that, it was the 'First bastard' . . . to name it in order: 'First bastard', 'Second bastard' . . . It's worked canvas, you know, ponies over little trees, all of those things there . . . beautiful, with a ribbon . . . and at the top, where it closes, my name is embroidered. A signature, but embroidered, understand? Then, what am I doing? Ah, I am preparing a series of things . . . different from everything . . . I commissioned . . . uh . . . three pairs of double bed sheets. And they are stretched out on the frame or on two bases . . . the fact is that they should stay upright, I mean, standing . . . therefore they are tall, imagine, 3 metres by 2.5: it has to be an immense thing. I didn't think that the sheet was so big, right . . . One is placed . . . one canvas behind and then a sheet in front, with the fold that, however, that covers it or is left, when I mount it, in a way that it falls down: covers it a bit, hangs down a bit.

Another, instead, has four or five pillowcases, I don't remember, with my name on them. Smaller than normal, in a way that it's all in the length of the sheet. And they are attached with pins. Look, Tita's arrived.

TITA: Oh . . . Prrr! So, we record, and I'll be famous, too, I entered the *Cubo*.

FABRO: Ah, you entered it?

LONZI: Yes, in Foligno he went in it, yes.

FABRO: And then, what do I do? Oh, well . . . Italy, but Italy is quite the comedy, I mean, of the concept.

LONZI: Ah . . . sweetheart tell me.

FABRO: So: the map of Italy, I stick it to a metal sheet that's 5 millimetres thick, that really weights a ton, a map that's a metre and a half tall, like that, I cut out the whole sheet . . . I have it cut out, because I don't know how to execute that kind of work . . . I don't have the patience and then, there's always someone who has more than I do.

LONZI: No, no, in *Cielo* ('Sky') you had enough patience. Luciano, now you confuse me . . .

FABRO: Yes, but there is also the effort . . . I have them cut it out following all of the little gulfs, as exact as possible, and hang it with a chain, something, to the ceiling, hanging it by the foot . . . From right here, you know, by the boot. And screw Sicily and Sardinia on the other side. I started from the *Pendolo geodetico* ('Geodetic Pendulum'), rather serious even in its irony and now, we hang Italy up . . . and Italy too would then be a pendulum, you know? Look, before these, that is only after the casing, it's *En attendant la pluie* . . . it's been a year that I've needed to do it . . .

LONZI: *En attendant la pluie*?

FABRO: *En attendant la pluie* ('Waiting for the Rain') is the title. So: it's my cast, of my figure, standing, like that, with that attitude . . . That is: I am in a little bathing suit, *pendant* an erection . . . and with the hands, like this, like I'm waiting for the rain. It's really difficult to make a cast of the erection that still isn't . . . Ahhh . . . Ahhh . . . You know, with

those little briefs . . . I studied the whole pose, everything . . . For the cast I should find someone to help me, who has enough experience . . . and enough time. Only, it's difficult to find someone who knows how to do it really well and who is willing to work on it . . . because it must be perfect. It shouldn't be those things like . . . Segal, who understand the sense of casting, because, after, it would be, I don't know, meant to be made of bronze, like a real statue. It shouldn't have markings, or any fuss, or . . . Something that risks cracking even before it rains. I thought of this for the 'Landscape Intervention' Triennale. Then, little by little all of those troubles happened at the Triennale . . . I felt . . . what can you say? . . . a prediction of disappointment . . . Really: a symbolism of that year. But who knows when I'll make it . . . Now, I am making things with plants . . . I made one with ferns. I set them to dry, like a four-leaf clover, actually, one should be ready, and . . . they turn out beautifully, they're rather, you know, baroque, like that, crushed, the colour stays enough, a greenish . . . lightish . . . Then, I put a glass in front of them, more or less of the shape that this plant has taken, anyway more or less oval, according to the movements . . . and, behind, a sheet of lead, which holds the plant pressed, it should be held together tightly, well . . . it should be attached . . . and, then, it overflows here and there out of this form and makes a frame. There is still this other thing, what you call 'the cloak'.

LONZI: Yes, let's see this mystery.

FABRO: It's a sheet over me and I am seated on the ground, a bit like Buddha . . . and here is a hole like the one in the alms box. A perfect slot, well cut, through which passes, I don't know, a hundred lire, I wouldn't say five lire, but a hundred lire, at least. Otherwise, I make it in the form of a dollar, yes. I make this cast, like this, then I get out and reinforce the inside. Anyhow, that remains white. I would make it from canvas inside plaster . . . but, you should feel the canvas enough, see the canvas.

LONZI: So, the sense of the cloak remains.

FABRO: Yes, of a cloak . . . in a way that you get a little glimpse of the head. The head is also covered, completely. Like that, when you toss a sheet over your head to play . . . what's it called . . . to play ghost.

TITA: Mamma! Mamma!

FABRO: Think of, in Florence I wanted to present a table from the morgue, you know, to dissect . . .

LONZI: You go slightly towards the macabre . . .

FABRO: Mmm . . . Well, besides that, I didn't tell you about the object that I won't call 'no name' . . . I decided to call them no. 1, no. 2, no. 3, no. according to the period in which each was 'incubated'. They are presented on a pedestal, with a diaper over it that covers . . .

LONZI: I, that sensation, I had that sensation from *Dispositivo per ridurre il peso*: for me, it already had a macabre side, a bit . . .

FABRO: I want to pass the whole . . .

LONZI: All the whole spectrum?

FABRO: The whole spectrum. Now you've seen that I'm getting to the comic . . .

LONZI: But always an uncomfortable comedian, right?

FABRO: Nooo . . . but it's fun because, then . . . like this, the little colours of Italy, all these . . . Yes, there is the weight, right . . . the weight of the metal sheet . . . when it's moved

it probably makes that movement of something very heavy, that doesn't feel the air. Even if it wavers, it isn't like something light and, when it wavers, you feel that it's light.

LONZI: But, these are things in progress or, for now, they're ideas?

FABRO: No no, in progress. I am also making another *Cielo*: I made one of them, I am always thinking of making them . . . The metal sheets are ready and, little by little, when I have some time, when I feel like it, I still make a small piece, another little piece of the sky . . . In *Cielo* there is a lot of this element: that you do something without any tension . . . but, it's something that transforms itself underneath. You prepare this mask, then you attach it to a black background and a little piece of sky comes out, like this, each time, when you detach the mask, you see it clean, white . . . It doesn't have perspective, I'll never manage to do the whole thing . . . At a certain point you arrive at the pole and you have a little piece of round sky, you understand, instead of being . . . What I made is the equator, a little piece of the equator . . . little by little as you go north and south it begins to get like that.

LONZI: Of course, after you also arrive at the poles. As an idea.

FABRO: Yes, as an idea, exactly as an idea.

LONZI: In ten years or so . . .

FABRO: . . . ten or so years, yes.

TITA: Only?

LONZI: You're as sly as a fox!

CASTELLANI: It may also be that what I've said up to now, speaking in a political key, giving them political motivations, it is nothing other, rather, than a real necessity to work, I don't mean aesthetics, but . . . When I speak about rendering the creative moment perceivable, it's because I believe it to be the only . . . only valid moment in the artistic process, in the process of the transmission of something and . . . yes, the only thing one works for.

LONZI: In this discourse I hear, a bit, the disappointment of someone who made a work that wasn't refused but was accepted. A work that was accepted, admired, had success, people bought the work, shows were done, and, besides these rather symbolic gestures, nothing was given to it in exchange. Society absorbed it, but, really, didn't react. So, now you think about how you can bring this society, which has actually accepted you, how you can bring it to truly take interest in your work, making them see how much attention it needs and not only to be accepted as a product. One cannot make use of the recognition that is given in exchange, one cannot do something with it. It seems to me that all artists have this experience. Some spoke to me about the Biennale and I heard voices like this: that the Biennale should be destroyed for the simple reason that it created a false mirage for artists, for no other reason. Because people longed to get into the Biennale, they wanted it so badly and then, once they got there, what did it mean? So, one thinks of the most alive moment of his work, and it isn't that.

CONSAGRA: Why have, we artists, remained, let's say, blocked, in part, with the story of protest against the Biennale? Why we didn't raise our shields, despite the fact that we feel we have the credentials to face the situation in a less conditioned way than any other branch of society? Artists, they do have this feeling, of having been active out of hunger, out of dissatisfaction, making proposals for things that have nothing to do with what there already is. We've been played by another feeling: that this attention towards Biennales, towards artists, this protest that came from a certain so-called global protest, right? as if it were a happening around art, as if it were a kind of tribute, also, to recognise that art is something vital where intolerances, and things to repair, also emerge. We didn't only see it from the point of view of aggressivity towards art, but as if it were recognised as the place where this aggressivity occurred.

CASTELLANI: The protest is not directed at the artists as such: in the end, the accused were always the ones in Power and the structures in which the oppressive side of Power is recognisable. If we politicise the discourse, you can perfectly well consider the Biennale as a form of entertainment created by this very Power to stop certain truths from being spoken. Because what does the artist do? He tends to get into the Biennale and be satisfied with it, or at least the attempt made on the part of Power is this: to look for a structure in which all of the efforts of the artists are directed and are then channelled in that sense there, with this preventing them from dispersing and going in directions that Power cannot control and which could actually be dangerous for Power itself.

LONZI: But, when I arrived in Milan, at the end of this meeting about protesting the Biennale, a motion was brought forth claiming that the artist should first say to the whole of society, 'I am a whore, because I was enslaved by the System.' Once we got to this point, there was no doubt: the whole of culture's bad conscience was trying to make an alibi for itself . . .

CASTELLANI: I said to him, 'But, so, are you paying him for fuck's sake . . . what do you want to do, excuse me? do hara-kiri thirty thousand times?'

CONSAGRA: We were alarmed by this behaviour on the part of these protesters, that's clear . . . But I'm not convinced with the reasoning that Power is satisfied with giving artists a phoney objective, right? I see this: that, for now, the artist uses whatever . . . but, when he's in his studio and produces his own work, there's no Power that conditions him. I'm certain about it: the artist, frankly, does what he wants even if afterwards, he just opens his door, tosses out a work, they give him money, they don't give it to him . . . Whoever is behind the artist's door is the same, and whatever road he travels: if he finds a Rolls-Royce, they put him inside, they have him take a trip around the world . . . then, he returns to his studio and he behaves like Donald Duck, that is he makes something against those guys. Because, for me, by now the artist is the consciousness of dissatisfaction, or else of a satisfaction about something that the artist has invented that must be satisfying. This was to be put into focus because, there, it came out that the artist was exploited by power. Instead, frankly, you wanted to say, 'No, look, the artists who showed at the Biennale, let's say 80 per cent, 70 per cent, 65 per cent, 51 per cent were revolutionary intellectuals, who gave you part of the awareness you have today, to shake you, the artist gave it to you, isn't it true? . . . even if you understood it badly.' It seems to me the protests should have also focused on this . . . naturally, they didn't, and we artists don't really give a damn. It's also a product of ignorance, because there, at the Biennale protest, I was disgusted by this sense of indifference, and I was amazed . . .

TURCATO: The students, they had created this revolution for their own sake, that's fair . . . The global protest, in the end, happens really at the foundation of a generation that goes against previous generations, and since this society, at the moment, the society we have thanks to the so-called Resistance . . . which, however, lacked any continuity . . . it's

like it's petrified, with the same individuals, with the same slogans, with the same prizes . . . naturally they felt the need to not wait eighty years to be able to become something. In fact, the world, and especially in Europe, is still in the hands of very old people. The frenzy, then, that pushed those from generations like my own and also those who are younger, but also who were always shut out of the student movements, to weave their way in, I don't know if it was a matter of good taste, see. No, it wasn't a matter of good taste because . . . people who, then, in the end, had manipulated the whole apparatus in their own personal interests in every sense, therefore they couldn't protest, right. Right. Because there's an opportunistic element . . . and then, opportunistic at all costs, really, not wanting to miss any train. Naturally, in practice, it becomes grotesque. But it's enough to see the impression they made . . . now, to give you an idea . . . the impression that some colleagues made at the Biennale protest. But how? Sooner or later socialist unions came in, then they went out,

now they'd made a whole operation to get a prize, then, however, the youth revolution happened . . . so no, because you need to be at the avant-garde, so you need to be for the youth revolution . . . But, really, let's stop acting like clowns. They turn over the paintings, but they turn them halfway, then the critics come and they turn them over again. I say, what are we doing? . . . But who is with these people here? But they're buffoons, really. Now, they ran after me in Venice because I was supposed to sign a document for Arnaldo Pomodoro. But I don't sign any documents . . . I don't take any responsibility. How? You crossed oceans and seas, to enter into this commission . . . okay, you have the right to come in just the same . . . at a certain moment you resigned and so, they write a document where you justify yourself, in a certain sense, or you find the right . . . But no, I don't sign any documents! But I don't give a damn about you. Uh, c'mon.

CASTELLANI: In a state of ignorance the students are kept partly conscious, because the schools are what they are . . . and I think consciously above all because, otherwise, there would be no reason for the schools not to change, right? currently. There is a culture that wants to tow its own line, that seems to guarantee the most serenity to them, that's clear. Who gets to Power arrives with certain skills and with a certain experience of a given culture and they don't want to move away from that. It's up to those who aren't in Power to impose a different way of seeing, other skills, of creating another situation. Now, it is clear that school, until it truly enters into crisis in the possibility, yes, that whoever isn't in Power intervenes, if this doesn't happen, school will always be designed for a classical skill sets, academic. Indeed, revolutionary appeals are addressed at searching for a management of Power that is not the current one and does not consider the delegation of Power by those who don't have it, that is this enormous mystification that is so-called universal democracy-suffrage. Because it is perfectly well known that people who are delegated to represent certain categories, arrive at this mandate

once they're so distant, by then, from the experiences at the base, of those they are called to represent . . . because, to get to Power, they have to spend a lifetime making various alliances, that, once they get there, they're not by any means representative, they are too far from the real problems.

CONSAGRA: By now they've reached the same solid state as Power itself and they get immediately confused. On the other hand, the mechanism is still this. You, even with a communist who's got to the top of the party, you can't talk to him any more.

CASTELLANI: We have a Head of State who fought in Spain, right? leader of the International Brigades: he doesn't open his mouth if he's not talking about the fatherland. A deputy prime minister whose politics we see as they are, despite his years as a revolutionary, therefore . . . It's really the System that carries this continual frustration that tends to maintain the status quo. It's a well-devised trick.

LONZI: At these Biennale protests and at the Triennale people talked about the artist and didn't know who he was. There were those who said, 'We don't use this word any more because it's an antiquated word, the artist-creator . . . creation doesn't exist because the world wasn't created by God.' People who had no experience of the artist or of what art is, nonetheless they talked about artists and art. Fabro and I presented a text, I'll read it now, that was signed then only by Paolini and one other. Really nothing moved, they looked at us like we'd come from the moon. Here's the text: 'The individuation of the artist does not come automatically seeing that, while a worker or a student are defined through their belonging to a labour category, being an artist does not necessarily hold together those who work with painting or with sculpture, it does not correspond with joining a union. This is why it is necessary to carry out this work of clarification. The artist has concerns, which are historically founded, that to pass from an interpretation of bourgeois culture to an interpretation of Marxist culture is in any case to move to

a terrain that is unsuitable for his liberation, since he does not feel he can disavow himself in a role in which he does not recognise himself and he cannot interrupt an activity in which he believes a connection with every amenable individual is possible and vital. For the artist there is no alternative identification with this society or with another hypothetical society, because it is his ability to not identify himself with the social structure. The artist is willing to want a breakdown of institutional systems because in the actual state of culture, his identity is inappropriate for society's provisions. In its process of mediation, culture recognised that the artist did not set himself up as slave of the System, but it considered this fact as unimportant, non-dangerous, and neutralisable. It's obvious that now, it is culture that must justify "its own" enslavement to the System. Culture, being unable to abstain from taking into consideration the newest and most pronounced personalities of the modern movement – and regarding this choice we can reassert our adhesion – has nevertheless behaved in a way that makes it inoperative on the conscience of the individual. The artist, therefore, has no reason to disavow himself, neither before himself nor before the proletariat, since it is his premise to disavow culture in as far as it is a channel of estrangement from free movement, self-regulation, from which works of art are born. Culture tends to create a falsified image of the artist, of his personality, and of artistic phenomenology: it is there that this commodifying distortion emerged, which was already clear to Marcel Duchamp fifty years ago. In the pretence of translating the implications of a difficult system of signs to society, culture brought forth a mystification. The object of the mystification was the artist, who saw his work instrumentalised, made futile to the extent that the motivations of culture have been futile.'

CONSAGRA: One becomes an artist when every experience had is taken as a personal fact, when any information received is always ascertained through the foundation of

one's personality, through the foundation of one's freedom: one creates a great awareness of oneself. This does not mean that the artist is self-centred, ego has nothing to do with this, because the artist, in this case, is also a man who suffers a great deal, one who is having all experiences possible . . . commensurate, naturally, to his natural range: an artist is capable of having some experiences, another artist is capable of other experiences, like, naturally, any man has some qualities and doesn't have them all. Now, an artist becomes an artist little by little, step by step, developing this awareness of making every experience a personal factor, an experience within oneself. What does this lead to? It leads to the fact that each of us, each artist, believes he's something like this recorder here, an individual who collects experiences . . . And these experiences help him to have an accessible record of the things that have happened around him. In this way, the artist is continually present with the life of man: he relates, more than any other individual, he empathises with the person, with what he does. And this, there is no other profession that . . . The political man, who can seem like the individual with the strongest identification between his vocation as a politician and his personal self, he isn't in respect to how this is for the artist. What comes out of it? It comes out that the artist should be the least disassociated individual of all. Now, in this non-dissociation, there is a great susceptibility: the artist, in this case, is the most vulnerable man possible because, if he is reprimanded, from the point of view of a human, it's like he is reprimanded from a professional point of view, from the point of view of his work. The artist becomes the weakest person because, in any way he's attacked, in any way he's criticised, everything's involved. This is, let's say, very strenuous, in a certain sense, but that's how it is. While any individual . . . someone drives a car, an anonymous person, who makes a mistake, the other driver calls him 'idiot', anyone has the ability to dissociate from this episode and not get offended. The artist, on the other hand,

is offended, because he, in this case, is immersed in his personality, because the artist is even absorbed with feeling like an artist when he's driving a car. Everything is involved, also when he makes an anonymous gesture. It takes so much training . . . see why we see some artists with their destroyed lives, because it's difficult to deal with. Little by little as a man matures, if this maturity is coherent with the development of his work, everything goes well, but if one of the two is detached, then there's drama. If the man, as an individual, starts to understand that his work productivity doesn't follow his maturity, the man begins to be afraid to do this job, to be afraid and to feel himself, really, in a sea of discomfort, right? Or else, it's the contrary: when an individual has been taken up as an emblem, the symbol of the development of a given point of art and, therefore, they give him a lot of credit as an artist, he finds himself to be an individual detached from the earth, when his maturity still isn't perfectly tied to the importance from the point of view of the art. Therefore, this individual finds himself very embarrassed, and makes moves that can be criticised, moves that make him suffer. An artist, therefore, what is he? He's like a cell that has freely changed

direction, has grown, creating this complex nucleus between man in society and his work, his observations and his product . . . this is important . . . and his product. Now, in this case, what work has the man done? He tried to be a free man, because it's clear that the human motivation is this: to try to be free. For this reason, an artist is free like man, he is free in his profession and this is the centre of the whole thing. When an artist finds that he's conditioned, he loses a piece of his freedom . . . either a part of the man or a part having to do with his creation, his activity . . . that's where drama comes from. Therefore, if one cedes to this external conditioning, he loses more of the central nucleus, which is important, since it tied together the two things: it diminishes in quality. Let's take, for example, the architect: the architect, probably, who's he? He's the man who's born already conditioned by technical factors, more than by those of freedom from his human experience. So, what happens? The architect does not become an artist, the architect is led astray, is inserted only into the technical track, of the technical aspect with regards to life. He is no longer that individual who put the two things together: the side of the absorption of experiences, as facts that affect him directly, and the side of experiences that are an outside technical element . . . the same for all men who work in that profession which keeps the individual dissociated. The lawyer is at his desk in the courthouse, then he is an individual who involves himself with things, politics, maybe he involves himself in art, music connoisseur, goes fishing, etc. He doesn't put the two aspects together, he'd never put them together . . . in fact, he wants to completely forget these two aspects. The architect is one who, maybe, will be tormented by this, not like the lawyer, isn't it true? He really isn't like the lawyer . . . but, he's one who has continually lost responsibility. The artist is also, let's say, used to being trained in escaping from things that can hold him prisoner and, therefore, is willing to compromise. It's important, this, in respect to the architect, who never wants to give

up anything. The position of the architect, in this, is the opposite of the artist's: the architect believes, like that executioner in San Francisco who said, 'I killed 150 people, I'm not ashamed to be an executioner, I did it because I am humane and a very charitable person and if I didn't turn on the gas for those condemned to death, someone else would have done it, who, perhaps, wouldn't be as humane as I am.' Now the architect thinks in the same way, that the thing in his hands is saved as much as possible, has a chance of being saved. And, therefore, he accepts all the compromises. This is a mechanism that has its righteous side in a certain sense, unquestionably, because society puts him in a determined condition, and he accepts a determined function. And that's the function. On the other hand, the artist doesn't. The artist will never accept the executioner's reasoning, nor that of the architect. The artist will say 'I renounce, I don't care, I give up.' That's it. Therefore, it's a position, let's say, of absolute freedom and, therefore, society doesn't take up this position. In any case, however, if society does take this up, he feels responsible. That's why the crybabies don't interest me or the ones who think the artist has been overwhelmed, they don't interest me . . . The artist, being a free man, uses the System for what he needs, he takes advantage of certain sides of the System in order to do what he wants, and in this lies his ability to modify things: using one of them and eluding others. I think that all artists in general . . . when an artist is alive . . . Let's take a young one: what's he do? He sets about . . . from what he knows, he intuits that one side still needs to be clarified or that he can give his part to add clarification on a certain theme, and this theme brings him forward. While, it could be, that an artist has reached a certain equilibrium, between a way of living and a way of working, right? the sense of research is no longer interesting to him or it interests him less . . . And so, what does he look for? If this man has already lived in a way that very few things are left for him to experiment with, to understand, as a man, he tries

to make his work, really to make a product that concerns himself, that still concerns what he has foreseen, what he has lived. If this satisfies him, the artist can have the tenderness to carry forward the thing that he has made; this is not a negative element. For me, an artist can arrive at this limit here when it happens that society no longer traumatises him, in a certain sense.

SCARPITTA: The first move was to do it on the fourth floor, in my studio on Park Avenue South, to make an automobile in my studio. I wanted to find the pure and simple motive again and render it much more, I'd say, as photographically clear as was possible, this element that's so consistent in my activity: a racing car. Naturally, on the fourth floor, in a studio that's 10 × 7 metres, where the door, yes and no, three quarters of a metre, you can't make an automobile: it's a bit like old sailors who put the ship in a bottle . . . And it was a bit like that, it was. I began to bring pieces I myself had made into an environment . . . because, the first car, it didn't exist as a

mechanical fact. It only existed as a copy, as a facsimile, it was an optical illusion. That car there, Rajo Jack, is completely fake, haha! . . . But it's there. And its appearance is exact, it is. It's an exact model of a racing car I saw when I was thirteen or fourteen years old. I took two pieces of wood, I carved them, they became the chassis, I made a cast of a motor and that was a motor, for me . . . I took things that happened to be to hand, that I knew, that corresponded to the exact proportions and then, there, I constructed an optical automobile. When I saw it . . . it was so real, it fit so well . . . Some racers even came inside to see it, they didn't know that it was fake. So, I said, 'But it's a shame, it should really be an actual car.' And I went around lots of North-Eastern States looking for basic pieces: chassis, suspensions, wheels . . . things that, naturally, can't be constructed, there's an industry behind it. I took this half-sentimental collage, because it referenced the car that I loved when I was a boy and, I'd say, technical means, because now it was about rebuilding, restructuring, representing a racing car from the era when I was so fascinated with these things here. With all doubts, nostalgias, dance cards, what- ever you like, I doesn't matter to me, it's enough for it to still seem hot, not under a little glass dome, but still aggressive enough to be pushed onto the street and that people would say 'Look at that! it's alive, that car is alive.' I mean in short, I wanted to bring what was only an optical illusion into its real- ity . . . however, painting this car, really firing it up, really with a bodywork job, to intuit how much a car was then, because, truly, it still seemed, not only in working order, but still com- petitive. And I more or less managed because they often ask me, 'But how fast does it go, what speed do these cars here get to?' And they are very disappointed when I respond that they reach a modest speed. So, I don't say anything any more, when they ask me how fast they go: I say 'They're so fast, they are.' Naturally, I don't say how fast . . . but they are very fast because to the eye they are very fast, and still mirror, I'd say, substantially, the car of today, even if they are cars from

another era. It's always a certain suit tailored to fit a certain man, who slips in there like a hand entering a glove . . . they're like clothes tailored to the size of a specific man. The car I'm working on now is for a certain American man, about 1 metre 85 centimetres tall where, to look at him when he'll be in the car, they need to be able to see his back, to see his head they need to be able to see his hands at a certain height. When he touches the brake, his elbow needs to rise to a specific height. I want a man, when I made a car, I want a certain man that's inside. So that, when they're empty and someone looks inside, he imagines the man a bit, the kind of man. That car there is all iron, a rare thing because many are aluminium – there are six here now, many are in aluminium, many are in fibreglass – but that car is all iron, it is. So, it's necessary to have a certain type of redneck, 1 metre 85 tall, that has a sense of these things: of dirt tracks, of the dust clouds . . . And they are still the Americans that go around today, it isn't true that the Neanderthal has vanished, and so, for me, the car has this sense, yes, of a lid, of a jacket, a straitjacket, if you will, that holds a certain man inside.

ACCARDI: This winter a friend, an avant-garde film director, one evening he said to me, 'There's not much to do, for you, as an artist, you're no longer interesting for the society of the future, you're way more interesting as a professor, I mean, you should be a professor.' He says, 'I was in Berlin, instead of being a director there, I went to take part in these things.' So, I thought about this a lot, because since they even accused me and they said to me 'Well, but you . . .' and, instead, I believed, I felt like I had always behaved like the one that . . . Then, here, it turns out everyone has always felt an antagonistic relationship with society, now I don't even feel like saying it . . . Haha! . . . One evening, there was a young university student at the Da Cesaretto restaurant and I said 'Well, I'm protesting, I am so . . .' He looked at me with misty eyes, that said 'But her, where'd she come from?' Because they say 'This is Carla Accardi.' But I earn my living as a schoolteacher! . . . No,

that isn't true, that I always only earn my living as a school-teacher because, every so often, I have a work, but I have to work hard on it . . . So, I say 'I, as a middle-schoolteacher, am treated terribly by society, therefore . . .' They tell me 'You're known.' But I am a continual problem, for me tomorrow is such . . . However, on the other hand, one guy came and told me . . . I'm interrupting too much here, right . . . and he told me that, as an artist who had acted within a time period and in the bosom of a society, I also had my share of integration, understand? So, I set about studying this thing. In fact, once I said to a young man, I said it quite arrogantly, I don't know if it's right or wrong, 'You know, I, really, I always did things that the next morning I wouldn't have to regret, I have always considered this to be a non-false, non-corrupt gesture.' This young man . . . who, however, I know what type of person he is, so, really, he's an example, one makes this mistake, taking everyone you meet as an example, right? This guy had said, 'Ah, I don't even ask myself this question, what does this mean, what is it? purity?' So, I was hurt by this fact . . . On the other hand, instead, I insist on this point, now, because if I see Italian society, it seems to me that the purity of gestures is something we haven't begun to think about. But it's not like we have to do this only in a group of ten, everyone happy that one of the other nine doesn't make these gestures. No, I, in this period, I have the feeling of imposing it on others, insisting upon it. In fact, I told you, this year I'm changing schools, regrettably, because in the other one, no matter how much I tried, I had a lot of confusion, days when I left the classroom and I said 'Kids, I am going on strike for an hour because I don't know how to resolve this problem of staying with you, here.' Then, I tried in many ways, remember? I want to go there this year, without nervousness, each morning studying what I have to do that morning, but really studying it starting the evening beforehand, reading books, looking a bit, understand? I have some doubts, some uncertainties, however, now, something, from the experience, I've

understood. For example, good work is work that makes them speak freely, to express their own objections in which I, certainly, am involved, because I understood what was going on, and, then, to reason with them and argue until the problem is exhausted, to see why I argue with them, why they hurt me, to tell them even 'Kids, this offended me, let's try and understand why it offended me.' Last year I had very particular little kids from Primavalle, very troubled, in fact, I am sorry to go away . . . anyhow, what happened in this school was dramatic and shameful, where even I was responsible, because I wanted there to be differentiated classes and review classes, while the Principal didn't put them in place, because he didn't want them. I had some arguments, but then it's not like I did what I promised, to go to the Ministry and make a report, or else talk with a journalist: I didn't do it. Instead, from today forward, I want to see if I can do it. Because what is it to go to the Ministry? If I'm not afraid I can go, right? Isn't that right? And then, to speak with a journalist friend, they even asked me 'If you want to say something, say it,' isn't it true? A senator said to me 'If you want to make something known, I'll tell it to the Senate,' and even a member of the Parliament and then TV journalists. Even us, aristocrats, who see all of the messed-up things in Italy and we don't move: for me it's a gross negligence, because there are some people, poor things . . . I met a Christian Democratic journalist who works in television: he was ready to listen to what me and Elvira said, 'Parliamentary debates should be heard on television.' And he said 'Ah, it's interesting . . . well, it's something to think about.' So, if we could get close to these people and say 'Do this . . . do that . . . ,' something would really happen. Abroad they always laugh at Italy, because of the Authorities, right? the Consulates are filled with disgraceful people . . . A friend of mine was there, in Casablanca, and she realised this. If she weren't afraid for herself she'd go and say, let's say . . . Zagari's no longer there, undersecretary, but first there were the socialists, no less . . . 'But what stupid people you send there, but what is this shame

about socialists, then, they have fascists abroad to represent them: so sabotage them, if falsity is of any use to you, at least use it to sabotage whatever's corrupt.' Like you said about the Italian Pavilion at the international fair in San Antonio, Texas, about the people . . . or else in the schools . . . If one isn't afraid . . . And then, you have to, sort of, overcome laziness, because I believe that, afterwards, one feels such satisfaction that it's an extraordinary thing, don't you think?

TURCATO: There is one fact: that the current masses are composed of the petite bourgeoisie. The petite bourgeoisie, in the end, is not a class: specific classes come from a specific economic situation, better than the one before them. Therefore, it isn't that they have a special or particular taste about how they should express themselves: it is still something shapeless, that however, slowly, slowly, could take on its own characteristics, and, therefore, give a certain feeling to all general expression in the world. The petite bourgeoisie has always been a disaster, in general, but on the other hand, given that the current world aspiration is to become a member of the petite bourgeoisie, including also, I don't know, the populations of the Third World. We are witnessing this phenomenon and, therefore, we must, naturally, pay attention to it. I think that even the Chinese world . . . I was in China and, after all, their aspiration is to be like us, through a kind of communism, let's say, Trotskyite. But they still don't have an idea about art because, in the schools and academies, the Chinese make monuments to miners, to their mothers . . . This is something obvious. However, they preserve, in the cohesion of the Chinese people, a sense of good taste. Now, they were forced to go towards a realism, in the end . . . more than anything else they'd be more inclined towards the expression of abstract aptitudes. But the government, undoubtedly, doesn't want this. It could be that Mao's decalogues are the beginning of a sort of abstraction of society. It's important that they don't become a byzantinism, though: because there's also this danger.

CASTELLANI: However you handle politics you've got it on top of you. So, rather than have others do it for you, it seems preferable that you would do your own politics . . . then, it's cultural politics in the case of artists . . . Speaking of designers, architects and such, in the precise case, contingent, in this moment, it seems to me that their politics must be a politics that breaks with current structures, that doesn't allow them to carry out what they've imagined . . .

LONZI: It doesn't allow them to imagine . . .

CASTELLANI: . . . for the life of man, to make it less chaotic and less alienating. The designer doesn't exist: in the end, the industrialists are the designers, this is one of Mari's jokes, but it isn't a joke, it's a truth. What is that association of designers in Milan called? There are so many, I don't know, thirty, fifty. Besides, they're part of this association where there are also industrialists. Yes, because it isn't unionised, but it's an association like that. To think, the only true designers are the industrialists, because they're the ones who decide everything: to make a certain product rather than another. Instead, it should be the task of the designers and, in fact, they have this task, but it's carried out by the industrialists, naturally according to their economic system, asking those fools to design them something like this rather than that, because like that it would sell more.

PASCALI: Listen, what strikes me more than anything, for me, are the sculptures by Negroes, really: their objects have such a legibility, such a strength that they capture me, they possess me. The books I buy, now, about art, are these here. To me every object, also craft work, anything they do, that's authentic, drives me wild much more than a modern designer, I swear. There's a terrifying abyss between one of their spoons carved with a hatchet and in that way, with that decoration, and one of ours. I find industrial things are too elegant. See, design is always slave to taste: in terms of consumption, the objects they make aren't invented, they are constructed according to taste, middlebrow or highbrow, but

still according to taste. I am much more convinced by a leaf, woven together to make a drinking glass, than a crystal glass with a certain design. Way more. From consumer civilisation a product is born . . . on the other hand, the Negroes, when they make an object, they create a civilisation, they create it in that moment, there is all of the intensity of man who creates machinery, science, creates everything. The different between specialisation in a work of taste and that which is human in the invention of the world, the strength that creates, really creates this little black god made in a certain way but, in that moment, creates a religion, understand? There may be the greatest sculptors from the fifteenth, sixteenth, seventeenth centuries, however you see it, who made Christs . . . for me, in respect to that intensity, there is no comparison. But, maybe, I'm exaggerating. In every way, I prefer the Negroes. The primitive man, the man who walks around naked and who notices the sun rising to the right of that mountain and setting to the left of that tree . . . the man, like this, who's walking

through the forest discovers that the sun can also rise behind another mountain, for that man there, who needs to drink, and makes a form with his hands, just in that very moment, while he does this with his hands, there is all of the energy you could want to create a civilisation yourself, create your own system: it isn't the object, it's really the intensity he puts into making these things. Here, at the most, one can think of a glass that must persuade one to drink. I don't want to speak ill of these facts . . . in fact, I've always liked the most polished things, but what I was talking about is the actual strength to create a civilisation. In the end, it's the problem with the Italians, with Europeans, understand, and you need the intensity of someone who has nothing to truly to be able to create something.

LONZI: I realised, in the analysis of your paintings, that the markings that occur in them correspond to signs that populate an infantile writing from the first stage of scribbling to the emergence of the representative experience of reality. That is, that the system of signs that you use corresponds perfectly to the pre-figurative sign system of childhood, to that sign system that had come to be considered chaotic manifestation pure and simple. Until some psychologists, quite recently, found a perfectly coherent and structured way to grasp a particular kind of experience of the world. Prior to Euclidean spatial relations and perspectives, there were elementary, so-called topological spatial relations: of closeness, separation, opening, closing, intertwining, succeeding, outside or inside, continuity, etc. Researchers in child psychology have, with this, demonstrated that this science, topology, just a century old, is, in fact, the basis for Euclidean operations and projections. Since your paintings constantly reflect these topological relations, one can't help but ask if you are aware of this or not. This question comes to me spontaneously because some contemporary painters have confronted, explicitly or not, the problem of topology. This doesn't exclude that often their spatial methods reflect deviations from classical norms

of space without, however, getting to a system of interventions of topological spatial relations. Would you feel a confirmation of the value of your work due to fact that in your paintings the signs are connected according to relationships whose importance is emphasised by science and psychology?

TWOMBLY: (silence)

NIGRO: In music, rhythm corresponds with time because it makes you notice the passage of time through pauses; in painting, on the other hand, the pauses aren't perceived one after another, you take them in all at once, therefore time nullifies itself, you have the feeling of space. In my most recent works you have the feeling of proper time because these rhythms are all unequal and tied to one another in a geometrically progressive way. So, the gaze flows because, little by little as it passes from one point to another, the journey is different, never uniform. Also, for the iterations from '48–'49 and above all from '50, we can speak of time and, later, I titled some of those paintings 'Drama in Space and Time' when I began to unravel my methods of serial programming, in '55. The serial programming responded to a rigid feeling about the sequence of events, a perception that I myself define as fatalistic. In fact, when I have a line and when I have all of the sequential and simultaneous lines and I trace all of those iterative and progressive little squares, evidently once I begin with one, I know where I'll end up, and this is a fatalistic event, isn't it? At a certain moment, I feel this need to rebel and to rebel violently. This is my period of informal influence that's from '56 to '59, but, probably, I didn't much need this influence. After this period, at first, I picked up the experiences from '54, *Spazio totale* ('Total Space'), then I abandoned it for making the collages as repetitions, as vibratile kinetic parts. Now, the experience of the collages, for me, they're more valid as my continuous research, in the sense that these patterns that repeat – although very rigid in their cut, in fact, I make them as collages and not with the brush because I need clear divisions, therefore there is a fatalist rigidity – they have

in themselves that vibratory material that truly comes out of that fatalistic sense and creates many little surprises . . . That aren't perceived one by one, the painting is seen all at once, however, in the painting, there are very subtle vibrations and these vibrations are a surprise. At a certain moment, I have to stop this period because, technically, I can't develop it and also because new problems come to me that bring me to *Tempo totale* ('Total Time'). I can't deal any more with this thing about space that continues, continues: I need time. This need for time emerges in the same collages. Because the surprise vibrations determine a frame of mind that for me isn't expressionistic, but simply about psychological vision. So, this psychological element distracts me definitively from architectonic prompts that come from my preceding itera-tions of *Spazio totale*. What comes to me, instead, is the need to identify this psychological question: so, slowly, I delimit the perspective projections which are ideally inscribed within some rhombuses. Naturally, since they aren't geometrical

figures uniformly painted, and so they'd be seen all together and they would have a Concretist or at the most Suprematist function, but perspective visions delimited within ideal rhombuses and they themselves are formed by lots of rhombuses which are all different and all in strictly geometrical relation to each other, this continual relation instinctively implicates the brain in spinning with the thought from one rhombus to another. So, the gaze stays immersed in this delimited series of rhombuses: therefore, I no longer have the feeling of space, absolutely, but it is time that develops me.

CASTELLANI: In Foligno, the canvas pulled to the corners of my space was a revival of the old corner pieces. It had the same function, now more sensitive there, to make it as little perceptible as possible . . . to create a space as little physical as possible, the most dematerialised. In a certain sense, yes, with those corners there I was able to do it because they were groping towards it: they didn't realise the distances and the dimensions. What interested me was the disappearance of the dimension, making one forget the physical dimension. No, because everyone is complaining about the fact that you can't photograph them, while this is really what I wanted, that proves it to me. My colours are colours that I always experimented with in function with this space of mine, in the formation of the surfaces. I also made some paintings with metallic colours, with anilines that have reflections that are a bit metallic, and then I made them with aluminium paints. This is very interesting to me because it dematerialises the light, the reflections even further, which are dazzles of colour. They reconnect to what I would have liked to do with the concave and convex metal sheets: I wanted a certain curve, at a certain distance, to create a void of image, the image is destroyed. There was, however, always the danger of a reflected image because, if you stand next to it, you're reflected upside down or straight. It was too conditioned to the point of view of the user, you could also interpret the thing like concave funhouse mirrors. It was only at a certain

distance that this void was created, that void of the image, of very unreal light. If you stand at the centre of the curvature of the concave mirrors you no longer see the image, but a light that, naturally, is conditioned by the ambient light. Anyway, you never see it . . . meaning, the object, you never see the object.

ALVIANI: In the object in Foligno there is this research, like, about setting the space, of taking the possibility of dimension away from it, in other words a space, even small, to make it become huge or to make it become very . . . Only optically, not for pneumatic virtues or things of that nature, really, but for optical virtues. Now, see, this here seems like an enormous congestion, right? It seems that there are dozens of things . . . there are only three cylinders, which obviously reflect each other . . . you don't know where it ends . . . however, there are only three. This object creates an indeterminate space, it loses dimension, it seeks to make you lose sense of dimension, for this reason it was all white . . . the floor, the

ceiling, the walls . . . the non-colour. Inserting into specular-
ity, repetition still towards the infinity of the non-colour, that
can concretise itself and also vanish, it gives you this sense of
loss of dimension. It was a research: in this sense I want them
as elements of research, understand? See, this interests me a
great deal because, in the end, it's never that it comes from
nothing, like 'Ah!', but always from knowledge, little by little,
for this reason I don't want ever to use the expression I cre-
ate, but I elaborate, I develop things. Things exist: they show
their properties, I give them a bit of mine until they become
something else. That's where the idea is, then what I'm really
passionate about is structure, the functioning: the joint,
the . . . the stop, I don't know, the attachment, you understand,
really the bone of the thing, the organicness, what it is, what
makes it turn, what makes it be. Yes, I really love to research.
This in Foligno they made quickly, they made it themselves.
Obviously, that isn't an object I made, that's clear. And when
I produce this object there, then it will have all of the trap-
pings that I think all of the objects I've made up to this point
have. Exactly because, also in this sense, the object shouldn't
be disturbed by anything. Think of this image: you have a
wall that's completely white, all white, you can say that it's
clean, that's one thing. You put a black splotch on it, the wall
stays the same, all white, but it becomes dirty, which is some-
thing else entirely, you know, it's another thing completely!
For me. And obviously: there is this here that's a scratch, it
becomes the object + scratch: if the scratch wasn't supposed
to be in its economy, it's all a mistake. That's all in there. It's
to bring the finished object . . . I don't know about finished,
meaning a research that's concluded, about knowledge, like
I was saying before, about instruments, about contemporary
means, that we have available to us, it's obvious. But it cannot
not be disturbed, there cannot not be anything else, because,
instinctively, I have to think that the disturbance is significant,
therefore, if it is significant, then I am immediately forced to
read it . . . here, it's clear. And, it becomes an important factor,

more or less, however, for me it's irritating, upsetting, right? The disturbance, therefore, should be desired . . .

ACCARDI: They say: 'Power is interesting, but because you aren't interested in Power and insist upon it: but why so modest?' This isn't modesty, really, I would like to make it understood that I am mortified when this modesty is attributed to me . . . I hear it repeated 'You're modest, you're simple, you're not . . .' But it's not true, I'm not, I'm not modest, how is it they don't understand! Anyway, I have to say that I have known Power, the woman knows Power, Carla, carries it on her shoulders, she knows it, and it isn't important if I was once a bossy girl, who had a strong personality. Well, no wonder, otherwise, now I wouldn't have done anything, not even in my work; how can one think? . . . However, this doesn't mean that I shouldn't complain . . . Even if my husband comes and says 'But look, that girl, she has the courage to say that she suffered under the power of men.' Of course, I suffered it: as education, a system of the society they established, with the strength . . . it could

be a strength that dates back a thousand years, I don't care . . .
with domestication, with subjugation, with stupefaction, ulti-
mately. I am the daughter of my mother, who was a woman
who was subjugated by men in all of her being, drenched in
subjugation, because she was raised by her father, when she
lost her mother . . . Her mother, meanwhile, died, first of all,
literally killed by men. I don't want to clarify, now, how it
was, but I am so convinced of it, of that fact that she went
crazy two years after the wedding . . . You tell me, a gorgeous
woman destroyed by a husband who, not being able to win
her over, what do I know . . . but I imagine unbearable things
behind it all, because he was small like this, understand? You
know, if you don't have a bit of madness in your head you
can't resist . . . if she, on the other hand, had or created lovers
or did . . . Then, my mother came, a woman who had studied
as a girl, who was lacking nothing, and instead, what did she
do? She never decided her actions for herself, never her own
powers . . . her powers would have been these: that she was
heir, on her mother's side, to property . . . she never enjoyed
any act of kindness. Each morning she had to ask my father
for a thousand lire, and the moment of the thousand lire was
like this: she wandered around the living room, this beauti-
ful living room . . . and she had, maybe, a nightgown on, all
torn because my father didn't give her money . . . A thousand
lire each morning, she went pale, you know, I saw her, each
morning she had this heartache . . . Then she went to pawn
some diamonds and my father accused her all her life, as if
she had a lover, he always held it against her. I always liked my
father . . . but I liked him because, with me, he didn't exercise
the unpleasant side of power because otherwise . . . I'd say so
long, understand? With me, he had that gracefulness that a
man has with a young woman, cute, who's his daughter: but for
my mother he didn't have much, understand? He had loved
her a lot, her not so much, but he, then, you see that this pro-
cess transformed him . . . They bickered with my grandfather,
you know, for various reasons, about money, they grabbed . . .

what do I know what they grabbed? . . . things . . . they broke
things . . . and we prayed kneeling at our bedside . . . Did I ever
tell you this? Then, they say, 'My father is a sweet man, within
the bosom of the family my mother decided everything her-
self about what the children did . . .' This thing is really . . .
They say 'In the South the woman decides': but what does
she decide? She decided within those four walls, so that she
dominated this man because she then took care of this side
of . . . yes, it was a kind of stupid thing that she contented
herself with, it's not like one day she made a scene and said
'Go to Hell . . .' She contented herself with imposing certain
restrictions on her husband, understand? So, I say 'Power' for
this, it's not that I'm modest, it's that I, in order to dominate, I
have to study a type of Power, like this Negro writer said that,
in fact, enslaved everything for all the millennia. But he was
able to think this because he is a man, even if he is a Negro. I
don't even think this. I, in order to dominate, I would think of
lighting a candle with a little light that would last, for exam-
ple, for a thousand years, what can I tell you. I don't know,
to study something different, maybe, from this that's mys-
tical . . . Otherwise nothing, not study anything and that's it.

NIGRO: The observation I want to make is a human
observation. Naturally it's also tied to a condition of criticism,
not a fact of absolute humanity in and of itself. Let's take the

action of the critic: the critic, when he makes a choice for a selection for a group show, or when he chooses someone for a prize, or when he writes criticism of exhibitions, sometimes yes sometimes no, or else when he writes scholarly books and talks about some artists, others he doesn't mention, or when he speaks well of someone and speaks badly of someone else, it's all human action that has precise consequences. Also in the best-case scenario, in which the critic claims to be acting in good faith and is effectively in good faith, he does an action whose repercussions are immediately felt right away in the economic order because, if we consider this in mathematical terms, the sum of all of these actions of all the critics, every day, for years and years, as a result we have a ranking of all the artists. I don't know, on the one hand there are those who earn millions, billions, and on the other those who die of starvation, or change profession or kill themselves, or have wrecked families etc. etc. This is a consequence of criticism. They say, 'You can't do without it.' But, at a certain point, the critic has to think 'But why decide the economic fate, the vital fate, even of the development of someone's research?' Because, evidently, the influence of the critic, if it is a beneficial influence, can even reflect positively on the research of an artist, or else it can reflect negatively, in as much as the artist, tied to a market, can't make excessive variations in his experience. You often see the repetition of certain experiences: the artist, instead of making one work, makes ten, a hundred, a thousand for a reason that's almost exclusively economic. What's the result, then? The result is the observation that both the critic, or the dealer, or the artist, they're tightly tied to a type of society. Therefore, that which is a contestation and a fundamental element is that in order to conduct truly free research in art, in order to have ample freedom for research, it would be necessary to establish a society in which Power is eliminated. So, research would have a different aspect and the art dealer would no longer exist either, because consumption would no longer be a speculative consumption, but it would

be a consumption that's integrated in society, for which society itself consumes, daily, the fruits of this research. Isn't it true? I would like to briefly examine, since I happened to be there, the principle of these acts of protest by artists. I remember that a French critic wrote in '48 . . . I remember, yes: Impressionism is not simply an aesthetic phenomenon, like that, pure and simple, Impressionism is a true and real revolution of the artist, who frees himself from the subjugation of a certain determined society. The artist stops making portraits of the general, stops making propaganda for a dominant class, and melts into the bourgeoisie, the humblest bourgeoisie not the powerful one, but the democratic one, and carves life into canvas. I don't know, let's take a Renoir who goes around in bars even or other artists who go to the riverbank, to the countryside . . . And Impressionism is, really, this element of rebellion on the part of the artist, who is aware of himself and tears down the template of the artist-jester at the service of the nobleman, of the powerful, of Power and, therefore, at the periphery of society. This phenomenon of redemption carries with it a tension between artist and society in as far as we see the phenomenon of Gaugin, of Cézanne, artists who, at a certain moment, were forced by society into a life in isolation, precisely because society itself rejects them, no longer wants them. But, after this transitory phenomenon, comes another phenomenon that's more important, when the birth of Abstract Expressionism definitively frees the artist from intimidation, from the representation of something that prevents it, and it's not only this, well, aesthetic freedom, but it has the formation of movements like the Bauhaus, De Stijl etc. which form very precise instances. In the content of their manifestos they seek to combat individualism in favour of the universal, they seek to combat the artist-idol, they seek to make a progressive society where art is truly integrated into the use and consumption of society to combat the mystification of the artist and, therefore, the commodification. Then, these movements take on the Marxist concept of art

that must be reproduced on an industrial level. Now, here it should be observed that their process, especially as picked up by El Lissitzky, Malevich, Tatlin, after the October Revolution, was of this sort, which was however paraphrased and domesticated, then, by American designers. The birth of industrial design is what really emasculated the process of these artists, which, instead, was a constructive process, with the intention of putting art in contact with man. But, I think, the fundamental error . . . not error, I'll say obstacle, if anything, for these artists . . . is that of taking on the concept of art as superstructure, according to the Marxist concept, right? Marxism says, 'Art is a superstructure,' but they themselves, when they began this process of integrating art into society, they do nothing but, even unconsciously, nothing but free art from one state of superstructure and bring it, instead, to a state of structure. They weren't even aware of their actions, and, in fact, they gave space to industrial design, okay? I don't know, then, what kind of result they would have had, because they operated for just a few years since social realism came to the Soviet Union and, therefore, that cultural involution that marked the revolutionary involution, a Social Democratic State and not a Marxist State in evolution. Because, even Marxism cannot be taken as static, otherwise it invalidates the very fundamental concept of Marxism, in as far as it is based in historical materialism and cannot take itself as a crystallised reason but only as a reason in transition. Now, the concept of art as structure and no longer as superstructure is not a concept of Marxist criticism because, instead, art according to Marxism is freed from the artist-idol, typically bourgeois, where art is mainly superstructure. The more reactionary the reason is, the more it is a superstructure, the more progressive the reason is, the more art becomes structure. Therefore, the artist has to get here, with his revolutionary method, to be able to realise art as structure. This research is extremely demanding in a society of this kind, and so I reattach myself to the function of criticism and of the market because, if there weren't critics,

the dealers would perhaps find carriage drivers, but they would always find some means of tying the artist to the super-structure, because they, actually, combat the structure, they are its most ferocious enemies. If the Soviets, the Bolsheviks are the enemies of art as structure because they are anchored to a medieval mentality about art, the dealers are even more so, and even more so is the bourgeois world, right? That's how the human situation also becomes a situation of an aesthetic nature. Ultimately, there is a clear link between aesthetic humanity and the history of society.

LONZI: Now, it seems to me that there is another factor, especially among the young: that their defences are broken down, in some of them you see that their defences have been broken down, like Kounellis, Pascali . . . Pascali didn't care that much about it . . . he was like a beautiful woman with lots of admirers, in the end he doesn't . . . doesn't see the problem. That was Pascali a bit, because he . . . at the last minute every-one jumped on him.

FABRO: But as soon as you have lots of admirers you no longer see the problem, this is obvious. Really, why? Not because you don't consider the thing important, but because you turn your nose up at it. Ah. But it's one thing to blow it off in as far as you find yourself in the situation that has your side and the opposing side, and you don't consider the dif-ference. Because, even Pascali, as soon as he saw that things happened against him . . . look, he went crazy. Exactly, it's like a beautiful woman who goes crazy who, at a certain point, sees someone who couldn't care less. Actually, it seems to me that, like a beautiful woman who throws a tantrum and sees no one gives a shit, he was keeping a lot of anger in, see, nice reactions, yes . . . he was someone who felt the need to swim at full strength to stay afloat. Of course, then, I don't know, when you're surrounded by life-buoys, then you make a farce, but the key is always something else. In the end you, even playing the beautiful woman, favour this way of doing things. Yes, because then, they will find others, who aren't

considered beautiful women, to feel the weight of your prestige and of the people who surround you giving you prestige and to whom you give prestige.

LONZI: This is a side that, in artists, can be annoying: when they end up giving prestige to some critics, despite considering them discredited . . . because I have never heard an artist talk about a critic with interest, understand? Or else, some, with indifference. For example, Consagra, he's very indifferent to criticism, he says 'But who are critics? some people who come and stand at the door . . . who never came in, well it gives you what it can give you . . .'

FABRO: I'm also more or less of that thinking . . .

SCARPITTA: I am interested in this man because he is the only one who can drive this car. If I'm not able, on the steering wheel, to do specific things, wrapping it with tape, trying to give warmth to the steering wheel . . . for me, the car remains just so, empty, waiting for someone to enter it. I trick myself, I delude myself maybe, that when I make an automobile it would be perceivable what kind of man goes inside. Naturally, this means that I am interested in a certain typology of American, and I effectively am: for me, this country is still quite the mystery, it's a rather violent country, in which I am looking to measure a small part of this violence.

Only, I want to measure it without the expressionistic tragedy of my judgement, I don't want to judge this man in an a priori sense, I want to measure the container for its content. And I am measuring this vessel, if we want to call it such, to see how it feels to be inside and, maybe, in this not-oblique but, I'd say, indirect way, maybe I can have some information, maybe I can find some evidence, maybe I can find some reasons to explain to myself this man who interests me. Because I don't love these cars for their heroism, mind you: it's true that racing cars have something fascist about them, however, looking carefully at them, if the fascists were all racers, the world would have moved forward just fine, because they wouldn't have killed anyone but themselves. And, so, it isn't really fascist, it isn't only heroic either: there is a certain cheerful taste in its noise, its colour. In the end, it's a happy matter . . . the terrible matter of accidents is a lateral product, it isn't the main cause: the main cause, for me, is that sense of thrill that one feels in having this car that responds precisely to one's desire, and that has its own way of singing, it has its own way of ringing, it has its own way of protesting, it has its own way of refusing to go forward. There's an objectification inside there, for me, there's a way of projecting into the actual person as an inanimate object, there's a dualism, but it's a dualism where one see-saws a bit between an objective situation and a subjective situation: therefore, the death of a driver is also the death of a car. I know a hunchback, here in New York, a racer: he has a hump, behind, that seems like the back of a racing car so much that it's evident; they have to construct a special seat so that his hunchback can fit in the back of the car, he has scrawny legs . . . When he's inside there, he's the same as everybody else. The racing car allows him, who's physically a mess, to enjoy the same thrill as those who don't have this disaster: the desire to go fast, to be so reactive as to be able to make the exact manoeuvre where the others would find it extremely difficult and, all of this, at the extreme of his own strength and risk. It's a matter of risk and, maybe, the pleasure

in an error that isn't repairable, there's also that thrill there, maybe, however you don't think of it . . . I agree with them, I believe that they don't think about death, otherwise they wouldn't race. It's the same thing when someone says 'But why do you paint? In the world 250,000 people paint!' But it's the pleasure in making your own works that's important, not the comparison with those who aren't interesting, famous or unknown. It's one's own experience that is entangled in a few instants of extreme precision, under incredible pressure . . . this confidence in the power to react at the right moment. To be an artist is to have quick reflexes: in this sense we're close to the racing car drivers, I find. I know that it's like this for Turcato and like this for Consagra . . . we have, in our genera-tion, a lot of people with quick reflexes, there's no doubt, for me, about this story here and if the youth want to race with us, they're welcome to, sometimes they may even surpass us . . . But they have to be careful about the gasoline . . . Look out, you might run out of gasssss! . . . Hahahaha! . . .

TURCATO: So, if America has become violent . . . okay, they get tired . . . First it was for other reasons, but the current reasons are, also, because there is an American unity. Now we, what do you want, for us to become violent in Italy? . . . But no, but it would be fine. It could be a dialectic of the United States this being violent, in the sense that, before a government that still has more or less democratic laws, but in the Washington of the 1700s and anyway and alright . . . At a certain moment I say 'enough' because, in the end, the ruling class, the families that dominate are Anglo-Dutch. The Kennedy family will have its reasons, but they are still fami-lies, understand? It's not even the Roman empire, because, in the end, the Roman empire destroyed even the family, this here is the point: there, instead, they are actually families . . . They always think, in fact, of the Roman empire. There's a parallel between them and the Roman empire, however. Yes . . . I mean, it didn't persuade you, see, the country? At its core: the Mafia saved the Italians. If there wasn't the Mafia

they'd be worse off than the Negroes. Uh, do you agree with
me? Sure, worse than the Negroes. And the Jews took care
of the artistic situation . . . and banking, in a certain sense.
But I mean, you know, we're in a feudal world, actually, if we
look carefully, because, this bourgeoisie and also the state
situation in Russia, is of the people . . . On one side there's
the bureaucratic apparatus, on the other there's an appara-
tus of people who have Power in their hands . . . there's not
much you can shake off. But, look, I absolutely don't care
at all about the Negroes in America. I agree with them, but
I agree with Clay, who didn't go to the war in Vietnam and
turned down the world title. That was the only thing done
well. And he's an extremely intelligent man, Clay, because he
truly understood what he had to do. Yes, and they cheated
him out of the world title. You know, there's also a process,
but they can't manage doing it, because then, there are laws,
for which . . . The rest, what is it? The Negroes . . . okay, they
make a revolt with the Negroes, equality with the Negroes.

And then? The Negroes become nationalists like Americans are nationalists with the rest of the world . . . What do I care, sorry, about this whole story here? I don't support pressures, I don't want to know about them, right. Understand? It's impossible, right . . . Well, we also need to look at how Ezra Pound was treated . . . But, you, have you read Ezra Pound's book *Consigli alla borghesia americana* ('Advice to the American Bourgeoisie')? It's so important, because he treated the American bourgeoisie like trash and he said to them 'to become a reborn bourgeois person you should do this, this, and this'. Back then there wasn't even the Museum of Modern Art, there was no Guggenheim Museum, there were none of these colleges . . . And they hated him, and maybe also for this reason he became a Nazi, anyway they hated him in such a way, so that . . . And later, however, they did all those things. Because you see, America is a country where you, you delve into a certain thing: but, they eliminate you immediately, and then they do it themselves. Well, no, this here, you know . . . And, in fact, even the villains of the world . . . even the Russians have learned to do this. So, it's better to stay still, understand? Because you venture to do a thing . . . this has always happened, let's be clear . . . however they say, 'Okay, but I don't want that this one here . . .' so they eliminate you first and, later, they do it themselves. Well, alright, this here is bullshit . . . but, anyway, it's there, pinpointed, official. And so . . . Understand? And he wrote this sort of Garibaldi-esque book *Consigli alla borghesia americana* because the American bourgeoisie was like the bourgeoisie from Milan, that made the cheese, took money and so on, however . . . they swallowed any culture. No, there was a naïve American cultural act, but, in the end, it's an act of the people that then falls apart, like in Westerns, that literary history there, none of us gives a damn about it, understand? Ezra Pound said this, they got him out of the way, he became a Nazi, then, even him, true, I mean . . . And like that they made Museums, the various Vanderbilts, Rockefellers, Guggenheims. No, there's

this book, you should read it, you should read it because it's impressive, I read it. There there's the secret of how it went . . . Hemingway, then, was really a copycat . . . Well yes, Hemingway was cut out, because he still believed in Europe: instead, now, America sees Europe like a fiefdom. On the other hand, what do they know about Europe? . . . What can they take from Europe which is stuck, here, between those very Americans, who if they want to have an uprising they do . . . because, then, there is also this. But no, here we need to resolve things rather quickly, by ourselves, because here, now, here they've installed a mess of a government. Well no, look, those memories of Garibaldi are important because he always speaks badly of priests . . . and okay, in the end, alright, we're no longer anti-clericalists, it was an erroneous moment, it was an erroneous politics, however, for Christ's sake, as soon as there was a crisis they plucked out the best of the clergy and of reactionarism. The others, then, they don't know how to do this . . . because communism wants to get into the government, priests and non-priests, they don't give a fuck. On the other hand, what do you want to break, even, what? In France, Brezhnev said that the unions shouldn't worry about the youth revolt because it's not appropriate . . . Nothing, he could have . . . uh, Pasqua . . . Uh, I, then, I don't agree that you have to go . . . look, you could do things much more . . . however, since here there is no union in any sense, then you can't do a fucking thing.

LONZI: What are you alluding to, Giulio?

TURCATO: There's an institution, there is this Strega Prize, right? Last night we went out for a bite to eat, now we go . . . anyway, there's that story about the theatre, there, very nice . . . Now, this is an institution, right? I wish students would come and occupy it, but, I think, this here was all a manoeuvre so that the students wouldn't occupy it, look. At a certain moment, how does this whole situation end? The Hell it ends, because we don't have the situation, and so . . . They have some institutions, because, here, we must have some institutions . . .

some newspaper, something, well . . . what do we do here, now, we go and read the articles by those guys there, we go here and there, but, I mean, effectively we don't have the strength. I'm not talking about instituting prizes, please. No. However, I'm saying, the institutions: where is there a modern situation in Italy? There isn't. They have the Strega Prize, the Accademia dei Lincei . . . everyone is in their hands, that is people who are sixty, seventy years old. So, what can you do, here, to rid ourselves of the whole shebang. We are still at Sade: where the ladder is never tall enough to attack the castle, understand? Because they are united, you know, these here who make up these institutions, who the writers don't even . . . Anyhow the writers, as far as they say . . .

CASTELLANI: What was important about what happened is that it was really an effort of global analysis of the situation, through the politicisation of the vision of reality.

LONZI: No one could ignore some of the things that were said, the accusations that were made, the suspects . . . Even if something ended up misunderstood, like art. You really see that in society it wasn't clear enough, right? Because the students said, 'We don't give a damn about art,' believing they were saying something very revolutionary. This was rather strange. You really saw to what point these Museums, Galleries, all of this business meant nothing, because they have an idea about artists and art that's really phoney. For them, I don't know, Argan and Fontana are practically the same person, the same humanity, because that one speaks out of the mouth of the other.

CASTELLANI: I think that at least the most aware would have said it above all, then there are the imbeciles . . . who would have said it, the same way we could say 'I don't give a damn about yachts' because we know that they have nothing to do with us and we can't have one. In fact, why do they fight? For the very reason that they feel conditioned and they know that, in such a situation, they will always be more and more conditioned, right? And they rebel against this

progressive conditioning. They've seen that when they leave the University, they will be even less free than now, actually at that point the cycle of conditioning will be complete hence they will be machines, wheels to insert into a particular mechanism. This is what they rebel against. Thus, they rebel against the ignorance in which they are kept in regard to certain facts . . . They also seek to understand what the role of the artist is, the possibility of the artist's revolutionary intervention in society. And then, anyway, they are aware of being cheated out of something that the artist possesses, that he could give and give, and that they are unprepared to receive. They said 'We have been cheated of beauty,' they said that, right? 'Because we are unable, as such, to understand it, to . . . to enjoy it.' These here are very prepared people, aware, they aren't some bumbling fools . . . Because then, if we look at the genesis of what happened in Milan, we need to keep this in mind: that we are the ones being accused, we began the protests against ourselves. Then they followed . . . students who

weren't recognised by the Student Movement and they came there to tell their stories purely as individuals, and therefore they were also less prepared, some failed artists, a CIA agent, I learned last night that . . . The protest about our role, we did it ourselves: then, every so often, the thing broke up and there was someone who, actually, said 'We don't know what to do with this bullshit.' Therefore, it was an awareness and knowledge on our part. Then there were those who tried to take advantage of something . . . those who never did anything or who always did some bad shit, who interpreted this event as a clean slate . . .

LONZI: Then the artists disappeared, they didn't show up again.

CASTELLANI: We were also on hold, because the students say 'All you artists,' they still have this mania of considering artists a category. Now, we had a resounding denial of the idea that artists make up a category, right? We dealt with these facts. Therefore, when they point at artists, at someone, as a single individual, then it's okay. In the end, we're people who, for the very life we lead and for a certain level of open-mindedness, we're also rather close to them because we don't have anything to gain. Even on an existential level, right? So it's just fine, certain work can be done together, everything is about studying . . . Then they also have a lot of prejudices: they say 'Could you make posters?' So I said to them 'But, look, making a poster isn't about painters, it's about experts in making posters . . . if anything, we study certain slogans to illustrate and we give them to an illustrator we know, right? . . . it's not that the artist needs to be used for making posters.' But they have this curiosity in respect to people they consider as a category, but that, anyhow, have a way of life that's totally different from the bourgeois norms, basically. And then, you know, talking about students . . . their movement is growing rapidly . . . Besides, it's logical that it would be this way, otherwise they would already be a party, which is what they refuse to be, right? And they have enormous problems, structural

problems . . . For example, now they were saying 'Up to now, we have operated as students who go against the system, in which they are students.' For this year they propose a programme of behaving, yes, as the Student Movement, at least as a label, as such, but bringing their actions outside, political action, something they had already begun. This also tactically, because, for instance, I don't know, these contacts they sought out with the workers, in the majority of cases it ended up going nowhere, because the workers have a particular mistrust when it comes to students, they consider them a part of the bourgeoisie, they consider them the potential foreman, those who will be aligned with the owners. And then, there is above all the resistance of the unions that tend to discourage, even to block a relationship between workers and students because they see a certain power escape their grasp. You know, unions are a centre of power, look at America, here they're going in this direction there, right? Therefore, presenting yourself as political agents, like that, without . . . namely, they would like to bypass the discriminating factor which is their condition as students. On the other hand their revolt was born directly from the school, from the analysis of the structures in which they work, right?

CONSAGRA: These guys who go to Piazza di Spagna, these so-called long-hairs, hippies, who dress like bums, who are with girls who dress like bums . . . This is a way to remove yourself from the category and insert yourself into life, to take on an attitude as a position in life. Therefore, the student should really insert himself into society carrying out actions that take more incision, not with problems, really, within the category of students and departments and their difficulties, but also as elements of examples of life, I mean, of a young person. And this, little by little, is done, however, because with the fashion, with the songs, with the exhibitionism that, sometimes, maybe, could be taken as unpleasant, however this left a much deeper impression than the actions of the students themselves.

CASTELLANI: This attitude is also very dangerous because, yes, it could be considered simply as a moment of youth growing up or else a question of fashion, as such. Instead, the students want everything they do to be considered a political stance and would have, not only a political conclusion, but an immediate repercussion and effectiveness. And so, for example, in respect to the hippies who . . . yes, hippies are alright . . . but they are also an escape, if anything they're a moment of anarchic revolt, but which hasn't yielded much, has it? Which is immediately instrumentalised. They make a business out of it, the clothes, films. The whole thing is immediately subsumed into the mainstream and accepted, consumed.

TURCATO: A youth revolt was also about inventing some songs. Now, the youth no longer sing opera, can't sing it any more. And, also in Italy, an effort was made because the Italian language always rhymes, but instead they managed, in a certain sense, with the likes of Rita Pavone, Mina, Celentano, to put out a music, effectively, that no longer sounds like opera. No, besides those of us who never loved opera, but, now, I also mean in a popular sense . . . And, then, there's another question: the revolt of the miniskirt . . . They can't even see films with antiquated clothes, because, now, the miniskirt

has become a thing . . . The French, however, have a greater freedom: while the miniskirt in England became a uniform against the Elizabethan system, in France they were already used to having freedom in their style of dress, and here also it's the same thing. This, however, is a revolt that the youth made, the truth must be spoken, because it's not like Vedova and the others carried out this revolt. I don't want to harp on about this. The discourse is complex and difficult to explain. But I think what our bosses still haven't realised, de facto bosses not those who win elections, is that, effectively, Italian society had the situation of the Resistance, all extremely just things, however they never developed it. They created a monument, but they didn't create the base upon which . . . so, it's a situation that stabilised. And, so, you see how the youth revolt is against this stabilisation. Years cannot pass, twenty to twenty-five years have already passed, still we go forward, everything still, absolutely . . . the faces are the same, the ones that once were. And then there wasn't even one clear cultural idea, let's speak clearly. Because in Italy, for example, it's not like the so-called true anti-fascism brought a culture with it; it didn't, because it didn't have one. In America . . . well there, there was a different structure . . . then there's Puritanism at the base . . . naturally shaken in a certain sense, which we, in the end, don't have. There are many religious, psychological, ethical complexes that differentiate us. On the other hand, Puritanism, American Quakerism, was a strength for them which brought them certain conclusions, also of violence, of power. Yes, first of power and then of violence, basically. However, even now, it's strange to say, you don't find America like it was in the '30s any more, also with a socialist, humanitarian base . . . this America isn't there. Maybe, the only aspect of this still is Hemingway, but he seems so old. Every American situation, now, shakes its fist because it wants to have, probably, what it never had. We, on the other hand, maybe in bad faith, believe we had it . . . Maybe, this is where the real difference lies, okay. Maybe it's a play on words, but

a play on words, naturally, that has some truth to it. And, undoubtedly, the revolution . . . it's not enough to walk around barefoot or to have . . . the fact is that there, the bourgeoisie is such an encrustation that, naturally, the youth feel like rebels, of course they're born rebels. Here, instead, we have a very soft bourgeoisie, generally very conservative, and, indeed, here we fall back on the glory of our fathers which, by now, has become something abstract, distant, and so . . . Naturally you get ripped off, in this sense . . . however, the European youth in general, maybe excluding the French in this very moment, still lacks clear and precise ideas about what it could be like. Besides, in America, there is no Communist Party: the Communist Party, unfortunately, is responsible for conformism from which it is difficult to get out from under and so . . . then it renders innocuous any desire for revolt. Now, also in the case of Pasolini . . . it's not okay for him . . . well no, because he says, 'The student class, because they are rich kids, they can't revolutionise a thing.' We're against rich kids: however, if some rich kid says something that's right, it isn't the least bit true that he can't be right about something. Well . . . I wrote it, but, indeed, I wrote it in this sense because, effectively, this is how it is. Then, the reason, about the sexual revolt they want to have . . . On the other side, seeing young people wearing miniskirts, romantic love can't be conceived of any more, like Francesca Bertini, or not even more or less, it's absurd, isn't it? Erotic movement will be much freer, much more natural. In the end, the Romans, the Greeks, they were in this situation here . . . it's the first tremor, in that it came about in this sense . . . bah, against Christianity, and Catholicism in particular . . . No, there's not even anything to discuss, no, no . . . But it's obvious. No, their strength was thinking in that way there: individually they thought a lot about this thing . . . however, their strength was finding a way to agree with an entire generation in saying 'Enough of this hypocrisy, enough here, enough there, I want to go out in the evening, not . . .' Because then, psychologically, the mode of being gives way to a mode

of thinking. It isn't true that there's an absolute in the head of man or in cognitive human faculties: how one thinks is formed in a certain way in accordance with how one is forced to move. Undoubtedly, it has shown that the European failure is the failure of a certain secularism, unfortunately. Yes, because if secularism was more lively, certain things wouldn't have happened, right . . . Instead we went towards Nazism, we went towards a conformist communism . . . Because then, when you get to an orthodox situation, you get to a byzantine situation: in the name of work, of workers, you shouldn't do this and that. Then, so what, even the Holy Roman Church gives, in the end, the same things. That I, then, stay closed up at home and I can't go to a certain place, because the working class or Jesus Christ tells me so, from a point of view of life, vital life, the situation is the same.

CASTELLANI: To take hippies as an example is not very effective on the political level, because the structure doesn't change or . . . anything. It changes certain reflex behaviours, for assimilation, for opportunism, but it leaves the substance intact.

CONSAGRA: That story about the 'old fart', right? That all the kids, children started saying 'old fart' to their parents, it precedes this global revolt, let's say . . . Ultimately, it created a sort of crisis between the youth and the 'old farts', it's an awareness of youth in general, independently . . .

CASTELLANI: They could be harbingers . . . and then, also, I don't know, the hippy movement is just fine, however if this movement of spontaneous struggle doesn't become conscious and politicised, it will remain something that's immediately exploited.

CONSAGRA: As for us, we want the students to arrive at the point of making the Universities better for themselves. When I think of the student, I only think of this, however, when I see a hippy on the street, I think he's doing another job, that isn't inferior to this job of the student who wants to improve the University.

PASCALI: Certain long-hairs, dressed a certain way, have their presence, their own beauty because, truly, making fun of society, and rebelling at the same time, according to a silly avant-garde idea, however, at times, they're able to pull together certain clothes with a certain face, with their hair in a personal fashion . . . Determined by many factors: they found that clothing there, that they liked . . . one makes clothes for themselves because there's the fabric, it's not like you create the fabric, you have a very clear world around you. Like the Negroes, when they have to make a sculpture, they use a piece of leather from a zebra and a piece of wood, they use what's around them, and so do we, understand? However, the problem is in putting these things together: it's there that one truly determines their own space and, therefore, their own image. That's why I am interested in materials because, like that, to know all of them . . . Not in the sense that you say 'plastic'. . . Plastic, I can't use it because it's a medium that doesn't belong to my nature: it's as if I were a savage, instead of a savage I am an Italian who lives in Rome, to use plastic means entering into a certain dimension, it should be like going into the stationers and buying a piece of paper, so you buy plastic and make a nice little work . . . you do it, but, since it isn't like this, you don't do it. The world is made like a big Meccano set where you have lots of pieces. Only, the pieces aren't all the same, but are all different and, really wedging them into one another, a possibility is created or else is rejected, if there's a possibility that fits into another space of ideas that doesn't belong to us. It's as if I were to attach a sack to a frame, emphasising the stitching, some holes: so, I automatically enter into Burri's space. But if you, rather than the sack, find material x, and if this material has the evidence of a certain simple idea of nature, that belongs to you, to your world, to your time, if this material is organised in the identical way to the choice you have made for that material, then it belongs to your space. The mistake certain people who want to be super-modern make is to use plastic with a mental space that

belongs, if not to Burri, to a previous space: so, it becomes a kind of modernism. But, if the American man uses plastic, it's truly a new space, understand; an Italian who uses plastic, as long as he doesn't live somewhere where they only make plastic . . . what can I say . . . I don't mean to be polemic.

KOUNELLIS: These are images, I don't know, of sacks, of things like that . . . I thought that tying this here, one sack after another and hanging it on the wall, should have been like this, underneath, and after it should have been very big, right? It should have been, underneath, like an accordion, leaning against the wall: so, I thought that, if I connected my sack with another, I could carry out this operation here. I believe that in both senses, Burri's and my own, they're part of an aesthetic operation, but of good sense, really. Only, Burri's is more greatly tied to a culture, a certain conception of painting, so . . . today, you could call it more archaic, in the cultural sense. The presence of the sack is neutralised by the compositional effect that he gives: so, this is a means for remaking painting, it wasn't really the sack. I don't know, Picasso's monkeys, who puts some objects there, they aren't Schwitters's objects, but the monkeys are made of children's toy automobiles. Despite the fact that these painters' operations are authentic, really, because we need to talk about the authenticity of an operation, although, this isn't about neutralising the sack, that is by placing it there. And then, I don't know, Burri repeats the same action, while, with what I make I don't really want to repeat myself, I don't want to find something formal, right?

CASTELLANI: For the student, arriving at the state in which he is, currently, this making for themselves a better University is only one moment of his will to change the world, a necessary moment, for which he asks, yes, the help of the proletariat, because it is directly involved in the problem of the school.

CONSAGRA: I don't know, did the students take a stance, for instance, on the pill? Did they take a stance on divorce?

CASTELLANI: Yes, but much tougher stances, much more drastic, more extreme, more just, naturally, because they really don't care about supporting the Fortuna Law, about divorce. They take stances on sexual freedom because, exactly, they said, 'We are cheated out of loads of things . . . out of beauty,' they said, 'of sex, of . . .'

LONZI: This sounds strange to me . . . that the student has a side of consciousness, however, let's say, that's less creative . . . What does the hippy do? It's not like he says, 'I'm cheated out of sex.' He looks for a way to live, understand, this is something very different which I liked about these hippies. The students are politicians, that is, they see situations, but they don't think that the most important thing is themselves and living what they are entitled to live. As long as, that is, they don't give them sex, they don't take sex. The student, as a category says, 'They don't give us sex,' and stays there. The hippy, he doesn't say 'They don't give us sex': he takes it for himself, whether they give it to him or not.

CASTELLANI: Anyway, this is allowed for them, why? Because they are a minority, a minority in a society so . . .

LONZI: How do you know that they're a minority? Who knows if they're a minority?

CASTELLANI: . . . that at most, could have influence a bit in terms of clothing styles, but the hippy will never change the structures.

LONZI: Still, he changes himself. Instead, the student, doing as he does – I now bring up a question I've reflected upon a lot – the student doesn't change himself much . . . Among the hippies you might find more willingness to engage with art, so to speak, rather than a student, who, being politicised, is older in his mind, because politics is older as a demand, as an instrument, as a way. It's always a specialist's way of proposing something ideal. Instead, there is a part . . . which is certainly favoured because there are conditions of such prosperity in the United States and, in other places, I don't know if it would be possible, but it's very

meaningful that they don't sacrifice themselves, understand? They change themselves, they think the most important thing is to transform themselves, therefore to 'truly' have an experience of sex, to 'truly' have an experience of a promiscuous and collective daily life, to 'truly' have a child in your house that you want as he is, naked, who runs around . . . When you've done this, you're a different person from the politician who sacrifices himself and thinks within history. Instead, the hippy has had experiences, by hippy I mean something beyond the political . . . Wallace from Alabama, when he wants to incite reactionaries against someone, to indicate them as an irreconcilable enemy, he trots out the long-hair, the hippy. There's a moment of humanity, of youth, that is very beautiful, when one says 'I immediately grab what I deserve, I may be privileged, I may not be privileged, but . . .' And this has an effect on the bourgeoisie, look, that makes their hearts drop, while if they see the student who fights and debates, they say 'We also fought for ideals in our time' . . . 'rightly' or 'wrongly' however, they see a motivation that isn't completely foreign to them . . . they don't see someone who has obtained other things, truly

valuable in terms of life, basic. Today, what makes the world die of envy is when you hook onto that thing that all of society doesn't want to give you and you hook onto it and you say 'I have it . . . I am holding onto it and I'll enjoy it.' Isn't it the thing most . . . ? Because to hear a young person say 'I'm lacking' I don't really understand, because it seems to me that, first of all, he's banging his head in order to grasp it, that thing. It's the University, you know . . . because the hippies aren't 'from the university', some of them are students, others not, still they come from less cultural, really, experiences, understand, that culture always has this stretch, this stubbornness to resolve a problem through a path of deprivation, with asceticism, if you like, with debates, discussions. Don't you see them debate, discuss. And, instead, it's lovely . . . – also, together with this, which is always so commendable – however, a part of humanity, you know, runs ahead and takes . . . takes a walk, let's say.

CASTELLANI: It doesn't run ahead. In that sense there it runs to another side completely. It takes advantage . . .

LONZI: It gets satisfied, because 'ahead' happens when one is satisfied, in my opinion. Wherever you come from, cultured, uncultured, whatever, to me, this is my impression, this.

ROTELLA: Eroticism is very important for the life of a painter, a bit as experience, a bit as a fact, let's put it this way, progressive, like sap on which a painter can nourish himself, to continually create erotic works, or even non-erotic works. It would be like an act of satisfaction . . . yes, a psychological but also physical satisfaction. And therefore, I think that I should share my ideas: that I, in addition to my work, take very much into account my erotic life, which I never overlook, because this also serves as inspiration and, perhaps, for the work, at the same time. I don't know, I personally conceive of life as a continual unfolding of actions, actions that in part I provoke and in part come along, but they come along because they are attracted by these vibrations that one of us may have, like in my case. And . . . I don't know, walking in the street, I see a beautiful girl and I try to provoke an action. I, for example, move closer to her and I ask a question for which there may also be a probability of success. My life hinges on this fact, on these sexological, erotic adventures, that then, at a certain moment, are the base for our future or present work, let's say. I believe in a new way of making love, okay? And therefore, this would also be part of the so-called sexual revolution. Because I think that, now, the way of making love like our grandparents or our fathers is already old-fashioned, it's been surpassed, a mechanical fact. Today, I think that woman is in need of new emotions, new stimuli, and to be looked at or to be left alone. This, naturally, also has a certain importance in terms of the new sensibility of woman in relation to the new sensibility of the artist. Does eroticism go with feeling? Without a doubt, because this matter of intention is also included in eroticism, as is the matter of language, and therefore, of understanding between the two sexes. Otherwise, I don't believe eroticism is complete. I think that the sexual revolution begins now, naturally there are years to wait before it's fulfilled. Already there have been steps forward from the point of view of free love in relation to the hippy movement that, as such, moved forward, paved the way . . . the miniskirt,

anyway, revolutionary habits, habits also applying to ways of dressing . . . I think that we will continue to move forward towards a wider freedom of erotic habits.

TURCATO: The situation of the youth, then, doesn't only happen in cities like Milan, Rome . . . I was also in Florence: the girls say 'I want to go out at night,' it's a reaction. First woman said, 'I want to work,' okay, and so, excluding certain corners where there is naturally an encrustation, but, so, these have already been overcome, everything was going well. However, when woman says 'I want to go out at night, I want to have fun, I want to have, really, my freedom, my personal freedom,' it's begun . . . It's important that there's a sexual education, so that wretched things don't happen, as for the rest . . . No everything is okay . . . everything's natural, really, everything's obviously right. This here, let's be clear, this was also desired by affluent society because, naturally, being better off, given a certain working condition, so people begin to think more, and are no longer slaves to absurd prejudices. Anyway, you know, at least in a certain world of artists, it isn't something that caused much astonishment because, effectively, the world of artists has always been rather free, perhaps considered poorly by society. No, they're not free, then, in practice, but in concept, their world should be freer than it is for the bourgeoisie, by and large.

FABRO: It's not like the tautology was born in me spontaneously, as such, it was born as a critical element of a specific situation, this I have to confess: since I saw myself surrounded by an ostentatious series of tautologies. Schmaltzy tautologies, so I wanted to say a small word precisely about tautology. I wanted to say 'Well, in the end, what the heck is tautology?' That, tautology, for me doesn't exist, there simply exists an obliging transcription of a literary-cultural behaviour. When I say, I don't know, 'What is bread?': 'It is bread,' I reuse a convention in order to define the convention itself, however in effect, nothing changes. Instead, I transported the tautology, really, to the experience of the thing.

PAOLINI: I would only like to give you a testimony. In that writing from '63 that, by the way, I gave to Carla, yes I was angry with negative solutions: I indicated on the one hand the ease of the quip, of the gesture and on the other hand, tautology. I literally wrote 'tautology'. Now, it seems to me that you have found a way to get out of this dead-end street of tautology, by actually doing it, taking it up in action and, therefore, making use of it critically.

FABRO: My coming closer to the experience of tautology manifested as something that went very beyond my presuppositions, at least beyond what I was able to extract –something that is is extractable by whoever or, anyway, was adequately described, it's not for me to say. I think that whatever wanted to be some sort of a voluntary behaviour of mine about the operation itself, etc., escaped me, slipped out of my hands, I think. When I returned a bit critically to look at what I had previously done, I realised that, in effect, everything could be a part of tautology, it was a key that could perfectly . . . This enclosing the situations, naturally, I observed it in others as well and the *In Cubo* ('In Cube'), maybe, it was . . . in this sense, I think, it was an opening; but the perimeter, the running-around this thing that was interesting, was made on the basis of wanting to say, anyway, a thing about the thing. The fact that I made a cube based on human proportions considered the person implicit, the fact that the person would find themselves in a tautological behaviour was implicit; however, my behaviour in regard to this work, was still rather spurious, to consider this shell stimulating to make a tautology, to employ tautologically, see. I consider *Davanti, dietro, destra, sinistra* ('Front, Back, Right, Left') the last tautology, because then I made *Cielo* ('Sky'), that I however will still title *Davanti, dietro, destra, sinistra*. There are three panels, I made three panels for ease of movement, upon which is enlarged . . . no, I wouldn't say enlarged . . . anyway what is enlarged is a map of the sky as we know it so far, according to our astronomers, given that

I went to Brera to ask for the latest versions of the maps, which they didn't have . . . Effectively, maps of the sky are missing, they don't have them. This is a Czechoslovakian map, from which Harvard University made photocopies, and it is the most precise one that is currently available. Yes, it is from 1950, the sky of 1950. Yes, well. I took a piece of this sky, this panel, and I enlarged it so they come out, merging the three panels, on a black background all of the stars come out, naturally in their various size ratios, which are ratios of luminosity. Really with a cartographic method, see: on the black background there were these white stars, for which there is also enough to recall the starry sky, the impression is quite similar, and, then, I make a little square with writing on each side, naturally as it comes *Davanti, dietro, destra, sinistra*. The 'back', naturally, is written upside down, the 'right' from the bottom to the top, the 'left' from top to bottom, on this little piece of plexiglass, extremely light, I don't know, 7 × 7 centimetres . . . Attached to it is a little magnet that can be moved however you like to any point of the sky. Now, I consider it the end of tautology, because I consider it a possibility, while

tautology is the realisation of a thing that you already know, it's a kind of circumnavigation of one's consciousness, of one's experience. In this, instead, a projection of one's own consciousness occurs. I think it is a more limited operation, more elementary, perhaps also more imaginative, for this I liked *Cielo*. And, then, another element emerged: if I put this little mark, this way, you identify it with that position there, you don't identify it in an abstract way, but you should identify it in a concrete way, because *Davanti, dietro, destra, sinistra* presupposes a physical presence, not an intellectual presence and, roughly, at a certain point, this little figure will be perpendicular to the sky's plane. Now, the ratio of this vertical is a ratio that's purely . . . terribly thinkable, without counting, then, that the distance between right–left or front–back, will consume millions of light years . . . Yes . . . Ahhh! It seems to me that the element that's so intellectual, that pleasure of staying in your own thoughts, at a certain point was reduced a bit like a fairy tale, something like this, that has its little plot . . . Besides, this part of the sky is purely indicative, because you could perfectly well expand it in one sense or another. It's a circumstance, as such it's determined, occasional. In effect, the three metal sheets are three metal sheets: placed one next to the other, they indeed grant this notion of possibility of multiplication. Oh, another element like this, a corollary, or anyway . . . these metal sheets are leaned against the wall, they aren't to be hung up and, being metal sheets, they are rigid enough that they are ribbed here and there, however they have that little bit of a dip so when you lean them they make a kind of curve. All of those solicitations that I recall, to which . . . I don't know . . . I quite like to appeal to, see . . .

SCARPITTA: I don't want to make up a nostalgic history, however, I have to admit that a painter, like any man, can find himself in a crisis of expressive order and . . . strangely, all at once, he looks in the mirror and says 'I need to shave, I have a long beard': something that grew outside of only thinking

things, something that just happened, I'd say physically. And so one says, 'Yes, I touch my beard and it's grown a bit, I need to shave to be like I was yesterday.' Instead, one says, sometimes, 'No, I'll let it grow.'

PASCALI: To look at yourself in the mirror is also a mess, because you look there and you see a person who never . . . It's like, I don't know, seeing a horse on the street, no really, you say 'What, it's me?' You see yourself, you who live in a world of mental habits . . . there's some sort of collage of images, of things, that doesn't belong to your exterior figure, it's like looking out of the keyhole and all of a sudden seeing what's outside. And, sure, what one is from the outside is always very emotional because it's like seeing yourself for the first time: one isn't aware of being a certain thing, a certain object, physically having a presence. One sees . . . I don't know, sees hair, sees sideburns, I mean, sees the little nose hairs, sees if he has a beard, sees, even, that he has a good body, if one is like that, everybody does that, or else if the skin's starting to get wrinkly, or else he could say, 'I have a small torso and hefty legs . . .' You understand, you say this, but you, in the end, for many reasons, you don't have this image within yourself, so that to see it, it's as if it would come back, to your outside, to your inside. It's like seeing an automobile and a horse, that are these two things here . . . I, sometimes, when I talk, I end up in places, just so, that I hadn't even predetermined. It's like when you work: you want to do one thing and then you do it with your own means and, therefore, it ends up in other possibilities that have this idea. I like to begin really from the material because, in the material, there is its own limit. If you choose a certain material, you project your own possibilities within clearly defined limits. I don't think that you can do everything with a given material, you can only do one thing, and this single thing is an idea of oneself: to waste an entire life actually so as not to repudiate it, in order not to end up on the other side, it's ridiculous. I am interested in this richness of possibility because it gives me back my own presence, I

don't get worked up about the image of myself that I have predetermined, I am able to see my image again and again, in the mirror, in a strange way, not strange, in a new way. Not to say 'Yes, I am Pino Pascali and I have high sideburns, 1 centimetre under the ear, and, maybe, I've had a moustache all my life.' I, today, I grow a moustache, tomorrow a beard, tomorrow I even let my hair grow or, maybe, I cut it short. But, by doing these things, I am able to understand the length of my life. I truly think this way . . . It's a terrible example I'm making, a sly trick.

ALVIANI: For me, the machine is also a material, material in the highest sense, meaning: glass. It's not that from glass I make empiricisms, there needs to be the necessary tools to work with it, to do a given thing . . . if they aren't there, to try to create them. Because the machine carries out its function like glass must carry out its function, every object has its native properties within itself. It's a serious mistake to make, I don't know, bowls out of glass, when it is perfectly well known that bowls are made out of clay because they are thrown by hand . . . see, you understand this, right? Glass can't be thrown by hand, therefore they have to make them in a false manner,

they have to throw them with moulds and make something phoney. So, to always search for the true origin, how it's composed, or, if it's to be modified, to modify it: in order to enrich it, with materials. The interrelation between material and work, today, we bring it to a higher level because the machine has intervened, the dynamic, the progression . . . Of course, in the past, instead, there was empiricism each time, 'Who knows what happens,' on the other hand, now, they certainly know the mechanical resistances, strengths, potentials, the totality of the sciences, of technology . . . for which, each time that we say knowledge, we say situation x . . . tomorrow there will be more consciousness, therefore another situation, situation y. The thing is, however, even more interesting regarding what I said before, is the fact that the machine doesn't have any concessive element, and when it does it's wrong. If it produces a curl while it's making an extrusion, that should be, I don't know, square and shiny, it means that something isn't working.

FONTANA: The intuition of youth isn't their primary thing: from any gesture you grasp if that young person there is predestined to do something. I . . . I don't know, it's not like I want to brag . . . however, I've always grasped it. In fact,

I have a collection that's worth diddly squat, they're all tiny pieces, because ten years ago I didn't have enough money to even eat, and I didn't buy clothes, a pair of shoes and I bought a piece for ten or twenty thousand lire. So, from Yves Klein, to Arman, Tinguely, Soto, they're all in my collection, yeah . . . from Burri himself, the first painting that he sold at the Venice Biennale, I bought it from him, from Fabro . . . And also from Pascali: the cannon is not the matter, however, even that cannon, it's realised in a way that demonstrates the brilliance of the artist. There, it's difficult to intuit, understand? You need ten years . . . in fact, the critics get there generally ten years later, except for a few exceptions, and so the youth remain left alone . . . Today, it's a bit easier, no? There's also a snobbism about wanting to discover something, and they discover false values, united around these, however, foreseen in something minimal and, also, mistaken, a man of talent . . . Now, that Pascali makes bathtubs, you understand . . . He says, 'But then it ends.' But it's not true! We have the demonstration that artists as such, it's been twenty years, thirty, that they continue to evolve and well, therefore it isn't true that it ends. Even Castellani himself, immediately, I understood, so . . . and with Fabro the same thing, right?

SCARPITTA: Let's take an example from American Drag Racing. American Drag Racing is: a straight racing track with very powerful very sophisticated cars, with very high horsepower, that start from a standing start and arrive at a finish line from a quarter-mile of distance. They are very interesting cars, completely constructed for the straight track, they are monstrous and beautiful things to watch: their rear wheels are as large as those of a tractor and, in front, they have bicycle wheels. The motor is 500, 600, even 1,000 horsepower. The man is seated, in fact, behind the rear wheels: all the weight, the whole situation, is based on the maximum power to complete this quarter-mile. In this sense, there is a technique, there is, already, almost, I'd say, a predisposition of the racer for this straight track. Really interesting cars. If this car

here, strange, at certain moments even obscene, as the sum
of its engineering and mechanics, you put it next to a rac-
ing car on the track, that has to make, for example, turns . . .
if you put this imposing car, that seems like a rocket, near a
manoeuvrable Formula 1 or, like, Indianapolis racing car, the
Indianapolis car immediately seems almost a paddle boat, a
silver paddle boat for the dykes of Holland, for the canals,
strangely it immediately has a grace, a proportion, a ratio
between the distance of wheel placement and the cockpit.
There is, formally, a completely different situation for the
car that has to race on a full track, on the racetracks where
manoeuvrability is more complex. They are less flashy, less
monstrous, but I'd say they're more suitable for changes in
the course, changes of situations, of speed and breaking. The
Drag cars, with young acrobats at the wheel, are brakeless,
they have parachutes for braking, they have other braking
systems, they don't have the same ones as the cars for the
racetrack. The brakes are extremely important for cars for the
racetrack, and so our generation . . . Our generation needs ter-
rific brakes in order to be able to navigate through the turns,
we need power on the straight track, if we have it, we need a

car, I'd say, that does everything, not only overdoes it . . . In
this sense, I'm very adroit at making aesthetic comparisons,
artistic comparisons about the value of the rocket beside me,
for an anachronistic contradiction, to the bicycle. For me, you
can go around the world on the bicycle, but, with the bullet,
geometrically, for me, there is only one path to be taken: that
of the parabola, and not the Aesopic parable but the ballistic
parabola, the trajectory . . . And, so, in this sense we are living
a ballistic fact, here in America, a ballistic-aesthetic fact. And I
really love my generation, because we are for the open circuit,
for the racetrack, if you will, for certain manoeuvres, certain
controlled skids, called drifts by the English, where the car
actually leaves the ground, positions itself in a certain move-
ment to take the turn. And it is, I think, in those circumstances
there that the risk, even if there's less speed, everything is
connected to causing, yes, expression to increase, instead
of always becoming more encapsulated, always more like a
bullet, also more closed in space. And, in this sense, the ratio
that we make, now, trying to talk with you about the young
and the old, is still based, not on having ended the races, but
on navigating the turns. To navigate the turns, for me, is to
race: it's not only the straights that matter, here, because in
Indianapolis, you have four straights, and eight turns. And so
we are always in the ratio where it's the turns that decide the
races . . . meaning that, with the rear European motor, Jimmy
Clark – poor thing, he died the other day, two or three days ago
– in Indianapolis, with the rear motor he handled the turns at
a greater speed than the big American cars back then, in '63:
on the straights, the Americans went ahead and, on the turns,
our friend Clark won the race. Like this, making a bit of fun
with this story, it's a comparison a bit like this, free-wheeling,
I find certain values to compare also to the artistic situation
here in America, to certain artistic experiences of today, that
I enormously admire, but that I want to see get to the turns
to be better able to contend with them because I don't plan
on destroying the motor of my car: for me, the race is 500

miles and what doesn't go to 250 miles isn't a race. It's like this Carla, how I see it, and, in this sense, I find many young people who come with me, who've understood, they've grasped that the race is 500 miles and, so, they're very patient with my qualms, just as they are, occasionally, rather excited by my ideas. We find ourselves in good company, there's room for everyone.

ACCARDI: The idea for the tent was brought about by a thought, that came to me when you showed me that image of the Turkish tents at the Museum of Kraków. They gave me the idea that those tents, so beautiful, the Turks brought them with them on their travels, in war, to plant them down, then, in moments I imagined to be very difficult. It seemed to me a pure aesthetic act. So I, the other day, when you came to the studio, I said: 'I am only doing an aesthetic thing.' I felt myself in the position of someone who makes a beautiful product that doesn't have any use, for looking at and that's it, and it seemed to me that there, in that moment, nothing would happen, in respect of a young person, let's say, who does research in a field that you haven't thought about. So, you say 'I got all the way here,' I put my cards on the table. However, the great value of even doing one such thing became clear to me, really honestly, with great simplicity, where you don't add anything. Now, the new element is to have to experiment with what one can produce by removing even more emotions that seem inherent to art, that maybe are in certain periods, but I didn't know that it would happen because removing everything could also leave nothing. However, maybe, if a person has a certain way of being, a certain care, trying to understand, yes, to see in a new way, removing, in the end it isn't true that there's nothing when everything is removed. For me, it was an experience that I liked, it was a pleasure. So those who say, 'Ah, Accardi is losing herself with the plastics . . ', 'Sure, you're the one who's lost' I say. I have the right to make the most ordinary, simplest gesture, to experiment if, doing it myself,

every day, trying to live in a way that isn't vulgar and removing everything in the way, this, then, remains. To arrive at removing, removing, removing seems to me a sign of maturity, a very refined part of maturity that then one can find in many artists. I remember that I always said it, like a need that was completely mine, which I hold very dear, this word that continually came out of me: for me, it was more important to remove than to add. I said that referring to black and white, for example, but it's a behaviour that I've always had, also in the paintings where this wasn't really evident. In front of what I now make the spectator can feel a kind of poverty, of emotional scarcity, I risk making empty works, I risk not even being able to make a work because that element is missing. But it doesn't seem that way to me. I think that they have this fact of pure aesthetics, that is this pleasure in making useless products: it doesn't come out of an activity of mine, it isn't even useful to me because it drains me, it isn't a substitution: it's only making this gesture, to find the time to do

it, see. Then – since one has learned to suffer, to really live in life – so there, in those hours, one only puts in what works. Refined, naturally, since it has reached a point of quality . . . therefore, it isn't any old game, but an exquisite intellectual pastime. One has to be able to offer this to humanity as well: a pastime of great quality, an art that no longer has that character of substitution for life. One then proposes . . . However, it's true that in every age there are offers of experience out of which humanity is enriched. I believe in this. In the end, now, we don't really know what we have to propose, it escapes us: this could be a thing. Because think of how the human psyche has been examined over the past fifty years, I don't know if one can go much further. Now this psychoanalytical act has been done . . . therefore, out of it a different way can emerge of accepting one's life, not to resolve suffering because that's impossible. I don't want to insist too much on this fact, because, before, I said something else, I said: 'I want to make an optimistic work.' No, it's no longer about optimism, see: I know how to do this and I do this, this operation, then there are many others of them . . . in fact, other people have done them, naturally. Out of my optimism, which was immature, came this desire to free myself from excess and to leave the thing a bit cleaner, a bit more balanced. Sure, it's not like optimism saved me from suffering, you understand: optimism was to defend me from suffering . . . instead, I realised that there is this fact. But, I mean, then, to suffer, we don't know what that is. What is suffering? This is an interesting subject: there is, rather, a way of living full of many facets. Now, this story about optimism related to my work, bothers me so much, this idea was truly at a very low level of consciousness, of experience, because, now, it's not that I am a person for whom everything's clear, who's okay with everything, so, 'Ah, this is a person . . .' No, it isn't true, facing life I am always clueless, meaning life is always too strong, it's not like I have it clutched in my hand, no, it's always more mysterious . . . we have time to continually be

discovering new elements. For this reason, it's not that I've exemplified it, no, in fact, I watch what comes out of me, out of others.

KOUNELLIS: Before, I don't know, I could have given you the description of something, while, now, it isn't possible because the structure is missing, there isn't a clear structure. It's like this, it's like that, and it could happen elsewhere . . . only, it could be placed there, I don't know. Now I want to make one where there's a great cloth, what are those for the boats called? A sail, but of a certain height, 2 metres tall, moved halfway from the ceiling to below and which cuts a room diagonally, not as a structure, but how it's placed . . . now, I'll tell you what I think of it, it could also be in a different way, but . . . later, painted vermillion, but it has to be seen at that moment, because . . . This also: to say or photograph, once in a while, this thing is losing value, really, because it becomes intentional, becomes a painting, becomes something to pre-serve. While this here wants to be something, yes, to have an aesthetic sense in life, in daily life, and not aesthetic in a lim-ited sense, so, really, ambiguous. I always said aesthetic to say something I disdain. But, in this sense, really, aesthetic means essential, right? Look, all essence is also aesthetic, the essen-tial is aesthetic, because there is no outside order to aesthet-ics, right? One can say many aesthetic things. A scientist, one time, told me that he discovered that animals, some birds, have an aesthetic sense to life, that when they make a nest for their eggs, it's not only for a practical reason, but they add certain things for aesthetic reasons . . . it's demonstrated that that's not so practical, they really add in particular things, essential in an aesthetic sense, right?

FABRO: We always have an aesthetic attitude towards things, if we aren't forced to behave in a deceptive way. This is not a poetic, it comes automatically, for a life process. Like the pleasure of walking: it's a whole, a perception of the thing, it isn't a sensual or sensitive fact, it's a global experience that comes from not letting any of these moments of life pass by.

It's the very reason why we like suffering, not on a masochistic level, but because it allows us to realise what it means. There's a difference between feeling and taking hold, that's actually what life is: only in the first case you receive it, you're the victim, the object. For me, the aesthetic attitude is when we live through a thing, when we live it and not when we endure it. This type of aesthetics is common in various ways. So, it's not about instituting a poetic, but about removing all the poetics. The danger of poetics is precisely this: to render not what's hypothesised in evidence, but to make the processes themselves prohibitive. The error is always in the hypothesis: you can be incapable of perceiving the error – sophists, scholastics, etc. – the argumentation lines up perfectly, but, at a certain point, you find yourself outside. Look, instead, at Bacon, Descartes, Galileo, the Renaissance types: they remove everything, each hypothesis is peacefully accepted. Look at the chivalric poets who exaggerate, indifferently, within each hypothesis: there's everything. Look at Shakespeare who now says one thing, now says the opposite, now he's bourgeois, now he's revolutionary: he's interested in how things move forward, not the coherence of a framework, the poetic.

LONZI: The interest Klee had in children's drawing was like a consequent, posthumous reflection. He wanted to know

how certain forms were born, with the intent of rediscovering a behaviour just as spontaneous and forms just as elementary. His painting also makes one think of children's drawing, but in a different way. Have you ever had any similar interest?

TWOMBLY: (silence)

ALVIANI: My behaviour feels like a responsibility to me, as a fact, you understand, very aware of . . . you know, they are all rather big words . . . However, I have a responsibility to work in order to see the results, like this, and so they will be what I expect, in the end, that is my spirituality, very much of an order, of a system . . . I'm very systematic, still classical, right? I have to see the object taken from above, from below, from the left, from the right, setting up, I don't know, from 20 metres, from 10 metres, from 5 metres. Someone could say to me 'But why not from 7 metres and 55 centimetres?' Okay 'And why not from 7 metres and 56 centimetres?' Because I consider that, well, really all of these differences are substantial and not invented or random. Then, I could also put 'chance' there: just so, the camera, while I saw these objects, it fell, 'Look what it made it become': but it's all documented. See 'chance' . . . but I have to say 'See, this, this is it, it's chance.' I want to stress: seen from the right, seen from the left, seen from above, seen from below, seen from 10 metres, from 11.5 . . . then, just so, just as a curiosity, because, in the end, that's also a result: 'chance'. I don't absolutely abolish chance, rather I have to define what it is, ultimately, I can't . . . I can't spiritualise an object that is born from chaos only because I like it, understand, because I came into contact with it, I didn't make it. In this, I should add beneath it: 'the chance'; I carry it like a document. So, my carrying this object, becomes, also spiritually, mine, because I identify it as what it is. I am very realist, in the end . . . very concrete . . . see, like this, concrete. No, not realist, I wouldn't know, the term 'realist' has too much of a given sense . . . concrete, concrete in the sense . . . In these graphics, which are only three, here, about tension, obviously – now I am working – there are dozens, really dozens, but

always with a system. I mean: this equals this, the centre is the sum of these two . . . always an optical work aided by the most precise instruments, which are mathematics or the machine, which is made from a mathematical base. Not that there are these things in the mathematical tradition . . . so, everything is mathematics . . . in fact, it's true that it's everything . . . But to bring it to the level that it's an entity because, even the most shapeless things, if we go and analyse them, deep deep down they become perfect particles. See, I go searching for those ordinary particles. You said to me, remember, one time, speaking of that object, which was this one here, really you said to me . . . see, you read very well, 'Any shape, even something shapeless, that you make, in that situation becomes a tidy object.' Through repetition, an object acquires order even if order isn't there. So, many things, understand: taking an object that is like order and bringing it forward as order, to make order out of objects, however, always on a level of . . .

KOUNELLIS: I don't understand, this, what sort of language is this that doesn't actually speak, doesn't speak at all, right? This is the western attitude, simply, American and also European, really, to carry it to these consequences. But, these consequences, what to do with them, then, afterwards? It's not that I'm saying 'What do you do afterwards?' and I'm overtaken with anxiety, this isn't the case at all about this thing . . . For Newman, it could be, also this, a freedom, but it isn't possible to proceed in this way: it becomes absurd, inconceivable, to leave everything around, floundering . . . What kind of language problems are these? The problems of language are problems that are born and die, these are proper problems: they pass and other questions come, and the painter does this work here. The painter is a channel of communication, he communicates things that are slippery even in the common language, really, which is very instrumentalised. The painter employs situations, also as a personality and, with these means, he proposes situations. If you take this away from him, what a thing to be constantly doing . . . Yes, he can also get to

a more extraordinary precision, also at conceiving of some-
thing more . . . but, I find it . . . I find it ridiculous, because I
haven't seen Newman, but it could be that I like him, this isn't
the point, only that I don't give a damn, right? I don't give a
damn either about all of the others who make Newmans.

PAOLINI: The flag is a chrome-steel pole that ends with a
typical laurel-leaf decoration in brass. The pole is about 180
centimetres tall, around the height of a person, and holds,
instead of a single flag, fifteen flags. The flags are a 70 × 100
format. The title of this work is *Averroè* ('Averroes') and . . . and
it's a title that, I realise, sounds very intellectualistic, smug,
but, at a certain point, it seemed to me that this flag could
have been misunderstood. The flags that I chose, these fifteen
flags, aren't worth anything in themselves, they aren't 'those'
flags, they are simply more than one flag and, therefore, they
are those fifteen or another fifteen, or others still, or even all of
the flags except those fifteen. The choice of number and type
of these flags has no readable character, but only a numeric
character. In fact, I would like to make, besides this example,
two other identical structures, but each of them with fifteen

others and fifteen others, in order to give, like that, a method open to the sequence . . . *Averroè* would have been the symbol of this ambiguity in choice and in quantity, in such a way that, indeed, this becomes an imprecise flag, an impossible flag. Although, later on, it becomes a representation of itself, the first occurrence is only a pretext, like that, incidental, to create an object that is forced into its own absurdity, but not as a flag, as an idea of this object, understand?

FABRO: It seems to me that also this flag serves you as an excellent pretext to not-make colouristic juxtapositions . . . In these works, there are noticeable formal valorisations, concerns about using elements that are refutable: you use the flag . . . however, you didn't invent any flag, you didn't want to invent any flag. I, in this story here, of *Cielo* ('Sky'), I have a part of the sky that will be absolutely illegible, since the scale is missing . . . yes, but, it is the sky. You often used, in many other cases as well, standard elements. And we have never spoken about this scrupulous use of standard elements, but without exploiting either their formal character as such or their own . . . now, I don't know how they put it . . . its ability to have a message, I don't know, to transmit meaning, see. However, at a certain point, can we arrive at an explanation around this fact? . . . That we always use elements that we try to reconstruct with absolute scrupulousness and, at the same time, we couldn't care less whether this scrupulousness is controllable or not.

ACCARDI: We touch the side of love, here, that no artist touches and instead saturates everyone's lives, right? Last night, I said to you, 'Oh, I like that man, he's so handsome, his wife is so ugly.' This happens: now that I'm a single woman, I always have these thoughts. But, of course, for this reason someone, then, isn't happy with certain things: if one has experiences of a certain pleasure or of a man who you really care about, it's logical that, later, it becomes a bit difficult because, if you don't find someone, it's not like you can adapt. In fact, woman, they've always believed that she could adapt,

so they said to her, 'You're single, why don't you . . . ?' I had confessions from single women, they always said, 'I might stay single . . . but, that guy society wants to impose on me, I won't take him.' Then, I thought, 'But this, it's like one wants to get used to things that are too refined, too indigestible, or else to an exotic dish, or to an extraordinary drink.' On the other hand, men have always desired the best women who are around them, within 2 or 3 kilometres, isn't it true? In fact, man is more consumed, for sure, I don't have a doubt that man is more consumed in terms of sexual relationships, he has more difficulties: if he's got a great love he's unable to forget it, even if he has other relationships. I've known a lot of men like this, bachelors and non-bachelors, married men: they hit rock bottom, like I read in these books about the consciousness of the process of the sexual game, so they no longer expect great surprises in that area, nor a great power – you know, when somebody has something that emancipates him, it trans-forms him . . . – I mean, of transformation, understand? And, instead of giving them the power to be transformed, they use the power in a mechanical way. So, they know that, first, there's the courting, going to bed and the fatigue, and they always begin again. I realised that they attribute it, scholars, to an acquired element of the male part of humanity, because I read a bit . . . A bit less for Reichians . . . Now, I am talking about something that is socially diffused, because then, Reich, indeed, is extraordinary, but his is a voice that you have to think about, to clarify it, to spread it, to see it from the female point of view, isn't that right? So, I realised that they do this, they split themselves: they become excellent lovers who seem to you like they put their whole heart in it, instead, then, the next day, the comical thing is that, they, this heart, if they put it out there, they've closed up, afterwards, the deadbolt, they've turned off the lights, really. Now, I have realised that, if this happens to a woman, it comes from a strong neurosis, a trauma that's conditioned her . . . so, I am led to conclude that men who go around in this way, which seems an emancipated

way, modern, or – if not modern, because it's rather tradi-
tional – or else a behaviour that's part of the male essence,
isn't it true? for me, a form of neurosis brought to stability. I
have tried, with my experience, with extraordinary people . . .
Can I speak a bit? . . . personal experiences that were so sweet,
without exhibitionism . . . a tenderness, a heartbeat . . . The
morning after, they were amazed that I kept even a memory
of it – I give you my word of honour because, they, they didn't
keep this memory . . . I was about to say something else that
makes me die laughing on this topic . . . So, I say: if a society
bases its current sexual experience on these experiences, it's
making a mistake . . . that's why I don't want, for example, to
insist on those experiences that they have in certain places, or
among certain groups of avant-garde intellectuals, to insist on
the possibilities of sex, it's a serious mistake, it's the same as
that stuff about the critics.

TURCATO: What annoys me in America is the Puritanism
they have. You know, if they fuck, the morning after they say
to you 'We were drunk.' Bah. It's a shame, right. The Swedish
are another story, they live in a kind of limbo, they . . . no, no.
But . . . no no. No, look, so it seems. The Swedish don't have
Puritanism. We went there, right at Christmastime, and we
went to a Swedish church, Puritan: there was only one that
was playing music . . . It was me, Vana, and two other peo-
ple . . . there wasn't anybody else. Everyone was thinking of
drinking, look. Ugh, God forbid, there wasn't anybody. No,
they're atheists, maybe too atheist, they don't even believe
in . . . However, since they are honest and for them the state
system works well . . . See why it's a limbo compared to us:
when you arrive in Hamburg it seems like you're in Naples:
confusion, 'Achtung, Achtung,' the train, here and there. A
complete mess. Instead, there, they are truly atheists: now,
they have surpassed the limit and they need belief in some
sense, you understand? Because, for them . . . Well, yes, they
have complexes, maybe someone suffers because his wife
makes love to someone else . . . however, it isn't such a strong

suffering that it causes him to draw some conclusion. Then, they're calm, they don't even ask . . . they know that a woman is more sensual than a man. A Swede said to me, 'But, in spring, here it's a massacre, you've got to always keep your dick straight . . . you can't.' No no, they really have . . . okay, in any case . . . they have surpassed . . . They don't believe in anything. See, that's why there are suicides, because, even the sexual revolution, it's not like a cure-all revolution. You know, you fuck, you fuck, then after . . . okay. Well, you understand?

ROTELLA: I think to provoke something in women, something that, at a certain moment, can give her pleasure. Naturally, in certain types of women. In fact, you see why I invented, a couple of years ago, this sort of test that I call 'erotic-Surrealist': to know, let's say, the erotic reaction of a woman. Therefore, I don't know, here's the sociological, I don't know, sexological fact . . . naturally, the kind of woman I am interested in is an erotic woman, an erotic woman in the modern sense of this word. On the other hand, during all of the interviews I've done, in Paris, with these young ladies, I was able to question the notion that youth goes onto an erotic plane that is, I don't know, of a masochistic, sadistic character or else with clitoral tendencies and therefore lesbianistic, of homosexual experiments . . . This, naturally, is a new element, that didn't exist before, as I see it, or at least, that it's heightened recently: the woman who wears trousers, who acts masculine, or who likes, maybe, to be hit, or tied up . . . This, tells me that all, or part, of the character of the modern woman, ultimately, has changed, is changing. For me, it's something positive as far as eroticism goes, the sense of eroticism and of a new sensibility, erotic sensibility, of women. The questions that make up the test are: at what age did she have her first sexual experience with a man; the second is: at what age did she have her first sexual experience with a woman; the third is: the experience of having seen a man and a woman making love and the reaction she felt before this vision; fourth: if she loves her father and her mother and, in this case, who she

loves more; then, there is another question: the age at which she masturbated for the first time, if she has seen a woman do this, if she has seen a man do this, and what her reaction was; then, I don't know, also a question about an exhibitionist element: if the woman, the subject, likes, I don't know, to show certain parts of her body to excite the man she loves; or: loving a man, if she prefers, I don't know, to make him suffer or to suffer herself, so sadomasochism; or: if she loves money; if she has had experiences of suicide, of suicidal manias or not. See, here, hiding beneath, there is this element of abnormality, if we can call it that, psychological or sexological abnormality, therefore, at the end of these questions, one can have an idea of the erotic, psycho-erotic percentage of a woman.

SCARPITTA: So, like I said, Carla, we are turned to look at the nano-car, that red car there, still the kind of car I am interested in, it's a Midget, an American car. There are three categories, more or less, of racing cars, in the classic American sense: there's the Midget that would be the nano-car; there's

the Sprint that's the kind of car we have before our eyes, the American Sprint kind; and then, we have the Championship which would be the car of great championships, like the Indianapolis. Roughly, these are the three types of uncovered cars: the man drives with his shoulders exposed, with his body outside where it can be seen. Then, there are other types of cars which are used more for touring, that, really, are also for racing, where the driver is protected by the car body. The Midget has a special configuration for shorter tracks, the dimension ratio and the power ratio diminish according to the rules of game: we have the nano-car that gets up to 150 horsepower, while the Sprint gets up to 300 horsepower, and the Championship, by now, at Indianapolis, gets up to almost 600 horsepower. This Midget is the only car of its kind in my garage-studio; mostly there are cars that can be remade into the American Sprint, which then, during its time, was the Championship Car, that is, the car of championships. As you see, the dimensions have a lot to do with the game that I've posited. The Sprint is based on the 1928 model: as a prototype, the car of Frank Lockhart, a young American from that era, who raced in a car very similar to this and he won the Indianapolis as well as on a number of wooden racetracks. It's strange to say, back then, in America, there were great motordromes where the surfaces upon which they raced were beams

placed one next to another, and the speeds reached, then, between 1925 and 1928, were simply astounding, because they got to median speeds of 147 miles per hour, on a 1-mile track. And so Frank Lockhart was really a great champion: 147 miles per hour in '27, it means more than 230 kilometres per hour today, or almost, an enormous speed considering the kind of tyres that they had on the car . . . Then, it was really taking your life in your hands. I modelled myself on this kind of car because it's exactly this kind of man that I was interested in.

CONSAGRA: What is it to be an artist? It is the tendency to recuperate naturalness, continually, to not lose oneself in the absolute, total artificiality, through which we see the world . . . I don't know, the little ladies who live in the city, the office workers, government ministers, tram drivers . . . in what way don't we think of them as completely destroyed by an artificiality that, then, wouldn't be rewarded with a recuperation of intelligence about things, information, an enrichment of personality? We find them at a level, yes, a bastard level, between animality and artificiality: we see them as they let themselves go, get fat, go to the market, make gestures with a certain naturalness . . . however, we see them off-balance, bastardised in an unpleasant dimension. Now, the artist is someone who does not have an unpleasant dimension within the city. Why? Because he is a man who continually recuperates this relationship with poetics, that is truly a call to naturalness, to animality, in a taking-back, continually, within himself and within relationships with others . . . See, this fact of falling in love easily for artists, or of constant little passions on the level that is, well, so superficial more or less . . . in the end, this continual attempt, this possibility of falling in love that the artist always feels, is really the awareness of never having to miss out . . . You see the poetry, the poet . . . The poet seeks to be tied to feelings . . . feeling, this lament, in general, or joy, what is it? or love itself, what is it? Love is, really, clearing the space around oneself of all mechanical elements, it is a state of absolute naturalness. This extraordinary oasis that is love,

it's this. The artist will never be an artificial person. To me, all of those who talk with the character of technique, of cybernetics . . . for me, already, they are . . . they're robots, see, those don't interest me, because nature exists, it's a total element of life, there's nothing to do about it. And then there's the city . . . however, the city, one needs, I think, to consider it, in its detachment from the natural, as the possible realisation, at the highest level of one's qualities, of recuperating the pleasure of living, of understanding, of intelligently widening relationships with life, with information, with conversations . . . To enter into the human relationship in the most total way possible. See, for me, people longing for affection or people who are very affectionate, they feel this tenderness, really, of animality, within, it's the beckoning of these elements in order not to lose them in artificiality. The city, I see the city as . . . once the boat has left the port, if it becomes something else, if it becomes an island, this island has to totally be an island, it has to be an island where there's everything, the maximum. There's a possible intellectual return, there's a possible return with consciousness: maybe, let's say, someone like Jesus Christ, yes, capable of returning and of expressing himself as if he's understood everything. A return in that manner, naturally, is rather utopian, because no one can have such a strong beckoning from his animality, to return to being animal, and also be conscious of everything, it's impossible.

ALVIANI: No, I am researching heat, that is, using heat. Very simply some phenomena that are found in nature, but that still, brought to the stage of visualisation, are therefore aware of the reason why they are not there. In some problems, for me, things must be invented, in others it's enough to acknowledge them, meaning to observe at the presentational level, at the level of optical fruition. This interests me, really, also didactically, because, in the end, also didactically, all of these things, I would like it if they were provable in their procedures, really. These are objects of authentication, almost didactic objects and other things. The production of a series

of objects is very interesting to me, really for this obvious affinity with technique, with the mechanical instrument that, exactly, it's right that it's this way. It is right socially, because the majority of people know this research, the majority . . . this whole thing is demystified, it becomes a profession like many others, in the end, a profession that . . .

LONZI: What is it that becomes a profession like many others?

ALVIANI: Uh, behaving plastically, meaning to be a plastic creator. It becomes a clear profession, really, aware that it has very clear-cut foundations.

ROTELLA: I also performed shows at the Chelsea Hotel. Shows that weren't on the level of a happening, but on a level of truth, I call them 'Truth-Shows'. I use a model, one or more models to perform these 'Truth-Shows', in the sense that they're not prepared like the happenings from America, but they're improvised shows. One of these shows was the one I called *From the Chelsea Hotel with Love*. At a certain moment, I

dressed like a guru, in the style of a guru, with the semi-nude model at my feet. This was a kind of yoga ritual, yoga ritual or transcendental meditation, that I tried to carry out at the Chelsea Hotel, where I was staying. Naturally, photographers photograph these scenes, there were three or four friends who assisted, and from these photographs I extracted a kind of poster that was the result of the show, which lasted about three minutes. These shows I did there with the conviction of doing something new, in the sense that I think that an artist, at a certain point, I'm not saying that he has to stop painting or being a sculptor, but he has to put on shows. And, these shows, it's not that they have to happen in an Art Gallery, but they have to be given in public places like, I don't know, a hotel or in the middle of the street: I think that this is very important. So, this was my intent. There was an element of humour because, naturally, there is also humour in works of art and therefore . . . So this is how these shows occurred. And that was, yes, the difference with the American happenings that,

according to me . . . I'm against happenings, not the American ones, the happenings they do in Europe, because it's always an imitation of what . . . In the end, happenings are American, it's something born in America, therefore, let's leave them to the Americans.

PASCALI: They talk about ideas about performance in relation to my things, but I don't think it's fair: I do an exhibition, and my gesture is identical to that of other sculptors who do exhibitions. If you do an exhibition, automatically you are doing a performance, but not in the theatrical sense: sculptures aren't actors, they also aren't stage sets. Theatre is theatre because there is the living man, if there is no living man it is no longer theatre, it becomes something else. At the most, if one wants to make a comparison of genres, which can also be dangerous, one could say the spectator becomes the actor, and, in fact, for me it's almost a sadistic amusement, a kind of wickedness to see the spectator. The painting, the wall, the Gallery truly become that space because there are no walls in Galleries: they are white, abstract . . . there is a place where you rest your feet and a place where you watch, this place where you watch is one thing, a physical thing, it isn't that the Gallery becomes a stage, the Gallery isn't there, it's truly your paintings that make the Gallery. I don't believe one has shows in Galleries, one makes Galleries, one creates that space that is one's own space, and since it's always the man who looks at the painting and not the painting that looks at the man, one can talk about the spectator-actor, from this point of view. I too say, yes, 'the performance', but I simply mean in the sense of that human organisation that created Galleries and shows. That's the performance, that's the social, political phenomenon, through which the painter wedges himself into society, through which he justifies himself: it's the only means he has to be able to exist in society. Without this place the painter doesn't exist, by now, he becomes an artisan, a specialised worker. The Gallery is an abstract place in which a man can, as such, say: it's a kind of pulpit, let's call it

a pulpit if we want to give it a bit of an ambiguous, Christian, dimension, in which a man says his own mass, right? and you find these kinds of little altars attached to the wall. You understand, in the Gallery, they become little altars, and the object functions if one makes it with that intentionality there, with that attention, with that indispensable existential reality . . . if it's not indispensable it becomes a decorative element. Once the gallerist takes your things and you show them in the Gallery, these here become another thing, they become a, maybe, the negative of painting, however, indispensable. They become a kind of graveyard in which these things are truly tombs and at the same time the simulacrum, the altar, the Bluebell, anything, but they become the object to look at and at the same time the object that completes this spatial journey of the Gallery.

KOUNELLIS: It's like, I don't know, having a space as big as life itself . . . but, to fathom the space, there needs to be something in it, even something small, right? This is religion, a compact structure that's there, and you understand here all of the space, otherwise it would be the infinite, it would be inconceivable. To give a sense of the space it's enough to put something really like this, not really . . . and, so, one conceives of the space that's around us.

FONTANA: By now, there is no longer measure in space. See, now, the infinite . . . in the Milky Way, by now, there are billions, billions . . . The sense of measurement, of time, is over. Before, it could be that way . . . but, today, it's certain, because man speaks of billions of years, of millions of billions to reach . . . and, so, to see the void, really, man reduces himself to nothing. And man reduced to nothing, it doesn't mean that he destroys himself: he becomes a simple man like a plant, like a flower and, when it is pure like this, man will be perfect. Because, we, we have mystery, man has this great mystery which is intelligence, this fact that we are, structurally, the same as animals, how we live, eat, suffer, and so on, but we have this mystery of intelligence that, still, is

overpowered by the material part of man, by this materialist way of living on earth, that hasn't conceived of the infinite. When man realises . . . that he is nothing, nothing, really, he is pure spirit, he will no longer have material ambitions, you understand? When science has demonstrated to him, what it is already demonstrating, that he can be composed . . . If they discover a human cell that replicates itself, I said it to a priest, 'That is the end of the world.' Besides the fact that, if they discover a cell that automatically self-replicates, the sensual part is lost . . . okay, it will be disappointing for those who are living, but for the men of the future, no . . . It's the end of the world, because the end of the world won't come as an earthquake: God made a man-spirit, He thought of him as similar to Himself, He put woman near him . . . this is my own science-fiction, but it's worth as much as a Catholic's theory, isn't it? . . . then He put Eve by his side and he sinned. Then God said 'You, now, are a materialist man.' But God exists, and if someone believes in God, how can he say that the world will end? At a given moment, God gives a scientist, or a hundred scientists, the ability to create pure spirit and, so, the cell is created, and matter is over: man becomes like God, becomes spirit. Look at the end of the world and man's liberation from matter. I say that, instead, man, with these great discoveries, with this understanding that we're nothing, with this understanding that it isn't necessary to be Napoleon or a scientist and go down in history . . . because Napoleon, in one hundred thousand years, will no longer exist . . . So, man will become a simple being, like a flower, a plant and will live on his intelligence alone, on the beauty of nature and he will be purified of blood, because he constantly lives in the midst of blood. Maybe he will no longer kill animals, he will create pills, he will live artificially . . . because he's still a cannibal, isn't he? . . . Men will no longer kill one another, wars will end. It will take hundreds, maybe thousands of years, but science will bring him there, right. Because I, today, if I were a Pope I wouldn't want to be painted, I'd hope that, once I'm dead,

there would be nothing left, I would no longer want anyone
to call me Pope XV, there . . . If I were President of a State, I
would want my actions to end on earth, I wouldn't want to
aspire to a monument, afterwards . . . What are those? They're
materialist ideas, right? And my art is also carried towards this
purity, towards this philosophy of nothing, which isn't a noth-
ing of destruction, but a nothing of creation, understand?
And the size, really, truly, the hole, the first holes, it wasn't
the destruction of the painting, the informal gesture that they
always accused me of and I never said anything, it was really
a dimension of the beyond of painting, the freedom to con-
ceive of art through any means, through any form. Art is not
painting, sculpture, alone: art is a creation of man, that he can
transform into anything . . . as it can also end, because there
will also be such unusual facts . . . Art will seem too elemen-
tary: it will be surpassed by the intelligence of man and other
activities will replace art.

NIGRO: I, in *Spazio totale* ('Total Space'), continue research
in all possible, imaginable, directions, that can be truly exist-
ent: we don't know. Anyway, it doesn't matter, what counts is

to have an optical impression of it, don't you think? A very vast world of investigation presents itself to me and, yes, the realisation of a painting gives the spectator the opportunity to daydream . . . On the other hand, in this latest *Tempo totale* ('Total Time') research, the spectator's fantasy is sacrificed. However, psychologically, the element of the sensation of time passing intervenes and puts the spectator, not in a condition of formulation of images, but, halting his attention on a limited progressive series of the same image, it constrains him to a recurrent thought . . . maybe the acknowledgement of time passing. This is the fundamental element that constitutes man's most primitive essence, I think. Man, in the end, lives in a very rich, very broad way, has many experiences . . . then he realises, at a certain moment, that there is a single fundamental experience: he who lives and time that passes. Other than this experience, the rest is an episode. There can be, yes, a series of episodes which can, yes, have their importance, but, I think the most important thing for man is contemplation, but of nothing. When man is able, not even to contemplate, but to know only that time passes . . . for me, man has reached perfection. Otherwise, there would be the terror of death . . . I mean: the colour of these rhythms of *Tempo totale* is simplified into the truly essential question: as a term of psychological counterpoint to the sign that develops. Naturally, I'm able to carry forward two or more series of iterative progressions inscribed in an ideal shape – because they must have a limit, woe to them if they don't – and so, when I make two or more series, I can make two or more different colours and I execute them according to the moment in which I am living, according to my mood. I don't know, it could be the juxtaposition of bright colours or not . . . 'allegretto', 'andante', 'mosso'.

ACCARDI: Several people tell me about their experiences, experiences that I have also had . . . but, I realised really . . . maybe because I, in love, I also have this parallel that may also have to do with creativity . . . that everyone

could have, because who doesn't have creativity in some part of their life? Now, joking aside: I know that certain creativity, the creativity of my work is also in my daily life, therefore, if others are a bit careful, they also have it, certain points. So, they, also in sex, should understand that this must be safe-guarded, because if they get mad . . . I was talking with Toni, it was very interesting, with Toni Maraini, you can leave the name in, if you intend to write something . . . and she said, rightly . . . I like to put the good ideas I've heard with the people I heard them from, you know, I never appropri-ate them, you never noticed this? I always cite . . . You, so much, you, you do it, but so do I, really, I like it, it's part of my everyday speech and, so, why shouldn't I put the name in . . . and, then, it enriches things a lot, right. Toni said 'Look, this was an unbearable habit taken from Anglo-Saxon culture, this going too deeply rationally, denaturalising all relationships, women imitating male behaviour, instead . . . there needs to be transformation . . .' Like you said, 'Let's transform women.' No. You said . . . wait . . . that there are also men . . . Ah, what a shame I forgot this, because it was

important . . . the transformations . . . I'll remember it for sure, and now that I have this recorder here, it makes me suffer. I'm also a bit confused because it's been all winter that I've been thinking about these things, which is why it all comes rushing back to me. And, in fact, I think I've said enough for the moment, on this point. Yes, I leave it for a while, yes. To speak about Reich brings us to a field that, then, everyone says 'Ah, what, you're a Reichian, but how? so you're interested in love!' Of course, I want to see who isn't interested in it. I realised this . . . I spoke to you about it the other night, so I want to mention it, because we said that everything that I would mention, everything I could remember . . . when I have to do something or I think of my desire for an encounter, or I think of love, I'm very prudish. Then, I realise that men have drenched their lives with it, they think of it a lot, they talk about it among themselves a lot. On the front line, aware . . . for example, a man takes a trip and says 'I make sure I have a person to meet there, in that place.' Like me, when I went to New York, I said 'I have such and such a friend who's coming to pick me up at the airport': this gave me a taste of the stay in New York. And I thought '*Madonna*, Carla, what kind of person are you . . .' Then, I realised that they do it that way. This, however, isn't something that disqualifies them, because they are specialised guys, industry managers, they are obstinate in their thoughts, this doesn't distract them . . . they are unbelievably respectable people. I find this division almost condemnable, I don't like it, really, I don't think it's interesting . . . however, I mean that this kind of behaviour is quite common. It's for this reason that Samuel says 'You seem like one of those women who before everything says: I am a woman here, look at me as woman.' Hey, I'm not pushing for this man–woman antagonism . . . however, this point exists, and I wanted to insist on it, now.

PAOLINI: If we consider the roots of our work a bit, I don't want the term to be too . . .

FABRO: . . . radical . . .

PAOLINI: . . . radical, but regarding our previous work, a bit, mine and Fabro's, which characterised our respective activities a bit, if I understand correctly you are widening the perspective, establishing a new perspective of work. And I mean a development of your work on motives that absolutely don't contradict the above-mentioned roots and that, anyway, seek to focus them on research that is always rigorous. It seems to me that these elements that you've defined, speaking of *Cielo* ('Sky'), are more fantastic – it seems to me that you used this term – they absolutely do not compromise the validity of the research. And, namely, that this research would always happen according, as such, to a very careful investigation. Anyway, indeed, there is the happy, uhm . . . concurrence of a much more enjoyable work, I mean, always, however, on a very rigorous level. That there would be a kind of embellishment of a certain philosophy, well, if the slogan holds up. This, maybe, is an argument that I brought forth, as such, conveniently and, maybe, I don't know if it fits . . . later, you will have the chance to contradict me, anyway, I brought out these considerations because, as for me, I perceived a development that in general is analogous: that moves more lightly, with less severity, simply, see. I believe that, as for me, to make use of qualities of embellishment, I almost want to chase . . . I don't know whether to say beauty or . . . balance.

They are very improvised terms, but in substance, of exquisite approval, see. Naturally I am touching on arrogance . . .

FABRO: No, you're touching on a bluff.

PAOLINI: Uhm . . . uhm . . . Maybe, I'm inclined towards developments more of the image and I hope that, at least, it might be possible to approach my new works here according to criteria that could be very similar to that used in certain criticism of ancient art. And, namely, the analysis of the particular, of a certain type of image that doesn't appear culturally, but, together with this, something more complete, more relative to the image itself.

KOUNELLIS: But one thing is true: that, this stuff about unity, I also hold it to be the only possibility and the last thing to do in this situation in which we find ourselves. It's a proposal . . . that is, it isn't a proposal, it's something said in a simple way, it doesn't have a nostalgic reference, does it? I think that, this is connected to the fact that I'm Greek, with wool, but wool is also a means, in this way, it is the most fluid

material, it allows me to make this gesture, like this, to tie it, it isn't a technological material or one that recalls some sense, as such. If it's tied, it helps me, unconsciously, to have more contact . . . so, it could be that I also have a particular contact with wool, however, this is relative, it isn't an extremely important thing, right? If you're in America, certain visual things come to you and you use them in different ways; it's more than natural, there, I don't know, the presence of filth in a painting. To accept a dirty material, really, it needs to be lived, to have visual experiences of this kind here, and it isn't possible if you don't have them and if you don't automatically address a public that has the same visual experiences, nothing comes to you. It would be a strange thing, like many who wrote, here, Coca-Cola. There are some problems . . . one can accept it or not, however, there are experiences of this kind there, there are. I can't do that, it seems incredible to me: if this also recalls Greece, as such, it could be. It's that many people understand the thing, only that they want to neutralise the real problems, so they throw it onto this level where it can be easily neutralised, right? Because, I don't know, they don't accept another alternative, they accept problems of the same kind, while I mention them for another thing, that has absolutely nothing to do with what happened there. And they are fixed on poetics in order to eliminate the problem of what might have a historical consequence, right?

FABRO: One thing happens, it seems to me, in your works, that you, Paolini, never admit, I don't know if you deny or if you don't admit it, anyway . . . beyond this care that, I think, is an attention to style more than intentionality. You naturally give a lot of attention to the style of a, let's say gesture not in a gestural sense, anyway of an operation. However, the key doesn't seem to me to be in the style itself. The style is a form, as such, to embellish a certain thing, you see. You can even ask for a coffee with style, and they say that you are someone with style. You do a bit, I think, what I do in other things . . . now, what I do . . . okay, anyway it can be useful:

you work with style, like I work with philosophy. However, the key to the work isn't . . . Actually, behind your style, there is a whole series of operations that are, then, the key to the work, because style alone wouldn't hold up. You see, like how behind my work there is a key in which this philosophy, okay, serves this purpose, in a very approximative way if one comes to bring it back up with me. It isn't reversible, I don't accept reversibility in certain philosophical behaviours of mine, in as far as the key is beyond, in an immediate contact, in a kind of scruple towards the person who finds themself facing this thing . . . to leave them an operative field that could be only limited by its own limitation. At the very moment that I'd see one of my works circumscribed in its own hypotheses, I'd discard it. Hypotheses are like when I was talking, I don't know, about the equilibrium of structures, of the deviation of the beams in a specific room with a beam: it certainly wasn't the thing I was interested in, it was the element that I showed off, simply in how much I predicted it as a primary behaviour that, if not shown off immediately, would have eventually arrived later and would have been the end point, while it could only be a point of departure. Like if I show you a box that you've never seen, I say to you 'Look, this is a box of matches': you can do all the maths about the matches and you can consider it beyond this wonder which then, in the end, would be resolved by discovering that it's a box of matches. See. And, like this, I feel it happens to your work as well . . . with this style, with this improvement, with this attention to taking certain elements, in showing them with discretion . . . but there is something implicit behind it, that immediately goes beyond. In the same moment in which you saw yourself rewrite these things or ideologise or reach, as such, a revival on a level of the ideas in your work, you immediately felt, in a certain sense, offended, in as far as it was an extremely implicit element, extremely vague and extremely augmented, that wasn't reducible to the literary presuppositions of the work itself.

SCARPITTA: What is it that defines a car in a historical sense? I say: this is a car from '28. It's not like it existed previously: it became a '28 because I'm working, here, like a man from '28 didn't exist in '28, minus some pieces that I used almost as collage, but the car became from '28 because the systems of work are the same, because necessities and desires are the same. In this sense, I don't make anachronisms and I don't do restoration either: I try to recapture a certain kind of man that I find still exists in the United States, hasn't changed at all, it's the same as the men who get in the most powerful cars of today . . . It's strange how his face beams when he enters into this atelier-garage. Because he recognises, in here, the same needs that pushed him to race and, how to put it, comparing a racing car to a rifle, there are ballistic developments in gunpowder, there are also important modifications like the shape of a piece, however, like the barrel, we're always there, and the marksman clearly sees this analogy, when he comes in here and, even if he is curious about some archaic fact, it's strange how he finds himself, *tout de suite*, at ease. For example, a car from '28 . . . well well, one immediately thinks, if one's up on these things, of a fishtail: cars from the '20s have a longer tail. So, one studies the ratio of this tail in respect to the rest of the body, one studies this lower tail, one tries to make it light, however also the dimension . . . And so, we move on, to the dashboard, that in cars from the '20s is higher than those that came later, and the driver looks this way, he rules a bit more from above. Now, racing cars are made in such a way that the driver is almost lying down inside, seems like he's looking at the moon, like Manolete when he would make a pass. In these cars, on the other hand, the driver sits properly, almost as if he were in church, with his head positioned at the centre of the dashboard, looking down, along the line of the car all the way to the radiator, and forward, just so, holding him nearly symmetrically within the car. The dashboard is made precisely for the driver: only his goggles should be visible from above, and his position is already different from that in the other

cars I've made, already the way he sits in the seat is different: he becomes a man from the '20s, and he has the attitude of a man from back then, who still races wearing a tie. The car I'm constructing now is the oldest one yet, the oldest of all the cars I'm interested in. And I don't want to go further back, I don't want to get to brass, to curious, enormous, extraordinary cars, of the epoch before and after the war, because it seems to me that we enter into a field where romanticism falls too far outside of the severity of the language that I've set for myself. I have to keep myself within a sphere of standards almost, of laws almost: I don't want to enter into the bizarre, I don't want to enter into the capricious, the exotic, I want to hold the line, I mean, in the sense that my cars are part of, almost, a pre-established geometric shape, I don't mean to make them baroque or anything else, I want to reduce them to the structural minimum, also aesthetically.

FONTANA: For me, it's almost a moment of crisis, but not of a crisis of renunciation, understand? Seeing, now, this entire total change in contemporary art among the young . . . because, now, it's no longer how it was thirty years ago: painting, not painting, Modernism, Futurism, avant-gardism . . . Now, I believe that the structure of art, really as a whole, has completely changed, hasn't it? I truly didn't expect this boom, this evolution that came so quickly and so homogeneously with all of the young people who are so uninhibited, let's say, with new research. And, so, an elderly man, an artist who, I believe, also recognises the value of others . . . I'm not so self-centred that I believe only in myself, because I have an extremely up-to-date collection that began also . . . he remains as confused, almost impotent . . . and says 'But, me, what do I do, now?' Then, I resign myself a bit because I say 'Well, in the end . . .' it's useless, modesty, it's also idiotic, 'Well, you've already done enough, maybe the young will do what you wanted to do, that you weren't able to do because the time wasn't right yet, maybe you sensed this.' You could talk about the future forty years ago . . . not even

today can we say what the future will be, however, in these forty years of my activity and of what I see in the artistic world, there was a future, really a transformation about the end of painting, of painting itself: art carried to a fact, which is by now structural, but not in a constructive sense, structural in a philosophical sense. Art went after a concept that I had always imagined. My crisis, now, it isn't a crisis of impotence, maybe it's a crisis of maturation: the *Spatial Manifesto* speaks clearly, therefore we have almost arrived at what I aspired to do. Only, the young come in with a new organisation, because it's logical that the young always have fresher things, and I would feel . . . if I had to use lights, even neon, today . . . to copy. I'm not a fool, because I say things that I don't care if they are published, this ugly habit of people who haven't done anything, today they occupy positions, let's say, also in the avant-garde, but they've never understood anything. We have someone like Vedova, who I call 'the Prime Electrician of Italy', who has always painted, and, I don't

know, talks on television about light without ever naming any other artist, people who have done research, he doesn't remember who came before him by ten, twenty years and speaks as if he has invented all of it. The thoughtlessness . . . Those are really the ones who destroy art because they do things that they haven't understood, because, today, you get an electrician to put little mirrors in front of a floodlight and it makes modern light. And even there there's the bad artist and the good artist. I say Vedova like I could say fifty other names, but I say Vedova because he had the audacity, really, to speak for an hour on television declaring himself creator of all the movements that were happening, going as far as to say that drawings he made when he was twelve years old pre-empted, yes, the organisation of the show in Montréal. Crazy things, you don't think an artist can lose control and not really have a way of seeing thing clearly, you know? Now I, naturally, always try to renew myself, modestly and without taking huge steps and, maybe, still thinking myself avant-garde. Because now, I will show my oval paintings in Rome, I truly believe in them, because I believe more in a philosophy of nothing, right? Also, these machines that function, like this . . . it's kind of figurative art, it makes the light appear . . . they're machines that stop, we still don't have the proper machinery to do these things . . . I believe that they are very useful for a guy on the street, who sees that art can be made by other means . . . however, I think that the road is still long, really long, to get somewhere. Maybe, as I have always maintained, art is socially finished. And this stuff about reproducing art in a thousand copies, a hundred thousand copies doesn't get anywhere new, because in a book Michelangelo is published a thousand times . . . it's the same as if I printed a drawing a thousand times, what's it mean? Tiredness, it's about wanting to impose things on the public that they don't want to accept, because art isn't of the people, art is a science. That myth saying art is made for the people . . . no, I never believed it. Art is made for a certain popular education: the

people, with time, understand it and must be helped, however they are artists' creations, that, today, are almost those of scientists. Art is a science like mathematics . . . not everyone can be a mathematician, they can do two plus two is four . . . someone can paint an apple, but it's not that he understands art. Here is the very serious problem. Instead, they believe that everyone has to understand art. Basically, you say, 'I see it, I can judge it.' No. It's the only thing that it's suited for, really, that's the mistake because, before a mathematical or geometrical problem or one of Einstein's theories . . . the same for the other sciences, in medicine . . . man is silent in as far as he doesn't have the preparation . . . instead, in art, starting with politicians, they all see themselves as . . . And, there, they unload their asinine ideas, their imbecility blossoms as they let loose about art being here and there, and so on. Instead, they haven't begun to understand that art is a science like any other discipline, right? If I make art for the people, I should be . . . the people I said, not the workers, all of the people, also great philosophers, great doctors: one can be a great doctor ignorant of the facts of art, like I, an artist, am ignorant of the facts of medicine. And, so, we have to work for evolution, really, and woe betide one if . . . not only in painting, but also in the sciences . . . if one has to work for the popular mentality: we would still be in the primitive stages. Instead, the people must be educated, must evolve through these scientists, through these explorers who push the average man on the street's life years and years forward. Think of it, an atomic scientist came a few days ago, he saw these ovals and asked if I was a mathematics researcher, if I studied Einstein, because, he says, they have the shape of Einstein's mathematical organisation, the universe is crushed and long, it's almost like a cigar. And in reality it's accidental, right? It's a shape that I studied for a year: it's the simplest and most modest there could be. Nothing: it has its usual holes, this space is always my ideal: I change the shapes, I use lacquered wood, materials that are also current, now. It's not

that I want to discover something, it's quite something else, I want to continue as I am.

TURCATO: Here, it isn't about making social or sociological art, here it is about seeing, in a century, which are the predominant ideas, that give variation to a given universal situation. So, now, in the twentieth century, what do we have? On the one hand, okay, the socialist struggle, and we agree, that however, unfortunately, it didn't know how to take anything, and then the Nazis, because there is also this story here. Well, it's not like . . . well . . . Now, the colonial struggles have emerged . . . but they always take that shape, that's the same phenomenology that we had. Actually, our war of independence was the first war of the anticolonial order . . . okay, in a more evolved country, even if it was a real disaster. However, the shapes of underdeveloped countries, like in Africa, take their shape from the Nazis, there's nothing to do about it. Then, there is now spatial history. Then, there is sex, which is no longer the sex of the Surrealist order, it is sex itself, real, I mean. Surrealist sex was already a literary thing, out of fairy tales, recounted. In De Chirico, in fact, there is never sex. It's that De Chirico, everyone knows, bothered some people and we also said, okay 'He's a wimp because he doesn't defend . . .' On the other hand, in these recent times, he has defended very well . . . he's even inveighed upon art . . . Now, he thinks himself to be the only genius in the world, right . . . and maybe he isn't wrong, and maybe he isn't wrong, because look, Picasso is managing in a very frightening way, right. He says, 'I am there, then I made compromises, but these compromises are part of my life and of my character, take me as you like.' In the end, his situation is quite candid, all things considered, it's not like he overdid it. Even in France, Matisse is superior to Picasso, I mean, let's be honest . . . You know, Matisse, in his last things, the collages, from the point of view of colour he invented a colour, that silver . . . very important, right. In American art there is Noland, no, Newman, there's also . . . yeah, okay, interesting however, still too theoretical, right . . .

Because, you know, even Abstract Art, like that, has to . . . No, Rothko follows tradition, but Rothko makes New York sunsets, all in all, looking carefully, New York sunsets are formidable, I don't know if you've seen them, especially in autumn, he frames them . . . No, a big painter, but, really, I think, the creators of this century are these, what do you want . . . the others either they belong too much to a D'Annunzio-esque element, or they belong too much . . . Also Burri is a great artist, let me be clear, but he's a post-war artist, well. He's an artist of the collapse, he's not the artist of the addition. However, he saves himself well, because indeed . . . he has something crepuscular . . . even ironic, you understand . . . It's not simple to judge, like that. And, still more difficult, to calculate in twenty years, in fifty years who will be, from now, the best. But no, you can't! You know, they created, once, the Museum of Useless Machines . . . for example: Stevenson invented the locomotive, right? The whole Museum was made up of those who tried to invent the locomotive . . . there was also a locomotive with mechanical legs, you understand? Now, in this, science and art even agree. No, I think, we are out of tune, in the current moment, we are confused about seeing things not from their point of view, truly . . . And, like this, the relationship between men and women is out of tune: the wife who is too clingy is out of tune, the wife has a job in society in respect to her husband . . . The husband, however, shouldn't be jealous of his wife, the wife can also do as she pleases, what's important is that she is in a certain setting. And then, women who fuck around are perfectly right, what should they do? They were born for that. It's self-evident, I say.

PAOLINI: Any radical behaviour, either in style or implicitly seems rhetorical to me. The implicit has to be implicit: if the implicit is translated into the explicit, in the blink of an eye, in the sense of a homage to a certain rigour that is too marked in the work . . . When the lack of accessories, of style, to use this term, is even desirably exhibited, when the style is cancelled ad hoc to the advantage of the implicit . . . An example

could be that of critical moments of any avant-garde. In the most communicative moment of every avant-garde, that is, when it is born, there is always this radicalisation of meaning in the face of the enjoyability of the work, this reducing of the terms to essence. I don't believe that a rule can be made of this: this has its precise reasons in certain precise moments, in certain precise situations. I don't believe that this radicalisation of meanings can be chosen as a custom, without minimal attention to . . . completeness. Indeed: beware of satisfaction with the implicit in ourselves, that, in the end, is still more aesthetical than compresence, which on the other hand is the more natural, of the two things. Aestheticising satisfaction is to reduce everything to this essentiality of discourse and, therefore, is perceptible only implicitly and not to be seen.

FABRO: In the writing you read yesterday, that one there, that long one, that Lonzi had already seen before leaving for the United States, there was indeed, an observation, if you remember . . . I wouldn't want that you had intended . . .

or that I had expressed myself badly, referring to the implicit. There are two types of implicit: one implicit that is truly implicit in the most logical sense, the most natural, and then there is a kind of board game about the implicit, because, I think, it's the opposite of radicalisation . . . What you call, actually, 'the blink of an eye' about the implicit, is not implicit . . . We all agree on considering it implicit, but, in fact, it isn't at all: it's on a level, just so, of a mental snapshot. Like the story about the jokes, I don't know, you might have heard it, about those travelling salesmen who on the train said 'twenty-four' and they laughed, 'twenty-five' and they laughed, 'twenty-six' . . . Yes, because every joke corresponded to a number, since they didn't want to repeat the whole joke. See, I wouldn't consider this implicit, but something more explicit than other things: in fact, not only the content is explicit, but also . . . the form is explicit. Because, when the guy says 'thirty', the others don't laugh because it was told by a guy who wasn't good at telling jokes. A moment ago, just now, you were speaking, Giulio, about how things have changed . . . Our conceptions of experience, of embellishment, of the implicit . . . they can certainly be misunderstood, in a moment like this one, when they differentiate themselves in a fundamental way from the initial moment in which they were made. When four or five years ago, I on one side, Giulio on the other, had these discussions and analogous discourses, we could contain them perfectly well in a structure that was also quite, let's say, general, in as far as the development was tied only to us, it was ours personally, so we could bring in the specific elements of detail directly through our work. They couldn't be misunderstood since, in that moment, they were still only our ideas, humble things that we carried behind us as we were able to pull out what we could pull out by our own strength. While, now, we work in a context in which, from one day to another, this idea becomes a common asset, and it is immediately generalised. It follows that we are required to bring in a much more subtle specific

contribution, much more probative than we were interested in bringing in before, because, indeed, the fact that certain ideas pass, from one day to another, from personal things to current ideas, from one moment to another they become hasty ideas. In the same moment in which they are accepted, they are smeared and transgressed, betrayed, you see.

ACCARDI: I used markings, right? In the thick of it I could say 'I make it completely anew,' and use another thing. No, because if I don't feel it instinctively, you understand? . . . I can even feel that I no longer want to make the markings, right . . . however, instinctively, what do I feel? I reason a bit too much, by now, it's not that I'm truly in that phase any more, the truly instinctive phase. So, a tremendous diffidence overcomes me: I absolutely try to do what appears to be a bit tied to my subconscious, you understand, to my needs . . . This story, now, about how I want to a make a huge tent, I want to know tents, this stems from some situation of my own, truly, and so I feel some legitimacy to continue with it, and this love is what can tie me to the thing. I can't have a participation in life that unfolds, that transforms, to such a point that I completely transform with it. No, I don't believe in this, it would become an estrangement . . . More than two, three great things, really, it's not that you can . . . and so, who knows? Then, it's not like I've concluded anything, because I don't know what to conclude, you understand? I feel very close to those who are younger than me, and to everything that happens, very close to their demands, their ways of reasoning . . . About the world, I'm interested in everything that came after the post-war period, however, biologically, my life is temporally, it happened in that certain way. So . . . Instead, with my peers and those who are older than me, I no longer have much . . . when they talk they don't interest me; this is something that, surely, happens. However, I don't feel able to say 'I am completely separated and I make something from scratch, really.' Which could be, even, the intrinsic reason for wanting to make

something from scratch, okay? Then we see, it will be exam-
ined, right? Certainly, it's not like you can behave like you
were born yesterday, really, so, you see. So, I would like to
already see myself, me, as I am in relation to others . . . how-
ever, I absolutely have to accept that I can't see myself from
outside. Every so often, this torments me a bit: I say 'Who
am I?' In relation to my generation: 'Who am I, what am I?'
This, I have to resign myself to the fact that I cannot, maybe,
ever know: others can know it, but me, not so much, right?
What came from me, as it is being conceived, it was me who
thought that . . . then, if an idea is born without my partic-
ipation, I, absolutely . . . yes, yes, it's a field which is really
absolutely outside of my jurisdiction. In that thing there,
really I, I should not interfere, absolutely, understand? When
I made the tent, it was because it came from my need: so,
I feel a legitimacy about that, because we spoke together,
remember, it didn't come out of the fact of seeing a work. I
can see a work perfectly well, I've always done it, right, even

as a girl, always: if I see a work, it influences me, perfectly well, I take over when it comes to some things . . . however, it's a suggestion, something else entirely, very different . . . then with my little brain . . . On the other hand, I see the finished work, I understand it, from someone else, so, in the moment, I can no longer touch it, and in fact, I don't want to, well, it's not that . . . So, I made this little environment for Marlborough: I had been thinking about it for a year, first I made an object, than another: it came out of some needs that I had clarified . . . Even if I didn't know how to resolve this issue. You see that it's the truth: I said to you 'I made this environment': my question mark always stays the same 'What is this, what am I?' Do you understand? Because, naturally, it's an environment that's less . . . you can say 'This is not conceptual.' Naturally, it isn't like Fabro's, Pascali's, which departed from the fact that they expressed a concept about what exists: so, really, a concurrence happened . . . Instead, in me, it derives from a flow of my feelings that have lasted a long time in relation to outside life, with the enrichment of other means that, in the meantime, come to be automatically chosen, even with common means . . . always, however, with that tact, you understand, without consuming it, ultimately, with both hands. Then, every so often, I have the desire to make something greater, more . . . lots of space, in a big, beautiful studio that I'd like to have . . .

NIGRO: Next to the title of *Passeggiata prospettica con variazione cromatica* ('Prospective Walk with Chromatic Variation'), I put subtitles: *Le quattro stagioni* and *Il corso della vita* ('The Four Seasons' and 'The Flow of Life'). I don't know if I introduced it with or concluded with an autobiographical note. It's sad because, in this moment, I'm in crisis in diverse areas, aside from certain personal questions, but really on the level of development . . . For this, I rather need to experience something new not only in art, but, I think, also in life. Because, I don't know, I might feel like someone who's retired, like someone who's already dead, understand? For me, the retiree is a corpse who's waiting for physical death, but it's done for good. When the creative act is over, that's it, there's no more purpose. Yes . . . well, unless other purposes come up or different things. Unfortunately, in my work periods of exhaustion have always happened around certain problems. And, so, that's where the critical points come in. Naturally, when we're younger, I, mentally really, I think that we surpass ourselves. When, on the other hand, when we get on in age, there is this kind of fear: of no longer being able to create anything else, of no longer being able to do anything else. This is the terrible fear that I have. I mean, look, I, for practical reasons, I can even live off the income of works I've already made, I don't do anything but repeat, and remain a painter like that, like many others. It's not that I want to be more than the others, but, for a matter of conscience, I would like, maybe, to repeat the mistake that I made in the past having experiences that didn't bring me anything, but that represented in themselves something new, for me, as experience, rather than remaining in an experience that I can't even develop further. Yes, there is the problem of life, that you need to live and to eat every day and, therefore, this fact leads you to being truly an employee, an employee of painting, I don't know. It's not that I want to give a transcendental value to the artist: I truly embrace Malevich's idea, in which the artist-idol doesn't have to exist . . . But, the artist, for me,

is like a scientist, who always tries to investigate and therefore to produce knowledge, since knowledge doesn't exist, it exists when it is produced. Just as art doesn't exist, but exists as the research of art, the production of art, as the identification of an element that we call art. When we are no longer able to do that, necessarily we have to do something else . . . or else make terrible decisions, that we don't want to make.

LONZI: What could be, according to you, the reason that justifies, in your work, the abandonment of old spatial methods, for the emergence of new topological relations? And what is their value? Could it be that the modern man, in the progressive spoliation of every security and ideological protection, finds himself, like a child, in the condition of considering his personal point of view as the only possible and trustworthy one, therefore is completely alone in constructing his truth and his reality? The need to affirm without proof and to dictate without limits (magic) would come to be in such a way the fundamental traits of the relationship with the world in artistic experience.

TWOMBLY: (silence)

PASCALI: What's important is really moving towards something that's scary . . . not that's scary, something new. Truly, I think that for me the best thing is to make a mistake, I use a strange term, just to understand each other, but it isn't that I err, I have all of the responsibility for my errors, that for me they aren't errors, what can I tell you. It's clear that if someone, thirty years ago, was a fascist, it's not that he made a mistake: it means that thirty years ago, he was of that moral and human stature to be a fascist. Later, to change doesn't mean to deny the past, nothing can be cancelled, one is truly another thing in respect to that past because he has historically changed, his own presence. I cannot understand how a ninety-year-old painter paints like when he was twenty years old . . . it really means insisting on youth and on a time and a history that no longer exist. Thus, an evolution . . . not an evolution because it could be that there's even a regression . . . if a

cognitive fact is determined I think things are okay. Anyway, he always creates an interest for life and returns to the mirror in a certain way, understand? He sees the mirror and says 'This is who I am' . . . he goes there, and then returns, 'That's who I am.' I don't want to say now 'the theatre', because in the end, you know, actors put on many clothes, but they always act in one way, because even they have this personal mania . . . On the other hand, one's own personality is an inexistent element, constructed and demolished according to one's will to annihilate oneself and, therefore, to reconstruct oneself. Not to annihilate oneself in a complete sense, but in the sense of sides that are already tested and already useless. In the end, this is nothing other than the technique of industry that always and continually denies what it does . . . I say, if it's like this for those who make automobiles, we think highly of the most idiotic people in the world, just think of us . . . Meaning no, because now, on a modest level, we can't even say that the people who construct automobiles are idiots, rather . . . Maybe, morally, from a human perspective, you can say they behave in a negative way, but, as an economic system, in an economy of thought, it's something intelligent . . . truly one manages to re-destroy and re-create oneself in different ways, never being what one was before, or else always being what one used to be precisely because one doesn't want to be . . . and what do I know. However, it's important to always do new things, not new to others, new for yourself. The child that copies his father and carries a gun, because the father carries a gun, and he puts on a uniform, because the father wears a uniform, it would be sad if he dressed like his father, with a uniform made for children . . . Instead, the child carries a stick in place of the gun and he puts on a jacket made of paper or a hat made of cardboard. But it's beautiful. Copying the father, in the end, could sometimes be, for me, like making horses. I copy a horse: since I can't give it a hide shining with sweat, with flies that buzz around and with the rotundity of the muscles that are continually moving I, with the material

that's simplest for me to use, put canvas on some wooden ribs. It isn't that I want to use canvas because it resembles the hide: really it's in order to create that exterior element, not that interior content.

KOUNELLIS: I believe that there has to be something common to everyone, far from that protection, really, that's culturalistic that tends to place things in traditional channels of communication. For this reason they're protective, because they're hollowed out by a mental order that you can't escape from: you continually go on like this having the feeling that you're, I don't know, a cultured person. With that phoney protection they have the feeling of being free, really, while they move within traditional channels, where there's very little freedom, within that, isn't there? These things here need to be rebelled against to be able to be free, otherwise . . . what kind of freedom is it! It doesn't exist. There is also a stuffy legal mentality, I mean, there is a protection of good and bad, that goes on inside there. Also, I don't know, you say 'avant-garde', all of this here . . . but, until today, the avant-garde was conceived of by people who were truly revolutionary people, many times. But, how they're absorbed into people who have nothing revolutionary . . . absorbed, integrated . . . this labyrinth helped even further, because every time it becomes a channel, but everything is in there. These are not gestures that go outside of it, that no longer accept this rule, really, of submission . . . Life, in a certain sense, as it is conceived of here, is in agreement with this system of channels, such that you always have the feeling of freedom while you are never actually free, right? It's all conceived of like this, even protections are false guarantees: you say 'At least I'm protected, like this,' but they protect you from things that you, if you do them, are little things, they don't disturb the common order. To disturb the common order means to shake it up and show that the channels used up until now . . . to make seen their monstrous points, right? It's from there that they don't let you escape . . . for which it also becomes exasperating: when you

clearly see how things are, that's when exasperation comes. In fact, I don't know, in America, which is a much bigger country, all of these things are more obvious, more compact, more monstrous still because the game is more subtle: if you don't notice it, it's all made of cotton, isn't it? So, look at the painters, they continually live under pressure and they work under pressure . . . for this reason American art also has an expressionistic quality, in any case, because the painter comes to be under this force, really. Real proposals are lacking, generally, not only in painting, in politics, in the entire American social world, but it has its own physiognomy, its own particular structure, organisation as well . . . the forces have their own particularities. The painter is crushed, there, makes gestures that are more . . . like, extremely . . . not expressive, but truly Expressionist because, under pressure, it's Expressionism. And, moreover, they're even clamorous, because clamour is useful to satisfy, in part, the personality that is offended by this thing here. There is a small reward, but, in the end, it ends up being a personal factor, a presence, indeed. The clamorous gesture justifies this presence, but it's missing someone who brings forth something and has a broader idea. Because it's not possible, right?

NIGRO: In '53, if you recall, I am speaking of a return of tragic feelings: when I made those notes, in '54, I say 'the tragic returns'. Because I saw that this classical research, which could be cooled off in academic research, wasn't enough for me, for the reason in itself of new openings and, above all, because an external situation that I examined, that echoed through me, it brought me to the verification of a state of tragic things. This tragic returns in my research, through the pattern work in the background, from which extremely violent lights appear, like a sense of freedom, hailing from other options in chiaroscuro, that I made, which gave off a dramatic sensation. And I think my true informal period, if it can be called that, is precisely that period there: I didn't, evidently, need an additional informal period, which then wasn't even part of my way of

researching. It was an exasperation, it really came from an exasperation that I had wanted to avoid. But, as you see, surprises, unexpected events, I mean accidents always work for me. And, there, they brought me, then, to an error, I don't know . . . there are various conditions, external naturally, of moments that I have experienced . . . but, effectively, I had already surpassed the informal in the moment in which I realised these optical options with these violent backgrounds and, therefore, there was already a symbolic sense, already in these, isn't it true?

SCARPITTA: The story of Frank Lockhart is very lovely, and I would like to flatter myself that there is some relationship between his way of behaving as a racer and my way of existing as an artist. I remember a moment from his life: this young racer didn't have the means to buy a new radiator . . . he wanted to race, he had the car ready . . . a radiator cast in aluminium: I'm talking about that casing that covers the radiator, that casing there. So, in order to buy a piece cast in aluminium, there was a certain cost and this young guy didn't have the money. He didn't have the money, but he wanted to race, and it was necessary to have this part to finish his car, he needed that exact thing you're touching there, that cover, that radiator; he had to pass the inspection, he couldn't really bring a car that wasn't complete out onto the racetrack . . . And, so, the last two nights before the race, he made a sculpture of

a radiator, he painted it the right colour and, when he brought
it to the line to race, no one knew that this racer had a car
with a very important piece made out of wood. It was regu-
latory to have all of the pieces to pass the inspection: nobody
noticed it, because he'd done a great job: it was nothing but
an aesthetic piece, but let's be clear, however, it was a nec-
essary piece. Well, despite this fact, I don't know if it was a
bit lighter than the other cars, anyway, Frank Lockhart won
that day, with a wooden radiator. To put something on the
car, made of wood, when the car, as it happens, has its unity of
material, was to turn the racing car into a collage. Well, in 1925
or '24, whenever it was, I don't know, I don't remember, Frank
Lockhart made a collage out of a racing car that won a race.
And this anecdote, truly, it made me smile because, when I
had my first experiences with cars, I built models, facsimi-
les, like I told you. So, to discover that there was a man who
raced and didn't have another way of expressing himself than,
maybe, by making a collage in order to race; it was enough
that he had the motor, naturally, but he had the motor, he
had the know-how . . . I hope that he had the means to buy
a radiator like he needed . . . However, I'm convinced that, in
certain circumstances, human ingenuity helps desire. These
cars of mine are based, in large part, on desire because I didn't
have any experience in building automobiles and, even today,
I really feel more like an acolyte than an expert . . . however,
as an acolyte, with desire, I was able here, at least according
to what I see, to make an automobile that exactly corresponds
to a three-dimensional photograph. We stand before an auto-
mobile that corresponds down to the smallest particulars of
the car to the epoch of Frank Lockhart . . . About the structure
of the auto, I would simply like to tell you this, Carla: that
inside the chassis, naturally, that's the shell, there is the *raison
d'être* of the car, it's the propulsive force . . . above, there is
that which, I flatter myself, is my true expertise: to install the
body panels on the car. That is the work in which I've truly
specialised, that is its optical figuration, its optical presence,

its substantive presence, I wouldn't say as an aesthetical fact, but its individual presence, its skin, that is my responsibility, above all. In this sense here, I am truly an expert because the skin, on my cars, is authentic and corresponds in the smallest particulars to the needs, to the height of man, to his proportions, to his way of getting into this car, like, I would say, how a man gets into his jacket. Given that this is a car made completely of iron, given that it is a car of iron made for an iron man, the relationship between the weight of the man and that of the car has to be very well maintained . . . However, to work with iron and to work lightly, means having to work very precisely, saving every ounce you can.

PASCALI: In the end, my things were always on the outside, never on the inside. The cannons as well: what's important, for me, is that they looked like cannons. There was this green paint that covered all the flaws, and that was the cannon, it wasn't wood or iron . . . I don't think how they were made was relevant, as long as they looked like cannons. Like these things: it's important that they look like sculptures. I'm not interested in the inside, but just in the epidermic part: it has to truly be this light thickness that shapes around it. It's the fiction that automatically determines the identification

with a certain image, a certain word in the dictionary, cannon, sculpture, Brancusi. In certain things of Lichtenstein's this here is really true. He, eventually, is like this: he repaints Picasso's painting with the method of a comic strip. I pretend to make sculptures, but not such that they become the sculptures they pretend to be: I want them to become something light, that they are what they are, which explains nothing . . . I made them like this, it went like this. Being what they are, they are made of some canvas on ribs, which strangely resemble sculptures, images that we have inside of us. I am really interested in this. Living, one beautiful day someone puts on a tie of a certain colour because it looks good to him . . . but to look good doesn't mean that it doesn't remind him of an image, right? The tie is nothing other than a transfiguration of the image that he had in mind. By realising it he transfigures it, because the mediums change and he who transfigures himself is the image. A person who buys a house and puts furniture inside, placing it in a way that automatically determines its identity. Someone makes a corner in the style of Caravaggio, another person makes a house that seems like a castle, other people don't make a house, others put things in the rooms that give them the normal rhythm that might serve some purpose . . . others, on the other hand, build houses in the same way they build their insides, creating a fantastic space.

ALVIANI: Deep down I, spiritually . . . and, in fact, I wanted to tell you this . . . I feel very primary. Primary, by now, has become a style . . . I want to go to the ABC . . . to start with a very tight cylinder, but always like that, indeed, yes. Then, I take the cylinder and I put it there and I witness the cylinder, understand, it's at its best with the cylinder, and I show everything: how it cuts the light, the lengths, I phenomenise it, I make it give a lot. Not to create a new fetish, a bit more current, but still a fetish, to always be charming. Myself, rather, the being I want to give to the world is the awareness that this is a cylinder. I say 'Look, a cylinder.' Tomorrow it could be useful to me to insert this notion into another problem,

to continue to see things: that specific materials at heat or at high atmospheres, with other agents, I don't know, have a behaviour, they have another behaviour. One of the objects, I gave up back then, one of the phenomenal objects . . . back then I didn't have much knowledge about . . . it was an object run on gasoline and fine aluminium powder: putting the aluminium powder in the gasoline a continual reaction happens; this aluminium powder moves alone inside until it runs out of energy, until it has progressive development. And this is interesting to me, precisely because it is in the becoming of things . . . maybe it doesn't develop, I'll leave it like that, as a curious fact, it doesn't get to anywhere else, however it's interesting to me because it's dynamic. Tomorrow, when, instead, this here . . . that's why I left it there . . . I don't know, were it to become the confirmation, 'Look: what's happening?' – like, now, these lines above a source of heat, 'This happens, it leads you to this' – when, however, it would have taken that sense that I need to give it. Therefore, it remains there, it stays there like many things, that come out when they mature on their own . . . Right . . . you jotted down a line and this could become

a letter of the alphabet, you don't know yet. Tomorrow you establish that the letter of the alphabet will be this way . . . you understand, Carla . . . see, it's already there.

PAOLINI: I realise how much what I said before regarding embellishment, style, might be misunderstood . . . Objectively, you really cleared it up for me that it's much easier to observe concerns about style and improvement in the work of other artists . . .

FABRO: . . . of others who are barely artists . . . ahhh! . . . ahhh . . .

PAOLINI: . . . barely artists, in the sense that in their work this stylistic concern is much more explicit. I believe that for embellishment we can't only be referring to criteria of exclusively figurative taste . . . It seems to me that the package, let's say, of a figurative work can find, at least today, in my opinion, a certain possibility in that which can be called a rush of taste that, in fact, simultaneously comes from all taste in general. I certainly don't want to pay homage to colouristic, compositive, or solely figurative taste: rather, I am interested in pursuing a certain . . .

FABRO: I have to immediately interrupt you. No, because now I am trying to work in a maieutic manner, I try to be Carla Lonzi, see. As far as you are talking about style, taste, as such, very generally, it's that, I think, the problem of misunderstanding. When certain people apply style, that is embellishment, they do it based on what presents itself in that moment of the panorama of style, and that's what renders the works so insinuating, that allows them to insinuate themselves, because they have all of the characteristics of the accepted rigour, of the rigour of style that's accepted in that specific moment. They have, as such, that component that's rich enough, has enough . . . But, in the same moment, that style – it's this, indeed, that I wanted to tell you – it overpowers the key to the work. No, it's what renders it more acceptable. For them, style is a big tip that pleases the waiter. In fact, I think, what you want to say, or what, I think, has to do with

your work, has nothing to do with a big tip, has nothing even to do with a tip at all. Your style doesn't overpower the work, but it is the work, I think, that has the modesty to present itself as style alone.

PAOLINI: Beh, at this point, I feel so . . . uhm . . . uhm . . .

FABRO: . . . excited . . . haha! . . .

PAOLINI: . . . excited and truly 'shocked' by your precision. No, actually, I agree with you. The fundamental misunderstanding is, indeed, what you've underlined just now: not considering the two things as overlapping, essence and packaging, but considering only the first one, but duly presented or, anyhow, if anything only the second one, that would be, as you said . . . so modest, so little compromised, to seem transparent in respect to the first one.

KOUNELLIS: One doesn't undertake poetic research that isn't research into language, but poetics means unity. I don't know, in Italy, there is a reformist mentality, from the post-war period, about language: how in that post-war period every sense of language was interrupted, after it was a race, really. Also, this mania of the critics for continually talking about language . . . Because it was in that period there, that the Picassoians came, a bit late . . . and, up to now, it's the same operation, language is interpreted in that manner, not as a unity, as a proposal . . . but the proposal is made of two things put together, right? For this reason, I said, I don't know, 'visit other countries' . . . For example, the Turks are like in America, because there, the folk language or the traditional language that exists is at the same level . . . a paradox, really. The same conception has arrived in Turkey, because of tradition and, in America, because of maturity. Therefore, to go, I don't know, to listen to different people, also talking about things, so, social, but without prejudices . . . ultimately, to be open, and, after, naturally, to talk to European artists, meaning more congenial personalities . . . and, so, it becomes quite lovely, right? I believe that there is a mental vice in our way of conceiving of art also as progression. I don't know, at the

show in Paris, at the Biennale, I went, it was very meaningful
that . . . the Pavilion next door was the African Pavilion . . .
those Africans were Cubists, really, right? It's something that
really sheds light on many things. One should not go to see
the African Cubists, not because, like that . . . for someone
who was living in Paris, an African, it's natural that in 1910
he could have also been a Cubist, but someone who lived in
Africa, in 1968, is a young man who makes Cubism, it's crazy,
really. While there, they could have been people with great
original ideas, an extremely different conception of life from
our own that, for us, it's this that's important. And, later, to
open up the discourse. We have our reflections about life,
here, but that doesn't mean that the future, really, is made of
electronic brains, it certainly doesn't mean this. I don't know,
the war in Vietnam, where the Americans did it, had shown
the opposite: it showed that a country so poor, that has its
own conception of life and holds onto . . . rather, it will be
them who influences the Americans, soon, and this is a great
lesson, outside of the particular event of the war. This means
also having a conception of particular conditions, of the envi-
ronment in which one lives. I believe that they conceived of
the war in a manner that is the opposite of the kind of war, of
a, well, of a heavily industrialised country, and they demon-
strated that they have the same strength, even more strength,

with a specific conception because they really fight on their land. The Arabs lost the war because their system is that of a country, not only backwards, but ideologically inexistant. They have no political conscience like the Vietnamese, which is the reason they are the avant-garde in this sense here, precisely. It is a pseudo-fascist government also, a sort of bourgeois nationalism this here . . . In fact, Russia supports them because of this bourgeois nationalism. It's an illusion for the whole socialist movement, Russia supporting governments with bourgeois-nationalist characters, because they believe that it is the phase that precedes the socialist revolution. Only that, since they are countries with colonial issues, these ones, so the bourgeoisie take on a national physiognomy, meaning it guides them. But, today, capital is so vast, really, that financial operations are made in New York and all the bourgeoisie are the same and have the same interests. Today, it's really absurd to support a system like this, and the Arabs are in the condition they're in, because they didn't manage to disentangle themselves, and to have a specific conception of politics.

TURCATO: I think that Europe, as it always has, has to look at eastern art or any exotic art, because, ultimately, even in difficult moments, Europe resolved things by looking: the Sienese undoubtedly looked to India or China, like the Beatles did with Indian music. No, because everything seems wonderful, instead one needs to think that the 1800s was a period of terrifying decadence in which Art Nouveau was also a meditation around a certain style, in a certain way, structured also out of reinforced cement but inside it was something rather exotic. The same Imperial style, after all, it had this . . . well, then there was the rhetoric of the Roman empire seen in a certain sense. But the same Roman art, which then was Greco-Roman, had already elaborated also on many things seen in many conquered countries. Europe, in the end, has a meaning in this sense . . . For example, there is the *Warrior of Capestrano*, there are things that are quite strange. Then, the dimensions they used, they aren't really

Greek dimensions, there are also dimensions that are completely autonomous, actually. There were really a blueprint and an urban planning that were quite . . . yes, on the grid, the castrum . . . however, I mean, not bad, right. It seems to me that art, whether it's in France or in Italy, has always replenished itself, in a certain way, by looking towards the east. Yes, I too undoubtedly have looked at things . . . then also, you see those *Porte d'Egitto* ('Gates of Egypt'), they're an inspiration . . . Well, this here derives then, from a whole . . . not German Expressionism . . . it comes from a certain French-German current . . . However, effectively, there is also the illuministic phenomenon, in Europe, which comes from contact, through studies carried out by various philosophers and writers . . . French art, until a certain moment, was Gothic, then . . . I think, the Gothic also continued with the Baroque, it's quite true that the so-called late Gothic was already Baroque. However, later, there was a relationship with rococo, then they looked to the Venetians because they had this contact with the east. Undoubtedly, in order to break free from this let's say, psychologically Catholic structure, and to look for new horizons and new forms of style . . . Because, style also comes from a psychological component and, therefore, also from research into greater freedom . . . And alright . . . Borromini is undoubtedly eastern . . . also the Porta del Popolo, here, seems like it was designed by Michelangelo, but, really, it's orientalising . . . the gate there in Palermo, what's it called? . . . well, there is the meeting with other civilisations, with the Spanish civilisation, Arab. Eastern populations are still the first source for gathering . . . Then, there is Negro art, but we only know that which was eruditely imported by the Cubists, by the French, by and large. About Negro art, we still know, that, relatively . . . really about that Negro civilisation that comes from Timbuktu . . . After all, Mathieu is all about gesture, however, ultimately, it's orientalising, isn't it? Same for Van Gogh, right? But French art, you know, that is rich . . . because it's still rich

now: if we put the mass of French art in comparison with the mass of American art, well, the French win, there's nothing to do about it. Where do you put Monet? I don't know. You saw . . . Sure, past, however a past . . . you know, late Monet influenced American art a great deal, right? And then Matisse, because we have to deal with him as well. No, the enormous squalor here is this: all of the efforts made by the Italians to get out of the blind, closed alley of this provincialism . . . who, then, they talk about the Nun of Monza . . . but, yeah, the Nun of Monza becomes a romantic drama of a certain importance or of customs, really, imposed on a provincialism . . . okay. From there it isn't possible to get out because the attempts, that the Italians have made to get out, have never been officially approved by anyone. See how phoney the situation of Italian criticism is. Well, figurative . . . Figurative of what? Because I don't know, if you talk to me about a figurative that, at a certain moment, has rather profound grafts also towards an abstraction . . . But abstraction

becomes a word, like saying, I don't know . . . various, green-ish, really. However, when you, by figurative, mean remaking realist things from the 1800s . . . sure, go ahead, then no one will know, it's no longer culture, it has no appeal. No, because now, the figurative . . . gosh, so there's Klimt, then there's . . . But also Expressionism was fucked because, at a certain moment, the German Gothic situation became too preva-lent, even if it has interesting things to it, but . . . I mean, for me, basically De Chirico is superior to Picasso, he's someone who knew . . . Which, then, his was also an academic revo-lution and I understand perfectly well what he says against Cézanne . . . then he degenerated, ended up making comic strips of the 1600s, but this stuff here isn't important, it isn't something so . . . Yes, it's horrifying to see those paintings . . . but, he had a very happy moment, and then . . . I don't know if you know the painting at the Museum of Modern Art with those arches and that locomotive that comes forward . . . I mean, hey . . . Then, he looked at, I don't know, the coast-line of Pozzuoli where there's the cement factory, and also these Greek rocks, temples. At first it seemed like something mentally structured from a cultural-philosophical point of view, now, instead, it's clear that this thing has an importance in the sense that he managed to grasp it, transforming it in the sense of a painting . . . and there, I think, the painting matters . . . this paradox, I don't know, created by the indus-trial Italian bourgeoisie, that puts the cement factory near the Temple of Vesta, understand? No, but this here is very important, yes . . . then he puts in some biscuits . . . On the other hand, the mannequin, for me, matters as much as the duellers, there, from the 1600s: it already becomes some-thing forbidden. While, before, he had a brilliant idea when he made . . . really, the Belvedere cast is in all the schools, then he put the prostatic glove next to it, the surgical glove, in red . . . well, you know it, right. And we aren't in a liter-ary idea, because that one there is already a pictorial idea, understand? This is the fact. In *The Disquieting Muses*, there is

already a literary idea, this is what comes through the most. I, look, I have nothing to do with De Chirico, really, nothing at all . . . nonetheless, I'm interested in him, because I see that he was a brilliant man . . . Sure, a certain apotheosis was needed, but he wasn't well understood, this here is the point.

FABRO: On a given work, both me and Paolini, we place a title that, roughly, changes the work itself. You can try to reverse the situation: if it didn't have a title, it would present itself in a certain way, with the title that we give it, it takes a specific appearance instead. Now, I think that this, meanwhile, comes out of a certain sense of disloyalty towards the thing in itself, such that we feel urged to give it a specific sort of nominal precision. However, at least in my case, this mending, through a name or a certain kind of title, a character, doesn't preclude in any particular way the perception of the object itself. I presuppose that the object has a sort of dialogue on two levels: between the spectator and the title, and the way in which I make the object or the nominal direction I give to the object come together . . . and the other, between the spectator and the object itself. It seems to me a bit that I tend to create these two relationships, like a doubling of the personality, the one side on a literary level, the other side on a purely experiential level. I believe ambiguity, in part, comes out of this: from making . . . not lining up, but simply, rather, from making them rub up against each other, I don't know, or by creating friction between these two types of behaviour. It happens very often, at least I notice it in my things, that they have trouble remembering my titles, although they are the most relevant. I struggle a great deal to find someone who says 'asta' ('pole'), when they see *Asta* ('Italy at Auction'), when, in fact, it's really a pole, however, since I presented it, like this . . . they call it 'asse' ('axle'). It seems to me, really, it's a consequence of this friction that, on the one hand, one has, like that, an impression of the thing in itself, on the other I give it another sort of input. From these two inputs some kind of thing is born of

which, one is right, but, it isn't completely contemplated in the other.

PAOLINI: Also, for me, the title has a salient importance. I always try to title the work, maybe differently from how you tend towards this parallel channelling of the title to the work . . .

FABRO: Carla, take this, okay. Be a bit careful anyway . . .

PAOLINI: As opposed to this parallel channelling, I repeat, I attempt an obviously parallel identification, since it is about a title and a work, but, yes, identificatory rather than alternative. In the sense that it often happens that I attribute the same weight, that is the same participation on my part, to the work and to the title. In the moment that I write the title on the back of the painting, I feel invested in the same world as when I execute the painting. There is no qualitative difference between bestowing the title on the work and executing the work itself. The difference, if anything, is in your critical subtlety of lucidity in the moment in which you bestow the title, probably, and, on my part, instead, an intention that's more, maybe, aestheticising, of finding a very ambiguous point of contact, maybe, but noticeable, between the word and the painting. In the past, for example, I entitled my works with images . . . in other words, on the back of the painting, I placed an image, and instead of writing the title, and only on the back of the painting, I applied an image or recently, the title that I should have written on the back of the painting, came to constitute the painting itself, it was written in a specific way on the surface of the painting.

FABRO: In fact, in the relationship between title and painting, what I said before about myself might even be true of you. I wasn't talking about an intentional friction, but about a consciousness that exists in this friction. The title, for you, isn't descriptive: it can be . . . however, the elements of description don't necessarily constitute the material of the work, but they are really a material component of the work. *Non sunt substantia, sed substaniales sunt.* Haha!

PASCALI: I have an image: the focus in my eye has this limit, and I cut where my focus is. It isn't an optical focus in a strict sense, it's a structural focus: which is why these sculptures are cut where the structure I'm interested in is cut. Yes, after you get into psychology, into psychoanalysis, you can pull out a ton of things, correct, incorrect, interesting without a doubt. However . . . Above all, look, those cuts that I made, more than cuts they are sections . . . the cut, already, is a gesture and, therefore, there's a factor of sadism, and so on . . . there, on the other hand, where there is a cut there are two clean sections, and that's it. These sections are nothing other than two shapes where the sculpture ends . . . that is, the sculpture conforms in that way because it seemed to me the least structurally intentioned . . . that cut or that shape were so natural that they didn't stimulate a formal problem as a problem of a certain drawing: for me the sculpture ended there, it was done. Later, to decapitate animals it's more fun to say it: 'Decapitation of the rhinoceros', right? But it isn't decapitation, it's a decapitated rhinoceros: there's a difference. This is a decapitated rhinoceros like those ones that were trophies: dinosaurs pinned up on walls, cutoff dinosaur heads hung on the wall. If someone puts up a deer with antlers in his house, couldn't he put up a sculpture, at least do that. Later, at a certain point, I violate this same idea and I put up four of these trophies and these four, it's clear, will take up a room. Before, understand, the idea is that 'Well, so I hang a sculpture that seems like a trophy.' Then you say, 'But no, it's better not to hang anything': you do four of them, they all go together on a wall so that, that person becomes a collector of trophies that are a metre and a half long by a metre and a half, understand?

ALVIANI: I make this as a professional and it isn't my profession to consider, to make judgements . . . see.

LONZI: But, you have reactions, or do you think that someone like you doesn't have the right to have reactions since . . . No, really? Be clear about it, because it's too fun.

ALVIANI: I think so. If I have reactions they could be, immediately, classified by me on a sanguine or emotional level, that is to say independent from pure thought. I don't know, I might be tired, so my blood flow is off-kilter; I might have a fever . . . obviously you well know that because of a mishap of the nerves . . . However, there are regressive situations, fewer of them, situations that aren't optimal . . . rather, they are 'bad' situations, therefore I avoid being exposed to them, rather than analysing them, judging them, drawing conclusions from them. I draw the primary consequence, I say 'This, I don't know, it gave me a fever,' see, the only thing that I can say . . . I don't know, hearing a lot of people screaming could give me a fever, understand? The same thing, being in a hot environment could give me a fever, but sanguinely, in other words my blood circulates in another way, as these waves enter . . . Because for me, by now, all of life is an object. You speak: for me it's really an object . . . sometimes I have images, I was going to say normal images, about these things that come to me, understand? When something gets on my nerves, I have images that come from somewhere, through my pores, and they make my nerves spin. I only have consciousness of that, right? of which I am aware, 'it made my blood pressure rise, or it stopped it,' I don't know, like when you can test your fear when you overtake someone in a Porsche . . . your blood freezes, really because the situation freezes you, in other words, it stops moving . . .

FABRO: The title is nothing other than the certificate, the key to the birth of the work. Now I explained this: that, in my comparisons, the title is born, yes, as a certificate. Naturally, in the moment in which I come up with the idea for this work, I think of it as such . . . however, the next step immediately follows, when I have the primary experience of the work itself. And it happens precisely just like how a person is born: the person is born of Antonio Petronilli and Giuseppina Saltimbanchi. That's it. Naturally this creates precedents in the development of the individual, however, they give access nonetheless to some unpredictable developments. The *Davanti, dietro, destra, sinistra* ('Front, Back, Right, Left'), what was it for? It was to determine a direction of violence: the spectator who, turning around the room, at a certain point looked 'right' and if he found it before him, he felt something like an ideological constraint in considering a position that was foreign to him. Precisely this, how can I put it? this spatial coercion would have given a meaning to the work itself, while, as I explained, the work is born from a spatial position. Now, I think the two things go perfectly together. The work is born in as far as I individuate a spatial position . . . however, I construct the work in as far as I can control it, I don't know, I can live inside of it and I can have life experiences which can give me access to the work itself. Otherwise I wouldn't do it, otherwise it would remain at the level of the idea and myself, intellectually – assuming that the intellectual element would interest me at all – intellectually it could be more than sufficient, see. In fact, I construct it because it can begin its life journey and can take directions that, really, finding itself in a context of situations, it comes little by little to acquire. Because of which, this that was the static element of a position, becomes a dynamic element of experience that behaves differently each time, according to the perspective from which it is taken in. For me, this is what's interesting. And like that, yes, this is valid for titles, titles are valid as the certificate of a thing, of a beginning of a process.

Then, naturally, that the child of these two, who we men-
tioned before, becomes an engineer or becomes a binman,
can in part be tied, yes, to birth, however, there are many and
particular elements that can contribute to him later being a
binman or an engineer or the President of the Republic or
Johnson the executioner, which cannot be second, in impor-
tance, to the element of birth, the constitutive elements that
brought him to be born. The importance that I give to the
experience of the work, to the development of the work, to
the growth of the work as experience, explains, also, how I
pass a certain period of time between one work and another. I
make it, the work, and in that moment I am interested in what
I am interested in . . . I want to create this moment of birth . . .
then, I want, yes, to have all of the experiences tied to this
particular work. The experiences tied to this particular work
are, practically, the work, the pleasure that interests me in the
work, and they move forward in all directions. Naturally, I
make a second work as soon as, I don't know, we can continue
to find similarities with man, as soon as this person, this work,
has arrived at a certain development, as a capacity of experi-
ence, from becoming fecund, to having the ability to fertilise
other experiences from which another work can be born. I
think that this similarity can in some way give the idea, even
if it's in wacky terms. I, as author, can transmit, communicate,
only how the work is born, I can only say 'It's born this way,
it's born that way.' All the rest, what comes after, isn't misun-
derstood, or ambiguous, no. It's that I, in the moment that
I've finished it, I place myself, even me, as a spectator before
the work, and it's obvious that, being someone interested in
the work more than any random spectator, I end up having
many more experiences than I think, presumptuously, any-
body else could have. Anyway, not all of the experiences oth-
ers have . . . as a mass, as points of interest, I believe I have
more than them. So as to, when I find another person has had
an experience different from my own, I include it as a contri-
bution to the experience I could have had or am going to have

myself. You see. The moment isn't born from an expansion of the work outside of my intentions, but from an independence of the work from my intentions. When I or Signorina or Signora Whoever go to bed, we do a certain thing from which a child is born, or we go to bed to make a child, but everything that child will be, afterwards . . . Naturally we will enjoy him, we will support him, we will kill him and he'll kill us . . . the relationships that intervene later are relationships tied to birth, but not determined by birth, aside from the birth certificate, see.

CONSAGRA: Now, this talking about the city . . . *La città frontale* ('The Frontal City') . . . of the people inside, you go outside, the aeroplane, the grass, the fear of getting lost . . . it's a beauty, for me, because every so often I find myself talking as if of a sculpture, as if I am speaking of something I'm imagining . . . I've never been able to speak for a long time about a sculpture, you never speak about a sculpture, there's nothing to say, you make this sculpture, it's all right there. Isn't that right? It also bothers you when someone tells you something they see, etc. Any interpretation that an art critic makes irritates you, who always misinterprets it, really you never recognise yourself in what others observe. Once, with Fabro, we were saying that the artist expects to hear his wife say something true regarding what he's done. The artist thinks that what he has done has a reflection, and he expects to see it in the observations of his wife. But instead, the wife always says something else, so this wife, yes, always makes . . . that bad impression I was talking about the other night. Because the artist, then, knows perfectly well that there is no reflection

coming from whatever he's made, that what he's made is without reflection. However, with the wife, he commits this misunderstanding, expecting this reflection. Because of this, the wife can become something unbearable or a pain in the neck, because you're continually inside this fact that you don't want to accept, that it isn't there, although you know it.

TURCATO: Even the French youth revolution is an existential revolution, in the end: it's against some specific institutions that want to show that France is right. Europe is still existential, it's not in a structural phase. America will have been able to be and will have found its crises, but, here, we still aren't ready here, at all. No, I wanted to say that we still don't have an idea of what the Roman empire was, in the sense that, at a certain moment, these legions, made of defeated people, and that, then, had taken an oath . . . they killed everybody. This here is an anti-fascist idea, really . . . they put them in there and said 'C'mon, fight with me.' So, see the Teutons who go to fight in Africa, some others who go to fight . . . understand? From there, then, confusion from various barbaric situations unfolded . . . Aside from that, now, there is the American theory that the invasion of the Roman empire came about because, first, there was humid weather throughout the whole world and, then, instead, came a dry climate, so all of the eastern populations escaped because there was no possibility . . . there was no water, so they came down, right? Meteorology, I mean: if they were there, they could stay there, but seeing that . . . understand? This is the latest theory. But the Roman empire really managed to find balance, with compromises, I mean, right, because the emperors are frightening compromisers, because it was enough to swear allegiance to the insignia. I mean, with this, a very modern empire, well, even now it's enough to swear allegiance, in the end. No, because . . . understand, here we're behind.

SCARPITTA: You asked me, Carla, about this method used by the builders of American dirt-track racing cars, Dirt Truck Racers. And, naturally, during the most recent period, the last

instant of a quarter of a century, there have been enormous modifications, however, substantially, the dirt-track racing car is long, from hub to hub 91 inches, and it's 56–63 inches wide. This 91-inch-long chassis from wheel to wheel, 56 or 63 wide, gives us a certain rectangle that, at centre, once the car is built, should balance itself perfectly. This formula would be the way by which a car can enter the turns, maintain torque, called power ratio and engine power, in order to throw the car into a skid while always going to the left and not getting too far out of the skid, not passing a certain limit, after which the car would do a 180 turn. To hold the line in the turn with the wheels positioned towards the straight, the car parallel to the track without doing a 180: always, however, with the car in a controlled skid. There is, really, a formula that the engineers use, they've been using it for a quarter-century, up to today, in order to navigate these flat tracks, that aren't like velodromes, with a 30° or 45° rise, like some European tracks. These are flat tracks, on which the car is thrown into the turn without the help of a railing to obviate the centrifugal forces

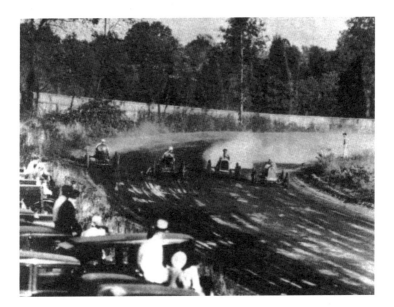

of the car. This is carried out with great expertise by the driv-
ers, who know how to throw the car into a controlled skid, to
have the same wheel revolutions coming out of a turn, to be
able to re-enter the straight at full speed. And, I assure you,
it is something to see, and I would really like to go when you
come back, because it's impressive. Naturally, the tyres are
extremely important, every track has its own type of tyre
here. There are a half-dozen famous American dirt tracks
still in use today, and then another two dozen less famous,
every track has its particular composition: according to the
kind of dirt found there, more or less bituminous, they will
use different kinds of tyre. Some are smooth tyres, some are
just a bit grooved, others are, on the other hand, almost like
the kind for tractors, that kick up dirt 20 metres into the air,
they really devour the earth, they're earth-eaters. The beauti-
ful thing, in a similar world, is to enter into the garage of the
engineers who build them, they are craftsman, they are quite
independent, outside of big industry, they are men who have
to fend for themselves as best they can: according to their
respective economies they are able to whip up a creation that
races, competitively. Naturally, I'm interested in this because
to find a man, alone, in a garage, or surrounded by two or
three friends, in a world, today, that is conversely extremely
sophisticated, industrially, it brings me back so clearly to the
American epoch of guys somewhere between cowboys and
bankers, a bit of a strange mix between individualism and a
kind of dependence on industry. Naturally, the motor and
everything else comes from industry . . . however, the chas-
sis, the suspension, and the body, if we choose to call this
sort of shell a body, and lots of other particulars, are the free
choice of the individual, of the individual American crafts-
man, alone, like I said before, in a garage with friends, trying
to arrive at a functional result. This functional result is based
on many things: the fact that these things are a bit like a pro-
vincial bullfight, it gives them an economic limit. Therefore,
with the means at hand or, at least, limited ones, they are able

to create an object that has no equal in the world. We aren't, here, facing Ferraris or Maseratis or Fords, produced with huge costs and publicity, here we are facing men who want to race, who have rather limited means, but a great desire to get their cars on the track. In this sense, in America, the men who work nowadays – not in the sense in which I work, because I deal with cars that, I think, represent the prototypes that represent this thinking that I am talking about – they make competitive machines that aren't too distant from the ones I'm making... The car that I have is the father of the cars of today and the physiognomy is uncannily similar: it's the car of the American cowboys, it has a physiognomy that has something of the aeroplanes from the first and maybe the second, the Spitfire, world war. We are in a particularly American field, in some way provincial and in some way, on the other hand, terribly significant, in a sense that's even cosmopolitan. And, like the Drag Racers that became popular in England and elsewhere, today in Australia, I think that one day in Europe as well, there could be interest in this special car, constructed by men drawn, really, from this special type of racing.

PAOLINI: It seems to me, as opposed to Fabro's case, that my works have no future. That they exhaust themselves and they are exhausted in the very moment they come to life, in the sense that they are testimony, like that, naturally, descriptive and therefore open, but in a certain way already exhausted, of that which was the itinerary to the work. Therefore, it's about, indeed, results very close to a certain steadiness of the image, to an elaborated image, overlapping, complex, but still a bit less than simple.

FABRO: There is a common behaviour in respect to the birth of a work: neither of the two of us stop in the act of birth in itself, at the moment of birth. Both of us consider it as a moment, so, how could we put it? of grace, which lies outside our responsibilities. Naturally, you, Paolini, it seems to me, you try to circumscribe your activities, your interests to this moment of grace; I, as such, because of a behaviour

tied to my personal character, because of character more than behaviour, yes because I consider it an act of grace, I take it for granted and I go . . . I mean I'm interested, in, like that, other things. I think it's important to, I mean, fair, to clarify this: that – tell me if I'm wrong, please, make sure I don't make any mistakes – that we don't think . . . we don't have much faith that this moment of grace is transmissible. See. I seem to detect it, in your works, from this fact: that you never bring up the moment of grace again, but you stop just a moment before. Your painting is always the last moment right before the moment of grace.

PAOLINI: I tried to outline this fact before, with little success: the complexity, at times, of elaboration, of certain works of mine, stops, however, always a degree under the supposed simplicity of the work, in the sense that it always tries to subtract from what I consider the conventional image of a work, just that much for which the moment to report is the one that implies this complex elaboration of subtraction from a simple form. Just past this simplicity there is everything, I mean, there are all of the mechanisms and the reactions, the thoughts . . . therefore, I try to stop at this complex phase of elaboration of a thing.

ALVIANI: I think that thousands of things exist: hundreds, and more, are unknown to me, and one day I'd like to know them, but know them well, from the ABCs, to an elementary level really. While you're studying a new alphabet, you can't pretend to be studying the spirituality of Dante, I don't know, understand? To approach it, I think there's the need to know everything and, therefore, to get closer to the elements, to elementary forms. Think of a canvas that belongs to somebody from a hundred years ago: it was painted with ten thousand colours. Today, we have the necessity, the urgency to study only one of them and, so, we could understand that, that master there, he didn't know much of those ten thousand colours.

LONZI: Even though an interest in and a sort of vocation for European culture may be evident in your work, no one

could mix up the result of said work with that of a European artist. How do you explain this fact?

TWOMBLY: (silence)

TURCATO: A painter, more than where he's biologically born, it's in the place where he had his education . . . Naturally, what he picked up as a young man, then he explains it in a certain sense. Yes, also looking at landscapes, usual landscapes, gives you this specific . . . The Venetians: undoubtedly there were great painters, but, then, they also had very flamboyant sides. But, in respect to the Tuscans, the Venetians were undoubtedly able to modify colour in a way, if we like, that was also more agreeable, but less adherent to form, in the end. However, we need to think about one thing: Giorgione, in the High Middle Ages, looked to ancient Greece because, his are the dreams of a Greek, basically. For this reason, it's a romantic kind of painting. I don't see how our friends framed him . . . It doesn't convince me, see, there can be uncertainties. I think, in Italy, the figure of the critic has led to realism. And this thing here was their great defect. In fact, they didn't understand the Futurists, they didn't understand . . . even the Futurists started out with realist forms, you could say, however, from those, they were able to transport themselves

towards idealised forms that gave rise to upheaval. No, I drum
on about Futurism because I followed the Futurists' struggle
very closely, for them to be, in some way, held together in
this country. Before they said that all of this Futurist theo-
ry came out of Cubism . . . They don't have many works . . .
this, well, this was also a problem . . . however, looking at all
of their production, you see that, at a certain point, some of
the works, also like Balla's *Il fanale* ('The Light'), or Boccioni's
movement or even Russolo's things, really they had nothing
to do with Cubism. But this thing here, it needed time to be
resolved. I don't know . . . we, then, made some mistakes, be-
cause certainly, 'Forma I', it didn't have the strength of those
things, however, basically, each of us, uniquely, was able to do
something. You'd need then to see, if all of the chosen works
of the old signatories of this proclamation could be put to-
gether: something interesting could even come out of it. In
the end, the period is very different from the Futurist peri-
od, let's be clear.

PASCALI: The artists of the past . . . it's like, as a child, you
went to Church and you saw the statue of Jesus Christ. You
said 'Jesus.' You looked him in the eyes, those fake glass eyes
and, sure, you might even cry. However, eventually, when
this period passes, it becomes a funereal thing, an experience
that is consumed in a negative way. The old painters, the old

sculptors, even the contemporary ones, are interesting to me on the level of phenomenon. For example, what I didn't manage to understand about Oldenburg was – more than the object, the object couldn't amaze me, it had such a presence, it existed and therefore, you had to accept it – it was how he managed to change all of the cards on the table, to bring an object out of himself, how he had really made that phenomenon spring forth. And what seems unbelievable to me, also in the old painters, is really this fact. How in the Sistine Chapel Michelangelo is able, really – whatever they say later about it, about that chapel – to create that kind of frightening space, gives me a real sense of inferiority . . . more than inferiority, really ecstatic, right? But, maybe, this relies on the fact that they are old painters, and I am shocked to be looking at something made by such an important man. It's like Napoleon's jacket . . . not really Napoleon's jacket, but something . . . later, I don't want to be this random, it's clear, I don't want to diminish anything, but, in terms of a relationship to presence, I think that my emotions derive from factors that are quite extraneous to art. What strikes me, in the painters, are their presences, also that sculptor who made objects with living animals, for me that presence of the animals was enough in the Gallery, this idea, right? You go to the Sistine Chapel, you find, I don't know, Botticelli, all these guys and of course the names are terrifying, you're conditioned by many factors that you learned, before seeing them . . . This also happens for certain American painters of whom, until recently, nothing was seen: it's clear that you, maybe, you're almost afraid to see this guy, the biggest American painter. Later, you see the object and you truly understand how close to you it can be on a human level, how simple it can be and at the same time not monumental, not adorned at all, right? But instead, before seeing them, you always think about shoulder pads.

FONTANA: Now, all of my talking would be erased if I had come here to play the Eternal Father. The other way around no, because the *Manifesto* had not yet been signed, the young

people wanted to sign it . . . here, in Italy, they're all unsigned, the concepts were those there, however we always have some human weakness. In the end in life, you work . . . at least while you're alive, you don't want to be taken for an imbecile, do you? in front of certain people who truly are . . . so, you have that element of reaction. But if things were normal, I wouldn't squawk for a moment, I'd be real quiet, right? Instead, some-times, you also have to defend your personality, it's a logical fact . . . It's human, right.

ACCARDI: I am there to observe, since I'm not such an important character, I'm neither a Maestro, nor a person of Power, not even, I don't know, an artist who takes up the cudg-els for herself, because . . . for me, I could even stop painting tomorrow . . . I'd be sad for myself, however it isn't such a dramatic thing. Maybe there are other dramatic things that I see . . . understand? I insist that I always keep this distance. For me, it's more dramatic . . . Now, I try to clarify with a leap, if then you remind me where I had got to . . . For me, it would be more dramatic, they could hit me in a spot, really get to me . . . or humiliate me . . . No, it's not that they could hit me, I would feel hit if I could no longer understand transforma-tions, or stay, see, stay isolated from things that move around me, really from the part, like you were saying the other day, the part? . . . right, yes, the dynamic part of life. This, since it's something with which I've been in contact for just a few years, I have to tell you the truth, I feel very . . . very well, really, I feel very interested, I don't have fears, I like following things, I don't know how to say it . . . At this point I can find regrets while, on the other hand, in art . . . Since I had a great familiarity with art, I spent many moments, that I find, then, in other people, phases of a certain kind, I have some kind of knowledge . . . So, I know that it may even abandon me, or I know that I follow it in a certain way, but I'm not overeager, I'm not voracious, understand, in the field of art. And this, certainly, is a conclusion I arrived at by meditating as well . . . In the sense that you see yourself mature and transform . . .

so, I want you to be aware, because it might also be unpleasant for you: you realise it in order to justify yourself, right? Does what I'm saying make sense? Uh . . . Because I hold myself back a bit . . . understand? I don't like to say things too clearly, ultimately. I like for someone to understand where my heart is and where my words, instead, move, in a certain sense, right? For example, this winter I went to two or three places, I met someone: we always talked about the same two artists, always just these two names. But, let me tell you, it's crazy, because in an environment as I conceive it, with people who I seek out and want to be close to, this doesn't happen, this sort of talk. One says 'In this period I have an attraction so what so-and-so puts out,' and it's an experience, if you cut out the competition, that's pleasurable. I wanted to find what causes great suffering, understand, for which I've never been able to suffer. So, I remember that competition, dammit, I, really, I swear to you . . . Maybe, because I'm a woman and they are men, well, it could be, it has to be this, a lot. If they don't put us in competition, that's something they like, first of all . . . since the people you are most interested in, where you've got, they're just a few, to tell the truth, well . . . so, it's a pleasure, right? But no, you go there and you always hear talking . . . This stuff about consumption . . . First of all consumption is harmful even for the others who have to put up with it, like Barnard, see. But let's leave it.

PASCALI: The next things I want to make are things made with water. It could be that I'll never make them, however I want to make them, now. Water fascinates me a great deal, it becomes like a mirror, water has many aspects . . . I would like to make puddles. Let's see up to what point I can use it and it can use me, because if, later, it uses me, it's over. However, very often, when I think of things beforehand, they come out badly, you know . . . on the other hand, if the image is just hinted at, just barely, it always comes out well, because it's realised more automatically, certain unpredicted elements are stimulated, and this becomes interesting. That sculptor

who shocked me, as much as it may seem, well, negative, that
American sculptor who did the show at La Salita Gallery, and
there were real animals in it . . . now, aside from the things
that he made, to see a real pig inside a cage . . . cage aside . . .
a shape, what is it . . . I felt an emotion that was so strong that,
very nearly, like that, I'd try to put living animals inside . . .
Only that . . . of course, there's this factor, understand, of the
licence: practically, someone did it, you . . . In every way, it's
something that's rather interesting, it's something that arouses
my curiosity a lot, only that I discarded it for a number of
reasons. These animals, like water in certain forms, were in
certain forms. I had thought of making a big sculpture that
was like a fence, you know, a metal fence, moulded in such
a way that it was in the middle of the Gallery, but not on the
ground, but in space, right? And, inside, there was a monkey.
However, later, I didn't do it any more for a bunch of reasons,
who knows why. I won't do it, I don't think. Because there is
this sort of mental block: somebody else did it and . . . it's an
automatic thing, it's terrible, maybe I'm too much of a slave
to it, in this sense, yes. If something is a road that someone
has begun, really I avoid it right away, even if I don't think that
the thing has been fully realised, as a possibility. It's a matter
of pride, maybe. I liked the idea, really the fact that these ani-
mals are living, it created for me . . . Now, let's return to the
story of the animals . . . however, they gave you a strange . . .

FONTANA: You know what happened, that sculpture on
the ground, *Il fiore* ('The Flower'), in the Museum of Turin,
when I sent it to Belgium for the first time? An argument
with the director: he hid it under a plant. So, Minguzzi and
I put it back in the centre, in a field of grass. That director
came again, he was an old sculptor, he made me bring it . . .
basically, I had everyone on me, there . . . the gardeners, the
Belgians, they said I was an arrogant Italian . . . So, one day
I said 'If you touch it . . . I'll shoot you, I'll smash your head
in' . . . 'Well,' he said, 'Italians' . . . 'No, I'm an Argentinian, first
of all, I'm not Italian and so I behave like an Argentinian, not

like an Italian.' And while we were there bickering, just like that, Zadkine came and said 'Hey! . . .' – it had been ten years that I hadn't seen him, he recognised me – 'but, Fontana, what's going on here?' . . . 'Well,' I say, 'well look, this ape here . . . I make a sculpture, we were invited, and he wants to put me . . . anyway, he can't refuse me, he has to accept what I want, right?' It was that open-air show in Middelheim Park near Antwerp: in '51 I sent that one there. And Zadkine said to him, to that other guy, 'But, it's Fontana! *C'est un grand artiste*! . . . it's embarrassing that you're making these complications . . . if Fontana isn't put there, I'll remove my sculpture . . . it's crazy . . .' And, so, they left it there, while on the other hand, nearby, there were twenty handlers working on Manzù's sculptures: there was the usual cardinal laying an egg and, then, all the Christians latched on, in the open air . . . You saw him as god of the show, and me, on the contrary, poor wretch, standing there. If I, now, were to make a series of those metal cans on the ground, they'd tell me that I copy everyone, right? See, this is also inconvenient: I want to make them . . . however, now, everyone . . . the English, there, very well, no, beautiful, very respectable things . . . they make them. But if I, today, if I were to take the luxury of making one, I'm dead. Immediately they say 'He copied someone else.' And don't they say the same thing about light? Jucker's wife, who's a critic, came out with a defence in an American newspaper, because in America they asked – since there was a show all about light, I was excluded, and a magazine permitted itself to write 'But Fontana in 1950 . . .' – 'But who is this Fontana, here, there, what light . . .' So, she sent me the magazine and she dedicated ten or twelve pages of an article, documenting 'Whether they are straight or whether they're curved, it doesn't matter to me . . . these are thousands of metres of light that Fontana made: at the Triennale 350 metres, the ceilings of Art . . . lots of them, therefore it isn't something casual.' Because she says, 'Casual things are done once and then . . .' Instead no, there were 5 or 6,000 metres of

manufactured tubes. I say, it was not casual, understand? Also
this: if I want to do metal sheets, they come after you right
away, not artists, the intelligent critic, who's well informed,
idiotic, who immediately says 'He went and copied Caro,' I
wish. See, I, many times, I'm afraid of repeating my things,
also with light sometimes I want to . . . I worked with light,
theatres, cinemas for ten years. But I'm afraid, because I say,
'They're all coming after me.' You need Vedova's tough face,
understand, the inventor of light, who has the courage to say
'I do it all myself, I invented everything.' That sculpture on
display at the Museum of Turin . . . it's beautiful, you know.
It'll have its flaws, but . . . there wasn't form and then move-
ment, like that, like they make now, added pieces, like that,
really the criteria for everything that they're doing. There
was never volume, right? But, I made volume with the balls.
But see, it wasn't, really, the desire to make volume in a new
form . . . You know, volume . . . matter, the human body . . . it
was this form of nothing, split, enlivened by a hit, but it was
really the desire to build volume from nothing, right, to give
value precisely to nothingness, with a form, with a hole, like
that, right? And that was heavy sculpture, it almost seemed
like a completely opposite discourse to that of *Il fiore* . . . But
they always want to judge you by those things: the mate-
rial . . . even the ball . . . that they use material, they take it up
in an almost sensual manner . . . it was its own reality, because
I thought of these worlds, of the moon with these . . . you
saw them, which were then photographed . . . these holes,
this atrocious silence that worries us, and the astronauts in
a new world. And, so, these . . . in an artist's fantasy . . . these
immense things that have been there for billions of years . . .
man arrives, in a mortal silence, in this anguish, and leaves
a vital sign of his arrival . . . there were these still forms with
the sign of wanting to bring inert material to life, right? It was
very realist, just like the *Teatrini* ('Little Theatres') were a real-
ist kind of Spatialism, right? A bit, also, in the fashion of these
Pop Art things, because in the end, the artist . . . but with my

personality. These were forms . . . see, those ones . . . that man
in space desires, he doesn't know what's there, so he has this
weight of not seeing anything, of imagining things, right? So,
really figurative forms, one can say, because they were cre-
ated by a mentality, just, let's say, a philosophical mentality.
I'm not a materialist, there's nothing in any of my works of
material form itself. Naturally, if I use lacquered wood, it's to
completely make a document: I embellish it, with the use of
technique, as such, however, they are documentation. I could
do rustic wood, one would understand just the same . . .
however, like I tell you, there is also the material fact of life,
the collector, you give him an education through, almost, a
trick. Because the technique is this, you know, how to catch
birds with mirrors. A bit of deceit is also necessary, because
it's fantasy, a mirror so . . . because if I use rustic wood they
don't understand, 'Hey, but what a material!' Instead, like
this, maybe one is attracted to the beauty of the material,
the form . . . so it also helps to educate. Like I told you, I'm

against little light machines . . . I recognise them as valid . . . but, for me, they are still too naïve, right, too . . . They hide the cord that hangs, here, the outlet . . . then they stop: when it's still it's any old object that's lost everything . . . So, I think that it could be done with time . . . tomorrow with a perpetual motion, tomorrow through space . . . but valid. For me, maybe, Pascali's basins are more effective than a machine that goes, because the silence, the discovery, it's there anyway, also in something that's . . . it's not true that the thing has to be born in motion for you to be further ahead. Now, that's what's in fashion and, so, straight ahead, down with the machine, and go.

TURCATO: According to me, Europe . . . Napoleon should have won, there's nothing more to say. Think how in Europe we're still at Metternich, that is the truth of the matter, we are still at the Treaty of Vienna. You say no? But the Americans, who aren't arseholes – they're partial arseholes– they, in fact, said, 'Okay, Europe is still at Metternich's treaty, let's make a European alliance.' However, to them, de Gaulle is more useful than ever. Because we are at Metternich's treaty, my dear, and de Gaulle is still at Metternich's treaty. He isn't Napoleon, he's Louis XIV. Well, you need to see them, these things, otherwise, here, we'll never get out of them, you know. I mean. Sorry, but . . . he's Louis XIV. Now, he was forced, anyway, to give his resignation . . . however, in the meantime, the Treaty of Vienna goes on. And unfortunately, on this, the Americans were also influenced, because the idea to attack Vietnam is in Metternich's treaty, it's pointless. It's very simple to explain, because it says 'Europe is the fulcrum of Christianity, they cannot have new ideas, we can blend them in, slowly, slowly' . . . but they never blend them in, because there is a Jesuit hypocrisy in this society, 'So, we go to bring our news to the people.' See, and they go to bring their news to . . . – it will be American, anyway the French also brought it – to the Vietnamese people, who truly didn't want to know anything about it. Now, then, there should be a situation over the

American technological, cybernetic mistakes, because it was all a complete mistake . . . everyone made themselves rich. Yes, they're the richest of the Roman empire . . . Look, the Roman empire is a truly amazing history you know, seen in a way . . . Now, I'm reading *De bello civili*, Caesar's commentaries on the Civil War . . . check it out, it's amazing.

ALVIANI: I could tell you something I've always repeated to those who asked me why I do this job. Because, for me, above all, I tell you, what I want is to give an image in form. I remember, as a child, when someone spoke to me, came up to me, I would see him, I would hear, it was never the voice, understand, the sound of his words, they were simply forms. Someone I was thinking . . . was serene, and I saw him as a square, I thought about a crazy man and I saw him as another shape. Effectively, I thought 'I saw it like this.' Obviously, with shapes, I don't know, that were very simple, very . . . also in psychology . . . in an acquired, like, order: I saw all old people in violet, and I thought . . . why? Because I knew that the colour violet is for the old, for example, now I'm only saying it. Around eight or . . . ten years old. This wasn't, in the end, a big problem, it was at the level of impression, but I looked for the impression of things, negating myself, really because I always felt like a filter. If I considered something beautiful, it was because it was beautiful in itself, it wasn't warped by the fact that I was content, understand, seeing something as very beautiful because I am content. No. I have to see it as such because it truly has those components, it found me, found me in return, it's close to me. It's a fish with a specific form, no a fish 'like that, finally I'm free'. Obviously, there are also other components . . . there will be. Like there will be Martians, I don't know, all of the characters are made like . . . I don't know . . . I think of something else completely, understand, of things that we don't know, that we can't even say. Like at the point of, I don't know, ten thousand years ago they didn't know what magnetic waves were. For me, the Martian is this, the AP B_2, which isn't something that you communicate . . .

he must do things ab . . . absolutely . . . really completely . . .
differently. When man, I don't know, was in the caves and
didn't know about magnetic waves: we, today, we're like that.
See . . . Really unthinkable, right? The whole world to under-
stand and say 'Martians walk with three legs because there . . .
there . . .' Yes, maybe it is like that . . . however, for me, it would
be much more correct if it were AP B$_2$.

SCARPITTA: I told you Carla, talking in here, that I have a
constant worry about these machines together with man, this
individual that drives them, that drove them, this absentee
who, for me, is present in these cars. That, then, is present
not only in these cars, because I'm not looking for phan-
toms, but a kind of man who's still current, who's still with
us, today. From the posterior part, driving this car from '28,
the single-seater racing car, the tail is situated in a certain
way because I remember well how you saw a lot of him from
behind, when the car passed by . . . It's necessary, I think, to
give this impression that the man is really in the open, in here,
there is no protection: so, they didn't even use seatbelts. And
this man, so naked, I would say, so tender and, at the same
time, so decisive, with his shirt in the wind, has an extraordi-
nary romantic energy, for me, and I try, in here, to always see
the relationship between man and car, of the man seated in
the car, of the man who also moves quickly . . . Often I come
in here and I see them motionless . . . however, I let myself
dream a little, given that these cars are able to move, to grant
myself the freedom to look at these objects as if they were
still on the race track and not inside a garage-studio, which
is mine . . . So, I always move forward while also thinking of
certain men who I knew, from the period of these cars, men
who I can name really one after another, from that era. For
example, there's, from '28, Frank Lockhart . . . then there's, on
the Pacific coast, the champion Jimmy Sharp . . . then there's
Ernie Triplett . . . then there's Wilbur Shaw, Billy Arnold, Chet
Gardner, Ted Horn, Kelly Petillo, Robert Sharp, Rex Mays,
'Shorty' Cantlon, 'Wild Bill' Cummings . . .

ACCARDI: But I don't want to posit it, now . . . I want there to be this problem, woman–man, and that's it. One day some guy says to me 'There's no such a problem.' No, no, no . . . the next morning I get up and the problem's there. There's, even if it doesn't have to be made of . . . I didn't make it about hatefulness, not at all, because I developed it like an exam, like a reflection . . . however, there isn't hatefulness, this comes purely from my own essence. What interests me about Elvira is that she has a bit of hatred. You rightly said 'But, I am someone who loves to secure a piece of happiness for myself.' So, I thought 'This is right': because a woman, if she has to change methodology, always has to keep present the fact that she is fighting, but, in order to enjoy a piece of happiness. After all, I think that even this violent influence exists in women, because it isn't that women, then, are only these sweet beings . . . it might also be that someone, happiness, she searches for it even in that way, I don't know how to say it. It might be that one day, when you were on your own, you find a great happiness in accumulating . . . it's like the Negroes . . . a great happiness in accumulating hatefulness, as long as the next day, however, the machine of hatefulness doesn't continue. I remember certain aggressions that you had towards the male sex, and I very much liked to listen to them because, for me, it was new, you understand what I want to say? Because I had never formulated them. You have to think that, for many years, I didn't formulate anything, beside some specialisations, like I say. To me it seems that a one-dimensional man means this: that in the post-war period a certain way of developing oneself has been established, all specialised, that was the watchword thrown around every-where, exactly, by man, always, who had to have his career, who had to impose his personality . . . so, the methodology was the same, very professional. Instead, now, this global character has emerged, a person is interested in other things, it's a great asset, and historically characterises, I believe, the individual of this period. While before, the individual was

characterised by one of the last obstinate outbursts of personality. Certainly, though, will the individual of ten years ago not have had some merits?

Afterword

'As if extraordinary things were possible between beings'
Claire Fontaine

Carla Lonzi's *Self-portrait* defies easy classification. It does so partly because of the method of its composition – it's a collage of transcribed recorded conversations with artists, featuring images that entertain a complex relationship to what is said – but also because it was written by an art critic who was about to abandon her profession. Fourteen men and one woman (Carla Accardi, like Lonzi a founder of the feminist collective Rivolta Femminile) are her interlocutors, but the book is signed only by Lonzi, and enigmatically titled *Self-portrait*. One of the artists, Cy Twombly, remains totally silent, and his lack of participation is included.[1] Battista Lena, Lonzi's son, is featured as Tita, and contributes with some comments: children's voices are an integral part of the life experience of many women, and the effort required to recapture the concentration lost every time they interrupt a train of thought is rarely accounted for.

Recording, for Lonzi, isn't only a means to capture exhaustively what is said (only a small part of the conversations made it into the book), but a tool for the transubstantiation of speech. This 'condensation', this becoming-ink-on-paper of something that was once only sound, is a change of state in

which thoughts preserve the freshness of spoken language, the replies and questions stemming from the presence of the person who inspired them. The writings resulting from this process are fundamentally different from academic texts, written and read in solitude and silence, at a safe distance from life. Orality is typical of Lonzi's style: by bending language to the edge of incorrectness she resists patriarchal conventions and revives the undisciplined body from which the unexpected words have come. *Self-portrait* was born out of 'the need to spend time with someone in a fully communicative and humanly satisfying way': this statement in the book's introduction sounds like a casual authorial confession, but is in fact a political programme. Lonzi discusses with Carla Accardi the possibility of art being a form of expression that exceeds conventional culture, and which opposes the authoritative discourse of the critic. Purely intellectual knowledge is neutralising, cannibalistic and domineering; it's fed by the stubbornness of wanting to understand things on a mere professional level, containing and evaluating the artists, rather than truly listening to them. 'The critic' – Accardi says – 'has knowledge locked in a certain phase, in its own neurotic form.' To which Lonzi replies: 'I want to kiss you!'

The emphasis on what a conversation can do and why a shared moment shouldn't be used to take control or extract information, but to explore the other *and* oneself, is at the core of feminist practice and *autocoscienza* ('consciousness-raising'). It's through dialogue that processes of subjectivisation are inflected inside the collective where women become a help to one another, transforming and empowering each other. In this manner, Lonzi's words are always a wake-up call, rousing the possibility for the collective to happen, extracting us from the confusing nightmare of isolation: 'Yes, people have to be woken up . . . it seems to me most people are sleepwalking, a little sleepy'. Reading Lonzi is an experience that changes our idea of what texts can do. Concepts immediately enter our body and transform

our subjectivity. In fact the importance of her texts should be measured not only by the thoughts that they convey, but by those that they awaken in the reader. Because feminism is at once an epistemic model and a political position, a daily practice and a programmatic horizon, it provides the tools to re-examine our lives, detaching them from what we have long been told about them. It materialises an autonomy from the existing symbolic structures of our civilisation that allows us to perceive the connection between the different disciplines of knowledge and the hierarchical structure that they justify. Lonzi's feminist adventure cuts transversally through various fields – critical, artistic, historical, political, militant, philosophical – as she takes the paths that lead her straight to the points where she can unmask whatever normalises women's inferiority. By doing so she creates a voice that is unexpected, the 'unplanned subject' as she calls it, who disregards the place assigned to her, in order to move on and reach her full potential. A lack of respect for traditional culture and its institutions is necessary and healthy for this journey; 'deculturalisation', as she calls it, is a way of rethinking what knowledge and history should do in order to serve the purpose of our freedom, to connect us with the inner meaning that words acquire when they resonate with our existential experience of ourselves – what she controversially calls 'authenticity'.

Lonzi clearly remembers how from childhood she felt that 'extraordinary things were possible between beings', and this feeling led her to become an art critic. Retracing her journey towards feminism she writes: 'I began to look, being certain that it was expressed somewhere, that it would be manifested somewhere, a potentiality that I felt humanity possessed. I knew I had it and that I felt that it belonged to everyone'.[2] Although she was afraid that she might get stranded on the border of this promised land, Lonzi pursued this 'existential feeling' only to realise that she had to abandon her profession and continue her quest outside the workplace.

In 1969, the year of *Self-portrait*'s publication, Lee Lozano, an artist whom Lonzi didn't know, was making her 'language pieces' – sheets of paper each bearing a handwritten description of an artwork that was actually taking place in real life. On 21 April of that year, Lozano wrote *Dialogue Piece*: a project of having conversations with all sort of beings (including plants, animals and infants): 'The purpose of this piece', Lozano writes in a fascinating performative contradiction, 'is to have dialogues, not to make a piece. No recordings or notes are made during dialogues, which exist solely for their own sake as joyous social occasions.' On 8 February of the same year, Lozano had decided to withdraw from her professional context with her now iconic *General Strike Piece*, in which we read of her commitment to 'Gradually but determinedly avoid being present at official or public "uptown" functions or gatherings related to the "art world" in order to pursue investigation of total personal & public revolution.' The analogies and differences between the two positions are many (Lozano would end up never talking to women as part of her art practice, whereas a manifesto co-signed by Lonzi famously ends with 'we communicate only with women'),[3] but the climate that allowed refusals of the artworld in the name of a higher and less compromising form of success is definitely the same. It is also important to see how women's practices of deep exploration, which do not settle for mundane recognition and the false currency of integration within patriarchal society, lead to the abandonment of the professional space. Dropping out, practising conflict by subtraction, exerting forms of intersubjective intransigence are part of what we have called 'human strike', a form of struggle that aims at opposing the toxicity of normalised power relationships. Lozano and Lonzi both enacted human strike and paid the price, experiencing 'illegibility', the total misunderstanding of their position.[4]

Lonzi's stance on art as a professional context would radicalise over the course of the years; in 1971 she co-signed

a manifesto entitled *The Absence of the Woman from the Celebratory Moments of the Male Creative Manifestation*, in which we read that when men write or make art they do so for men: women have no place in this process and there is no possible liberation in taking part in a dynamic conceived only to exclude them. The manifesto ends with an invitation to refuse the belief that 'the benefits of art can be administered like a grace', like a medicine to cure feminine inferiority. If the role of the critic were seen as politically problematic, because it validated artists on the basis of alienated criteria, the role of the artist itself begins to appear as a form of expropriation of the general creativity. Artists enchant the current situation and profit from it, men more than women; Lonzi is adamant about this. In 1975 she writes in her diary: 'The artist persecutes humanity with the continuous display of a self-confidence that, for being existential, has been elevated in the culture to the status of ontological confidence . . . The myth of art will continue to crush humanity, which has created it out of its need to tame the persecutor. I would like a world where all expression remained at the existential level: writing, playing, painting, making operations of every sort and in any medium. For that to be realised it would be necessary that everyone, down to the last person, accept the need to express themselves. If a single person remained blocked, Art would maintain its roots in its spirit alone.'[5] This position would eventually divide her from the people dearest to her, like Pietro Consagra and Carla Accardi.

Self-portrait is deeply connected to another liminal book, *Vai pure* ('Now You Can Go'), published in 1980: both mark an existential turning point for Lonzi; both are composed of recorded conversations. *Vai pure* documents her final dialogues with her long-time companion, Pietro Consagra, who is also one of the voices in *Self-portrait*. In their exchange, the artist's creative metabolism ultimately appears as a threat to authentic relationships, and – because for feminists the personal is political and the political personal – this ends

up compromising the possibility of their love. Art needs to transform life into a means for its own production – a special climate needs to be created for the artwork to be born even at the expense of the most meaningful relationships. 'When I see that you ... are ready to betray me,' Lonzi writes, 'to betray the reasons for the relationship in order to replace them with the reasons for the work, either you prefer to sustain the work and yourself as author rather than yourself as participant in the relationship – well, there I have hit rock bottom'.[6] For Lonzi this state of affairs was already very clear when she spoke repeatedly in *Self-portrait* of the mirage of the Venice Biennale: 'One cannot make use of the recognition that is given in exchange, one cannot do something with it. It seems to me that all artists have this experience.'

It is possible that *Self-portrait* delivers the painful news that our productive metabolism is unsustainable, on a personal *and* on a societal level; that even artists whose work is infused with care are ready to deny this same care to humans if they get in the way of their career. The lesson might be even more disturbing, and reveal that capitalism is extracting from nature, women, artists something that it is not able to regenerate; that women's freedom is the most precious of resources and the most vital of renewable energies. And, also, that dissatisfaction might not come from being unable to reach our goals, but from finding out that reaching them doesn't give us what we had hoped for, that we are being paid in counterfeit currency. Ultimately, creativity put to the service of the art system and subtracted from the search for one's own freedom is a problem. It isn't by accident that Lonzi cites Duchamp as an alternative to escapes into exotic spirituality and mystical journeys: Duchamp who said that his masterpiece had been the use of his time.

1. The questions to Twombly, who at the time was living in Rome, were posted to him, but never answered: the artist is both physically and verbally absent.

2. In 1987 the French artist Philippe Thomas, echoing perfectly Lonzi's feelings and intuitions, would use exactly her words – without having read them – to create the agency *Ready-Mades Belong to Everyone*.

3. Carla Lonzi, Elvira Banotti and Carla Accardi, *Manifesto di Rivolta Femminile* (July 1970); Lozano's *Boycott Piece* is from 1971.

4. On this point see our essay, 'On the illegible' in *Deculturalize*, ed. Ilse Lafer (Museion Bozen/Bolzano and Mousse Publishing, 2020), pp. 145–55.

5. Carla Lonzi, *Taci anzi parla. Diario di una femminista* (Scritti di Rivolta femminile, 2010), pp. 1,173–4.

6. Carla Lonzi, *Vai pure. Dialogo con Pietro Consagra* (Scritti di Rivolta femminile, 1980; republished 2011), p. 10.

List of illustrations

All images courtesy of Galleria Nazionale d'Arte Moderna e Contemporanea in Rome unless otherwise stated.

356 list of illustrations

Photo: Ugo Mulas © Ugo Mulas Heirs. All rights reserved.

p. 241 Turcato with his family in Venice in 1917.

p. 248 Lonzi with her newborn son Tita in 1960. Courtesy: Archivio Pietro Consagra.

p. 249 Rotella in 1958.

p. 253 Fabro next to the work *Davanti, dietro, destra, sinistra: Cielo* ('Front, Back, Right, Left: Sky'; Notizie Gallery, Turin, 1968). © Luciano Fabro. Photo: Giovanni Ricci / © Archivio Fotografico A. Guidetti e G. Ricci.

p. 256 Pascali with Michèle along the Tiber in Rome, in the summer of 1968. Photo: Ugo Mulas © Ugo Mulas Heirs. All rights reserved.

p. 257 Fontana on leave from the front, with his brothers, at Lake Comabbio in the summer of 1918.

p. 259 Scarpitta in his studio in New York with Lonzi in 1967. Photo: Ugo Mulas © Ugo Mulas Heirs. All rights reserved.

p. 262 Accardi, *Tenda* ('Tent'), 1966 (Notizie Gallery, Turin, 1966).

p. 265 Fabro in nursery school in 1941. © Archivio Luciano e Carla Fabro.

p. 268 Paolini in Cagnes-sur-Mer ('Premier Festival International de la Pienture', 1969). © Anna Piva. Courtesy: Fondazione Giulio e Anna Paolini, Turin.

p. 273 Rotella in New York in 1968.

p. 274 Consagra with his mother in Palermo in 1950.

p. 277 Alviani in 1969, in front of one of his *Testura vibratile* ('Vibrating Texture') pieces. Courtesy: Centro studi archivio e ricerche Getulio Alviani.

p. 278 Variety Show by Rotella in New York: *From the Chelsea Hotel with Love*, 1968. © DACS 2021.

p. 282 Fontana with his wife Teresita (to his right) and friends during a trip to Egypt in 1963.

p. 284 Accardi.

p. 286 Lonzi in front of *Saffo* ('Sappho') by Paolini (De Nieubourg Gallery, Milan, 1969). Photo: Ugo Mulas © Ugo Mulas Heirs. All rights reserved.

p. 287 Kounellis with his mother in 1939.

p. 292 Fontana with Fausto Melotti in 1947 in Milan.

p. 297 Lonzi at Hemisfair, San Antonio, Texas, in 1968. Courtesy: Archivio Pietro Consagra.

p. 300 Accardi between Rotella and Piero Dorazio in Piazza San Marco in Venice during the 1954 Biennale. © DACS 2021.

p. 301 Nigro on the Venice Lido in 1952.

p. 307 From left to right: Campbell, Lockhart and Keech, 1928.

p. 309 Pascali in a camouflage suit photographing the missile launchers *Uncle Tom and Uncle Sam* on the terrace of his studio in Rome in 1965.

p. 311 Alviani, *Disco* ('Disc'), steel, 1965. Courtesy: Centro studi archivio e ricerche Getulio Alviani.

p. 314 Kounellis with his wife Efi.

p. 317 Giorgio de Chirico, *L'enigma della fatalità* ('The Enigma of Fatality'). © DACS 2021.

p. 322 Fabro with his daughter, wife, aunt, mother and uncle in Treppo Grande (Udine) in 1964. © Archivio Luciano e Carla Fabro.

While every effort has been made to trace and contact copyright-holders, in some
cases this has proved impossible, or has not resulted in a response at the time of
going to print. The translator and publisher would be grateful for any information
that would enable any omissions to be made good in future editions of the book.

Artist biographies

Carla Accardi (b. 1924, Trapani; d. 2014, Rome) was an Italian painter. She was a founding member of the art groups Forma 1 (1947) and Continuità (1961), and the feminist collective Rivolta Femminile (1970).

Getulio Alviani (b. 1939, Udine; d. 2018, Milan) was an Italian painter, designer and curator, who contributed to the Op Art and Kinetic movements and is known for his 'vibrating texture surfaces'.

Enrico Castellani (b. 1930, Castelmassa; d. 2017, Celleno) was an Italian painter associated with the ZERO movement and the Azimuth exhibition space. He was regarded by some as 'the father of Minimalism'.

Pietro Consagra (b. 1920, Mazara del Vallo; d. 2005, Milan) was an Italian sculptor. He was a founding member of the art group Forma 1, whose artmaking was informed by Marxism and formalism.

Luciano Fabro (b. 1936, Turin; d. 2007, Milan) was an Italian sculptor, conceptual artist and writer whose work was associated with the Arte Povera movement.

Lucio Fontana (b. 1899, Rosario; d. 1968, Comabbio) was an Argentine-Italian painter, sculptor and theorist. He was the founder of Spatialism (1947), which saw 'a new dimension of the Infinite' in art.

Jannis Kounellis (b. 1936, Piraeus; d. 2017, Rome) was a Greek-Italian performance artist and sculptor. A key figure of Arte Povera, he is known for incorporating 'real life' into his installations.

Mario Nigro (b. 1917, Pistoia; d. 1992, Livorno) was an Italian pharmacist and abstract painter. He is known for his chromatism, what he described as a 'metaphysics of colour'.

Giulio Paolini (b. 1940, Genoa) is an Italian artist, writer and set designer. Associated with Arte Povera and conceptual art, Paolini's work is concerned with 'the act of exhibiting'. He lives in Turin.

Pino Pascali (b. 1935, Bari; d. 1968, Rome) was an Italian sculptor. His shaped-canvas 'fake sculptures' and series of 'weapons' made from found car parts made important contributions to Pop Art and Arte Povera.

Mimmo Rotella (b. 1918, Catanzaro; d. 2006, Milan) was an Italian artist. Associated with the French Nouveau Réalisme movement and Pop Art, he's best known for his décollages of advertising posters.

Salvatore Scarpitta (b. 1919, New York; d. 2007, New York) was an Italian-American artist known for his bandaged canvases and racing-car replicas. In the 1980s he created video works, including *Sal Is Racer*.

Giulio Turcato (b. 1912, Mantua; d. 1995, Rome) was an Italian artist and founding member of the art group Forma 1. He was one of the most important interpreters of pictorial abstractionism.

Cy Twombly (b. 1928, Lexington; d. 2011, Rome) was an American artist who moved to Italy in 1957. Mythological subjects influence his abstract paintings, which have been interpreted as a medium for 'writing'.

Translator's acknowlegements

Like Carla Accardi I want to name the names of the people who have helped make this book happen. There have been many. Thank you Nicholas Tammens for those very first discussions and your endless encouragement. Thank you Marco Palmieri, Catherine Parsonage and Rosanna McLaughlin for that fateful dinner in Trastevere. Thank you Allison Katz for believing in this book from that night in Rome onwards, for wanting to help it come to life and for making its gorgeous cover. Thank you Anna Gorchakovskaya for seeing the potential in this book. And thank you Cristiana Collu and Battista Lena, without your generosity this translation would never have happened. I am honoured and grateful. Thank you to the Galleria Nazionale and the Carla Lonzi Archive, particularly Claudia Palma and Clementina Conte. Thank you also to Abscondita for your willingness to share knowledge about the Italian editions of this book. Thank you Michael Callies and dépendance for your trust and support. Thank you Matilde Guidelli-Guidi for reaching out to collaborate and reviewing a draft of the translation, as well as Kamilah N. Foreman, Jessica Morgan, David Morehouse, Karey David and Kseniya Ignatova-Yates at Dia Art Foundation; this publication is in part financially supported by Elisa Sighicelli. This book has taken over my life for the past three years and without certain people I don't know how I would have done it. Thank you Giulia Crispiani for your careful reading and willingness to work through the toughest passages with me. Thank you to Marta Federici for the discussions and engagement with me and this text. Thank you Giulia Quadrelli who supported me all through this unwieldy undertaking and helped parse even the strangest turns of phrase – living with a translator can't be easy and I am grateful for your patience and energy. Thank you Jamie Richards, a translator I deeply admire, for reading drafts and sharing ideas. And thank you Boris Dralyuk at the *Los Angeles Review of Books*, where an excerpt of this translation first appeared. I want to thank the curators at MAMbo,

Lorenzo Balbi, Caterina Molteni and Sabrina Samorì, who gave me space and time during the pandemic to think and write and work. I would like to thank Jacob Blandy, I've never met an editor so sharp, and Marianne Plano who has made this book so beautiful. Thank you to Divided Publishing – Camilla Wills and Eleanor Ivory Weber – who took a chance on publishing their first translation. This experience couldn't have been better, working with you has been a feminist dream.

Allison Grimaldi Donahue, October 2021

About the author

Carla Lonzi (b. 1931, Florence; d. 1982, Milan) was an art critic and feminist activist best known for her work with Rivolta Femminile, a feminist collective created in 1970. Following the publication of *Autoritratto* ('Self-portrait') in 1969, Lonzi published *Manifesto di Rivolta femminile* (1970), *Sputiamo su Hegel. La donna clitoridea e la donna vaginale e altri scritti* (1974) and *Taci, anzi parla. Diario di una femminista* (1977). Due to her uncodified practice, she occupies a singular position within post-war Italian politics and art, and is a crucial figure of European feminism.

About the translator

Allison Grimaldi Donahue (b. 1984, Middletown, Connecticut) is the author of *Body to Mineral* (Publication Studio Vancouver, 2016) and the co-author of *On Endings* (Delere Press, 2019). Her writing and translations have appeared in *The Brooklyn Rail*, *Words without Borders*, *Flash Art*, *BOMB*, *NERO* and *Tripwire*, and her performances have been presented in Italy at Gavin Brown's enterprise, MAMbo, MACRO and Short Theatre. She is a 2021–22 resident of Sommerakademie Paul Klee, Bern. She lives in Bologna.